Liam Kennedy is Professor of American Studies and Director of the Clinton Institute for American Studies at University College Dublin. He is the author of *Susan Sontag* (1995), *Race and Urban Space in American Culture* (2000) and *Afterimages: Photography and US Foreign Policy* (2015), and editor of *Urban Space and Representation* (1999), *The Visual Culture of Urban Regeneration* (2004) and *The Wire: Race, Class and Genre* (2012). He has directed an Irish Research Council for the Humanities and Social Sciences-funded project on photography and international conflict (www.photoconflict.com).

Caitlin Patrick was Postdoctoral Fellow on the Photography and International Conflict project from 2008 to 2011. She has also been a research associate for three other photography-based projects: *Imaging Famine* (2005), *The Visual Economy of HIV/AIDS as a Security Issue* (2008) and *I-Witnessing: Global Crisis Reporting Through the Amateur Lens* (2011–2012). She is currently based at King's College London as Research Methods Co-ordinator for the King's Interdisciplinary Social Science Doctoral Training Centre.

THE VIOLENCE OF THE IMAGE

PHOTOGRAPHY AND INTERNATIONAL CONFLICT

EDITED BY **LIAM KENNEDY** AND **CAITLIN PATRICK**

I.B.TAURIS
LONDON · NEW YORK

Published in 2014 by I.B.Tauris & Co Ltd
6 Salem Road, London W2 4BU
175 Fifth Avenue, New York NY 10010
www.ibtauris.com

International Library of Visual Culture 15

ISBN: 978 1 78076 788 8 (HB)
ISBN: 978 1 78076 789 5 (PB)
eISBN: 978 0 85773 574 4

A full CIP record for this book is available from the British Library

Typeset in 11.5/13.8pt Adobe Caslon Pro by JCS Publishing Services Ltd,
www.jcs-publishing.co.uk

Printed and bound in Great Britain by T. J. International, Padstow, Cornwall

Contents

Illustrations

(NTC) commander told AFP that Gaddafi was captured as his hometown Sirte was falling, adding that the ousted strongman was badly wounded. AFP/DSK/Getty Images 179

Plates

1 Martin Melaugh, "Bloody Sunday": large scale in situ', Bogside, Derry, 18 September 1997, Copyright Cain.
2 Martin Melaugh, "Bloody Sunday": large scale in situ', Bogside, Derry, 18 September 1997, Copyright Cain.
3 Paul Seawright, 'Black Spike, Belfast 1997', from the series 'Fires', 1997.
4 John Duncan, 'Untitled', from the series 'We Were Here', 2006.
5 'La Madone de Bentalha': a woman cries outside the Zmirli Hospital, where dead and wounded were taken after a massacre in Bentalha. Hocine Zaourar/AFP.
6 An image from Michael van Graffenried's *Inside Algeria*. © Michael von Graffenried, www.mvgphoto.com, courtesy Galerie Esther Woerdehoff Paris.
7 An image from Omar D's *A Biography of Disappearance*, Algeria 1992. © Omar D, courtesy Autograph ABP.
8 Burqas hang in a cell in a women's prison in Kabul, Afghanistan, on Thursday 29 November 2001. A month after the Northern Alliance marched into Kabul, the prison remains a reminder of the oppression women suffered at the hands of the rigid Taliban. Marco Di Lauro/AP.
9 Amongst others covered in burqas, an Afghan woman shows her face as she tells the photographer, 'we don't need pictures, we need food' while Afghan women and children beg for food and money in Herat, Afghanistan, Saturday 8 December 2001. Kamran Jebreili/AP.
10 Women speak to each other under a sign against cruelty to women in Afghanistan outside the United Nations High Commission for Refugees office in Islamabad, Pakistan, Tuesday 2 October 2001. John McConnico/AP.
11 Ethnic cleansing: Arkan's Tigers kill and kick Bosnian Muslim civilians during the first battle for Bosnia in Bijeljina, Bosnia, 31 March 1992. Ron Haviv/VII.

Contributors

Stuart Allan is Professor of Journalism and Communication, as well as Deputy Head of School (Academic) in the School of Journalism, Media and Cultural Studies (JOMEC) at Cardiff University, UK. His books include *Citizen Witnessing: Revisioning Journalism in Times of Crisis* (Polity Press, 2013). He is currently engaged in research examining citizens' uses of digital imagery in news reporting, while also writing a historiography of war photography.

Ariella Azoulay, Department of Modern Culture and Media and the Department of Comparative Literature, Brown University. Her recent books include: *From Palestine to Israel: A Photographic Record of Destruction and State Formation, 1947–1950*, (Pluto Press, 2011), *Civil Imagination: The Political Ontology of Photography* (Verso, 2012) and *The Civil Contract of Photography* (Zone Books, 2008); co-author with Adi Ophir, *The One State Condition: Occupation and Democracy between the Sea and the River* (Stanford University Press, 2012). She is a curator and documentary film maker. Among her recent projects are: *Potential History* (2012, Stuk/Artefact, Louven), *Civil Alliances, Palestine, 47–48* (2012).

David Campbell is a writer, professor and producer who analyses visual storytelling and creates new visual stories. The author of six books and more than 60 articles, he has produced three visual projects: 'Atrocity, Memory, Photography: Imaging the Concentration Camps of Bosnia', 'Imaging Famine' and 'The Visual Economy of HIV-AIDS'. David writes about documentary photography and photojournalism, the disruption in the media economy, and its impact on visual journalism, in addition to his long-term commitment to understanding international politics. As a research consultant to World Press Photo he directed their 2012–13 Multimedia Research Project and a 2014 project on 'The Integrity of the Image'. David produces multimedia and video projects, often in collaboration with photographers, and all his work can be seen at www.david-campbell.org.

Justin Carville teaches Historical and Theoretical Studies in Photography and Visual Culture Studies at the Institute of Art, Design and Technology, Dun Laoghaire. A former Government of Ireland Senior Research Scholar in the Humanities and Social Sciences (2003–4) and an IRCHSS Research Fellow (2008–9), he has published widely on the history of photography and visual culture. He has guest edited an Ireland-themed issue of the the the *Journal of Popular Visual Culture* and an issue of the journal *Photographies*. He is the author of *Photography and Ireland* (Reaktion, 2011) and the edited volume *Visualizing Dublin: Visual Culture, Modernity and the Representation of Urban Space* (Peter Lang, 2013).

Robert Hariman is Professor of Communication Studies at Northwestern University. He is the author of *Political Style: The Artistry of Power* (University of Chicago Press, 1995) and, with John Louis Lucaites, *No Caption Needed: Iconic Photographs, Public Culture, and Liberal Democracy* (University of Chicago Press, 2007). He also has published three edited volumes and numerous book chapters and journal articles in several disciplines, and his work has been translated into French and Chinese. He and co-author John Lucaites post regularly at nocaptionneeded.com, their blog on photojournalism, politics and culture.

Liam Kennedy is Professor of American Studies and Director of the Clinton Institute for American Studies at University College Dublin. He is the author of *Susan Sontag* (1995), *Race and Urban Space in American Culture* (2000) and *Afterimages: Photography and US Foreign Policy* (2015), and editor of *Urban Space and Representation* (1999), *The Visual Culture of Urban Regeneration* (2004) and *The Wire: Race, Class and Genre* (2012). He has directed an Irish Research Council for the Humanities and Social Sciences-funded project on photography and international conflict (www.photoconflict.com).

Wendy Kozol is Professor of Comparative American Studies at Oberlin College. She is the author of *Life's America: Family and Nation in Postwar Photojournalism* and co-editor (both with Wendy Hesford) of *Haunting Violations: Feminist Criticism and the Crisis of the 'Real'* and *Just Advocacy: Women's Human Rights, Transnational Feminism and the Politics of Representation*.

Paul Lowe is the Course Director of the Masters programme in photojournalism and documentary photography at the London College of Communication, University of the Arts London. He is an award-

winning photographer, whose work is represented by Panos Pictures, and who has been published in *Time*, *Newsweek*, *Life*, the *Sunday Times Magazine*, the *Observer* and the *Independent* amongst others. He has covered breaking news the world over, including the fall of the Berlin Wall, Nelson Mandela's release, famine in Africa, the conflict in the former Yugoslavia and the destruction of Grozny. He is a consultant to the World Press Photo foundation in Amsterdam on online education of professional photojournalists in the majority world. His book, *Bosnians*, documenting ten years of the war and postwar situation in Bosnia, was published in April 2005 by Saqi books. He also carries out research into the relationship between photography and conflict, and the coverage of human rights abuse and genocide.

Joseph McGonagle is Lecturer in Cultural Studies in the French-speaking World at The University of Manchester, UK. His co-authored monograph with Edward Welch – *Contesting Views: The Visual Economy of France and Algeria* – was published by Liverpool University Press in 2013 and he has published several articles on French and Francophone visual cultures in journals, including *Studies in French Cinema*, *Studies in European Cinema*, *French Cultural Studies*, *Modern & Contemporary France*, *Journal of Romance Studies* and *L'Esprit créateur*.

Caitlin Patrick was Postdoctoral Fellow on the Photography & International Conflict project from 2008–11. She has also been a research associate for three other photography-based projects: *Imaging Famine* (2005), *The Visual Economy of HIV/AIDS as a Security Issue* (2008) and *I-Witnessing: Global Crisis Reporting Through the Amateur Lens* (2011–12). She is currently based at King's College London as Research Methods Co-ordinator for the King's Interdisciplinary Social Science Doctoral Training Centre.

Christina Twomey is Professor of History at Monash University and an Australian Research Council Future Fellow, 2012–16. In 2012, she was Distinguished Visiting Chair of Australian Studies at the University of Copenhagen. She is the author of three books, including *Australia's Forgotten Prisoners: Civilians Interned by the Japanese in World War II* (Cambridge, 2007) and *A History of Australia* (Palgrave Macmillan, 2011) co-authored with Mark Peel. Christina has also published widely on welfare history, memory and war, prisoners of war and in the field of atrocity and photography.

Introduction

The Violence of the Image

Liam Kennedy and Caitlin Patrick

Photography has been instrumentally involved in the visualisation of international relations and conflicts since its invention in the mid-nineteenth century. In part this is due to the historical connections between the evolution of the medium and the worldviews of imperial Western powers, connections that echo through to the present day as photography continues to be an important medium in framing the worlds of distant, exotic and suffering others. Over this period, photography evolved conventions and frames – ways of seeing – that mediated the complex interconnections of humanistic and imperial perspectives. This book considers the legacies of these ways of seeing, examining the roles of (post-)colonial, humanitarian and cosmopolitan frameworks in photographic practice, and analyses the emergence of alternative frameworks for understanding representations of violent conflict and bodies in pain, and the role of new media landscapes and technologies on the imaging of conflict.

Throughout much of the twentieth century, photojournalism was the premier visual genre in news media framing of international affairs and it provides a core focus for many of the writings in *The Violence of the Image*. Photojournalism has a complex relationship with the visual production of national identities and their international extensions. It is intrinsically transnational, both as a medium of representation and as a political economy of image production, yet also commonly functions as a privileged medium of 'Western' values and worldviews. In concert with other news media, photojournalism has played a significant role in mediating the relationship between national and international affairs, shaping perceptions of the relations between the domestic and the

foreign. It conventionally frames worlds of conflict and violence beyond the nation state, thereby shaping the composition of differential norms – such as humanity and otherness – that are crucial to understanding ethical and political relations in international affairs.

A key tenet of the visual philosophy of mid-century photojournalism was its commitment to a democratising vision of human affiliations and an imaginary globalisation of conscience. It posited a culture of humanity as a universal ideal and human empathy as a compensatory response to global threats – particularly to the threat of nuclear annihilation – and promoted compassion as a commensurate response to the suffering of distant others. This philosophy promoted a complex moral economy that was fuelled by abstract principles of liberal humanitarianism, defined categories of human need and harm, and constituted caring and suffering subjects through conventions of visual representation. Photojournalism played an important role in giving visual form to this moral economy. Through its use of generic tropes and formal conventions, it fashioned scenes and scenarios and composed bodies and landscapes in ways that foregrounded issues of human relationality. For many photojournalists this economy was ethically underwritten by the idea of 'witnessing', which is historically entwined with the conventions of the genre and the charged, affective appeals to human action based on displays of human suffering.

This now classic model of photojournalism has been widely challenged and in some significant respects superseded. For some, the valorisation of truth claims and of humanistic appeals to empathy and compassion has rendered photojournalism fatally compromised or exhausted as a mode of visual-knowledge production. However, the frequent claims that photojournalism is dead are premature. In the twenty-first century its status remains somewhat diminished, and yet its mutations in relation to the new technologies of seeing and the new global scenes it represents have provided the photojournalistic image with an afterlife. We analyse these issues in relation to selected examples of photojournalistic representation and attention to the political economy of the industry.

Photography and warfare have long existed in a symbiotic relationship – they share technologies and 'ways of seeing' – and the emergence of new forms of warfare and of visual technology and representation underline this. In recent years, virtual battlefields of images and information have taken on an important role in the production of foreign policy and international relations. And so, management of the field of vision becomes a key component in the geopolitical stratagems of twenty-first-

century conflicts. For photographers there are new challenges to make visible the realities of warfare and conflict under such conditions. There are also new challenges to make violence and its conditions and results meaningful, for new forms of warfare have conditioned new forms of violence, much of it 'untethered' from the grand political narratives of the twentieth century. A key concern of this book is to examine the shifting relations between visuality and the violence of conflict, which now often involves protracted, 'managed' catastrophes for particular groups, often non-combatants, as well as high-tech or set-piece battles.

The proliferation and convergence of new media technologies – satellite, the internet, digital image production – has greatly expanded the media sphere in which imagery of contemporary conflict circulates, and also expanded the global capacities for visually documenting abuses and violations. With citizen journalists playing an increasingly significant part in such visual documentation, there are now many initiatives to capture and use this capacity. This has become especially important in the visual documentation and communication of human rights abuses. Photography has taken on a fresh valence in this context as an accessible mode of documentary evidence, yet it is bedevilled by issues of authenticity and verifiability that underline the ideological conditions of the relationship between seeing and believing.

Authors will look in some detail at ways in which photographic imagery of conflict has mutated in the digital age to both support and challenge the state's geopolitical visions. The advent of digital photography, of camera phones and of photoblogging has introduced new relations between photographers, the medium and the audience. The photographic image is today an electronic image and its ubiquity feeds the 'image wars' of the twenty-first century that are increasingly mediated by new technologies. The promiscuity of this imagery is enhanced by the disintegration of discrete categories and genres of visual information in the digital age. There is an ongoing blurring of the boundaries between news and entertainment, between professional and amateur journalism, and between modes and genres of photographic representation. The resulting instability of visual fields is a significant backdrop to the analysis of contemporary photographic visualisation of international conflict.

Running throughout *The Violence of the Image* is an inquiry into the high value (ethical, socio-political, legalistic) that continues to be placed on the power of visual media to bear witness and to stimulate social change. It presages a number of questions that echo across the chapters. How has the global dissemination of new technologies affected the role

of the image-maker as witness? What capacities for critique do images maintain? What new visual vocabulary is emerging to represent new forms of war?

The contributions to Part I are held together thematically by the authors' close visual readings of both iconic and lesser-known twentieth-century conflicts, ranging from the very beginnings of the century to its last decade. Christina Twomey undertakes a detailed exploration of the politics and institutional alliances that facilitated the creation and distribution of early 'atrocity' photographs from King Leopold's Congo at the start of the twentieth century. Challenging much current literature, Twomey argues that any link between these photos and larger concepts of 'human rights' and 'crimes against humanity', formally developed in the wake of World War II, is tenuous. While not denying their continuing social relevance, Twomey argues that the public impacts of these photos should be read subtly and with reference to historical records. Liam Kennedy's chapter analyses Magnum photographer Philip Jones Griffiths's work on the Vietnam War and its aftermath, exploring a conflict that has a globally recognised photographic legacy with a reputation for its critical and political effects. Kennedy addresses the possibilities for visual representation of imperialism and globalisation head on, arguing that Griffiths's photojournalism is able to transcend limited understandings of these popular framings while continuing to exemplify the ethos of 'concerned photojournalism'.

Expanding Kennedy's thoughts on how photojournalistic work might 'live on' after the events that it represents have ended, Justin Carville considers how photography has been mobilised both for and against dominant visual narratives of the Northern Ireland conflict. Carville analyses how a framework of relations between photojournalism, the mainstream media and the state worked to confine and define how photography could be used to express dissent in media coverage and judicial tribunals following the Bloody Sunday events of January 1972 in Derry. Drawing on John Tagg's most recent theoretical work, Carville illustrates how, once freed from the discursive burdens of 'proof' and 'veracity', re-presentations of photojournalistic work taken during the Bloody Sunday conflict and new 'late photographic' genres both participated in acts of public commemoration which challenged the violence of state-organised tribunals of appeal. Such uses of photography also began to establish a new societal place particularly for photojournalism, which has often been treated – both historically and in current times – as a 'throw-away', temporary or habitual form of

imagery. Finally, Joseph McGonagle introduces readers to a twentieth-century conflict that remained largely unreported in much Western mainstream media. McGonagle surveys the work of three photographers of the Algerian Civil War, which spanned the 1990s, to explore their diverse approaches to creating iconic moments, representing daily life during war and facilitating complex, ongoing processes of remembering and memorialising the dead and missing.

The Violence of the Image's second section addresses some of the long-standing issues for twentieth-century photography, moving these debates forward and engaging with significant new conceptualisations of photography as an ethical practice. While upfront about its limitations and sometimes problematic history, these authors are optimistic about the unique insights photography can offer into new forms of global violence. David Campbell deals directly with the popular concept of 'compassion fatigue' and ongoing theoretical and practical concerns regarding the political capacity of photography to 'move' its audiences. He delivers a compelling clarification and critique of the current melange of ideas subsumed by this broad term as it relates to photography, arguing that compassion alone cannot be the basis for political mobilisation given its limitation to a vicarious experience of suffering, usually on an individualised level. In her contribution, Ariella Azoulay expands on her groundbreaking theoretical work from *The Civil Contract of Photography* to focus specifically on the 'regime-made disaster' and 'infra-destruction', illustrating how photography might both expose and conceal aspects of such crises in Israel/Palestine. Azoulay demonstrates how Palestinians suffer as differentially isolated 'non-citizens', a situation that in her eyes damages the entire body politic and results in a situation where groups of citizens cannot 'see' the disaster their regime perpetrates on others as such. Finally, Robert Hariman provides a comprehensive update on both the changes and the continuities in practices of war and war photography, illustrating how the two influence and respond to each other. Hariman undertakes a close analysis of two recent significant theorisations of photography's relation to conflict: those of Susie Linfield and Ariella Azoulay. Photography's value for illustrating both the 'untethered' nature of much contemporary violence and for exposing the 'permanent catastrophe' of the non-citizen is laid out. Hariman concludes with a discussion of photography's long-term stylistic interest in 'fragments', 'traces' and 'banality', highlighting the value of these aspects of visual vocabulary for representing new forms of violence.

Part III rounds off the collection by addressing current conflicts and the new dynamics of their representation by both professional and citizen photojournalists. Stuart Allan's chapter contributes directly to these discussions with a close study of the recent uprising in Libya, including an analysis of the ethical and journalistic challenges of representing Muammar Gaddafi's capture and death, as visualised by his enemies and other eyewitnesses. Wendy Kozol takes up the concept of the 'trace' in photography as introduced by Hariman, developing this term with relation to visual documentation of women and girls in Afghanistan after Western intervention there in 2001. Kozol's chapter, linking to this book's broader themes of photography's connection to human rights discourses, highlights important photographic moments when Afghan women and girls 'look back' at the camera, the witness and the audience in unanticipated ways, allowing a destabilisation of traditional photojournalistic witnessing practices based on pity or post-colonial women's victimhood.

The final two chapters look beyond widespread twentieth-century understandings of photojournalism to investigate new spaces of viewing and conceptual approaches to conflict photography, discussion of which has been begun by Carville. Paul Lowe delves into the capacities of the photograph as a material object to act as a bearer of witness to past atrocities; this focus on the 'object' qualities of the photograph – be it digital or analog – is extended analytically to photographs of atrocity which contain objects, rather than suffering or victimised subjects. For Lowe, the often seemingly banal objects in such photos, particularly those of Gilles Peress, Gary Knight, Simon Norfolk and Ziyah Gafic, can act to disrupt linear historical narratives and 'touch' viewers in different historical times and places. Finally, extending Lowe's analysis of various forms of 'aftermath' photography and the 'traces' therein, Caitlin Patrick raises questions regarding the political capacity of such images, picking up on themes addressed by Campbell. Patrick surveys the recent blurring of photographic genres and the increasing presence of documentary photography and photojournalism in gallery spaces, evaluating critiques that such photography has come under for its alleged depoliticisation and ambivalence.

Part I

Framing Civil and (Post-) Colonial Conflict

1 The Incorruptible Kodak

Photography, Human Rights and the Congo Campaign

Christina Twomey[1]

Alice Seeley was unmarried, in her late twenties, and working at a post office in London when Kodak advertised its Bulls-Eye camera in 1897.[2] Quoting a special correspondent, who claimed that he was able to change the roll of film in his camera 'in the full glare of the tropical sun' during assignment in Africa, Kodak declared that its 'cartridge system' had created 'a perfect revolution in photography'. Having dispensed with the need of a dark room, the art of photography was 'within universal reach'.[3] Photography was now within the purview of 'Ladies, Cyclists, Tourists and Holiday-Makers'.[4] Alice Seeley was a lady with dreams of travelling abroad, to a place with tropical sun, but not to cycle or enjoy a holiday. She had just trained as a missionary and was about to marry John Hobbis Harris, a man who shared her vocation and with whom she would set sail for Africa in 1898.[5] The suffering that Alice Seeley Harris witnessed in the Belgian king Leopold's Congo Free State, captured on film with her camera, helped the organised campaign for reform in Congo to become the first humanitarian crusade of the twentieth century.[6] Among Alice Seeley Harris's most famous images were men, women and children who had been mutilated – by having their hands or feet severed – or murdered by soldiers licensed to maim and kill in rapacious pursuit of rubber and profit.

Just over a decade later, in 1910, Marguerite Roby, another intrepid British woman, set off to journey through the Congo with her camera. Roby was no earnest missionary. Kitted out in a man's hunting outfit, carrying a gun and riding a bicycle, Roby 'intended to be patient and keep my eyes open, for I meant to take photographs of any mutilations or other evidences of tyranny which I might come across during my

travels'.[7] She didn't find any, and instead illustrated her travel memoir with photographs of scenes and sights, including her healthy, well-fed 'boys', dancers, mission compounds and a smiling 'Chief who said he had nothing to smile at'. As one reviewer said at the time, 'It is hard to rid oneself of the impression that Mrs Roby "had her suspicions" beforehand.'[8] In her account, written in a 'jolly hockey sticks' tone, in which the natives are there to serve, amuse or invoke derision as lazy good-for-nothings, Roby derided Congo reformers and pilloried their well-known phrase about the 'incorruptible evidence of the Kodak'.[9] A picture of mutilation was not enough – information was needed on *where* and *when* the image was taken – otherwise 'mistakes and misunderstandings' would arise, which was a very unsatisfactory state of affairs 'in a case where a nation's honour is concerned'.[10]

By the time Marguerite Roby toured the Congo, it had been annexed by Belgium, after a most controversial period as the Congo Free State (1885–1908), a name that belied its status as the personal fiefdom of the Belgian king, Leopold II. Ostensibly a philanthropist committed to preventing slavery in Central Africa, King Leopold II had promised to allow free trade and missionaries into his domain. He thereby became a beneficiary of the Berlin Conference of 1884–5, which granted him authority over the Congo. The Berlin Act of 1885, an effort to regulate European imperialist ambitions in Africa, in effect delivered large swathes of territory to a monarch accountable to no one. Leopold's rule over the Congo, a region rich in rubber resources, coincided almost exactly with increased global demand for rubber products, especially bicycle and car tyres. Within a decade, Leopold had assumed proprietorship over virtually all land in the territory, monopolised the trade in ivory and rubber, and set exorbitant rubber-collection targets for its inhabitants. In order to enforce production quotas, men recruited into Leopold's Force Publique routinely used brutal tactics of hostage taking, murder, massacre, sexual violence and mutilation to terrorise and intimidate their subjects.[11]

One of the most notorious tactics was cutting off the hands of victims, either to intimidate them or as macabre proof to authorities that a bullet had not been wasted. The removed hand was meant to suggest that each bullet expended had achieved its purpose and claimed a life. There were European and American missionaries resident in the Congo who had complained of these practices since the 1890s, but some of the largest missionary organisations, concerned to keep their toehold in Central Africa, were reluctant to attract the displeasure of Leopold.[12] Furthermore, Leopold employed agents in England and the

United States to undermine, counteract and refute the claims of abuses, by suggesting that they were the work of disgruntled missionaries or frustrated traders keen to get their hands on the Congo's riches.[13] It is unclear whether Marguerite Roby was in Leopold's purse, but her efforts resembled many who were.

The significance of photographs for the humanitarian campaign to end atrocities in the Congo, which gathered strength from 1903, was not lost on contemporaries, as Roby's attempt to undermine them makes clear. The alliteration of Kodak, Congo (sometimes spelt as Kongo) and camera proved an irresistible combination. A pamphlet entitled *The Camera and the Congo Crime* and 'The Kodak on the Congo', a photo-essay of Alice Harris's images, featured in the reform campaign.[14] It was after seeing photographic images of the mutilations and suffering in the Congo, sent to him by English reformers aware of his reputation as an anti-imperialist, that Samuel Clemens (publishing as Mark Twain) decided to pick up his pen in support of the cause. Although its literary merit was debatable, Mark Twain's *King Leopold's Soliloquy*, in which the Belgian King rages insanely against his critics, proved a memorable intervention on the side of the Congo reformers. The book also included photographs, at Twain's insistence.[15] Twain made the most famous link between the Kodak and the Congo, one repeated by other prominent supporters of the campaign such as Arthur Conan Doyle and quoted many times since. Twain has Leopold declare, after studying 'some photographs of mutilated negroes':

> The kodak has been a sore calamity to us. The most powerful enemy that has confronted us, indeed. In the early years we had no trouble in getting the press to 'expose' the tales of the mutilations as slanders, lies, inventions [...] I was looked up to as the benefactor of the down-trodden and friendless people. Then all of a sudden came the crash! That is to say, the incorruptible kodak – and all the harmony went to hell! The only witness I have encountered in my long experience that I couldn't bribe. Every Yankee missionary and every interrupted trader sent home and got one; and now – oh well, the pictures get sneaked around everywhere, in spite of all we can do to ferret them out and suppress them.[16]

One review of the *Soliloquy* even claimed that it showed 'The Kodak as Emancipator'.[17] Indeed, the visual record of the brutality of Leopold's regime, particularly as it was captured and deployed by

missionaries in the form of photographs and lantern-slide lectures which utilised photographic images, is often seen as the turning point in the Congo campaign.[18]

There are scholars who even suggest that the use of photographic images by Congo reformers was an important moment in the evolution of human rights. Arguing for the importance of the aesthetic realm, visual cultures and spectatorship to the articulation of rights discourses (as opposed to the textual emphasis inherent in a focus on political and juridical spheres), Sharon Sliwinski argues that 'the very recognition of what we call human rights is inextricably bound to aesthetic experience.' 'The conception of rights did not emerge from the abstract articulation of an inalienable human dignity,' she writes, 'but rather from a particular visual encounter with atrocity.' In this reckoning, the Congo atrocities were a key moment in that evolution. The idea of universal human rights, Sliwinski concludes, 'were conceived by spectators who with the aid of the photographic apparatus were compelled to judge that crimes against humanity were occurring to others'.[19] Susie Linfield has also pointed to the Congo campaign as evidence of the 'intimate connection between an international human-rights consciousness and the photograph'.[20]

This chapter takes issue with the argument that photographic images of atrocities in the Congo represent an important moment in the way that 'spectators' and 'audiences' thought about and came to understand 'human rights'. Apart from the fact that the 'spectators' are never defined, nor even quoted, beside the loose assumption that they were horrified audiences in Britain and the United States, these approaches employ a teleological understanding of 'human rights' which assumes that this was a shared narrative of common understanding in the early twentieth century. There is now a vein of critical scholarship that dates talk of 'human rights' to the 1940s onwards, which is at the same time careful to warn against pedantry around terminology when criticising others for looking back and seeing the emergence of 'human rights' at every turn.[21] Clearly 'rights' – variously conceived – were a critical element of discussion in Europe for several centuries, but 'human rights' and 'crimes against humanity' are particular articulations that are largely a post-World War II construction and, as a mobilising language in humanitarian politics, more accurately dated to the 1970s.[22]

The fact that one of the earliest missionary critics of Leopold's role, African-American George Washington Williams, referred to the regime's 'crimes against humanity' in a letter to the US Secretary of State in 1890 does not mean that this became a defining discourse

of Congo reform.[23] It takes more than one swallow to make a summer. Sliwinski marvels at the mention of the phrase 'some fifty years before Auschwitz'.[24] Similarly, Adam Hochschild describes it 'as a phrase that seems plucked from the Nuremberg trials of more than half a century later'.[25] In practice, very few Congo reformers mentioned 'human rights' or 'crimes against humanity' at all. Mining the archive for mentions of 'crimes against humanity', one or two references to which have been found, does not prove a relationship between photography and 'human rights consciousness', at least not in this early twentieth-century period.[26]

One of the noticeable features of the language used in the Congo reform campaign is the difficulty that activists, journalists and others faced in finding just the right words to describe what it was they had witnessed and sought to overcome. Certainly, as others have suggested, the photographs were an important element in this campaign, but it is incumbent on the historian to ask why it was in relation to *this* issue that the photographic images of harm done to other human beings became so important. If there truly was a relationship between a nascent appreciation of 'human rights' and photography, one might expect greater evidence of it. For there were plenty of other horrible things that could have been photographed and publicised around the turn of the century – the appalling emaciation and suffering of the *reconcentrados*, Cuban civilians who had been 'concentrated' and effectively starved during the Spanish–Cuban war, the Boer women and children who had wasted in British concentration camps during the South African War, the Herero who had been massacred and subjected to forced labour in German south-west Africa. Similarly, when 'crimes against humanity' did achieve narrative centrality in 1915 in the effort of the governments of Britain, France and Russia to bring the Ottoman government to account for the massacre of Armenians during World War I, we might expect photographs to play a key role if they were central to a dawning era of rights consciousness. But they did not. The use of photography in the Congo campaign therefore needs to be considered as an exceptional case, rather than as indicative of a key shift in the development of 'human rights'.

Congo Critics

The London-based Aborigines' Protection Society (APS) had attempted to raise awareness of conditions in the Congo since the late 1890s, by holding meetings to publicise the revelations of visiting missionaries,

initiating debates in the House of Commons and sending deputations to Brussels. Its secretary, Henry Fox Bourne, had been tireless in his efforts to expose the abuses attendant on Leopold's rule, collating the evidence of missionaries, traders and officials in his 1903 publication, *Civilisation in Congoland: A Story of International Wrong-Doing*.[27] By that time, the exploitation of the Congo's people had also come to the attention of Edmund Dene Morel, an astute shipping clerk who had a facility with numbers and words. Regularly visiting Antwerp on behalf of his Liverpool firm, which supplied Leopold with trading vessels, Morel correctly calculated that the amount of arms and ammunitions sent to the Congo and the value of rubber returned to Europe could mean only one thing: the exploitation of the Congolese people in the pursuit of profit. The same year that Fox Bourne published *Civilisation in Congoland*, Morel launched the *West African Mail*, a trade journal at that time, but one which would ultimately be used, within a few years, to criticise the practices of Leopold's regime.

Fox Bourne had been in touch with missionaries critical of the Congo regime since the 1890s. In 1902 W.M. Morrison of the American Presbyterian Congo Mission had written, confiding in Fox Bourne that 'many are *afraid* to speak out, lest the Government take action against them.' 'If only Missionaries and others here would publish to the world all the shameful injustices of this wicked Congo Government', he continued, 'then would soon come, I believe, speedy relief.'[28] By 1903 there were missionaries who worked for the Congo Balolo Mission (CBM), run by the Regions Beyond Missionary Union, who had stations located in areas controlled by one of the most notorious private companies to whom Leopold had given a concession to tax the inhabitants and export the rubber they collected, the Anglo-Belgian Indian Rubber Company (ABIR). It was in this region, at Baringa, that John and Alice Harris conducted their missionary work. The sights and suffering they witnessed were deeply troubling, but their missionary union continued to publish a journal, *Regions Beyond*, as if atrocities were *inter se*, and the result of abhorrent indigenous customs that could be overcome by missionary endeavour.[29] The director of the organisation, Dr Harry Grattan Guinness, mindful of compromising the position of his project in Africa, stood aloof from the Congo controversy. Yet when the Leopold regime withdrew its support for any further expansion of his mission's work on the Congo and granted further favours only to Catholic missionary organisations, Grattan Guinness changed his tune.[30] Sensing the mounting criticisms of Leopold's regime, in April

1903 Grattan Guinness was prepared to countenance, publicly, that all was not well in the Congo and by late 1903 he was in frequent contact with reformers like Morel.[31] 'Atrocities' were now laid at the feet of the Leopold regime.

The Regions Beyond Missionary Union had used photographic technology to great effect long before their involvement in the Congo campaign. Grattan Guinness toured the world giving lantern-slide lectures about his missionary union's work – including a lecture on the Congo that did not include a critique of Leopold's rubber-collection regime or the practice of mutilation – and missionaries in the field used lantern slides to illustrate Bible stories for the 'natives' and to educate them about the spread of disease.[32] The journal *Regions Beyond* published plenty of photographs of the Congo missionaries and their work before 1904 – smiling children in hand-sewn dresses, converted evangelists, mission houses and their river steamer – but never any images of atrocity, mutilation, whippings or chained Congolese.

The missionaries were not the only ones producing photographic images of the Congo. Leopold also produced glossy magazines full of photographs of development in the Congo Free State in the late nineteenth century, and his Museum of the Congo, opened in 1897, was within a few years a publisher of thousands of images of the Congo illustrating colonialism as a force for modernity and improvement.[33] There was therefore a pre-existing textual and visual narrative about the Congo.

E.D. Morel's energy and single-mindedness was an important factor in the momentum that the Congo issue gained in 1902–3. The increased public visibility of Congo protest, thanks to what Morel described as an 'alliance' between himself 'representing a specialised free lance journalism' and Fox Bourne in his capacity with APS, persuaded missionaries based in the Congo, discouraged by their governing bodies' apathy, to make personal contact with both men.[34] Morel also joined forces with Roger Casement, the British consul at Boma (the Congo capital), who had been directed by the Foreign Office to report on conditions there after a debate in the House of Commons in May 1903.

The Casement report, completed at the end of 1903, provided overwhelming evidence to the British government of the inhumane treatment of the Congo's native people and it ultimately spawned the Congo Reform Association. Casement had travelled in some of the more remote regions of the Congo and assembled an astonishing array of victim testimony, a significant innovation in reporting on colonial

abuses in which the author's criticisms of the regime were channelled through the testimony of its victims.[35] It detailed horrific mutilations of hands and genitals and the massive loss of life in the Congo. Casement personally delivered his report to London, met with Morel and urged the need for decisive action, but then retreated to his native Ireland to recover from the intensity of his experiences in the Congo. From there he wrote to Morel, Fox Bourne and Grattan Guinness, suggesting the need for combined effort in the form of a 'Congo Reform Association'. Morel was an instant supporter. He sensed a groundswell of interest in the issue among some parliamentarians and the press, but remained convinced 'that the country is dead as yet'. He told the parliamentarian Sir Charles Dilke that there was a need to 'stir up Public Opinion in a more wide-spread form' or the momentum for reform would be lost.[36] Although Morel personally disliked Grattan Guinness and was wary of the organisation becoming a stalking horse for the missionary endeavour, he was enough of a realist to understand that Grattan Guinness, his missionaries and their evidence would deliver a constituency that the APS alone could only dream about. The Congo Reform Association (CRA) would become the spearhead of agitation over the Congo, Morel its indefatigable secretary and Grattan Guinness a committee member who brought the skills of oratory, lantern-slide lectures and the evidence of missionaries to the table. Casement was a key driver in the organisation's founding, but was in essence a silent shareholder, given his government post and need to appear impartial. The first meeting, held in Liverpool in March 1904, attracted a crowd of over 2,000 people.

Atrocity Photography

It is quite erroneous to claim, as some scholars do, that Casement's report was the key moment when atrocity photographs entered the public sphere. Contrary to the assertion that the report 'set off an explosion in the public realm' which 'served as a precedent in its treatment of the photograph as forensic evidence for the alleged acts of atrocity', there were no atrocity photographs published with Casement's report.[37] The report, which appeared as a parliamentary white paper with the unpromising title 'Correspondence and Report from His Majesty's Consul at Boma respecting the Administration of the Independent State of the Congo', was 60 pages of text that had been edited by the Foreign Office before release.[38] It was not a widely available or easily

accessible book. The Reverend W.D. Armstrong, one of the CBM missionaries who had accompanied Casement on his Congo tour, did take photographs of Casement's informants, but they were not included in the report.[39] There was brief reference to photographs being taken but Casement, who as a consul was in effect a representative of the British state, neither reproduced nor discussed the photographic images at any length. If he had, this would have given the photographs the legitimacy of accreditation by the state, an imprimatur they never received. Although the photographs Armstrong took were among the images that subsequently received wide circulation in the literature associated with the campaign for Congo reform, they did not receive their first airing in the Casement report.

Missionaries played a central role in the production of atrocity photographs and it was through their networks, not the Consul's, that they were transported back to England. The first atrocity images appear to have arrived in England in November 1903 via H.J. Danielson, a Danish missionary who had been in the Congo and worked for the CBM, managing its river steamer.[40] Danielson had, in fact, captained the steamer on which Casement had made his tour through the Congo, but arrived back in England a month before him, and delivered a set of atrocity photographs to Grattan Guinness.[41] Word travelled quickly among the Congo crowd, with Morel reporting to Fox Bourne in November 1903 that he had 'heard from a variety of sources that Danielson had come home from the Congo with some terrible information and photographs'.[42] Morel's journalistic appetite was whetted: he knew the value of Danielson's material. He implored Grattan Guinness to hand them over for 'immediate publication', but Grattan Guinness demurred and told Morel that the Foreign Office 'seemed to fear that the publication of Danielson's information might weaken any reports which Casement might subsequently have to make'.[43] This was deliberate obfuscation on Grattan Guinness's part, as Morel rightly suspected. Grattan Guinness told his own executive that the Foreign Office, in fact, had 'no difficulty' with the publication of the material, but he was holding it over for revelation at a big public meeting later in the year and publication of an illustrated pamphlet.[44]

Both Morel and Grattan Guinness recognised the value of the photographs, particularly in light of the imminent publication of Casement's report, but they were mission property that Grattan Guinness hoped to use to his own organisation's best advantage. It seems safe to assume that the photographs Danielson carried back to

England were Reverend Armstrong's. These were images of mutilated children and men, whose bodies were most often wrapped in white cloths to throw the stump of their black arms into stark relief. In January 1904, a month before Casement's report was made public and just after Danielson arrived in England, *Regions Beyond* published its first atrocity photograph. Its subject was a child, Lokota, who is not named as such, but rather stands in symbolic testimony to atrocity with the caption: 'Maimed for Life'.[45] Reverend Armstrong had photographed Lokota of Mpelengi in September 1903, when Casement visited the CBM mission at Bonginda. The photograph is captioned 'Maimed for Life' because Lokota's hand had been cut off five years earlier, when sentries raided his village for failing to produce its rubber quota, and harassed and mutilated the fleeing villagers and their children.[46] Lokota's photograph also appeared in Grattan Guinness's pamphlet, *Congo Slavery*, published soon after and distributed by the thousand at public meetings about conditions in the Congo.[47]

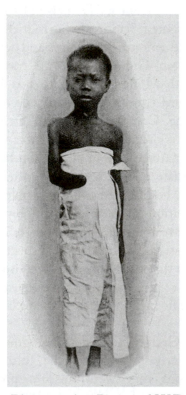

1. Lokota of Mpelengi. Photographer Reverend W.D. Armstrong, September 1903. First published in *Regions Beyond* (January 1904).

The photographs were usually accompanied by text or speech that framed them as proof that the atrocities that Leopold's regime had attempted to 'cover from European gaze' were real.[48] The work of Belgian apologists aside, Grattan Guinness insisted that 'the facts have to be faced, and the day of reckoning is near at hand.' Photography was an essential element in the armoury: 'Let the photograph we reproduce speak for itself – it has a message that demands a hearing.'[49] At the meetings, Grattan Guinness 'by means of a series of powerful lime-light illustrations […] proved his case against the Congo state, and the audience become more and more demonstrative as they realized the sufferings of their fellow-men in Africa'.[50] In the same way that earlier generations of missionaries had brought colonial converts to Christianity back to the metropolis as evidence of the power to civilise and Christianise, the atrocity lecture used the mutilated black body to demonstrate an evil practice they sought to overcome. Casement encapsulated this transition when informally commenting on a CRA plan of campaign: 'It would add to the interest of G[rattan] G[uiness]'s meetings if he could have one or two Africans on them at the platform […] If we had *Mola* (and I tried to get him home) we could raise a tornado!'[51] The photographic technology available by the twentieth century meant there was no longer a need to get boys like Mola 'home'. His image could appear projected on the stage in life-like intensity.

The context in which the photographs first appeared was an evangelising Christian one, despite Grattan Guinness's protestations that he was leaving religion out of it. In the early months of 1904, prior to the first meeting of the CRA, Grattan Guinness conducted a tour of Scotland, where thousands of people attended his lectures and viewed the lantern slides. As one of Grattan Guinness's early biographers noted, Grattan Guinness 'started the campaign with lecture and lantern'.[52] In light of the 'tremendous success' of the lecture tours, where the audience became 'enthusiastic and indignant', Grattan Guinness told Morel: 'I am anxious that you may not mistake where your real supporters will lie. Believe me they will largely be found amongst those who are pronounced Christian men and women.'[53] The tours were a great financial success too, covering all expenses and even contributing to the salary of the mission staff who helped to run them.[54] It was only after associating the mission's name with the photographs in this way that Grattan Guinness announced that he would have the photographs printed for Morel in London and allow him to use them in *King Leopold's Rule in Africa*. 'I shall ask you to acknowledge the source from which the pictures come,'

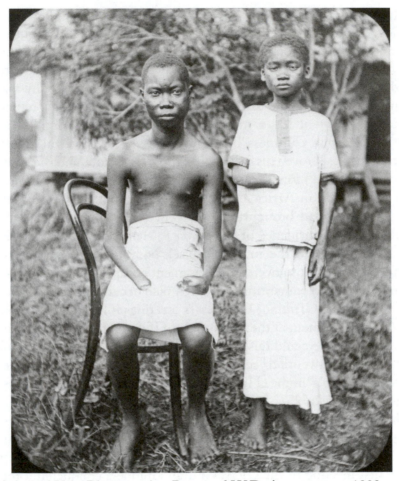

2. Mola and Yola. Photographer Reverend W.D. Armstrong, c. 1903.

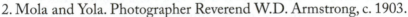

Grattan Guinness insisted.[55] Morel most certainly published the atrocity images, in both his *West African Mail*[56] and in a book: he used the image of Lokota in a triptych of photographs, which included Ikabo and Epondo, in *King Leopold's Rule* in 1904. Mark Twain used similar images the following year in *King Leopold's Soliloquy*.[57]

By the time Morel went to press, other atrocity images had made their way back to England, and he included them in *King Leopold's Rule*. They were all sent by missionaries, most of whom worked for the CBM. Armstrong left no account of why he chose to photograph the witnesses who presented themselves to Casement. Kevin Grant has speculated that Armstrong 'came upon this idea while watching Casement interpret the

3. Ikabo, Lokota and Epondo. E.D. Morel, *King Leopold's Rule in Africa* (London, 1904), opp. p. 112.

mutilated bodies of Africans as decisive proof of the state's brutality'.[58] Furthermore, Armstrong came from a missionary union with a strong visual culture. If the director had now given his blessing for criticising atrocity to become part of the mission's narrative, it seemed like a logical next step for that story to come with illustrations, just as earlier versions of the mission story had appeared in lantern-slide lectures and in the missionary journal with more benign pictures of smiling children and river steamers. The camera was an essential part of the CBM missionaries' kit. At almost exactly the same time that Armstrong took his photographs, other CBM missionaries, among them John and Alice Harris, began to photograph the mutilations and atrocities they had witnessed. In late 1903, just after Casement had visited the Congo, the Harrises ventured forth further inland from their mission station at Baringa and told Grattan Guinness about their journey: 'These we are undertaking with the camera & I do not hesitate to say that the stories about to be brought to light will provide you with material for the most damaging indictment that the State has yet to face.'[59]

The Harrises, Alice in particular, would ultimately contribute some of the most well-known images of the Congo campaign. Most were taken in the mission compound itself. The photograph of Nsala (Figure 4) staring at the remains of his daughter and wife, which he had brought into the mission station in 1904 as proof of the sentries' brutality, claiming that they had first murdered then eaten his family, focuses not so much on the mutilated body, but on its absence and the quiet grief of the father. The missionary Edgar Stannard, who was also present at the station when

Nsala arrived, later described it as 'an awful sight, and even now, as I write, I can feel the shudder and feeling of horror that came over me as we looked at them, and saw the agonised look of the poor fellow, who seemed dazed with grief [...] I can never forget the sight of that horror-stricken father.'[60]

Yet the photograph, in the stillness and contemplation of its composition, conveys to another audience the sight of that 'horror-stricken father'.

As the photographic images began to circulate, Leopold stepped up his campaign to discredit the missionaries and to imply that the photographs were fakes. This also demonstrated how the photographs always existed in relation to other images of the Congo, produced by Leopold's regime, which told a different story of benign rule and progress. Although the verisimilitude of photographs was part of their power, this did not mean that there was no room to imply that they were doctored images. The most overt effort of this kind appeared in the anonymous *An Answer to Mark Twain*, published in Brussels in

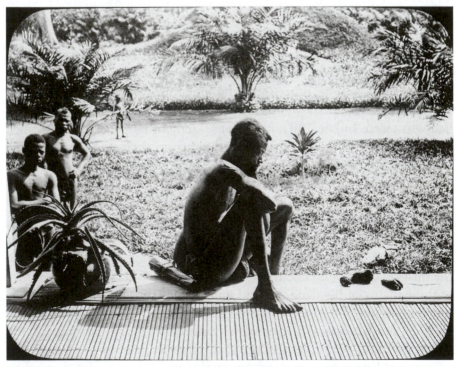

4. Nsala with the remains of his child. Photographer: Alice Harris, c. 1904.

1907. Comprising 62 photographs, printed beneath quotes from Mark Twain that the images are supposed to contradict, the booklet is a classic case of Leopold's propaganda. Underneath the quote 'The Kodak has been a sore calamity to us' there are photographs of substantial Congo church buildings and orderly congregations of Sunday school children. Beneath Twain's words describing 'the innocent blood shed in the Congo state' appear photographs of children at sewing, carpentry and technical schools. Similarly, there are photographs of railway development, roads, medical services and gardens. 'Truth shines forth in the following pages,' the introduction declares, 'which summarily show what the Congo state is – not the hell as depicted by a morbid mind.'[61] The *pièce de résistance* is the back cover, which depicts two women at work surrounded by pots. The second photograph is a copy of the first, labelled 'Potters at Work in the Congo', except in this one skulls have been superimposed on the pots, and the caption 'The Same Photo at Liverpool' has been added – a direct reference to Morel and his newspaper, the *West African Mail*.

Leopold's motivation for implying that the photographs were fake is clear; Alice Harris's motivation for taking the photographs is more difficult to divine. The Harrises were personally accused, in a slanderous article published in the *New York Times*, of manufacturing photographic evidence and attempting to profit from them by selling lantern-slide lecture packages.[62] Although Harris, like Armstrong, left no account of her decision to photograph atrocity, there is one clue in a pamphlet she co-authored with her husband. Despite John H. Harris's sole attribution as the author of *Rubber is Death* (c. 1905), this was a project that the Harrises worked on together. As Harris later wrote when accepting an appointment with the British and Foreign Anti-Slavery and Aborigines' Protection Society: 'there are two of us in the work.'[63] The photographs in the publication have clear attribution to 'Mrs Harris', even those which had appeared elsewhere, in publications such as *Regions Beyond* with other bylines, or, in the case of Nsala's photograph in Morel's *King Leopold's Rule*, to John H. Harris. The Nsala photograph concludes *Rubber is Death*, and is published beneath the line: 'Remember, too, that your mental vision cannot exaggerate this evil' and the caption reads 'Nsala, with the hand and foot of his little girl – all that remained to him of his wife and daughter after a feast by cannibal "Sentries".'[64] The photograph is at once confirmation of unimaginable horror, and an appeal to the sensibilities of the British, Christian public. 'Again and again when these horrors have been brought to our notice,' the Harrises wrote, 'we have been ashamed of the fact that our skin is white.'[65] The call is to the British

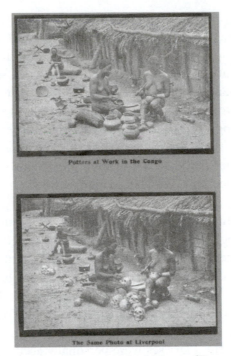

Potters at Work in the Congo

The Same Photo at Liverpool

5. Back cover of Anon., *An Answer to Mark Twain* (Brussels, c. 1907).

race, and their Christian faith. 'My Christian Countrymen, I APPEAL TO YOU. Shall these cruelties continue to be perpetrated? […] Has the conscience of Christian England gone to sleep?'[66]

The publication of photographs such as that of Nsala in Morel's *King Leopold's Rule* and Twain's *King Leopold's Soliloquy* gave them a broader distribution than was possible in the *Regions Beyond* pamphlets. It is important to keep in mind just how shocking such images were to the eyes of early twentieth-century viewers. As Bruce Michelson has argued, atrocity photographs 'introduced a visual experience that was almost pornographic in its starkness'.[67] One reviewer of *King Leopold's Soliloquy*, for example, openly contemplated the appropriateness of even publishing the photographs, describing them as images 'which sear the eyes – photographs which, even here, ought not to be seen or shown in all circumstances'.[68] Reviews of these works, and others like them penned by Morel on behalf of the CRA, demonstrate that rather than the photographs inspiring a dawning consciousness about human rights or crimes against humanity, as if this was some kind of inalienable truth simply waiting to be discovered, there was not a widely available language – or concept – to name what was actually happening in the Congo.

The reviews of Morel's next book, *Red Rubber*, published in 1906, are instructive here. In a later edition, Morel included a selection of them. There was some agreement that practices in the Congo constituted a 'crime', which, according to the *Spectator*, was a 'crime against civilisation'. Sir Charles Dilke, writing in the *Evening News*, decried Leopold's 'fiendish cruelty' and the 'iniquities of the Congo state'. The *Daily Mail* described the book as an 'indictment of personal rapacity, cruelty, expropriation of life and labour, maladministration and tyrannical atrocity'. Others described it as an 'indictment of the system prevailing', 'inhuman oppression and ghastly crime', a 'grim tragedy', 'awful business', 'well-nigh unbelievable barbarities', 'vile oppression' and a case of 'man's inhumanity to man'. Only the *Inquirer* labelled the events in the Congo a 'stupendous crime against humanity'.[69] The fact that one journal uttered the phrase that would become so well known later in the twentieth century does not mean that there was a broadly agreed consensus about how to understand or perceive conditions in the Congo. Indeed, the diversity of language and the struggle to articulate the 'crimes' meant that in the early 1900s there was no shorthand to label the behaviour of King Leopold II.

The predominantly Christian culture of the United States and Britain was the key context in which the images of atrocity were viewed. Kevin Grant has convincingly argued for the essential role of Christianity in the Congo campaign: his detailed study of the Congo reform campaign in Britain revealed that popular support was forthcoming only after missionaries became the key speakers and fund-raisers for the CRA.[70] After an initial spike of enthusiasm and donations when the CRA was first formed in 1904, for the next few years the cause languished, which was why Morel visited the US late in that year in an effort to engage the interest of celebrities like Twain. By 1906, Morel confessed to Twain that he was 'at the end of my tether, so far as doing more is concerned', and was at a loss to think of other ways 'to flog the slumbering soul of a nation into life'.[71] Casement's report had prompted the Belgian parliament to push Leopold to convene a commission of inquiry into conditions on the Congo, which largely substantiated Casement's findings. This was the point at which John and Alice Harris returned from the Congo on furlough and decided to stay in England and share an appointment as organising secretaries of the CRA.

The Harris-led CRA lecture tours, complete with lantern-slide lectures featuring atrocity photography by Armstrong and Alice Harris, reignited the campaign. The text that accompanied the lecture, 'Congo Atrocities' (note the emphasis on 'atrocity' – the keyword of the day – and

the absence of any reference to crimes against humanity), is structured around a demolition of Leopold's claim to philanthropy. There are four sections: 'Philanthropy in the Making; Philanthropy in Operation; Philanthropy Exposed; Philanthropy that may be'. The lecture begins with the context of the natural resources of the Congo, then builds to demonstrate – through photographs of floggings, mutilated Congolese and the 'tree of massacre' – the abuses and exploitation inherent to Leopold's regime, and the travesty of his claims to philanthropy. While men are depicted throughout, there is a special emphasis on the sufferings of women and children. The intimate details of the violence perpetrated on women, in particular, are declared 'too horrible to publish'.[72]

The lecture then shifts gear to emphasise the role of the missionary as friend and saviour. 'Ladies and gentlemen, amid all these tales of darkness there is just one ray of light.' Quoting the Belgian commissioners of inquiry, 'evangelical missionaries' are reported to be 'in the eyes of the native of the region, the only representative of equity and justice!'[73] John Harris is photographed with a Congolese chief in an image of friendship and welcome. The final part of the lecture, 'Philanthropy that may be', is centred on the work that missionaries can perform 'to train the intelligence, and to direct the activities of these unhappy people'.[74] And this is where the talk of rights entered the equation – 'we demand that the rights of humanity, even of black humanity, shall be recognised' – but this was an earlier language, which harked back to the era of abolition: 'it is because the native is a *man*, with the rights of a man, that we appeal for, nay, that we demand intervention.'[75] Yet this is coupled with the assumption that the black man 'has in his blood the instincts of a savage'. The 'negro' is confused by the corruption of the Christian message in the Congo:

> Contrasted at present with the teaching of the missionary, he has the white man's greed and cruelty. The missionary tells him that the Christian calls all men brethren; that the Christian religion bids its followers do unto others as they would like others to do unto them; that Christianity tames the passions and fills the heart with love, and the negro sees these so-called Christians […] No wonder they are slow to learn.[76]

Reassuring the listeners that men in the Congo can work, that the women are eager for domestic skills and proper clothing – complete with photographs of men sawing timber and schoolgirls in prize dresses – the

lecture draws to its conclusion: 'Are the Churches of Christ to remain silent? Will the heart of civilisation remain unmoved?'[77]

While Casement worked hard to secure the involvement of Catholics, there is little doubt this was an evangelical Protestant movement. Twain was as conscious as anyone of Leopold's and Belgium's Catholicism, and played the anti-Catholic card in attempting to mobilise popular support against Leopold. The opening lines of the book are printed in the shape of a cross, and Leopold's soliloquy begins with him kissing a crucifix. As Bruce Michelson has observed, Twain's book was 'gratuitously anti-Catholic' and his Leopold 'a caricature of murderous piety, a Borgia in an Edwardian suit'.[78] Casement was concerned from the outset that Leopold's agents would get hold of Irish Catholic press influence in the United States and worked hard to ensure that any Catholic donations to the committee were given prominent billing. The sectarianism that threatened to overwhelm the campaign did not in the end eventuate, in part because Morel disliked association with religion of any sort, despite his ultimate reliance on the work of missionaries like the Harrises.

A more relevant contemporary context that may explain receptivity to the photographs and the Congo campaign in general was Britain's recent involvement in the South African War (1899–1902). This too was on Casement's radar. In 1907 Casement confessed to a friend that 'the [South African] war gave me qualms in the end – the concentration camps bigger ones', and that this had shaken his faith in the British imperial project.[79] He once described the Irish view of Belgium as a 'small Catholic, pro-Boer country threatened by the ever-hungry England who has just swallowed the Transvaal'. Casement further suggested that the Irish would be averse to 'attacking the Congo regime of a small country like Belgium – and they say that after England's part in the Transvaal it ill becomes her to reproach the Belgians in Africa'.[80] He referred, of course, to the controversy over the concentration camps that the British had created in South Africa, where they had interned thousands of indigenous peoples, Boer women and children, many of whom had perished from poor nutrition and improper medical care. With so recent a blemish on its own record in colonial Africa, perhaps the response to Belgian cruelties was an effort to displace anxiety and discomfort of their own. It was only Casement, however, an outsider himself of sorts – 'I am an Irishman who knows and feels all the sorrow and suffering his country has passed thro' and that knowledge it is, I have never doubted, which gives me insight into the sufferings of Africans on the Congo' – who dared to voice that view.[81]

Of course, it was Belgium's status as a 'small nation' overrun by a larger one not so long after the Congo controversy, and the fact that Belgium's fate was one of the ostensible motivations for England to go to war with Germany in 1914, which meant that the memory of Leopold's cruelties in the Congo was quietly put aside in an effort to shore up support for 'poor little Belgium'. Roger Casement's execution for treason during World War I, when he attempted to secure German support for an Irish uprising, added further ignominy to the cause. Yet there were certain circles where the Congo atrocities were not forgotten. During World War I, African-American sociologist and activist W.E.B. Du Bois was of the opinion that: 'It is a fact that there is a widespread feeling among coloured people that there is a certain retributive justice in Belgium's present plight on account of its treatment of the natives in the Congo Free State.'[82] The Harrises would maybe not have gone so far, but after they left the Congo Reform Association in 1909, they embarked on a long career with the British and Foreign Anti-Slavery and Aborigines' Protection Society, continuing to raise awareness around the world in the inter-war period about the injustices visited upon the world's indigenous peoples.

The visual turn in the humanities in the last decade or so has seen a search for the antecedents of some of our own contemporary cultural practices, the visual documentation of human rights abuses being one of them. In many ways, the visual record of atrocity in the Congo had lain dormant until the 2000s, when it was rediscovered by scholars working in the diverse fields of imperial history, cultural studies, criminology and visual culture. Yet one of the first interventions, in 2001 by historian Kevin Grant, who made a careful study of the use of photographs in campaigns against misrule in the Congo, remains one of the best for its appreciation of context and careful reading of the way images were used and the forums in which they appeared.[83] There is too often a headlong rush by scholars to make claims about the impact of images, and responses to them and the debates they initiated, without returning to the historical record and making a careful analysis of precisely those issues. In the peak period of Congo reform, which can be considered to be 1904–8, there was no broad public narrative about 'crimes against humanity'. There was a pre-existing discourse of evangelical Christianity, into which the photographs were received, and their narration by missionaries was part of the public appeal. Even though it seems most people believed the photographs were real, we just do not know how many were persuaded by Belgian claims that they were fakes.

The reception and response to images is a notoriously difficult area to research, even more so when those images first entered the public sphere over 100 years ago. To claim that the photographs influenced the way people thought about human rights would require research that offered evidence that rights campaigns as they developed during the inter-war period made direct reference back to the abuses in the Congo, and more especially, make reference to the impact of atrocity photographs. This is not to deny the power of the Congo photographs, which is irrefutable, or to make a cynical claim about their makers' motives. The images do not need to have been the progenitor of some vaguely defined idea of 'human rights' for them to have had historical importance. Undoubtedly, the Congo images are clear evidence that Holocaust images are not the ground zero of atrocity photography. That alone is an important fact to establish, because it makes clear that ostensibly irrefutable proof of abuse and violation and violence has never been enough to stop it.

Notes

1 My thanks to Kevin Grant who generously read and commented on this paper.
2 The detail about Alice Seeley's employment is taken from the 1891 England Census, RG12, 224, 40, p. 71: 6095334.
3 *The Times*, 25 May 1897, p. 13.
4 *The Times*, 2 June 1898, p. 9.
5 Sybil Oldfield, 'Harris, Sir John Hobbis (1874–1940)', in *Oxford Dictionary of National Biography*, online ed., ed. Lawrence Goldman (Oxford, 2004, available at www.oxforddnb.com/view/article/40721 (accessed 18 February 2014); and Sybil Oldfield, 'Harris, Alice (1870–1970)' in Sybil Oldfield, *Women Humanitarians: A Biographical Dictionary of British Women Active between 1900 and 1950* (London, 2001), pp. 94–7.
6 Alice Seeley Harris did not take a Kodak camera to the Congo on this first trip, but the brand would become synonymous with the campaign, as this chapter will demonstrate.
7 Marguerite Roby, *My Adventures in the Congo* (London, 1911), pp. 17–18.
8 *Observer*, 5 November 1911.
9 Roby, *My Adventures in the Congo*, p. 267.
10 Ibid.
11 There is an extensive literature on the Congo. For a sample see Adam Hochschild, *King Leopold's Ghost: A Story of Greed, Terror and Heroism in Colonial Africa* (New York, 1998); and Martin Ewans, *European Atrocity, African Catastrophe: Leopold II, The Congo Free State and its Aftermath* (London, 1992).

12 This point was made at the time by E.D. Morel, *Red Rubber* [1906], revised edition (London, 1920), pp. 5–6.

13 For an example, see Henry W. Wack, *The Story of the Congo Free State* (London and New York, 1905).

14 *The Camera and the Congo Crime* was issued by the London Branch of the Congo Reform Association and was described in its *Official Organ*, c. 1906: 'There has been, and continues to be, an enormous demand for this invaluable production', filed in 'Images and Extracts from Congo Reform Association and Special Congo Supplements to the West African Mail', NNRU/MQNQ/LN/C, Anti-Slavery International, London. 'The Kodak on the Congo', *West African Mail*: Special Congo Supplement, September 1905; 'The Inconvenient Kodak Again', *Official Organ of the Congo Reform Association*, February 1906.

15 Hunt Hawkins, 'Mark Twain's involvement with the Congo Reform Movement: "A fury of generous indignation"', *New England Quarterly* 51/2 (June 1978), pp. 147–75; Bruce Michelson, *Printer's Devil: Mark Twain and the American Publishing Revolution* (Berkeley, 2006), pp. 198–208.

16 Mark Twain, *King Leopold's Soliloquy: A Defense of his Congo Rule* (Boston, MA, 1905), pp. 36–7.

17 *Pall Mall Gazette*, 13 June 1907, p. 4.

18 Kevin Grant, *A Civilised Savagery: Britain and the New Slaveries in Africa, 1884–1926* (New York, 2005), pp. 39–78; Robert M. Burroughs, *Travel Writing and Atrocities: Eyewitness Accounts of Colonialism in the Congo, Angola and Putumayo* (New York, 2011), pp. 86–97. See also John Peffer, 'Snap of the whip/crossroads of shame: flogging, photography and the representation of atrocity in the Congo reform campaign', *Visual Anthropology Review* 24/1 (2008), pp. 55–77.

19 Sharon Sliwinski, *Human Rights in Camera* (Chicago, 2011), pp. 58–9.

20 Susie Linfield, *The Cruel Radiance: Photography and Political Violence* (Chicago, 2010), p. 48.

21 Kenneth Cmiel, 'The recent history of human rights', *American Historical Review* 109/1 (2004), pp. 117–35.

22 Samuel Moyn, *The Last Utopia: Human Rights in History* (Cambridge, MA, 2010).

23 Sliwinski, *Human Rights in Camera*, p. 58, drawing on Williams to James G. Blaine, US Secretary of State, 15 September 1890, quoted in Hochschild, *King Leopold's Ghost*, p. 112. For biographies of George Washington Williams see John Hope Franklin, *George Washington Williams: A Biography* (Durham, NC, 2008) and Pagan Kennedy, *Black Livingstone: A True Tale of Adventure in the Nineteenth Century Congo* (New York, 2002).

24 Sliwinski, *Human Rights in Camera*, p. 58

25 Hochschild, *King Leopold's Ghost*, pp. 111–12.

26 Roger Casement also used the phrase in private correspondence to Sir Charles Dilke in February 1904. Cited in William R. Louis, 'Roger Casement and the Congo', *Journal of African History* 5/1 (1964), p. 115.

27 Henry R. Fox Bourne, *Civilisation in Congoland: A Story of International Wrong-Doing* (London, 1903). H.C. Swaisland, 'Bourne, Henry Richard Fox (1837–1909)', in *Oxford Dictionary of National Biography*, available at www.oxforddnb.com/view/article/31993 (accessed 18 February 2014).

28 W.M. Morrison to Aborigines' Protection Society (APS), 7 October 1902, in Bodleian Library of Commonwealth and African Studies at Rhodes House, University of Oxford, Papers of the Anti-Slavery Society (hereafter Papers of the Anti-Slavery Society), MSS Brit Emp s. 22, CFS [Congo Free State] to G261/Vol. 1 APS [1899–Dec 1903].

29 *Regions Beyond*, Special Issue: 'These Thirty Years' (January and February 1903).

30 Grant, *A Civilised Savagery*, pp. 39–78.

31 *Regions Beyond* (April 1903), p. 131.

32 *Regions Beyond* (March 1903), p. 107.

33 The magazine was *Le Congo Illustré: Voyages et Traveaux des Belges dans l'Etat Independent du Congo* (Congo Illustrated: Travels and Works of Belgians in the Congo Free State) and the museum publication of 1904 was *L'Etat Independent du Congo: Document sur le pays et ses habitants*, discussed in Wayne Morrison, 'A reflected gaze of humanity: cultural criminology and images of genocide', in Keith J. Hayward (ed.), *Facing Crime: Cultural Criminology and the Image* (Oxford, 2010), p. 199.

34 E.D. Morel to Fox Bourne, 30 January 1904, in Papers of the Anti-Slavery Society, MSS Brit Emp s. 22, C261/Vol. 2 APS [Jan 1904–June 1906]; Burroughs, *Travel Writing and Atrocities*, p. 77.

35 Ibid., pp. 61–70.

36 E.D. Morel to Sir Charles Dilke, 29 January 1904, LSE Archives, Morel; Edmund Dene (1873–1924); politician, author and journalist (hereafter Morel Papers), MOREL F4/3.

37 This claim is made by Sliwinski, *Human Rights in Camera*, p. 67.

38 1904 [Cd. 1933], Africa No. 1 (1904).

39 1904 [Cd. 2097], Africa No. 7 (1904), Further Correspondence Respecting the Administration of the Independent State of the Congo, describes a photograph being taken, but does not include the image, p. 16.

40 Their arrival with Danielson is recorded in the Minute Book, Regions Beyond Missionary Union, 6 November 1903, Adam Matthew Microfilm, Part 1, Reel 1, Centre for the Study of Christianity in the Non-Western World, Edinburgh. *Regions Beyond* (November 1903), p. 279 also reported that 'we [...] have just received from one of our own missionaries fresh evidence with regard to recent atrocities', but they did 'not wish to anticipate any use that the Foreign Office might make of them'.

41 For biographical information about Danielson see Grant, *A Civilised Savagery*, p. 55 and p. 186 n. 72. See also Seamas Ó'Siocháin and Michael O'Sullivan (eds), *The Eyes of Another Race: Roger Casement's Congo Report and 1903 Diary* (Dublin, 2003), pp. 14, 22, 250. Casement arrived back in England on 30 November 1903.

42 E.D. Morel to Fox Bourne, 23 November 1903, confidential in Papers of the Anti-Slavery Society, MSS Brit Emp s 22 CFS [Belgian Congo], G261/Vol. 1 APS [1899–Dec 1903].

43 Ibid.

44 Director's Minute Books, Regions Beyond Missionary Union, 6 November 1903, 26 November 1903, 31 December 1903, Adam Matthew Microfilm, Part 1, Reel 1.

45 *Regions Beyond* (January 1904), p. 9.

46 Details of Lokota of Mpelengi can be found in Morel, *King Leopold's Rule*, p. 377.

47 Harry Grattan Guinness to E.D. Morel, 2 February 1904, Morel Papers, MOREL F4/3.

48 Harry Grattan Guinness, *Congo Slavery: A Brief Survey of the Congo Question from the Humanitarian Point of View* (London, c. 1904), p. 4.

49 Ibid.

50 Report Glasgow meeting, 1 February 1904, in *Regions Beyond* (March 1904), p. 72.

51 Casement's comments on 'Congo Reform Association Plan of Campaign', 30 April 1904, Morel Papers, MOREL F5/5.

52 C.W. Mackintosh, *Dr Harry Guinness: The Life Story of Henry Grattan Guinness* (London, 1916), p. 72.

53 Harry Grattan Guinness to E.D. Morel, 2 February 1904, Morel Papers, MOREL F4/3.

54 Director's Minute Books, Regions Beyond Missionary Union, 25 February 1904, Adam Matthew Microfilm, Part 1, Reel 1.

55 H. Grattan Guinness to E.D. Morel, 2 February 1904, Morel Papers, MOREL F4/3.

56 *West African Mail*, Special Congo Supplement, June 1904, pp. 32 and 41 for picture of Epondo.

57 The child was named as Lokota in E.D. Morel, *King Leopold's Rule in Africa* (London, 1904), opp. p. 112. This image also appears in John H. Harris, *Rubber is Death* (London, c. 1905), p. 12. In Twain, *King Leopold's Soliloquy*, it appears opposite p. 38 as part of a collage with other amputees, with a quote from the text: 'The pictures get sneaked around everywhere.' The image is reproduced in Grant, *A Civilised Savagery*, and labelled as 'Epondo', p. 58. This cannot be correct, because Epondo was 15 at the time he was interviewed by Casement, and the photograph that Grant reproduces is clearly that of a child. See Morel, *King Leopold's Rule*, p. 360.

58 Grant, *A Civilised Savagery*, p. 59.

59 J. Harris, CBM, to Dr Guinness, 1 January 1904, Papers of the Anti-Slavery Society, MSS Brit. Emp. s. 19 D5/8.

60 Edgar Stannard to Dr Guinness, 21 May 21 1904, reprinted in Morel, *King Leopold's Rule*, p. 444.

61 Anon., *An Answer to Mark Twain* (Belgium, c. 1907), p. 6.

62 *New York Times*, 11 January 1908, p. 20. The author, South African F.J. Duquesne, was a well-known con artist who was later imprisoned in World War II for leading a spy ring in the US. Art Ronnie, *Counterfeit Hero: Fritz Duquesne, Adventurer and Spy* (Annapolis, MD, 1995).

63 John H. Harris to Mr Buxton, c. 1909, Papers of the Anti-Slavery Society, MSS Brit. Emp. s. 22 G262.

64 Harris, *Rubber is Death*, p. 21.

65 Ibid.

66 Ibid.

67 Michelson, *Printer's Devil*, p. 207.

68 'Mark Twain's terrible book', *T.P.'s Weekly*, 7 June 1907, p. 109, reprinted in Louis J. Judd (ed.), *Mark Twain: The Contemporary Reviews* (Cambridge, 1999), p. 549.

69 Morel, *Red Rubber*, 1919 edition, pp. xiv–xvii.

70 Grant, *A Civilised Savagery*, pp. 11–38.

71 E.D. Morel to Twain, cited in Hawkins, 'Mark Twain's involvement with the Congo Reform Movement', p. 167.

72 W.R. Louis (revised by E.D. Morel and the Rev. J.H. Harris), 'The Congo Atrocities', p. 23, filed in 'Images and Extracts from Congo Reform Association and Special Congo Supplements to the West African Mail', NNRU/MQNQ/LN/FHG/AN, Anti-Slavery International, London.

73 Ibid.

74 Ibid, p. 29.

75 Ibid.

76 Ibid, p. 30.

77 Ibid.

78 Michelson, *Printer's Devil*, p. 201.

79 Casement to Alice Stopford Green, 20 April 1907, included in an epigraph in Ó'Siocháin and O'Sullivan (eds), *The Eyes of Another Race*.

80 Casement, comments on 'Congo Reform Association Plan of Campaign', 30 April 1904, Morel Papers, MOREL 5/5.

81 Ibid.

82 W.E. Du Bois to Philadelphia Public Ledger, 1 March 1916, in W.E. Du Bois Papers, Special Collections and University Archives, W.E. Du Bois Library, University of Massachusetts, available at www.credo.library.umass.edu (accessed 10 June 2014).

83 Kevin Grant, 'Christian Critics of Empire: Missionaries, Lantern Lectures and the Congo Reform Campaign in Britain', *Journal of Imperial and Commonwealth History* 29/2 (2001), pp. 27–58.

2 'Follow the Americans'

Philip Jones Griffiths's Vietnam Trilogy

Liam Kennedy

Griffiths is the one who showed us Viet Nam as a country, not as a war.

John Pilger

In a lecture he delivered in London in 2007, the photojournalist Philip Jones Griffiths addressed budding photojournalists:

> We're living in a time that's so important for photojournalism. You've got to do it, no matter how trivial the magazines are, no matter how little money is in it. Find a way. This is such a historic period – this is the American Empire on the rampage. It hasn't happened since the Roman Empire was on the rampage and there weren't photographs then. Follow the Americans – that's what's important right now.[1]

The statement is vintage Griffiths, bespeaking several key, related elements of his philosophy as a photojournalist. Firstly, there is his passion to promote photojournalism as a critical mirror that must be held up to power; secondly, his sense that imperial American power was the lightning rod of international conflicts during his lifetime; and thirdly his faith in the evidentiary value of the documentary image as a revelation of the workings of power. It is a remarkably consistent philosophy, at times obdurate in its expression and impatience with alternative visions. As such, Griffiths was a particularly uncompromising example of the 'concerned photographer', an idealist who eschewed objectivity in his preference for reporting truth and illuminating injustice. While he denied political motives or partisanship, he readily acknowledges a driving moral passion, an empathy with the 'have-nots', shaped by his Welsh

rural upbringing and his photographic apprenticeship documenting postwar Britain. Despite his denials, this moral passion took on political hues in the 1960s as he began to report on post-colonial conflicts across the world: Algeria (1962), Rhodesia (1965), Zambia (1965), Mauritius (1966), Vietnam (1966–71) and Northern Ireland (1972–3). Throughout this work he developed a critical perspective on the workings of colonial and imperial powers and especially their impacts on indigenous subjects. In this chapter, I will examine his work in Vietnam, both during the war and after, to consider his critique of American power and its hidden effects.

Unlike many American journalists, Griffiths was not 'disillusioned' by the war in Vietnam; he was a sceptic before he arrived to cover the conflict and very deliberately set about producing a body of work that boldly illustrates and indicts the destructive military and cultural presence of the United States in South East Asia.[2] With few mainstream media outlets for the images he shot during the war, Griffiths put together his book *Vietnam Inc.* (1971), a benchmark of war reporting and an influential marker of the authorial role of the concerned photographer. He returned regularly to Vietnam for many years after the war and published two further books, one on the effects of Agent Orange and another on socio-economic changes in the country. Taken together, these books form his 'Vietnam Trilogy', one of the most extensive documentations of a war and its aftermath by one photographer. They evidence Griffiths's distinctive perspective as a war photographer:

> I'm not a war photographer. I just happened to photograph a war, and if anyone wants any proof as to the fact that I'm not a war photographer – guess what, I've been back to Vietnam 26 times since the war ended. War photographers don't go back to countries once the war's over; they go on to another war.[3]

Yet, he remains a war photographer in that he is interested principally in the effects and legacies of war on the cultures and values of a people and their way of life. His detailed attention to post-conflict scenarios and settings provides a significant example of the way in which photography can both follow and shape the temporality of understanding surrounding a major conflict.

Vietnam

Growing up in rural Wales, Griffiths was fascinated by news photography at an early age and inspired by the great picture magazines of the postwar period, especially *Picture Post*. Although trained as a pharmacist, he freelanced for the *Manchester Guardian* and other British papers and magazines, documenting social changes across Britain in the 1950s. In the early 1960s, when the appearance of Sunday supplements greatly enhanced the market for photojournalism, his career quickly developed. He joined the staff of the *Observer* early in 1962 and later that year had a major scoop published when he photographed a hitherto-unseen feature of the war in Algeria between French forces and the Front de Liberation Nationale (FLN). He trekked into the Atlas Mountains with FLN soldiers and became the first photographer to document the brutal French administration of remote villages. Griffiths would observe, in much more detail, the efforts of US forces to control a colonised population in Vietnam.

Travelling extensively in the mid-1960s to cover conflicts across the world, Griffiths decided he wanted to focus his energies on one substantial project rather than racing to cover many for short periods of time. In 1966, the same year he joined Magnum as an associate, he 'decided the important thing to do was to get passionate about something, and you didn't have to be a genius in '66 to work out that there was something very important happening in Vietnam'.[4] His approach was methodical. He read widely on the history and culture of Vietnam and on the origins of its recent wars. Once in the country he travelled across South Vietnam, visiting every province, and familiarised himself with the cultures of the Vietnamese. Although he often travelled with the American military he was not a central member of the media packs and had limited contact with other photographers; he worked quietly and unobtrusively, for the most part living with South Vietnamese at little expense. Financing was his biggest headache. Although he planned to publish a book, he also needed to publish images to bring in enough funds to remain in Vietnam, but the leading newspapers and magazines only rarely published his work – he was repeatedly told his photographs were too harrowing. Later he would suggest Magnum had not done enough to try to sell his images – a charge in line with his self-aggrandising commentaries on press coverage of the war: 'In general, 95 per cent of the press was in favour of the war; 4.999 per cent was in favour of the war but not in favour of the way it was being fought. And then there was me and two Frenchmen.'[5]

Griffiths claims he had an immediate affinity with the Vietnamese, likening them to the rural Welsh in terms of community bonds, resourcefulness and canny defiance of colonists. However romanticised this view may have been, it did draw him close to Vietnamese civilians as his key source of information and perspective, and certainly afforded him a very different perspective on the war to that of most journalists. As he learned more about the country and its people, he not only questioned the American narratives about the war and its progress, he grew angry about the absurdity of the disjunction between these narratives and the realities he observed.

> The things we were being told [about the war] didn't make any sense. So I travelled the length of the country for my own personal selfish reasons, to put together the jigsaw puzzle, and to produce a historical document. I wasn't the person working for the news agencies to make sure there was a picture on the front of the *New York Times* every morning. I worked differently.[6]

Working differently meant many things. First, as indicated, it meant working apart from the established media and military frameworks, even as he took advantage of American military transport and befriended US soldiers. It also meant looking for the 'why' of the war where few others were looking. He notes: 'Some of the best combat photography in the war came from the battles that took place at the end of 1967 [...] but the pictures are meaningless, because the battles were meaningless.'[7] This may be read as a harsh judgement of the work of fellow photojournalists, but it is also a characteristic statement of Griffiths's certitude and method. In other words, his photography rarely follows the event, nor does it indicate a sense of formlessness or incoherence about the war, even as metaphor.[8] Rather, his imagery is marked by his sense of clarity about what is being depicted within the viewfinder – his sense that they are historical documents.

The war *is* meaningful, Griffiths believed, and the places to look for this meaning were at the points of cultural contact between the Vietnamese and Americans and at the points of imperial myopia in the activities of the Americans. In the introduction to *Vietnam Inc.* he writes: 'I contend that Vietnam is the goldfish bowl where the values of Americans and Vietnamese can be observed, studied, and because of their contrasting nature, more easily appraised.'[9] His approach to this work of observation and to putting together his book is suggestive of that of a social scientist

in its rigour and critical method. *Vietnam Inc.* advances a form of cultural critique that operates through demystification, illuminating tensions and contradictions in the American worldview. For Griffiths, a critical role of photography is to reveal what is normatively hidden:

> The Vietnamese say that looking and understanding is much more important than caring about the surface. The Americans were completely blind to the subtleties of the Vietnamese language and the fascinating structure of Vietnamese society. All of the elements drew me to the country and strengthened my will to stay on, but what ultimately made me addicted to the place was the desire to find out what was really going on, after peeling away layers and layers of untruths.[10]

The key dialectic of his work is that of blindness and insight, and an urge to demystify – to peel away the layers and reveal truths – is evident in individual photographs and in the layout of the book as a whole.

A simple but effective example is a photograph Griffiths spent several days trying to produce. It depicts a busy street scene in Saigon. People are looking in different directions and our eyes are pulled across the scene looking for the locus of meaning, the point of the image. Then we see it, just off-centre, the young girl artfully picking the pocket of the large GI who is peering elsewhere, distracted. The image is suggestively composed. It is not a snapshot. Griffiths had waited for days on a first-floor balcony of the Hotel Royale across the street from this scene, and also photographed several similar scenes – four of them appear on one page of *Vietnam Inc.* The methodical preparation was typical of his work, shaped as it was to reveal something he was already aware of but which was rarely visible to Western eyes. This sense of illicit or subversive viewing is replicated in the image. The attempted robbery of the GI is but one point of urban spectacle within the scene – we note the act is being observed by one or more of the people around him. In his caption, Griffiths observes that pickpockets were tolerated by the Saigon public: 'Hatred of the Americans was such that no Vietnamese would ever warn one if his wallet was about to be taken. Many people could be seen surreptitiously admiring pickpockets' prowess.'[11] For Griffiths, the act of pickpocketing American soldiers clearly symbolises the more general Vietnamese activities of duping and undermining the coloniser.

This demystifying of the relations between Vietnamese and Americans is the organising basis of *Vietnam Inc.* The book is made up of over 250

black and white photographs, supported by blocks of informative text and spare, often acerbic, captions. It opens with a glossary, and the author wryly explains: 'A book about the Vietnam War is bound, unfortunately, to need an extensive glossary to guide the reader through the fog of Orwellian "newspeak" that the United States employs in an attempt to disguise its activities.'[12] By drawing immediate attention to what he terms the 'lexical war', Griffiths indicates that his book aims to reveal what the fog of war has so far concealed. Throughout, he is attentive in his text as well as the images to political and military rhetoric, and particularly questions the meanings of American discourses of liberation, modernity and freedom as applied to the US mission in Vietnam. The one-page introduction succinctly presents Griffiths's view that the war in Vietnam is a war 'for the minds of men', and that 'America is trying to sell a doctrine to the Vietnamese', that of 'Americanism'. As such, he views the war as a conflict of values and finds horror in the doctrinal myopia of the US, its 'misplaced confidence in the universal goodness of American values'.[13]

The image filling the page opposite the introduction depicts a GI with a young Vietnamese girl on his knee. Both stare intently into the camera. The GI is unshaven and sunken-eyed, his gaze solemn, perhaps even sullen. The girl's clothes are sullied and she presses her hands together between her legs. As he leans forward, she leans into herself. They are frozen together but it is difficult to interpret their relationship. Elsewhere in the book, Griffiths notes that GIs liked to befriend and be photographed with children, an attempt to identify with some form of innocence in the theatre of war. That may be happening here – the soldier's wedding ring may hint at an identity other than that of soldier. Their implacable togetherness, however composed, in the context of the introduction, suggests they are both victims of forces beyond their control and comprehension.

The book is divided into thematic sections. The first, 'The Vietnamese Village' illustrates what Griffiths sees as the essential values of the Vietnamese – wisdom, harmony and community – tied to the village environment and its culture. In particular, he draws attention to the importance of rice-growing as a staple not only of diet but also of communal rituals. One image shows a child sitting on a buffalo, which threshes the rice by walking over it; another shows peasants working the fields; and another shows the graves of the dead in rice fields, where 'their spirits will pass through the soil into the rice, so that their soul will be inherited by their descendants when the rice is eaten.'[14] For the

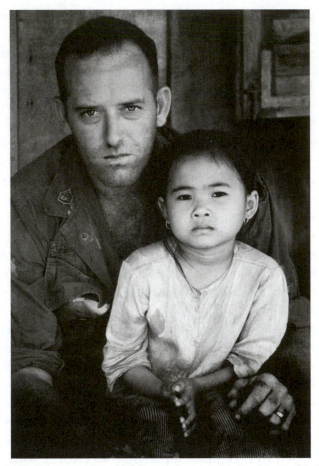

6. GI and child, Vietnam, 1967. Photographer: Philip Jones Griffiths/ Magnum.

most part, the imagery imputes a sense of a harmonious rural society, with only allusions to the threat of American despoliation – a reference to an absent mother, for example, gone to 'work' for the Americans. The final image of the sequence is jarring by contrast. A two-page spread, uncaptioned, it depicts what appears to be the dead body of a Vietnamese male, his upper torso visible in the top right of the image, a gun on the ground on the left, and what appears to be the shadow of an American soldier taking up the centre and foreground of the photograph. For all the graphic directness of his image-making, Griffiths does employ symbolism on occasion. The text in this section asserts what the imagery implies: 'what American policy has attempted to do is to obliterate the

village as a social unit. This, ostensibly, is to deny cover to the guerrillas, but, in reality, the purpose is to reconstruct Vietnamese society in the image of the United States.'[15]

The next two sections – 'Why We're There' and 'The Communication Gap' – begin to show the distance between the Vietnamese and the Americans, a motif that runs throughout the book. Children figure prominently as they are generally in closer, less aggressive proximity to the soldiers. In one image we see a marine hugging a child as the mother looks on anxiously; in another a child curiously feels the facial hair of a GI; and in another a GI offers a cigarette to a peasant girl in a field. In many of the images there is a sense of corruption surrounding the presence of the GIs – at a 'car wash' young girls surround a GI to sell goods and themselves. All the while, Griffiths argues in his text, the children smile and accommodate to take advantage of the soldiers.

There are several images of prisoners, composed so that the prisoner is at the centre of the image, accentuating their vulnerability. One of these compositions is famed as one of the finest combat images of the war, it shows GIs giving water to a Vietcong fighter who had fought for three days with a severe stomach wound that had forced him to hold his intestines in place with a bowl strapped to his body. The GIs admired his bravery and Griffiths honours this in his sympathetic composition.[16]

The communication gap is rendered more violent in the imagery depicting the frustrations of the American search for enemy combatants in rural areas. Griffiths records the growing resentment of the US soldiers as they take frightened civilian villagers from their homes and burn or call in bombing to the villages. One image, taken on a search-and-destroy operation with a unit of the America 1st Division in 1967, shows a woman cradling a child, overseen by an American soldier. The caption reads 'Mother and child shortly before being killed [...] this woman's husband, together with the other men left in the village had been killed a few moments earlier because he was hiding in a tunnel. After blowing up all tunnels and bunkers where people could take refuge, GI's withdrew and called in artillery fire on the defenseless inhabitants.'[17] The soldier's odd stance is one of detachment, likely also of resentment as we learn from the caption – the *pietà* of mother and child draws no sympathy, no sense of concern – Griffiths notes that this event occurred about six months before the massacre at My Lai (carried out by American soldiers) and implies that the murderous resentment among the soldiers was already apparent. Powerful as the image is, it relies on Griffiths's caption to fully contextualise what we see. Elsewhere, he has observed, 'I think

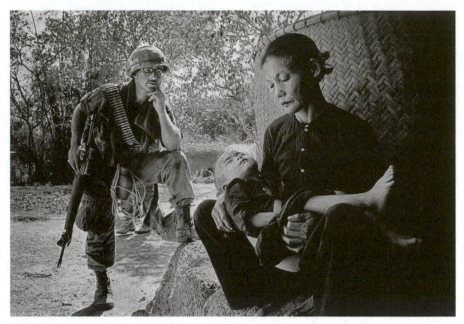

7. US soldier and Vietnamese woman and child in Rach Kien, Vietnam, 1966. Photographer: Philip Jones Griffiths/Magnum.

the problem with photography is that you can decontextualize it. What does a picture of a wounded body or a mother clasping her wounded child mean? Why is it happening? I want to know that.'[18]

The next two sections – 'Search and Destroy' and 'Relocation' – document the forced relocation of several thousand rural people in the Bantangan peninsula to the model village of Song Tra. This shocking dislocation from ancestral lands was rationalised by American strategists as 'forced-draft urbanization and modernization, which rapidly brings the country in question out of the phase in which rural revolutionary movements can hope to generate sufficient strength to come to power'.[19] Griffiths shows it to be a wretched destruction of a society and its ways of life. He portrays the burning of villages and the forced trek to Song Tra, where peasants are housed in internment camps, surrounded by barbed wire and signs announcing their 'freedom'. The degradations of the peasants are evidenced in incongruous scenes – one image shows peasant children looking at copies of *Playboy* magazine, distributed by a psychological operations officer who forgot to order 'indigenous reading material'.[20]

The next sections – 'Our Vietnamese Friends' and 'The Battle for the Cities' – document the degradations of the newly urbanised populace in the large cities, particularly Saigon, and the urban battles that ensued in the wake of the Tet Offensive in early 1968. By 1968 over three million people resided in Saigon, a city built for a tenth that number, many moved there forcibly or as refugees from dangerous or destroyed communities. Griffiths shows us a 'mass of resentful people', many of them refugees, homeless people and beggars, living in wretched conditions.[21] Graveyards are used as makeshift shelters and latrines, a desecration of these spaces. Several images depict commercial signage advertising American goods, ironically juxtaposed with imagery of destitution. These sections also provide more conventional war imagery in the depiction of the results of the massive aerial destruction of Ben Tre following the Tet Offensive and of the battle for Hue, one of the most prolonged combat operations of the war. As usual, Griffiths's focus is on the civilian victims.

The fullest sequence of imagery in these sections documents the Vietcong attacks on Saigon in 1968 and the confusion this caused among the American soldiers and the Vietnamese citizenry, both unaccustomed to being attacked in this urban centre. GIs look scared and bewildered as they take cover when their own artillery fire is misdirected and kills two of their number. There are several images of dead or wounded civilians on the streets. In one, a woman in bloodied clothes lies on a stretcher in the foreground while above her a soldier kneels and looks into the distance, and behind them people hurry past with their goods. It is a suggestive tableau, indicating the impotence of the soldiery to protect civilians or deter looting. Overall the imagery connotes confusion and loss of control as the city breaks apart and homes are reduced to rubble. The sequence ends with a powerful two-page-spread image which shows a woman in the centre walking to camera carrying many belongings – including stoves, pots and bowls – across her shoulders. On each side of her soldiers walk in the opposite direction, carrying their own accoutrements – guns, backpacks, ammunition belts. They pass silently, not looking at each other. The road is churned mud and they are surrounded by the debris of bombing on all sides. It is as though two worlds have walked right past each other. To be sure, the woman is a civilian victim, but she has her belongings and appears to move purposefully, holding what remains of her world together – an individual compressed into limited space – her belongings a metonym of her shattered world.

In the final section – 'Pacification' – Griffiths focuses on the effects of the renewed battle for hearts and minds following the upheavals of 1968

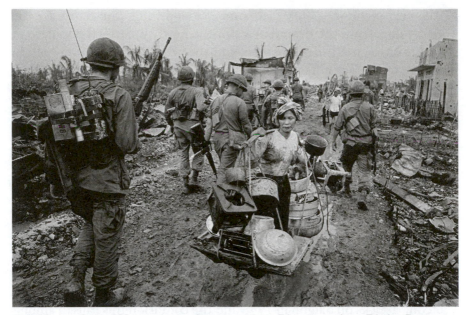

8. Refugee from US bombing, Saigon, 1968. Photographer: Philip Jones
Griffiths/Magnum.

and the further decline of social order in the cities. He later notes that
after Tet 'great disillusionment set in' among the South Vietnamese in
urban centres, and he 'found it a very interesting time photographing the
discontent and turmoil in the urban enclaves'.[22] Images of garbage dumps,
of elderly people living in institutions rather than with families, and of
young prostitutes on the streets combine to connote the breakdown of
a traditional order. The sequence focused on prostitution is particularly
disturbing, depicting girls as young as 12 with American soldiers. An
image of Vietnamese women seated in and grouped around an American
military truck reads: 'The women of Vietnam. In a society where they
are traditionally revered for their poise and purity, women have been
effectively dehumanised. They sit outside American bars waiting to enter
to serve the soldiers as everything from laundry maid to prostitute.'[23] At
the centre of the sequence is a controversial image showing two male navy
SEALS on a bed with a Vietnamese woman at the US naval base in Nha
Be in 1970. One of the men is leaning over the prostrate woman, who is
lying on a rug with her dress pulled back to her midriff, while the other
soldier crawls towards them on the floor. The woman's head is turned
away from the soldier whose face is lowered towards her, mouth open. It

is impossible to tell if the woman is laughing or screaming and the image can and has been read as a depiction of rape. Griffiths is more sanguine in his (later) comments: 'The girl is not a hooker – well, she may have been a hooker, she's certainly not an innocent farm girl – but she was there dancing for the troops, and these chaps got a little out of hand.'[24]

Throughout this section Griffiths notes the fast developments in what he terms 'automated war' – the use of computers and of long-range devices to conduct war. He mocks the absurdities of the use of computers to evaluate the degree of 'pacification' of Vietnamese hamlets. In one image, four military operators stare at a computer printing. The caption reads: 'The compute that "proves" the war is being won [...] Optimistic results on the "my-wife-is-not-trying-to-poison-me-therefore-she-loves-me" pattern are reliably produced each and every month.'[25] However, he also soberly comments on the emergence of a 'new warfare' that reduces ground troops and utilises electronic technologies, automatic fire-control systems and aircraft carriers. There are several images of personnel on an aircraft carrier. One caption notes, 'The sailors and the pilots on board have never been to Vietnam. They have never seen the faces of their victims, the Vietnamese people.'[26] The following image is of four seriously wounded victims of anti-personnel bombs, laid side by side on stretchers, all of them 'classed "terminal" and sent home to die'.[27] There follows several pages juxtaposing images of Vietnamese amputees and victims of napalm bombing, interspersed with images of American bombs.

The penultimate image in the book is one of the most famous images of the war: it shows a Vietnamese woman holding her hands up to her fully bandaged head. The woman has a tag attached to her arm which reads 'VNC FEMALE', meaning Vietnamese civilian.[28] The image has often been reproduced to represent the effects of napalm, but the tag actually states 'Extensive high velocity wound to the left forehead and left eye'. It is not surprising that it should be misinterpreted in this way as the symbolism of the image is rich and it has iconic qualities that transcend its moment of production. At the very least, it stands as an image of dehumanisation and so condemns the impact of the war on civilians. The tag accentuates this diminishment of the individual to a cipher in the administration of the war, while the cancellation of her identity can refer to the more general invisibility of civilians in the consciousness and lines of sight of the American military, media and public.

It is the realities and visibility of the victims' lives that Griffiths most forcefully dedicates himself to documenting in *Vietnam Inc.* and in his

9. Civilian victim, Vietnam, 1967. Photographer: Philip Jones Griffiths/Magnum.

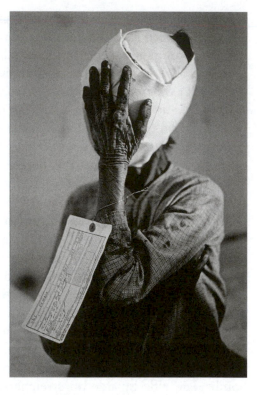

subsequent visual studies of postwar Vietnam. With *Vietnam Inc.* he produced an incendiary documentation of the war that took many by surprise and disturbed the field of photojournalism irrevocably. There was much that was startlingly fresh and audacious about the book. It moved the camera away from the American soldier to concentrate on the Vietnamese and to document the effects of combat seen through the eyes of civilian victims. The iconic images of the war in American public memory are images of victims of US or US-sanctioned violence, but they are only snapshots of such. Griffiths provides a detailed, in-depth illustration of the consequences of this violence, not snapshots but carefully composed and sequenced condemnations of the impact of the United States on Vietnamese culture and society. In doing so he also took an innovative step in positing the role of the photojournalist as an author. This is evident in his eschewal of objectivity in favour of working with a clear vision and a determination to interrogate the 'why' of the event. In this sense he took on the role of the photographer as witness, already imputed in the Magnum tradition, but radicalised it by producing a more engaged, interventionist photography than his predecessors. He also

demonstrated the authorial role of the photojournalist by producing his work on his own terms and publishing it accordingly. He published little of his Vietnam imagery in established news media but turned this to his advantage by transcending the agendas and frames of mainstream media.

It is impossible to measure the impact of the book on public opinion about the war, though many claim it was significant. Noam Chomsky later wrote: 'If anybody in Washington had read that book, we wouldn't have had these wars in Iraq and Afghanistan.'[29] It received some strong reviews in the very publications that Griffiths had had difficulty publishing his images in a few years before. In part this was due to timing, as more graphic material began to appear in the aftermath of the My Lai imagery, but also because his work provided one of the few coherent visual perspectives on the core years of the war. A glowing review in *Time* magazine described the book as 'the best work of photo-reportage of war ever published [...] The book sets entirely new standards for critical judgement of the medium of photo-reportage.' The *New York Times* described it as 'The closest we are ever going to come to a definitive photo-journalistic essay on the war'.[30]

For all the fame of the book and the photographer, its impact on future photographers is also difficult to measure. Without doubt, it influenced a coming generation – showing the possibilities of authorship available to the photojournalist – and it was profoundly influential in presenting the photobook as a legitimate and powerful form of photojournalistic expression. Yet it would be difficult to pick out very direct forms of influence in terms of style or approach. Few wanted to work with graphic black and white imagery as colour became dominant from the later 1970s and fewer still had the incentive or financial backing to spend three years on a single project. Out of print for many years (it was finally reprinted in 2001), *Vietnam Inc.* became a monolith and something of a conundrum: a great milestone in photojournalism, yet it was also almost invisible; a model, yet inimitable.[31]

Post-Conflict

In 1971 Griffiths joined Magnum as a full member. He was unable to return to Vietnam despite efforts to do so on an assignment for *Life* in 1972. Refused entry to the country, he was informed that President Thieu had personally demanded that Griffiths be banned from entry, reportedly saying: 'There are many people I don't want to see back in

my country, but I can assure you that Mr Griffiths' name is at the top of the list.'[32] However, Griffiths did return to Vietnam, more than 20 times after his initial return in 1980, to extensively photograph the legacies of the war and painful reconstruction of the society. Over that period he built a large body of work that he finally published in the form of two books, *Agent Orange* (2003) and *Vietnam at Peace* (2005). Together, they are important documents of the ongoing effects of the war and the reconstruction of a traumatised society.

Griffiths first heard about Agent Orange – the toxic herbicide used by the American military as a defoliant during the war – in 1967 while in Saigon:

> During the war there were these rumours that babies were being born without eyes and it became a quest to find them. I visited as many Catholic orphanages as I could, but I was barred entry from most of them and I became convinced that the Americans had put the word out – don't let any press in.[33]

After the war there was confusion and obfuscation surrounding the effects of Agent Orange on the Vietnamese. In the US there had been steadfast resistance by the government to recognising diseases caused by the herbicide, in large part due to fears of litigation, but also to a residual anxiety about the promotion of chemical warfare by the US. This resistance was complemented by a cultural reluctance to engage this topic in the US during a period when the war was 'forgotten', even as it was screened widely via popular culture.[34] In Vietnam, at the same time, there were restrictions on visiting hospitals or other institutions where victims were housed and there was state censorship of commentary on victims in the media. The effects of Agent Orange was an issue rendered barely visible in both countries as it was an unwanted knowledge, haunting the making of public memory about the war. Griffiths is attuned to this haunting element of his subject. He subtitled his book '"Collateral Damage" in Vietnam' (the quotation marks underscore the knowing use of what he termed 'Orwellian "newspeak"' in *Vietnam Inc.*) and collateral damage is an apt term to denote 'a calculated discounting of the wounded, the tortured and the dead' who yet haunt the visual culture of warfare.[35]

In part it was this embargo on memories of the horrors of the war that stimulated Griffiths to seek evidence of the ongoing damage caused by Agent Orange. Looking for answers and access led him to pursue several avenues of research and investigation and make numerous

trips to Vietnam. The first trip, an assignment for *Geo* magazine, was in 1980, and over the next 22 years he researched further and made return trips to photograph victims, building a small archive of material, though very little was published.[36] Griffiths determined that he would publish his material as a book.

Agent Orange is conceived as an epilogue to *Vietnam Inc.* as it picks up themes of that book – the American dedication to scientific forms of warfare, the desire to destroy the landscape, the lack of empathy for the Vietnamese people – and shows how these culminate in the ongoing, slow-motion destruction of a people for a generation after the war has formally ended. He understands the effects of Agent Orange as a legacy of the war, in which the poisoned land still damages and kills its inhabitants. The book is an unflinching documentation of the effects of this chemical warfare on the land, the victims and their offspring. The images, all black and white, confront the viewer with visual horrors that are, as Gloria Emerson notes, 'almost unbearable'.[37] They accumulate in a dark vision of humanity, lightened only by moments of compassion, but also charged by an anger at the conditions depicted. The clinical, almost forensic gaze is deliberate – Griffiths observes that 'a lot of what passes for concerned photography is not that removed from police photography [...] there are certain things you have to draw attention to. That's my task as a photographer.'[38] Yet he realised that his imagery would be challenging for readers and made a conscious decision to 'humanise' the victims and to censor certain images: 'The problem with this book is that the pictures are so shocking, you can't look at it [...] I tried to put pictures in that have some humanity [...] the horrendous pictures of kids with genitalia on their faces, I didn't use. The truly horrendous pictures are not in there.'[39] The reference to Goya is deliberate: this is a challenge to look, to understand, to act; the book is a provocation and an assertion of belief in the power of photojournalism to speak truth to power.

Like *Vietnam Inc.*, the book is organised to provide the optimal balance of emotion and analysis, providing a narrative sense of cause and effect that indicts the treatment of the victims of Agent Orange as collateral damage. The cover and insidecover images are of a US Air Force satellite map showing the 'spraying runs' by planes spreading Agent Orange. The abstracted lines of flight suggest the abstracted nature of warfare for those in control of it and their distanced perspective on the sites of impact and the lives of people who dwell there. Griffiths has noted that the map shows many flights over Ba Hao Reservoir and

claims that pilots dropped leftover spray in the reservoir, so further poisoning the populace.

The first photographs in the book are five double-page-spread images of defoliation during the war. Several are images taken in the 'Iron Triangle' 40 miles north-west of Saigon, an area of 60 square miles of dense tropical forest that the Vietcong used as a base for attacks on the city. Two of the images show military vehicles destroying homes which are surrounded by clumps of defoliated trees that evidence the effects of Agent Orange spraying. In an unpublished commentary on what the US military called Operation Cedar Falls, involving 25,000 American and South Vietnamese troops, Griffiths provides a vivid account of how 'in a demonstration of mechanical power unique in warfare the Americans are neutralising the triangle by uprooting the entire jungle and flattening everything which stands on the ground.'[40] The scale of such destruction is echoed in the final image of this section, depicting the 'denuded hills of Quang Tri Province that were covered in triple canopy jungle before the war'.[41]

These images reference the contexts of the initial use of Agent Orange as a strategy of defoliation during the war. The sections that follow categorise and document the effects. The first focuses on the 'ecocide' that results from 'poisoning the land' and presents images of efforts to recultivate barren or scrub-covered lands as part of a national programme of reforestation. While the landscape images are bleak, they also include several examples of children tending to saplings, which Griffiths captions as 'an opportunity to reaffirm the tradition of living symbiocity with nature that defines the people of Vietnam'.[42] This may be a deliberate counterpoint with the opening section of *Vietnam Inc.* where he correlated the relations between the people and the land, preparing us for the severance of that relationship by the US military. The historical ironies are part of the legacy Griffiths is exploring.

From the scarred and poisoned land, Griffiths moves to the damage done to humans. The section titled 'The Bell Jar' is a disquieting sequence of images of the remains of foetuses and stillborns preserved in formaldehyde held in jars at Tu Du hospital in Ho Chi Minh City. The remains are grotesque, deformed exhibits and yet also retain an affective human charge for the viewer. As Griffiths notes: 'At first impression it is a collection of medieval incubi, imps and demons arranged by Hieronymus Bosch. And yet, on close examination, there are glimpses of a nascent humanity – a touch, an embrace and the occasional appearance of dignified serenity.'[43] To be sure, these effects are partly due

to Griffiths's compositions, which speak to an underlying question posed by much war photography: who counts as human?[44]

From these 'remains' Griffiths moves to 'the human toll', the damages experienced by the living. Many of the images are of children held in institutions and in need of constant care. A good number are portrait shots, as disquieting in the close-up gazes of the children as the blank stares from the bell jars. That children are the focus of these images underlines the carry over of the effects of the war into new generations. Again, Griffiths works to humanise his subjects, most obviously by portraying the roles of mothers as primary carers. At the same time he draws attention to the haunting trauma surrounding childbirth and rearing for many women who 'have come to learn that procreation in their homeland, that most fundamental act of humanity, is now a squalid and terrifying exercise of chance'.[45] The compositions of mothers and disabled children inevitably recall iconic imagery of compassion. Eugene Smith's famous *pietà* image from Minamata is explicitly recalled in a shot of 16-year-old Vo Van Trac, who 'exhibits symptoms similar to Minamata disease' and who is held by his mother in a way that echoes Smith's image.[46] Similarly, an image of a mother with her two blind daughters has distinctive echoes of Dorothea Lange's 'Migrant Mother' photograph.

While Griffiths seeks to sponsor compassion in the viewer he is also interested in drawing attention to the forms it takes within a post-conflict society. He notes how important it is to familial and societal support for the victims of Agent Orange in Vietnam. In a section on victims in Cambodia he focuses on victims who have become beggars and learned to manipulate compassion in order to survive. This emphasis on compassion is reflexive, for it is also an important element of Griffiths's visual strategy to document suffering and prompt action. The direct appeal to compassion posits the ethical function of the image as a mode of evidentiary representation that bears witness to the suffering and degradation of others. Yet visual appeals to compassion are unstable interpellations of ethical or political consciousness or critique.[47] Griffiths does not want the reader's response to be diffused in pity and inaction and so the compassionate framing of individual victims is combined with the more didactic attention to the political and cultural contexts of protest and action. In the closing text of the book, 'The History and Future of Dioxin', he argues the need for further research on dioxin and proposes that Vietnam offers 'the ultimate laboratory where the clues to dioxin's murderous progression can be discovered'.[48]

Agent Orange presents photography as evidence, making visible what has barely been seen, and asking for a commensurate action to ameliorate the suffering documented in the imagery. The book was well received, though largely by readers and reviewers disposed to the issues and to Griffiths's point of view. Yet it helped lend a visual profile to a debate that had little public traction in the US. Just as pertinently, it challenged public memories about Vietnam and drew attention to the meaning and reality of collateral damage at the time of new American wars in Afghanistan and Iraq. *Agent Orange* performed a significant act in drawing attention to the 'discounted' victims of wars past and present, reminding us that humanity is a differential norm in representations of war and conflict.

Vietnam at Peace chronicles postwar reconstruction from the economic hardships of the period of American embargo to the embrace of foreign investments and consumer capitalism in the 1990s to the more measured responses to capitalism in the early twenty-first century. Across this period Griffiths focuses on and illustrates a range of legacies from the war – the boat people, children parented by American soldiers, MIA activists, victims of Agent Orange – and documents the effects of postwar changes on cultural institutions and everyday life in Vietnam. He very deliberately plots and strives for a comprehensive view, a systematic act of documentation based on his view of the key markers of Vietnamese identity in the postwar era. The book consists of over 500 black and white photographs categorised in 14 chapters which each have short introductions penned by Griffiths. As with *Vietnam Inc.*, he also supplies short, often pithy, captions.

In many ways *Vietnam at Peace* extends the ideological perspective of *Vietnam Inc.* In the earlier book, Griffiths views the war as an American mission to turn the Vietnamese into pliant consumers of American values and consumer capitalism, believing that this mission both underlay and transcended the military conflict. This was evident in his close attention to the impact of the American presence on Vietnamese culture, especially on its village culture and the effects of modernisation and relocation programmes. The American efforts to restructure Vietnam during the war, Griffiths implies, had damaging effects beyond the end of the war and are continuous with some of the traumas of postwar 'reconstruction' by the Vietnamese. To be sure, Griffiths's perspective is, as ever, an uncompromising one, assured of his point of view and certain of the long-term damage being done to the country by 'the venality of capitalism': 'Over countless visits to Viet Nam I've observed, mostly with sadness, the country's embrace of consumerism.'[49] Yet, this unabashed

subjectivity is not visually expressed as a one-dimensional view of the changes taking place. Rather, there is a sense he is trying not only to understand the country through the repeated visits but also to understand the tensions and contradictions of a post-conflict existence. Griffiths sees Vietnam caught between past and future perceptions of its identity and is aware that an intense revisionism of the war has taken place as part of the process of reconstruction and that a key task for the country is to come to terms with its recent history, for it is not yet 'at peace' with itself.

The early sections of the book depict muted victory celebrations in Ho Chi Minh City (formerly Saigon) and the rounds of life in devastated landscapes, now showing signs of regeneration with austere, Soviet-style apartment buildings and impromptu roadside shops. The third section, titled 'The Debris of War', is suggestive of the damaging legacy of the war as the unexploded ordnance from the American bombing continues to kill Vietnamese people – there are images of children beside unexploded bombs. It is also suggestive of the Vietnamese capacity to pragmatically make use of all scrap materials from the war. The scrap also forms vernacular monuments to the American presence, such as the remains of Camp Evans, the 1st Armoured Cavalry base. Carcasses of destroyed vehicles litter the landscapes. In a section on the Ho Chi Minh trail, the tangled routes which the North Vietnamese used to supply the war effort in the South, there are many images of rusting military machinery and of the appropriations of old weapons and other war remnants for new uses. Much of the metal is smelted to produce iron rods for new buildings, and we see how petrol pipes and storage tanks have been put to new uses to help develop rural economies; old shell craters full of water are now used for irrigation and 'fish and duck ponds'.[50]

There follow several sections that focus on the impact of the war on human relations and bodies. Many images illustrate the legacies and memories of the civil war for a range of individuals and communities. These include former combatants holding up photographs from the war or the dog tags of US soldiers they had killed. One image depicts the widow of the soldier executed on a Saigon street in 1968 during the Tet Offensive – the famous image taken by Eddie Adams. In Griffiths's photograph, the widow holds up a newspaper which contains the Adams image and also holds a military honour, presumably awarded to her husband by the state. Her tearful look adds a new dimension to this already iconic image and reminds the viewer of the very different perspective on the 'American War' within Vietnamese society and memory. It also symbolises the rift within Vietnamese society that has

not fully healed, and is followed by imagery of people in 're-education' camps where over one million Vietnamese were detained between 1975 and the late 1980s.

The few examples of an American point of view are pointedly handled by Griffiths. In two sets of sequenced images he portrays a returning US soldier who had been highly decorated in the war and a tour by Senator John McCain, who had been a prisoner in Hanoi for much of the war. In both instances, Griffiths visually emphasises their alien presence in the landscapes of Vietnam. The returning soldier, for example, is shown teaching his daughter to fire an AK-47 at the Cu Chi tunnels, standing among models of Vietcong soldiers. McCain is shown touring his wife and son around areas where he was captured and imprisoned – in one image Griffiths composes a shot of McCain and family strolling in Hanoi so as to have a wheelchair-bound Vietnamese man take up a full half of the image, though he is looking away from McCain and does not appear conscious of his presence.

The impact of the war on human lives is further explored with images of reform schools for heroin addicts and prostitutes and of Amerasian children fathered by American soldiers. We see how the fabric of lives and social relations has been damaged by the war, which has deeply disrupted familial and civic ways of life. There is also a series of images of people whose bodies have been disfigured by the violence of the war – these include images of amputees, many in wheelchairs, and of victims of napalm attacks and of Agent Orange. Most of the human-centred images focus clearly and closely on one person or a few people, usually children, often looking straight to camera. With the Amerasian children, Griffiths suggests a particular tension in terms of their identity and social relations: many look to camera with sombre expressions and Griffiths's text describes the racism many have suffered, especially the children of African-American fathers. He also adds further tension to the imagery by citing the names of the missing fathers in many of the captions, underlining the act of abandonment and inviting the reader to reflect on the implications of this for the children whose faces we scan.

There are series of imagery focused on sites of collective memory related to the war, including My Lai, the Ho Chi Minh trail and museums. In these sections Griffiths is concerned both to illustrate infamous sites of the war and to examine how the Vietnamese have remembered the war. The My Lai images are the most haunting as Griffiths photographs groups of children standing at the sites of the atrocity. In one image, a very young girl stands in the centre of 'the infamous path where hundreds of women

and children were murdered'; behind her in the middle distance is the blurred figure of a young woman carrying a child on her hip, echoing similar profiles in the images of the My Lai massacre.[51] The composition is calm and chilling. Elsewhere Griffiths illustrates how My Lai has become a tourist attraction and in a section on war museums he notes the 'commodification of history' has become widespread in response to tourism and the demands by the government to appease Americans in order to support tourism and other forms of investment.[52]

Vietnam's turn to foreign investment and consumer capitalism is the focus of the longest section in the book, titled 'Doi Moi – A Change in Direction'. It covers the effects of Vietnam's switch to a market economy in 1986 and the fuller normalisation of relations with the West – most significantly signalled by the lifting of the US embargo in 1994. In Griffiths's view this inaugurated a struggle over values that the Vietnamese have been losing: 'America's involvement with Vietnam started with genocide and ecocide. It has now coined a new slogan – culturecide.'[53] He illustrates this by depicting incongruities occasioned by uneven development or the contact points of the local and the global. For example, in one image a billboard advertising Japanese commodities 'casts a shadow' over rice fields.[54] Other images go well beyond the surface visual clichés of incongruity to document underlying structural or systemic elements of global forces and their impacts on human subjects.

Conclusion

The closing section of *Vietnam at Peace* is the most revealing of Griffiths's critical perspective on the effects of American power understood principally as economic and cultural imperialism (rather than military might), and glossed in the text and in interviews as 'globalisation'. It is a thesis that is clearly in line with his long view of the American role in Vietnam. Reflecting on this, he comments:

> I photographed the war because, frankly, in 1966 it was the most interesting story. I soon discovered all was not as it seemed. Viet Nam was full of contradiction and before long I came to see beyond the death and destruction. I argued in my book, *Vietnam Inc.*, that America was trying to impose its consumer capitalist values on the Vietnamese. On returning after the war I came to realise that the country was an effective fish bowl in which to examine the effects of globalization.[55]

Again, we sense a marked consistency in his critical perspective – the metaphor of the fish bowl is one he used in *Vietnam Inc.* to describe the opportunity to document and contrast American and Vietnamese values. What he gains in ideological clarity he risks losing in critical acuity for the conflation of varied modes and forms of imperialism and the presentation of globalisation as an extension of American power can be a limiting formulation to frame documentation of the Vietnam War and its aftermath. The power of Griffiths's Vietnam trilogy, though, is that it both delivers and transcends such formulations. It delivers by carefully documenting the ideological sinews of cause and effect in the making of war, both in cultural depth and across time, so that the historicity of the war becomes part of the frame. It also transcends the more constrictive formulations of imperialism and globalisation by producing imagery that is excessive of such frames and acknowledges the agency of those subject to them. In following his own injunction to 'follow the Americans', he has produced a singular view of the effects of American power, including the mystifications of that power. His Vietnam trilogy is an ambitious act of demystification that promotes the residual values of concerned photojournalism and holds up a consistently critical if inevitably distorted mirror to US foreign policy.

Notes

1 Quoted in Eliza Williams, 'Follow the Americans', *Creative Review* (30 March 2007), available at www.creativereview.co.uk/cr-blog/2007/march/philip-jones-griffiths-on-vietnam (accessed 18 February 2014).

2 Disillusionment was a term widely used to describe the impact of the war on American and other Western journalists. The photographer Larry Burrows, who covered the war for *Life* magazine, expressed his own experience in such terms. See Larry Burrows, 'A degree of disillusion', *Life* (19 September 1969), pp. 66–75.

3 Quoted in Peter Howe, 'The Vietnamization of Philip Jones Griffiths', *Digital Journalist* (July 2005), available at http://digitaljournalist.org/issue0507/griffiths.html (accessed 18 February 2014).

4 Graham Harrison, 'Philip Jones Griffiths', *Photo Histories* (2008), available at www.photohistories.com/interviews/23/philip-jones-griffiths?pg=all (accessed 18 February 2014).

5 Peter Howe, 'The dauntless spirit: Philip Jones Griffiths, 1936–2008', *Digital Journalist* (April 2008), available at http://digitaljournalist.org/issue0804/the-dauntless-spirit-philip-jones-griffiths-1936-2008.html (accessed 18 February 2014).

6 Donald R. Wilson, 'Philip Jones Griffiths dies in London', National Press Photographers Association, available at https://nppa.org/news/1463 (accessed 18 February 2014).

7 Howe, 'The dauntless spirit'.

8 It is by now a truism that there was an incoherence in the organisation and progress of the Vietnam War that tested journalistic talents and conventions to interpret its meanings and contributed to the shakiness of the framing – by both military and media – of the war. See Philip Knightley, *The First Casualty: The War Correspondent as Hero and Myth-Maker from the Crimea to Iraq* (Baltimore, 2004), p. 273.

9 Philip Jones Griffiths, *Vietnam Inc.* (London, 2001), p.4.

10 Russell Miller, *Magnum: Fifty Years at the Front Line of History* (London, 1997), pp. 213–14.

11 Griffiths, *Vietnam Inc.*, p. 174.

12 Ibid., p. 3.

13 Ibid., p. 4.

14 Ibid., p. 19.

15 Ibid., p. 13.

16 The scene was reconstituted in *Apocalypse Now*, a film that uses several of Griffiths's images.

17 Griffiths, *Vietnam Inc.*, p. 59.

18 Howe, 'The dauntless spirit'.

19 Griffiths, *Vietnam Inc.*, p. 77.

20 Ibid., p. 90.

21 Ibid., p. 106.

22 Miller, *Magnum*, p. 214

23 Griffiths, *Vietnam Inc.*, p. 180.

24 Howe, 'The dauntless spirit'.

25 Griffiths, *Vietnam Inc.*, pp. 164–5.

26 Ibid., p. 197.

27 Ibid., pp. 198–9.

28 Griffiths later observed that this was an unusual designation as 'the rule in Vietnam was that anybody who had been wounded was VCS, a Vietcong suspect'; he surmises that the medic who made out the tag was 'antiwar' (Howe, 'The dauntless spirit').

29 Amanda Hopkinson, 'Philip Jones Griffiths', *Guardian*, 24 March 2008, available at www.guardian.co.uk/artanddesign/2008/mar/24/photography.usa (accessed 18 February 2014).

30 Both citations appear on the cover of the 2001 issue of *Vietnam Inc*.

31 The book was published a week after the attacks of 11 September 2001. With the wars in Afghanistan and Iraq resurrecting interest in the imagery of the Vietnam War, Griffiths's work came in for some renewed attention and there were several exhibitions.

32 Howe, 'The dauntless spirit'.

33 Agent Orange is the toxic herbicide used by the American military as a defoliant during the war – it was first sprayed on crops as part of a programme to force villagers into 'strategic hamlets' and later more extensively to deny cover to Vietcong forces. More than 42 million litres of the herbicide were sprayed over Vietnam between 1962 and 1970, according to the Aspen Institute (www.aspeninstitute.org/policy-work/agent-orange/history). Dioxin, the deadly toxin in Agent Orange, remained in the landscape, causing ongoing environmental and human damage. In humans it causes hormonal and genetic changes that have disastrous effects on human reproduction. The herbicide caused long-term contamination of soil and plant life in extensive areas, further impacting on rural agriculture and subsistence.

34 See Marita Sturken, *Tangled Memories: The Vietnam War, the AIDS Epidemic, and the Politics of Remembering* (Berkeley, 1997).

35 See Allen Feldman, 'The structuring enemy and archival war', *PMLA* 124/5 (2009), p. 1712.

36 Until 1998 only one picture was published.

37 Quoted on the back cover of *Vietnam Inc.*

38 Graham Harrison, 'Philip Jones Griffiths', available at www.photohistories.com/interviews (accessed 18 February 2014).

39 Philip Jones Griffiths interview, *The Digital Journalist* (January, 2003), available at http://digitaljournalist.org/issue0401/griffiths_intro.html (accessed 18 February 2014).

40 Telegram report by Philip Jones Griffiths, dated January 1967. Magnum Photos office, New York.

41 Telegram report by Griffiths.

42 Philip Jones Griffiths, *Agent Orange: 'Collateral Damage' in Vietnam* (London, 2003), p. 32.

43 Ibid., p. 38.

44 See Judith Butler, *Frames of War: When is Life Grievable?* (London, 2010).

45 Griffiths, *Agent Orange*, p. 92.

46 Ibid., p. 96.

47 In part this is because of the compromised role photojournalism performs in promoting and sustaining a humanistic perspective on the violence of war and human rights abuses while operating within a political economy of media production skewed to represent the values and interests of dominant Western powers. Often, under these conditions of representation, compassion becomes the default frame that simultaneously invites viewers to engage the horrors via affective responses to agony, yet disengages them by eliding the geopolitical realities of power and violence that underlie the horrors. See Liam Kennedy, 'Framing compassion', *History of Photography* 36/3 (August 2012), pp. 306–14.

48 Griffiths, *Agent Orange*, p. 174. He further points out that Vietnam offers a relatively clear control study as the South was heavily sprayed while the North was not. This conclusion of the book is suggestive of some of the tensions underlying the admixture of compassion and accusation in *Agent Orange*.

49 Philip Jones Griffiths, *Vietnam at Peace* (London, 2005), pp. 70, 220.

50 Ibid., p. 58.

51 Ibid., p. 117.

52 Ibid., p. 176.

53 Ibid., p. 220.

54 Ibid., p. 229.

55 'Philip Jones Griffiths Q&A – war photography and Vietnam', *Open Democracy* (April 2005), available at www.opendemocracy.net/philip_jones_griffiths_q_a_war_photography_and_vietnam_0 (accessed 18 February 2014).

3 The Violence of the Image

Conflict and Post-Conflict Photography in Northern Ireland

Justin Carville

The Photograph is violent: not because it shows violent things, but because on each occasion it fills the sight by force, *and because in it nothing can be refused or transformed.*

Roland Barthes[1]

Roland Barthes's resignation before the brute opticality of the photograph demonstrates a prevailing sense that we can never stand outside the cultural frame of the image. Placed before its geometric dimensions, we are blinded by its animation of what seems to be the obvious, that which fills the frame of the photograph in all its naked transparency. This is the violence of photography, but it is a violence that is inflected rather than being inherent in the image itself. Barthes's statement might thus be seen as a caution not to be duped by the violent luminosity of photography or succumb to its aggression. This essay explores the violence of photography in Northern Ireland, not to identify its episodes of aggression, but in heeding the moral of Barthes's statement to explore how this violence has itself been transgressed.

The image has a long history in the Northern Ireland conflict and cannot be separated from the violence of identity politics which has engendered sectarian division. But while the communicative force of, for example, wall murals has remained largely within the divided loyalist and nationalist communities, the role of photography and photojournalism in particular in maintaining sectarian conflict has remained out of the grasp of both groups. This makes the violence of photography all the

more pervasive in reinforcing the stereotypes of sectarian division; the British press in particular have utilised photojournalism to construct a sense of national social cohesion.

I explore this theme through the representation of Bloody Sunday in the British press and the subsequent role of photojournalism in the tribunals of inquiry into the events of that day. My aim here is not simply to read along the grain to identify how the violence of the image is legislated for, but also to frame how photography has been mobilised against the dominant visual narratives of conflict. I take my cue here from the French philosopher Jacques Rancière's concept of 'dissensus', proposing that the use of photojournalism in acts of commemoration and the 'late photography' of post-conflict art do not so much offer alternative visual perspectives of the Northern Ireland conflict but rather directly intervene into fields of perception and signification that enact the violence of the photograph to which Barthes believes we are consigned. In a long conclusion, I pursue this theme in relation to the practices of late photography, arguing that as a culturally salient practice it opens the image up to the excess of meaning that the violence of photography has strived to contain.

Violence, the Image and Bloody Sunday

In his study of photojournalism and the representation of Northern Ireland in the British press during the 1970s and 1980s, John Taylor observed that despite the tensions between media organisations and the British state over censorship, misinformation and propaganda, the mainland print and broadcast media played a significant role in advancing the government's strategy to shift public perceptions of the conflict from one of civil rights and civil war to terrorism.[2] The place of the photojournalistic image in this consensus between media and the state is, as in most media studies analysis of the Northern Ireland conflict, dependent on an association with a broader realm of signification. In his discussion of how the photograph conceals the bias of editorial commentary under the weight of its pictorial veracity, Taylor proclaims: 'the objectivity of photographs is notional: the photographs are intricately sewn into the web of rhetoric. They are never outside it, and always lend it the authority of witness.'[3] Taylor's remarks here are in reference to the relationship between words and images in different print media on the events of Bloody Sunday, when British paratroopers

shot dead 13 civilians (the number rose to 14 after another victim died just over four months later) during a civil rights march in the nationalist Bogside community of Derry on 30 January 1972. Discussing the use of photographs by the Republican newspaper *An Phoblacht/Republican News* as 'proof' against the British military assertion that troops had been fired upon by snipers during the march, he suggests that despite the different political persuasions between *An Phoblacht* and the *Daily Mirror*, both utilise photographic realism to legitimise their journalistic commentary of Bloody Sunday as both objective and true. Through this approach Taylor identifies 'press of all political persuasions' as accepting 'the photograph as documentary proof'.[4] The only options available from the arena of imagery of the conflict, it would appear, are those that can easily be tinged by the overt political prejudice of the media organisation, or photographs that can mask the bias of commentary through their (photographs') claims of pictorial realism. Indeed, for Taylor, photographic images in general and photojournalistic images in particular are confined by the array of commentary and journalistic prose that accompanies them. Photographs are incarcerated within a rhetoric that both depends upon and authorises the photograph's claims to reality, 'the bias of commentary is inescapable.'[5]

While this modular framework of discourse analysis has and continues to be useful in the assessment of the media portrayal of the Northern Ireland conflict and its aftermath following the 1998 Good Friday Agreement, it locates the struggle over the communicative power of the photograph as between different media titles and in turn the media and the state. *An Phoblacht*'s use of photojournalism is thus to censure the mainstream British media for their distorted depiction of the events through the visual empiricism of the photographic record. The British press, and in Taylor's particular case study, the *Daily Mirror*, conversely use photojournalism in correspondence with what Taylor terms 'the official perspective, an orthodoxy that has a resilient philosophic and historic respectability'.[6] The difficulty with this theoretical framework is that the photograph itself is denied any agency, the photojournalistic image is simply an object to be worked upon by external forces that contain its visual amplification within a prevailing discourse. The photograph is rendered a mute witness to history, stifled and manipulated into position by exertions outside of its frame. The photojournalistic image is manoeuvred, as John Tagg describes it, to 'animate meaning' that already frames it rather than to pictorially reveal new or hidden realities within its flat visual plane that are meaningful in and of themselves.[7] Muffled

or made voluble by the processes of signification that put it to work, the 'connotations of the photograph', as Roland Barthes has stated, are controlled to 'coincide, *grosso modo*, with the overall connotative planes of language'.[8]

In the context of Northern Ireland and the representation of the 30 years of 'The Troubles' in the British print and broadcast media, it can readily be identified that the containment of photography by a shared perspective between the media and the state immobilised photographs' capacity to mediate social relations within and between nationalist and unionist communities. Despite the continual references to 'contested histories', 'fractured communities' and 'disputed territories' in the print media, the only discord over the photographic images' portrayal of the conflict on the streets of Northern Ireland, it would seem, was amongst the media itself. The identification of this containment of photography was further complicated as the consensus between the media and the state did not, as Taylor points out, 'mean that there is a conscious conspiracy amongst influential individuals, but rather that both groups share many beliefs about what reality is. This consensus is much harder to identify and disrupt than a conspiracy would be, because in a hall of mirrors, the values of one group are reflected by the other.'[9]

In his most recent challenge to the photograph's discursive positioning as the force of the real, Tagg has re-categorised this complicity between the realm of signification and the state as a more nefarious endeavour than simply a process of containment.[10] The persistent drive to ensure the photograph is always spoken for, the institutionalised and institutionalising labour that ensures that the photographic image is never detached from the discourse which keeps it in place, is a 'kind of violence that surrounds the event of meaning and arrests dispute'.[11] Crucially for Tagg, and unlike Taylor's framework of analysis, photography is not a 'docile instrument' worked on and over by external forces.[12] The language of photography and the discursive codifications that are always in attendance with it are rather 'violently instated' as they are simultaneously 'instrumentalised', tailored to size and 'imposed as a uniform code'. The violence that Tagg attends to thus

> acts in and across the bodies, spaces, and machines that make up the instructive tableaux with which we have begun to produce the discursive event, not only by marking it out, pinning it down, or cutting it to size but, above all, by calling it into place and exposing it, while making sure it stays within the frame.[13]

The distinction between Taylor's framework and Tagg's conception of the violence of meaning is crucial here, as any attempt to disrupt the containment of the photographic image by the discursive regimes that authorise and are in turn authorised by it cannot simply shift the photograph from one realm of signification to another. It is not a matter of wresting photographs from one context and situating them in an alternate one. Or, as in the case of *An Phoblacht*'s use of photographs to counter the 'official' version of events of Bloody Sunday, framing the photograph with an alternative realm of signification which goes against the grain of mainstream photojournalism's containment with a rhetoric that mirrors a shared perspective of reality between the media and the state.

In what is a sustained rebuke of the criticism of his earlier social power model published as *The Burden of Representation* (perceived by many as over-determined in its positioning of photography as having no authority of its own through its function as a transparent vehicle for the exercise of power which precedes it), Tagg argues that the violence of meaning enacted is not merely through the surrounding context or the cultural frame which may determine how photographs are interpreted. Rather, it is the case that photography is at every turn arrested within a discursive regime which, in the juridical scenario that Tagg explains it, not only determines what can serve as evidence but also the objections, the injunctions and the appeals. It is not so much that cultural and political dissent through photography or working against the grain of the dominant media is futile, it is that such appeals are expected, invited even, as such actions themselves are already arrested, pinned down and held within the frame that determines what can be articulated. In the same way that Michel Foucault cautioned that the archive structures and regulates the realms of possibility of what can be spoken – 'the archive is the first law of what can be said' – we need to recognise photography more broadly and, in the context of this essay, photojournalism in particular not as a technical apparatus but as discursive practice with its own field of possibilities and limitations.[14]

This is the violence of meaning that leaves its imprint on the photographic image; thus when *An Phoblacht* attempts to reveal 'the truth in pictures' it does so within a framework of relations between the media, the state and the photograph that both define and confine its dissent. In the context that Taylor discusses, photography's capacity to illuminate meaning becomes mired in the claims of truth, limiting its effect to be accepted, rejected or dismissed altogether as simply an alternative, warped perspective to the agreed map of reality.

The role of photojournalism in the campaigns, tribunals and journalistic investigations to find 'the truth' in the aftermath of Bloody Sunday are a useful illustration of this violence of meaning. In the days immediately after the events that led to the shooting of demonstrators, and in the years and decades that followed, photojournalism was, amongst other more subjective eyewitness accounts, mobilised to question the official version of Bloody Sunday pursued by the British state. Two weeks after the shootings, *Life* magazine published the French photojournalist Gilles Peress's photograph of the body of Bernard McGuigan lying in a pool of blood with a short editorial commentary that concluded with the reserved remark: 'British troops watched the crowds, then moved in to disperse them. There was firing – and chaos. Afterward, military authorities insisted that the troops had been fired upon first. But 13 marchers lay dead.'[15] Such ambiguous querying of the official narrative was tame in contrast to what would follow, but *Life*'s use of photojournalism to visualise the brute reality of the death of Bernard McGuigan (who was unidentified in the double-page spread) demonstrates how photojournalism would be used so soon after Bloody Sunday to contest official claims of the truth.

The Italian journalist Fulvio Grimaldi, who along with his assistant Susan North had been covering the civil rights march in the Bogside, published a short booklet in March 1972 that included photographs along with commentary and eyewitness accounts. Titled *Blood in the Streets*, Grimaldi published the book as a counter-point to the mainstream media's consensus with the British Army and state's version of events.[16] Grimaldi introduced the book by proclaiming: 'Our partiality and one-sidedness is indicated because it reflects the part and side of us, the masses, the people. We are not interested in objectivity, aloofness, that can only derive from indifference or vested complicity with those who have everything to lose.'[17] Grimaldi recognised first-hand the feigning of objectivity as a 'vested complicity' between the media and the state during Bloody Sunday. Giving evidence to the Widgery Tribunal in April 1972, Grimaldi recounted that after shots had been fired at the window of a flat in which he had taken refuge from the chaos outside, a woman remonstrated with him that 'this is at you for taking those photos [...] you must tell them you are a photographer.'[18] The lesson here was that even the public recognised the complicity between the media and the state. The freedom and authority to 'point and shoot' on that day was shared between photojournalists and soldiers alike as long as they didn't cause collateral damage, accidentally causing injury through friendly fire,

as it were. Grimaldi would later caution that 'They [the British military] kill to stop *unfriendly*, truthful photos.'[19]

The work of photojournalists and their own eyewitness testimony was also submitted as evidence to both the 1972 Widgery Tribunal and the Saville Inquiry, which was established in 1997 after a long struggle by the Bloody Sunday Justice Campaign to petition the British authorities for a new examination of the events of that day. Lord Saville even claimed that eyewitness accounts and photographs submitted to the inquiry amounted to 160 volumes of documentation, accompanied by some 14.5 million words, many of which 'spoke' of and for the photographs.[20] Grimaldi was even cross-examined in the tribunal about his account of the photographs he had taken of the shootings during the demonstration and, in the later Saville Inquiry, was asked to explain his admission of being biased in his version of events reproduced in *Blood on the Streets*, which had been published before the original tribunal had even been established.[21]

The photojournalists Coleman Doyle, Peress and Grimaldi, all of whom published photographs of Bloody Sunday in books and the print media that questioned the official version of events, submitted their photographs and provided testimony to both tribunals.[22] The *Irish Times* photo-journalist Ciaran Donnelly testified at the Saville Inquiry that numerous rolls of film submitted to the original Widgery Tribunal, taken at the time of the shootings, had since gone missing, and scratches to negatives of two of the surviving images, it was suggested, were deliberate attempts to distort the photographic image.[23] A type of violence in their own way: the distortion, control, destruction and absences of the photographic record, were easily adjudicated upon or dismissed as irrelevant by the tribunals, a minor distraction to the real job of juridical inquiry, the examination of 'actual evidence'. The accusation of missing military photographs as evidence of the suppression of visual testimony by the British state could even be counter-claimed by the army by retorting that civilian photogra-phers had been reticent to submit photographs by personal choice, or more sinisterly, coercion by paramilitary organisations.[24]

Photography and the Politics of Dissent

Despite the vast amounts of moral, ethical, legal and intellectual labour expended on the photograph as witness and testimony, it could not escape the violence of meaning that called it forth to object before the rule of law. As Widgery's boast reveals, photographs were

endlessly spoken for. The cliché 'a picture speaks a thousand words' was ritually stripped of its force as a cultural myth as thousands of words were spoken of and for the photographs submitted in testimonies by those called before the tribunals. Introduced as evidence and withdrawn, examined and cross-examined, appealed to and dismissed, in its presence and absences the photograph was summoned to provide its testimony so that it could be pinned down and exposed, and in its exposure be contained within finite space to diminish its effect. Indeed, as numerous commentators have demonstrated, the hasty report that resulted from the Widgery Tribunal was a whitewash, and not only because it exonerated the British soldiers from blame despite the admission from the chairman that the firing of weapons had 'bordered on the reckless'. More disturbing perhaps, was that despite the voluminous amount of eyewitness testimony and photographic evidence to disprove the British state's narrative of events, and the depiction of the bodies of victims shot indiscriminately by soldiers, the deceased and their families remained unacknowledged as victims. The tribunal merely dismissed blame of the military and admonished the victims for placing themselves in danger by participating in the demonstration. It is this 'double injury' as Tom Herron and John Lynch describe it, 'of a failure of justice compounded by the epistemological violence of Widgery's findings', that have initiated and ignited representations of Bloody Sunday that have sought to counter the failure of state judicial procedure and the lack of social justice in recognising the civil rights of victims and their families.[25]

How then, if we are to accept Tagg's model of the photograph's incarceration by the violence of meaning, can this accumulation of photographic documentation and the exertions of moral and ethical labour which have mobilised it to redress the lack of justice have any effect within popular consciousness? Can the photograph break out of this cycle of violence which diminishes and limits its agency to enact its own aggression against the forces that pin it down and contain it? Tagg certainly hints that it can, as he admits it is precisely the photograph's unruliness that motivates the violence of meaning:

> the image is always too big and too small for its frame, saying less than is wished for and more than is wanted. The cropping out of this excess and inadequacy in order to ensure that meaning falls readily into place is the work that I take to be a kind of violence that is, as we have seen, brutal enough in its own ways and does not balk at leaving its marks.[26]

This unruly excess should not be read as an admission that there exists a random semiotic code that allows a refracted reality to be read in every photograph which can shatter Taylor's 'hall of mirrors' in deconstructing the shared political values reflected in photographs.

Such oppositional readings remain central to post-colonial identifications of resistance to the social power of the media and continue to be of importance to understanding photography's culturally differentiated uses as recalcitrant to the conception of photographs having fixed, stable meanings. As Christopher Pinney has observed: 'the inability of the lens to discriminate will ensure a margin or substrate of excess, a subversive code present in every photographic image that makes it open and available to other readings and uses.'[27] However, what Tagg alludes to but unfortunately does not elaborate on, I believe, is something more than semiotic resistance in the cause for an alternative reading of the photograph because, as he has argued, this is already anticipated and legislated for. This is precisely the violence of meaning which he suggests is inflected on the photograph. Rather, what is required is a reconfiguration of photography in opposition to the established perception of its binding together of all those subjectivities that seek to find in it an inscription for their individual voices but are ultimately excluded by it. The photograph needs to be placed in conflict with the system that configures the belief, rightly or wrongly, in its power for restorative justice, the shared conviction that, placed before the weight of its visual empiricism, their pleas to right the wrongs against them will be acknowledged. What is required if photography is to instigate its own violence as having agency to mobilise dissent is for it to work against what Jacques Rancière identifies as the 'consensus system' that dreams of 'a world cleansed of surplus identities'.[28]

The use of photography in the popular protests and commemorations of Bloody Sunday, by and within the community denied visibility and justice by the British authorities, provides a particularly potent example of how photojournalistic images have been mobilised in opposition to the established consensus of their function within the state. In their study of the ethics of practices of representation of Bloody Sunday associated with campaigns for justice and commemoration. Herron and Lynch identify the place of photographic portraits of the dead victims of the shootings in the first and subsequent commemorations of Bloody Sunday as a critical intervention to force the state to officially and unequivocally acknowledge the innocence of the deceased individuals and their right to justice.[29]

In the first anniversary commemoration march in 1973, family and friends of the deceased carried placards with photographic portraits of the dead along the original route of the Bloody Sunday demonstration. As Herron and Lynch point out, these portraits are not the official photographs of the state – the criminal profile, the passport photo, the identity card. Yet, they had been subjected to a violence for all that: a brutal assault that extended the violence against the body 'to the photographic trace itself as it is incised from its private context and transferred into the grid of the mediatised public domain'.[30] Amongst the media these portraits were referred to as the 'collect', or sometimes colloquially amongst photojournalists wishing to deflect the trauma of violence through dark humour, 'dead-heads'. Cropped from family pictures gathered by photojournalists from parents and siblings, these photographs were arranged in uniform grids across the front pages of national and international newspapers in the days and weeks following the shootings. The function of these portraits ripped from a pictorial plane that previously organised the face into the domestic tableaus of family holidays, celebrations and everyday social events was to simultaneously individualise the victim while providing a unitary sense of the group as a whole. The uniformity of the passport-style portrait and the grids that arranged the faces of the dead across the front page of the newspaper through what might be described as the 'poetics of the same', allowed viewers to identify with individuals while ensuring that they were contained within a familiar, regularised pattern of visual experience.[31] This combination of personal individualisation and pictorial uniformity allowed the faces of the dead to be assembled as either victims of an atrocity perpetrated by the state, or as culpable for the violence that ultimately led to their deaths.

When the first commemoration of Bloody Sunday proceeded along the original march route undertaken by the demonstrators the previous year, these faces of the dead slowly wound their way through the streets of the Bogside mounted on placards at the head of the procession, and, in the years that followed, as large cloth banners held aloft amongst the crowd. This mobilising and mobile use of photographs of the dead meant that the image of the deceased was, as Herron and Lynch point out:

No longer constrained to mass cards or to the pages of newspapers, these images of the dead now began to move in and around the public sphere. They formed a continuation of the protest of the previous year, while adding a supplement that strengthened the protest itself. The

shift from private to public brought about by the displaying of the photographs (or manipulations of them) changed the emphasis from one of emotional reminder to that of ethical and political demand [...] Carried at the head of the march, held aloft at the very spot in which the killings occurred, they function as an enjoiner to look, to contemplate, to act. They are a forceful return of the repressed in a fleeting and uncanny moment of spectrality.[32]

The supplement that intensified the photographs' demand for justice is precisely the excess that the violence of meaning seeks to command and contain within its frame. Freed from the burden of proof, of the cross-examinations and objections of its veracity, the photograph in acts of commemoration was discursively and physically mobilised against the state which had previously subjected it to the violence of its tribunals of appeal. While the intervention of this ephemeral use of photographic portraits of the dead that appeared in the pages of the print media was spatial in its contestation of the dominant narratives and absences of justice, these transitory, fleeting appearances of the photograph gesture towards a more temporal dimension to the opposition of the photojournalistic portrayal of Bloody Sunday and its place in the mechanisms of the state that determine the limits of what it can reasonably be allowed to say.

During the 25th anniversary commemorations of Bloody Sunday in 1997, an exhibition of six large-scale photo-murals took place in and around the Bogside community of Derry. Photographs were pasted on walls in specific locations across the community in an exhibition that ran alongside other commemorative events and artistic interventions in the public spaces where the original demonstration had taken place. The photographs were all exhibited *in situ* at the site of the original events depicted in the photographs, spaces resonant with the trauma and mnemonic economies of Bloody Sunday and its commemoration. Included in the photo-murals was Peress's photograph of the body of Barney McGuigan amongst others he took that day. In addition to this exhibition of photo-murals, the Bogside artists constructed a painted wall mural to commemorate Bloody Sunday on the gable end of a housing complex that faced onto Rossville Street and adjacent to the historic Free Derry Wall, which had become an iconic symbol of nationalist resistance to British occupation. The new wall mural, just yards from the 1994 mural commemorating the 1969 Battle of the Bogside, which was based on photojournalist Clive Limpkin's

photograph of a young boy wearing a gas mask and carrying a petrol bomb, was a combination of scenes from three different photographic images of Bloody Sunday.[33] The central piece of the mural was based on Fulvio Grimaldi's iconic image of Father Edward Daly waving a white handkerchief at the fore of a group carrying the mortally wounded body of Jack Duddy, the first demonstrator shot by British paratroopers. The separate remediated images in the monochromatic hues of photojournalism unified three photographic episodes into a composite image of the collective 'visual post-memory' of Bloody Sunday.[34] *In situ*, the remediated and reconfigured photojournalistic image cast its shadow over the space of its production, not merely a simulacrum of itself but as the visible trace of the material past 'that weaves memory into the scene of everyday life'[35] (see Plates 1 and 2).

The spatial dimensions of the commemorative wall murals have been rightly identified as a counter-memory in the process of the mnemonic cleansing of the sites of atrocities.[36] However, the photo-murals exhibited during the 25th anniversary commemorations and the painted wall murals, including photojournalistic images, work in opposition to the common, agreed conventions which determine and define the role of photojournalism – shared principles which place a temporal limitation on its political agency. These agreed conventions are what Rancière might term the 'distribution of the sensible', the order of the visible and the sayable, which determines what can be seen and what cannot, what is considered discourse and what is dismissed as noise.[37] Until relatively recently, photojournalism has remained much under-theorised, and in the emergence of a critical discourse of the photojournalistic image more has been said on the oppositional visual rhetorics of photojournalism than on how it operates conventionally within the political economy of the media. I want to suggest, however, that what structures the conventions that allow photojournalistic images to become involved in politics in the sense of Western liberal democracies is that they obey a temporal logic that necessitates their atrophy, the fading from public consciousness. Photojournalism's logic is tied to the logic of the media which requires that it exhausts every story, every horror and atrocity so that it can endlessly be replaced by the next. The representation of Bloody Sunday in the British press and indeed the haste and violent finality of the Widgery Tribunal evidence such logic. The speed of the global media as it spreads its reach to even more distant catastrophes is simply a more intensified version of the photojournalistic visualisation of the drama of Bloody Sunday. As

Paul Virilio observes of the dromological effects of global media, in a world of the increasing velocity of the image, 'humanity is struck by myopia', a foreclosure of the perceptual field of vision.[38] To avoid this 'contemporary myopia of the media age', he suggests, society needs to adopt an alternative position: we need to step back and get some distance from the acceleration of the distribution of the image.[39]

The photo-murals exhibited on the 25th anniversary of Bloody Sunday are an intervention into the cultural politics of its mediatisation not solely because of their spatial presence *in situ*, as it were, but as the photographs linger on a quarter of a century later they simultaneously make visible a community that the state had rendered invisible and displace the logic of photojournalism that exhausts the images' political agency.[40] The exhibited photographs do not simply object or offer a visual protest against the injustices of the state; their stubborn persistence provides a new perception of the photojournalistic image, one that directly intervenes in photojournalism's drive to quickly wear out the energy of the story. The economies of photojournalism, its modes of global distribution and channels of dissemination may be entropic, but the photojournalistic image is not. The exhibition of the photo-murals on the walls across the Bogside, those iconic photographs seared in the minds of the community, is placed in opposition to the agreed conventions that wish them to disappear. As such they provide new possibilities for the political agency of the photographs, an alternative violence of the image. As the media philosopher Vilèm Flusser observes, in the 'photographic universe' of Western culture, photographs – and I would argue photojournalistic images in particular – have become concealed by habit.[41] Society has become so habituated to the ever-changing photographic universe that they occupy, that it hardly takes notice of the photographs which with increasing velocity flow through the photoscape of everyday life. The permanently changing photographic universe 'where one redundant photograph displaces another redundant photograph' has become familiar, 'run of the mill' to the extent that change – 'progress' – has become uninformative. What would be truly shocking, Flusser suggests, is a standstill situation, a society where the same photographs would be experienced day after day.[42] The exhibition of photo-murals intervene in the logic of photojournalism in precisely this way, providing the photojournalistic image with a sphere of agency outside the conditions that wish to see it exhaust its possibilities for dissent.

Conclusion: Post-Conflict and the Politics of Late Photography

In his critique of the re-emergence of 'late photography' in contemporary visual culture of the new millennium, David Campany cautions that its appearance as a more refined depiction of catastrophe in a global arena of imagery dispersed across multiple channels of transmission is not in itself an assurance of a critical perspective of political and cultural conflict.[43] Discussing Joel Meyerowitz's 9/11 project *Aftermath*, he warns that in its visual distancing of the event for the viewer it can also induce a response of 'indifference and political withdrawal', a 'kind of liberal melancholy' that equivocates cultural analysis and political explanation.[44] Such a caution has important implications for conflict and post-conflict art photography from Northern Ireland, as 'late photography' has been positioned as a significant cultural intervention into the problems of the mediatisation of the nuances of identity politics.

'Late photography', or what Peter Wollen has identified as 'cool photography', a practice that moves in to document a scene after the event, is contra to the logic of photojournalism that records the spectacle of conflict as it happens.[45] This cold detachment from the spectacle of conflict, the retreat from the *in media res* of photojournalism in favour of a more reserved, pictorially still depiction of its aftermath, I take to be an exemplary visual example of Virilio's call to step back from the accelerating velocity of the global image world. Yet Campany's caution must be heeded. 'Late photography' has become *de rigueur* for an art world obsessed with global conflict, a condition of what has been described elsewhere as an era of 'post-reportage'.[46] In its emphasis as the trace of a trace, the forensic depiction of the indexical marks left by conflict and its turn to the remnants, material residue and ruins of the destruction of technological warfare, 'late photography' has left itself open to the type of ambiguity characterised by post-modern doubt and uncertainty on the limits of photographic representation. It is such ambiguity masquerading as a politics of the image that has the potential to result in a collective apathy towards making sense of the political circumstances of conflict. However, the homogeneity of the aesthetics of 'late photography', as a global imperative to redress the failure of photojournalism to break from the complicity of maintaining social cohesion through the mediatisation of conflict, tends to eschew the culturally differentiated practices and political necessities for it as a politically salient practice. In Northern Ireland, photographers

such as Willie Doherty, Anthony Haughey, David Farrell, Paul Seawright, Victor Sloan and Donovan Wylie, to name but a few, have turned to strategies of 'late photography' to animate the political complexities of post-conflict Northern Ireland (see Plates 3 and 4). Doherty's 'The Maze' and 'Watchtowers' series have also been associated with what has been identified as an 'archival turn' in contemporary visual culture. Along with John Duncan's ongoing documentation of Belfast, this work continues to explore the interstitial state of post-conflict cultural politics.[47]

While the official perspective of post-agreement Northern Ireland is that there is now a cessation of hostilities, the peace process is just that: a process. The work of photographers using 'late photography' or archival practices has addressed itself to the salvage of the legislated erasure of the past, and the new political complexities of relations between communities whose sectarian divisions have only become more animated as 'official culture' is mobilised to re-imagine a unitary 'community'. In a media environment through which the image has been mobilised to maintain divisions, reinforce difference and preserve political segregation, where the photograph has in effect been made to take sides, 'late photography' has introduced a more open space of the image for the contested narratives and histories of the Troubles to be articulated. Contra to the violence of meaning proposed by Tagg, 'late photography' does not pin down or crop out the excess but provides for an active reading beyond the limitations of the aesthetic banality cautioned against by Campany. As Seawright commented on his own work, 'a lot of the meaning is constructed within the image as people look at it. A lot happens right here.'[48] Through the fragment, the residual trace and the everyday detritus of urban space, the seemingly trivial depiction of rural, urban and suburban spaces takes on complex political significance. More significantly, in its attention to the residual traces of conflict and the interstitial state of things, the excess that the entropic logic of photojournalism leaves behind, 'late photography' opens the pictorial space to the contested dialogues and disputed narratives of conflict. It is this strategy of inviting active contradictory readings in and through the image that avoids the aesthetic banality and political resignation that have become a feature of much 'late photography'.

To turn to Rancière once more, emancipation

begins when we challenge the opposition between looking and acting and understand that the distribution of the visible itself is part of the configuration of domination and subjection. It starts when we realize that looking is also an action that confirms or modifies that distribution,

and that 'interpreting the world' is already a means of transforming it, or reconfiguring it.[49]

No less than the photo-murals exhibited to commemorate Bloody Sunday, 'late photography' reconfigures the image of conflict as a new terrain of perception and signification, a territory that not so much provides an alternative to the violence of the image as intervenes into its saturation of vision. Barthes's claim that, set before its ocular force, we cannot transform or refuse the photograph's brutal realism may give reason to pause for a moment in the search for a photography that has the potential to break from the violence of meaning. But it is perhaps best to interpret it as a warning not to become blinded by the limitations that its pictorial frame presents us with. As the mobilisation of photography in the commemoration of Bloody Sunday and the strategies of 'late photography' demonstrate, the political agency of photography in conflict and post-conflict Northern Ireland emerges not from retreat from violence of the image, but from the direct intervention into that realm of perception and signification that seeks to constrict and limit an active engagement with the image that may transform its constituency of participation.

Notes

1 Roland Barthes, *Camera Lucida: Reflections on Photography*, trans. Richard Howe (London, 1984), p. 91.

2 John Taylor, *War and Photography: Realism in the British Press* (London, 1991), pp. 116–57.

3 Ibid., p. 10.

4 Ibid.

5 Ibid.

6 Ibid., p. 11.

7 John Tagg, *The Burden of Representation: Essays on Photographies and Histories* (London, 1988), p. 119.

8 Roland Barthes, 'The photographic message', in *Image-Music-Text*, trans. Stephen Heath (London, 1977), p. 29.

9 Taylor, *War and Photography*, p. 123.

10 John Tagg, *The Disciplinary Frame: Photographic Truths and the Capture of Meaning* (Minneapolis, 2009).

11 Ibid., p. xxiii.

12 Ibid., p. xxvi

13 Ibid.

14 Michel Foucault, *The Archaeology of Knowledge*, trans. A.M. Sheridan Smith (London, 1989), pp. 128–9.

15 'The beat of life', *Life*, 11 February 1972, pp. 2–3.
16 Fulvio Grimaldi and Susan North, *Blood on the Streets* (Dublin, Rome, London, 1972).
17 Ibid., p. 1.
18 Grimaldi's original statement to the Widgery Tribunal has been reproduced in the testimony and records of the Lord Saville Inquiry. These can be found in *Report of the Tribunal Appointed to Inquire into the Events on Sunday, 30 January 1972, which Led to Loss of Life in Connection with the Procession in Londonderry on that Day* [Widgery Report] (London, 1972), available at http://cain.ulst.ac.uk/hmso/widgery.htm (accessed 18 February 2014).
19 Grimaldi and North, *Blood on the Streets*, p. 32.
20 Quoted in Tom Herron and John Lynch, *After Bloody Sunday: Representation, Ethics, Justice* (Cork, 2007), pp. 3–4.
21 Widgery Report.
22 Coleman Doyle, *People at War* (Dublin, 1975); Grimaldi and North, *Blood on the Streets*.
23 See section 175: 'Missing Photographs and Other Materials' *Bloody Sunday Inquiry Vol. IX* (2010) http://cain.ulst.ac.uk/hmso/widgery.htm (accessed 18 March 2011) (original statements to the Widgery Tribunal reproduced in Saville Inquiry records). Despite missing photographs, scratched negatives and the acknowledged absence of military photographs taken on that day the Saville Inquiry concluded that there was no deliberate suppression of visual documentation.
24 'Missing photographs and other materials', *Bloody Sunday Inquiry*.
25 Herron and Lynch, *After Bloody Sunday*, pp. 6–7.
26 Tagg, *The Disciplinary Frame*, p. 14.
27 Christopher Pinney, 'Introduction: "How the other half . . .", in C. Pinney and N. Peterson (eds), *Photography's Other Histories* (Durham, NC, 2003), p. 6.
28 Jacques Rancière, *Disagreement: Politics and Philosophy*, trans. Julie Rose (Minneapolis, 1999), p. 124.
29 Herron and Lynch, *After Bloody Sunday*, pp. 27–47.
30 Ibid., p. 27.
31 The term is Deborah Poole's from what she identifies in 'type portraits' as the logic of the equivalent. See Deborah Poole, *Vision, Race and Modernity: A Visual Economy of the Andeán Image World* (Princeton, NJ, 1997), pp. 107–41.
32 Herron and Lynch, *After Bloody Sunday*, pp. 34–5.
33 The photograph also appears on the cover of Clive Limpkin, *The Battle of the Bogside* (London, 1972). The book was awarded a Robert Capa Gold Medal for best photographic reporting by the Overseas Press Club of America in 1972.
34 Graham Dawson, *Making Peace with the Past? Memory, Trauma and the Irish Troubles* (Manchester, 2010), pp. 197–8. The term 'post-memory' is Marianne Hirsch's from her study of how generational memory is passed through narratives of remembrance from Holocaust survivors to those of subsequent generations who never experienced traumatic events

themselves. See Marianne Hirsch, *Family Frames: Photography, Narrative and Postmemory* (Cambridge, MA, 1997).

35 Graham Dawson, 'Trauma, place and the politics of memory: Bloody Sunday, Derry, 1972–2004', *History Workshop Journal* 59 (2005), p. 165.

36 Dawson, 'Trauma, place and the politics of memory'; and Dawson, *Making Peace with the Past?*

37 Rancière, *Disagreement*, p. 29. See also Jacques Rancière, *The Politics of Aesthetics: The Distribution of the Sensible*, trans. Gabriel Rockhill (London, 2004), pp. 12–13.

38 Paul Virilio, *The Original Accident*, trans. Julie Rose (Cambridge, MA, 2005), pp. 48–9.

39 Paul Virilio, *A Landscape of Events*, trans. Julie Rose (Cambridge, MA, 2000), pp. x–xi.

40 Rancière makes clear that what is 'political' is not simply demonstration but an intervention into the spaces that determine what is visible to reconfigure them as sites of a community denied visibility by the state. As he notes, 'dissensus' is not confrontation but a 'demonstration *(manifestation)* of a gap in the sensible itself. Political demonstration makes visible that which had no reason to be seen.' I take this as a particularly instructive way of conceptualising what is taking place with the photo-murals as it is not a matter of shifting photographs from one contextual formation to another, but in providing a different perceptual experience of the photojournalistic image. This, I believe, provides photography with political agency outside the violence of meaning outlined by Tagg. See Jacques Rancière, *Dissensus: On Politics and Aesthetics*, trans. Steven Corcoran (London, 2010), pp. 36–9.

41 Vilém Flusser, *Towards a Philosophy of Photography*, trans. Anthony Matthews (London, 2000).

42 Ibid.

43 David Campany, 'Safety in numbness: some problems of "late photography"', in D. Green (ed.), *Where is the Photograph?* (Brighton and Maidstone, 2003), pp. 123–32.

44 Ibid., p. 132. See Joel Meyerowitz, *Aftermath: World Trade Center Archive* (New York, 2006).

45 Peter Wollen, 'Vectors of melancholy', in R. Rugoff (ed.), *The Scene of the Crime* (Cambridge, MA, 1997).

46 Ian Walker, 'Desert stories or faith in facts?', in M. Lister (ed.), *The Photographic Image in Digital Culture* (London, 1995), pp. 239–40.

47 John Duncan's work has appeared in several series: see 'Trees from Germany' (Belfast, 2003); 'Bonfires' (Göttingen, 2008). On the archive in northern Irish photography, see Colin Graham, 'Every passer-by a culprit? Archive fever, photography and the peace in Northern Ireland', *Third Text* 19/5 (2005), pp. 567–80.

48 Paul Seawright quoted in 'Northern star', *Irish Times*, 28 May 1997, p. 12.

49 Jacques Rancière, 'The emancipated spectator', *Artforum* 45/7 (2007), p. 277.

4 Dispelling the Myth of Invisibility

Photography and the Algerian Civil War

Joseph McGonagle

A widespread anti-camera culture, stemming in part from the use of photography to identify assassination targets, and the highly difficult conditions in which photographers had to operate, led the Algerian Civil War to be labelled an invisible, imageless war.[1] This partially explains why, in 1997, the Algerian Agence France Presse (AFP) photographer Hocine Zaourar's iconic image of a crying woman being comforted following a massacre in Bentalha secured him the World Press Photo award and, for the international media, instantly became the definitive image of the decade-long conflict. While Zaourar's image and other press photography has attracted some critical interest, no detailed studies of the wider uses of photography during the civil war and its aftermath have been published.[2] This chapter therefore aims to begin addressing this gap by analysing how Zaourar and other photographers during the Algerian Civil War – via the use of photojournalism and other genres – pictured it visually.

It begins by discussing Zaourar's photograph – indisputably the defining image of the conflict globally – before turning to consider the work of the most famous foreign photographer who recorded the conflict: the Swiss photojournalist Michael von Graffenried. Finally, it analyses the Algerian photographer Omar D's unique and crucial intervention in debates regarding the politics of postwar memory within Algeria. This chapter therefore ponders both what the photographs of the conflict that have entered circulation tell us about the way that it has been represented and how they shape understanding of the conflict itself. Furthermore, given the recent publication of a series of books containing images from the period, what are the stakes of such images entering circulation now?

Firstly, some historical context. Although pinpointing precisely when the civil war started – and whether it has ever ended – remains a matter of debate, the main phase of conflict began in early 1992 after a military *coup d'état*.[3] The Algerian army had seized power following the first round of parliamentary elections in December 1991, which saw a landslide victory for the Islamist party, the Front Islamique du Salut (FIS). Fearful of it winning the second round as well, the military cancelled the elections and declared a state of emergency. The FIS itself was later outlawed and many of its members arrested, which instigated a long period of guerrilla warfare throughout Algeria, where the military, police and civilians were attacked by armed groups such as the Groupe Islamique Armé (GIA). As the decade drew to a close, it was estimated that over 100,000 people had been killed during the conflict: later estimates would suggest the war had claimed up to 200,000 victims.[4] Major hostilities only ceased following the election of Abdelaziz Bouteflika to his first term as president in 1999. Later that year, his Civil Concord Law, which offered a limited amnesty to some of those who had participated in terrorism, won approval in a national referendum. It largely achieved its aim of quelling most of the violence, bringing a resolution to the conflict by 2002.

Throughout the civil war, working conditions for the national and international media within Algeria proved extremely difficult. Allied to the difficulties of working in a war that had no obvious frontline and was fought by a number of different groups, those in power actively sought to control what was seen and by whom. The press accreditation for certain photographers and news organisations would therefore be withdrawn without warning. Journalists would be compelled to accept escorts by security forces, thereby limiting their attempts to converse freely with civilians, and official permission would routinely be denied to visit the sites of massacres and attacks. Press freedom was also curtailed by the arrest and detention of many journalists, by recurrent state censorship, and by the use of laws that criminalised criticism of the government on the grounds of state security. The personal dangers those working in the media also risked were stark: often subject to death threats and seen as prime assassination targets, during 1993–7 alone, 58 Algerian journalists were murdered.[5]

Given such perilous conditions, the relative scarcity of images of the conflict disseminated – both within the Algerian media and internationally – seems unsurprising.[6] Arguably this only exacerbated the incomprehension of global viewers regarding the conflict, ultimately creating, in the words of the historian Benjamin Stora, 'a fantasised

Algeria that does not exist'.[7] The widespread confusion and suspicion that surrounded the war – encouraging many in the media to question exactly who the perpetrators of the many massacres were – led Stora to label it as a 'war without a face'.[8] Although his term sought to highlight the facelessness of the war's killers, as the next section will show, it was the face of a particular victim of the war that would come to form its defining image.

Picturing Grief: La Madone de Bentalha

August and September 1997 saw terrifying levels of violence occur in northern Algeria as a wave of massacres claimed hundreds of lives. The horror peaked on the night of 22 September 1997 just south of Algiers in the small town of Bentalha, where between 50 and 100 men went on the rampage for several hours, slaughtering over 400 people.[9] Travelling there the next day, the AFP photographer, Hocine Zaourar visited a local hospital to try to photograph the aftermath of the events. Despite being obstructed from doing so by security forces, outside the hospital he quickly took three photographs of a woman, apparently crying out of grief, being comforted by another woman beside her.

Much to his surprise, the image (see Plate 5) would subsequently be reproduced by over 700 publications worldwide.[10] Its visual currency then further increased as commentators began to ponder why Zaourar's image had so keenly captured the attention of the world's press.[11] In keeping with the wider practice of conspiracy-theorising during the conflict, its notoriety would also lead critics to question the photograph's authenticity and whether it was taken at Bentalha at all.[12] Moreover, the controversy grew still further when it was revealed that – contrary to widespread reports in the international media – the woman pictured had not lost eight children but three other relatives. Indeed the woman herself, Oum Saad, reportedly under government pressure, would later sue Zaourar for libel.[13]

This misinterpretation of the source of Oum Saad's distress undoubtedly powered the image's circulation globally. Positioning her as a mother mourning the loss of her eight children allowed commentators to draw parallels with notions of motherhood worldwide and to suggest her plight metaphorically mirrored that of Algeria more widely. This misunderstanding also conveniently allowed the media to play upon the image's aesthetic qualities too, which for many evoked *pietà* and

other biblical imagery from Western art history. As Sontag argued: 'all photographs wait to be explained or falsified by their captions' and Zaourar's image proved no different.[14] Names such as 'La Madone de Benthala', 'La Madone' or 'La Pietà' quickly stuck to it, a phenomenon that gave rise to reflection upon the Western media's automatic association of the image of a grieving Muslim woman with Christian iconography. For Martine Joly, this revealed a latent ethnocentrism within the press in the West and its blindness to the cultural contexts that inflect the reception of images, which consequently assumes that 'a good photo for us is a good photo for everyone, which is far from the truth.'[15]

As Juliette Hanrot has argued, however, very similar imagery – albeit without captions with such Christian connotations – could be found in the Algerian press at the time, suggesting that such images were readily embraced by the Algerian media and that such iconography resonated nationally as well as internationally.[16] Furthermore, for the artist Pascal Convert – whose 2004 series of wax sculptures was inspired by Zaourar's photograph and two other controversial media images of conflict in Kosovo and the Gaza Strip – such images provoked controversy within the West precisely because they lack the alterity that Western viewers expect to see there, leading him to argue that these are images that 'we do not want to see because they resemble us'.[17]

The generality of Convert's comments aside, the journey of Zaourar's image certainly illustrates how such photographs can quickly become sites of contestation, invested with a diverse range of meanings depending on when and where they appear. The example of France, Algeria's last colonial ruler, provides a pertinent example. There the embrace of the image's resemblance to Christian iconography can be understood as part of a wider transcolonial tendency, despite decolonisation in 1962, to dwell upon Algeria's Christian heritage. A spectacular example of this was provided by the intense coverage given by French media to the abduction and murder of a group of French Cistercian monks from their monastery in Tibhirine during 1996 and proved that – for all the conflict's supposed invisibility – some events during the Algerian Civil War proved particularly adept at concentrating foreign minds.[18] The welcome that greeted Zaourar's photograph can therefore, at least partially, be attributed to its success at resonating with wider discourses at work during the conflict, conforming with Robert Hariman and John Lucaites's definition of the iconic photograph as 'an aesthetically familiar form of civic performance coordinating an array of semiotic transcriptions that project an emotional scenario to manage a basic contradiction or

recurrent crisis'.[19] Here the selection of titles attributed to the image in the Western media, largely marginalising its Muslim specificities, further assured its readability for many audiences. Whilst emphasising the image's resemblance to Christian iconography certainly helped the civil war acquire spectacular visibility globally, it also validated arguments that peculiarly Western values and perspectives subtend photojournalism as a genre and practice.

Most of the titles used emphasised the gender of the photograph's main subject, and it is worth reflecting further here on the fact that – in its most famous version – the two subjects of the image are both women. Although full citizenship rights had been granted to women in Algeria by the 1976 constitution, the subsequent introduction of the Family Code in 1984 'clearly made women legally into citizens of a different class who would have to seek permission from men in the family to do things previously considered to be part of everyday life'.[20] Moreover, through introducing the code, the state effectively gave men 'the licence to treat women as minors whose actions were now subjected to constant surveillance'.[21] Predictably, therefore, many women found themselves the targets of threats and violence during the civil war.[22] Accordingly, Jacques Derrida described it as 'for the most part a war of men. In many ways, not limited to Algeria, this *civil* war is also a *virile* war. It is thus also, laterally, in an unspoken repression, a mute war against women. It excludes women from the political field' [original emphases].[23] Given such circumstances, the fact that the most iconic image of the Algerian Civil War only shows women makes its success all the more distinctive. On the one hand, it suggests a certain gendering of the conflict, conforming with conventional depictions of women as maternal figures and victims within war photography. This is confirmed by the fact that the original photograph, which showed a group of men standing in the background, was cropped by AFP to exclude them.[24] On the other, the recording of a woman in such vivid lamentation via photography – a mute medium – chimes metaphorically with Derrida's comment that the war smothered women's voices.[25]

As previously mentioned, Zaourar's image would eventually secure him the 1997 World Press Photo award. It is revealing to consider briefly, however, the contrasting fate of another photograph taken a month earlier in the Algiers region, entered in the same competition but awarded second prize. Taken on 26 August 1997 in the Bab-el-Oued area of the city, it captured a moment during the discovery of seven murdered women and children, whose bodies – some slashed and

decapitated – had been thrown down a well. Peering down into it, an unnamed photographer recorded an image of a young girl's contorted body being hauled up to the surface by rope. Like Zaourar's, this photograph would also appear in the international press but failed to acquire the same notoriety and so subsequently fell out of circulation. Nevertheless, if fellow photographer Benyoucef Cherif is to be believed, such images were precisely those that certain newspapers sought in order to represent the conflict. Out of respect for the dead, Cherif refused to offer photographs of people, for example, with their throats slit, which is why he claimed his images were not selected because of their lack of violence and blood. In more than a nod to Zaourar's infamous image, Cherif asserted that, when representing the horrors of war, 'the suffering of a people in tears says much more.'[26] Many viewers may agree in principle but, by not conforming so readily to Hariman and Lucaites's criteria – and by testing the limits of societal norms by showing the body of a bloody and mutilated child – its circulation was automatically more restricted. In comparison, Zaourar's photograph allowed viewers to project much more readily their own reading on to the image and, crucially, proved far easier for the media to caption.

Shooting from the Hip: Michael von Graffenried's *Inside Algeria*

This section now turns to consider the work of a fellow World Press Photo award winner, whose photography has tackled a diverse range of subjects but is also primarily known for his images of the Algerian Civil War.[27] Born in Switzerland and based in Paris, Michael von Graffenried travelled to Algeria many times throughout the conflict and his book *Inside Algeria* (published by Aperture) comprises images made there during 1991–8.[28] As its title suggests, his book played upon the insider perspective that von Graffenried could offer at a time when insights and images of the conflict were perceived globally as scarce. Moreover, this also helped position von Graffenried as the foreign photographer of the Algerian Civil War and consequently it is still often claimed that he was the only Western photographer to travel there regularly during the civil war.[29] The date of publication of the book, 1998, is not insignificant here either. Appearing a year before Bouteflika won power and eventually brought an end to the conflict's major phase of violence. *Inside Algeria*

offered an important glimpse into life during the civil war at a time when its end still seemed far from sight.

Given the extreme difficulties of working in Algeria during this time, von Graffenried chose to work furtively, a choice also necessitated by many people's refusal, out of fear, to be photographed. This led him to declare that, despite having visited many countries where 'the camera is shunned', he did not 'know any other place where photography is regarded with such suspicion'.[30] His image-making, therefore, had to be surreptitious. Abandoning his normal Leica, he wore a Widelux camera with a 150-degree panoramic lens around his neck, with which he learned to photograph without ever raising the viewfinder to his eyes. This explains the distinctive angle used in many photographs: much lower than viewers would conventionally expect. Conscious that not securing the consent of his subjects rendered his practice ethically problematic, he nevertheless felt compelled to work in this way because, he argued, 'it was the only way of getting photographs of everyday reality in Algeria.'[31]

Everyday reality is certainly a key theme within his work. Many of his panoramic black and white documentary images show civilians going about their daily business in spite of the climate of fear and risk of attacks. At the same time, the reality of wartime life always seems near, with the threat of violence and representations of its aftermath a recurring theme. A range of images thus show the victims of bombings, bereaved families visiting cemeteries and people sifting through the rubble and ruins of buildings following explosions. Here, von Graffenried's covert technique and network of contacts developed during repeated visits allowed him to capture moments that would otherwise be impossible, such as a raid on a café by the anti-terrorist police, known colloquially as 'ninjas' due to their distinctive uniform and black balaclavas (see Plate 6). With neither their or many of the detained men's faces clearly discernible, the image itself provides a metaphor for the way the war was perceived generally. The elongated field of view and wide aspect ratio also underscore the prevailing power relations that existed between civilians and the security forces during the conflict.

His candid camerawork and wide choice of subjects also mean that a broad cross-section of Algerian society is shown, regardless of gender, age or ethnicity. In a nod to the youthfulness of the Algerian population – its birth rates were among the highest in the world in the 1980s and 70 per cent of the population today are under 30 years old – children feature prominently in his images.[32] They also adorn the covers of both francophone and anglophone editions of his work. The sight of a young

boy shouting on the cover of *Inside Algeria* and another calmly eating an ice cream on *Journal d'Algérie 1991–2001* recall moments from a film also shot in black and white that depicted an earlier wartime era in Algeria: Gillo Pontecorvo's *La Bataille d'Alger* (1966).[33] By encouraging such transcolonial links, von Graffenried gives viewers pause for thought on what effects another long war in Algeria will have upon this generation of children.

At the same time, von Graffenried notably shies away from including bloody or very violent images in his work. Observing how seldom the photojournalist shows a dead body and how often he focuses instead upon day-to-day life during the ongoing conflict, the *Time* journalist Scott MacLeod argued that: 'in capturing the banality of the war he catches glimpses into the soul of Algerians in a way that a picture of a pile of corpses never could.'[34] In doing so, MacLeod echoes Cherif's sentiments quoted earlier, both maintaining that the visual power of war photography is diminished when such violence is shown. As John Taylor asked, however, when considering the stakes of showing such images: 'What would it mean for knowledge if the images ceased to circulate, or were never seen in the first place? What would it mean for civility if representations of war crimes were always polite? If prurience is ugly, what then is discretion in the face of barbarism?'[35] Macleod and Cherif conveniently choose not to answer these questions, prioritising instead the effects and aftermath of violence to convey the harsh realities of war. The final section now turns precisely to the aftermath of the civil war to trace the impact of a particular legacy of it that continues to reverberate throughout Algerian society: the fate of the disappeared.

Memory Loss:
Omar D's Unofficial History of the Disappeared

Following the end of major violence in the early 2000s, Bouteflika sought to capitalise on the relative success of his Civil Concord Law by formally marking an end to the conflict and encouraging national reconciliation within Algerian society via the introduction of the Charter for Peace and National Reconciliation, which was approved by a national referendum in 2005 and became law the following year. The terms of the charter, however, would attract international criticism and condemnation within Algeria, with some of the most controversial terms being those

that directly impacted upon the families of people who had been forcibly disappeared during the conflict.

It is difficult to estimate how many people have disappeared during or since the civil war. Whereas John Entelis states that 'since 1992, there have been between 6,000 and 7,000 Algerians who have "disappeared" while under police custody', Lahouari Addi estimates the total number of disappeared as between 10,000 and 20,000.[36] Whereas the charter proposes economic compensation for the families of the disappeared, to receive payments families are obliged to obtain death certificates for their relatives, a step many refuse to take while their fate remains unclear. Furthermore, article 46 of the charter effectively forbade discussion of the disappeared *tout court* by stating that:

> Anyone who, by speech, writing, or any other act, uses or exploits the wounds of the National Tragedy to harm the institutions of the Democratic and Popular Republic of Algeria, to weaken the state, or to undermine the good reputation of its agents who honorably served it, or to tarnish the image of Algeria internationally, shall be punished by three to five years in prison and a fine of 250,000 to 500,000 dinars.[37]

The implications of this for the families of the disappeared during the conflict have been profound. By introducing such legislation, the regime sought to turn the page definitively, something that depends on all discussion of the disappeared ceasing and their traces being erased. This is why the unique book by the Algerian photographer Omar D, *Devoir de mémoire/A Biography of Disappearance, Algeria 1992–*, is so important.[38] Commissioned by the British organisation Autograph ABP, it defies state silence on the disappeared and sheds light on an issue that those in power strive to forget. The chances of finding it for sale any time soon in an Algiers bookshop therefore remain stubbornly remote.

To work on such a project, however, presented Omar D with an acute problem: how can you represent a group of people whose whereabouts remain unknown? Although Omar D incorporates a mixture of photography, it is his use of identity photography (see Plate 7) that is most striking – a symbolic choice all the more powerful given its close association with state control and the profound complicity of the ruling regime in the disappearance of thousands of people in Algeria.[39] While the neat grids of such carefully reproduced and arranged photographs might risk an uncritical aestheticisation of such images and their attendant political context, the tears, creases, marks and blemishes visible on many

remind viewers that the original identity photographs also function as material objects too, thus underlining the 'centrality of materiality as a formative element in the understanding of photographs as social images'.[40] All the more so given how such images can often be the only ones that families possess of disappeared relatives. Cherished and revered by family members, such uses of identity photography also provide an emblematic example of how photographs do not merely function visually but 'must be understood as corpothetic, and sensory, as bearers of stories, and of meanings, in which sight, sound and touch merge'.[41] The marshalling of different senses is also made implicit by the inclusion of a number of images that connote the tactile, such as the reproduction of handwritten letters and statements, and the frequent emphasis in Omar D's broader photography of the texture of different landscapes within contemporary Algeria. The sight of rubble, broken walls and empty spaces provides a clear metaphor for the psychological trauma such disappearances have inflicted upon contemporary Algerian society as a whole.

Moreover, by encouraging viewers to ponder the fate of the disappeared, and the profound legacy their forced disappearance has had upon family members, Omar D also emphasises the 'grievability' – the conditions that dictate whether and how lives become worthy of significance and grief – of the people pictured. As Judith Butler has argued, the possibility of grievability depends fundamentally on the 'conditions of representation' in place within a particular historical moment.[42] Tightly circumscribed within Algeria itself, such conditions do not widely exist. Omar D's book therefore forms part of important attempts both within and beyond Algeria to create conditions in which their lives can be considered worthy of collective and public grief.

Bouteflika's longing to turn this particular page of post-colonial Algerian history, of course, does little to diminish the anguish of the relatives of the disappeared, the vast majority of whom still remain uncertain whether family members are alive or dead. As its use in a variety of other similar movements worldwide has shown, by emphasising the simultaneous presence and absence of the disappeared visually, photography here has an important political role to play.[43] Given the haunting quality of such images, Omar D's work also evocatively recalls the logic of spectrality described by Derrida.[44] For Derrida, acknowledging traces of the spectre and its characteristic oscillation between absence and presence, death and life, can highlight the deconstruction at work within a given object of scrutiny, troubling neat ontologies and previous certainties. Furthermore, as Colin Davis explains, for Derrida:

attending to the ghost is an ethical injunction insofar as it occupies the place of the Levinasian Other: a wholly irrecuperable intrusion in our world, which is not comprehensible within our available intellectual frameworks, but whose otherness we are responsible for preserving.[45]

Only by embracing an encounter with its alterity, by communicating with and listening to the spectre, can 'the structural openness or address directed towards the living by the voices of the past or the not yet formulated possibilities of the future' be grasped.[46] These possibilities of the future – including the conditions of grievability outlined above – are precisely the ones that the ruling regime so determinedly seeks to stifle. Nevertheless, human rights organisations – such as the Collectif des Familles de Disparu(e)s en Algérie and SOS Disparus – continue to campaign for justice. Despite continual police obstruction, small protests by mothers and relatives of the disappeared still regularly take place in Algiers, where identity photographs are used in a similar way to that in Omar D's book: placed in a grid on long banners or reproduced as individual portraits on placards held aloft or worn around the neck by protestors.[47]

Despite the charter's introduction in 2006, the determination with which the regime has continually impeded such protests in recent years implies that it still fears the publicity such protests could create. Bouteflika himself is clearly well aware of the power of such images globally: as he told a group of relatives of the disappeared during a final campaign meeting on the eve of the national referendum on the Civil Concord Law in September 1999. Able to confront the President directly for the first time about the fate of their family members, their questions to him were met bluntly with the curt reply: 'The disappeared aren't in my pockets [. . .] you shame me throughout the world, like hired mourners, with your photos.'[48] His callous suggestion is that the tears they shed are more performative than genuine, confirming that, in his view, the disappeared do not meet the conditions of grievability that Butler has outlined – and never will.

Here the French part of Omar D's book title – *Devoir de mémoire* – becomes especially important. For whatever the Algerian state might stipulate, the title implies that viewers have an obligation and duty to remember the disappeared and should actively resist state-led attempts to institutionalise their forgetting. Omar D's work thus epitomises the civil contract of photography advanced by Ariella Azoulay, which 'shifts the focus away from the ethics of seeing or viewing to an ethics of the

spectator, an ethics that begins to sketch the contours of the spectator's responsibility toward what is visible'.[49] By using photography to make visible people who have been vanished, Omar D defies the ruling regime and urges viewers to consider the ethical responsibilities the sight of such images engenders. As Addi asks, 'can a state order the wiping out of memories under threat of imprisonment?'[50] The logic of specularity would suggest not and, despite its best efforts, the regime may find that the ghosts that haunt Algeria will, in some form, ultimately return to hold it to account.

Conclusion

As this chapter has shown, Zaourar, von Graffenried and Omar D all use different techniques and types of photography to represent the Algerian Civil War. Therefore, while for much of its duration it may have lived up to its name of an imageless – and therefore invisible – war, the euphemism now seems increasingly inappropriate. The intervening years have been marked by a noticeable engagement with the conflict via images, and especially photographic ones. Indeed, photography has clearly played a pivotal role in shaping both understanding of the conflict and its nascent memorialisation.

Why has photography, however, rather than film or other visual media come to occupy this role within visual culture?[51] The difficulties of working in Algeria during the civil war undoubtedly favoured photography as a more practical means of documenting the conflict, and – given the widespread anti-camera culture the conflict augmented – it undoubtedly offered a more discreet technology with which to record daily life. This explains the preponderance of still rather than moving images of the civil war and, as the history of war iconography throughout the twentieth century has shown, the visual shorthand that photography can provide facilitates the summarising of such conflicts through snapshots. Yet even if many of the images studied here were made by photographers of Algerian origin, who live and work in Algeria today, the determining role played by international publishers and organisations is striking.

Given the transnational circuits of power that characterise the field of photography and especially photojournalism – as the circulation of Zaourar's image attests – this may seem unremarkable. The ways in which the Algerian Civil War has been represented and remembered, however, reflect more the postwar political necessities of those in power in Algeria.

The latter's scant disregard for preserving a visual legacy of this period affirms that this is a conflict that the ruling regime wants to consign to oblivion. Moreover, given the regime's attempts to institutionalise such forgetting via its legislation on national reconciliation, the civil war is one it has impelled Algerian citizens to forget too.

The defining image of this conflict for international audiences therefore remains Zaourar's iconic photograph. Its easy recuperation by the Western media and convenient elision of the specificities of the conflict facilitated its global resonance and continue to allow it to function as the key signifier for the wider civil war. The candid camerawork of von Graffenried, meanwhile, remains the most well-known body of images of the war internationally, offering unique insights into daily life for Algerians during the conflict. In contrast, much of the power of Omar D's work resides in its defiance of the state-sanctioned silence that Bouteflika's reign inaugurated. Reasserting the powerful challenge that photography can pose such forces, the calm soberness of his book's presentation belies the devastating legacy these disappearances have bequeathed so many families, as the accompanying text so vividly details.

In conclusion, the involvement of publishers and organisations such as Aperture and Autograph ABP in disseminating such images reminds us importantly that such examples of visual culture form part of what Deborah Poole has termed a 'visual economy', characterised by processes of 'production, circulation, consumption, and possession of images'.[52] Tellingly, given the Algerian state's refusal to sustain memories of the conflict, the visual economy of the civil war is increasingly being determined beyond Algeria, where the flow of such images can less easily be checked. As Martin Evans and John Phillips argued, however, when discussing the regime's attempts to institutionalise forgetting about the conflict and the fate of the disappeared, 'in the long term such official amnesia is unsustainable'.[53] When anamnesis finally flourishes – and surely flourish it will – a fuller history of how the Algerian Civil War has been represented visually can finally be written and the myth of its invisibility definitively dispelled.

Notes

1 See, for example, the title of the book on the conflict by the historian Benjamin Stora, *La Guerre invisible: Algérie, Années 90* (Paris, 2001).
2 Studies of Zaourar's image include: Pierre-Alban Delannoy, *La Pietà de Bentalha: étude du processus interprétatif d'une photo de presse* (Paris, 2005),

and Juliette Hanrot, *La Madone de Bentalha: histoire d'une photographie* (Paris, 2012). For brief surveys highlighting some aspects of how the conflict appeared visually in the French and Algerian press during the 1990s, see Stora, *La Guerre invisible*, pp. 79–84 and Hanrot, *La Madone de Bentalha*, pp. 32–40.

3 The term 'civil war' itself is not universally recognised either. As Le Sueur argues, 'some observers, particularly the French, have used the term "civil war" to describe an ongoing, armed conflict between militant Islamists and the state. Algerian officials and others have raised vehement objections to this definition, largely on the grounds that it cedes too much political and moral credibility to the extremists. By and large, this second group has preferred to characterize the conflict not as a civil war but as a "war on civilians" and as one between the forces of order and the terrorist organizations committed to a jihad': James D. Le Sueur, *Algeria Since 1989: Between Terror and Democracy* (New York, 2010), p. 6. Many other interpretations also exist; however, because it remains the term most recognised internationally, 'civil war' will be used here as the main term to designate the conflict.

4 Paul A. Silverstein, *Algeria in France: Transpolitics, Race and Nation* (Bloomington, IN, 2004), p. 4.

5 Le Sueur, *Algeria Since 1989*, p. 178.

6 Elisabeth Lequeret and Charles Tesson, 'Yamina Bachir-Chouikh. Des gens viennent voir leur histoire, leur vie. Ce n'était pas arrivé depuis longtemps', *Cahiers du Cinéma* (February 2003), pp. 26–31.

7 'Une Algérie fantasmée qui n'existe pas': Juliette Cerf and Charles Tesson, 'Benjamin Stora: L'absence d'images déréalise l'Algérie. Elle construit un pays fantasmé qui n'existe pas', *Cahiers du cinéma*, hors série (February 2003), pp. 7–13, p. 8.

8 Hugh Roberts, *The Battlefield, Algeria 1988–2002: Studies in a Broken Polity* (London, 2003), p. 220; 'guerre sans visage': Stora, *La Guerre invisible*, p. 46.

9 Martin Evans and John Phillips, *Algeria: Anger of the Dispossessed* (New Haven, CT, 2007), p. 239.

10 Delannoy, *La Pietà de Bentalha*, p. 15.

11 Hanrot, *La Madone de Bentalha*, pp. 49–50.

12 Paul A. Silverstein, 'An excess of truth: violence, conspiracy theorizing and the Algerian civil war', *Anthropological Quarterly* 75/4 (2002), pp. 643–74. The massacre itself would also form the subject of fevered speculation: hence the title chosen for a book by a survivor of the massacre: Nesroulah Yous, *Qui a tué à Bentalha? Chronique d'un massacre annoncé* (Paris, 2000).

13 Evans and Phillips, *Algeria*, p. 243.

14 Susan Sontag, *Regarding the Pain of Others* (New York, 2003), p. 10.

15 'Une bonne photo pour nous est une bonne photo pour tout le monde, ce qui est loin d'être vrai': Martine Joly, 'L'invisible dans l'image', *Sciences Humaines*, 83 (May 1998).

16 Hanrot, *La Madone de Bentalha*, p. 144.

17 'Qu'on ne veut pas voir parce qu'elles nous ressemblent': 'Pascal Convert – Triptyque', available at http://www.arte.tv/fr/pascal-convert-triptyque/666124,CmC=665812.html (accessed 18 February 2014).

18 Within France it duly remains one of the most notorious incidents of the conflict: borne out by the fact that one of the few recent French films to focus on the Algerian Civil War – Xavier Beauvois's *Of Gods and Men* (2010) – made this its primary focus. Its considerable commercial success, attracting over three million viewers at the French box office, showed that this is still a story that resonates widely amongst viewers in France, undoubtedly aided by the film's essentially consensual depiction of the monks' anomalous presence within a majority Muslim country.

19 Robert Hariman and John Louis Lucaites, *No Caption Needed: Iconic Photographs, Public Culture and Liberal Democracy* (Chicago, 2007), p. 29. Although developed in relation to images within contemporary American public culture, Hariman and Lucaites's criteria for an image to qualify as a photojournalistic icon – 'those *photographic images appearing in print, electronic, or digital media that are widely recognized and remembered, are understood to be representations of historically significant events, activate strong emotional identification or response, and are reproduced across a range of media, genres, or topics*' (original emphasis) – are largely met by Zaourar's photograph too: Hariman and Lucaites, *No Caption Needed*, p. 27.

20 Le Sueur, *Algeria Since 1989*, p. 29; Ranjana Khanna, *Algeria Cuts: Women and Representation, 1830 to the Present* (Stanford, CA, 2008), p. xiii.

21 Evans and Phillips, *Algeria*, p. 127.

22 Zahia Smail Salhi, 'Algerian women, citizenship, and the "family code"', *Gender and Development* 11/3 (2003), pp. 27–35, pp. 32–3.

23 Jacques Derrida, 'Taking a stand for Algeria', *Parallax* 4/2 (1998), pp. 17–23, p. 22.

24 Hanrot, *La Madone de Bentalha*, p. 82.

25 Tellingly it was the voice – and the politics of representing it – on which the Algerian writer Assia Djebar focused in her poem written to commemorate the first anniversary of the massacres in Raïs and Bentalha. See Assia Djebar, 'Raïs, Bentalha ... Un an après', *Research in African Literatures* 30/3 (1999), pp. 7–14.

26 'La douleur qu'exprime un peuple qui pleure en dit beaucoup plus': Benyoucef Cherif, *Algérie: une saison en enfer* (Paris, 2003), p. 67.

27 Noémie Coppin and Lucile Pinero, 'Les mondes clos de Michael von Graffenried', *Libération*, 27 April 2010, p. 24.

28 Michael von Graffenried, *Inside Algeria* (New York, 1998).

29 Claire Guillot, 'Michael von Graffenried: la réalité panoramique', *Le Monde*, 27 May 2010, p. 22. Although it may be shrewd commercially for von Graffenried to be positioned as such by the media, the work of French

photographers of Algerian origin, such as Bruno Boudjelal, complicates this interpretation. Also working in Algeria during the 1990s, Boudjelal used colour and black and white photography to produce an intimate and highly personal portrait of life there during the conflict. See: Bruno Boudjelal, *Disquiet Days/Jours intranquilles* (London, 2009).

30 Michael von Graffenried, 'Inside Algeria', in von Graffenried, *Inside Algeria*, pp. 14–17, p. 15.

31 Scott MacLeod, 'Images of a war in Algeria', *Time*, 19 April 1999.

32 John P. Entelis, 'Algeria: democracy denied, and revived?', *Journal of North African Studies* 16/4 (2011), pp. 653–78, p. 662.

33 Michael von Graffenried, *Journal d'Algérie 1991–2001: images interdites d'une guerre invisible* (Paris, 2003).

34 MacLeod, 'Images of a war in Algeria'.

35 John Taylor, *Body Horror: Photojournalism, Catastrophe and War* (Manchester, 1998), p. 196.

36 Entelis, 'Algeria: democracy denied', p. 672; Lahouari Addi, 'Disappearance as a consequence of a lawless state power', in Omar D, *Devoir de mémoire/A Biography of Disappearance, Algeria 1992–* (London, 2007), pp. 29–37, p. 35. Since 2002, the Human Rights Watch website Algeria-Watch has compiled a list containing details of some of the thousands of people who have disappeared in Algeria since the civil war began. In keeping with Omar D's book, identity photographs for many of the people listed are also included. See: 'Les disparitions forcées en Algérie: un crime qui perdure', available at www.algeria-watch.org/fr/mrv/mrvdisp/cas_disparitions/disparitions_introduction.htm (accessed 18 February 2014).

37 Quoted in 'Algeria: new amnesty law will ensure atrocities go unpunished', available at www.hrw.org/en/news/2006/02/28/algeria-new-amnesty-law-will-ensure-atrocities-go-unpunished (accessed 18 February 2014).

38 Omar D, *Devoir de mémoire*.

39 John Tagg, *The Burden of Representation: Essays on Photographies and Histories* (London, 1988); Addi, 'Disappearance as a consequence of a lawless state power', p. 35.

40 Elizabeth Edwards and Janice Hart, 'Introduction: photographs as objects', in Elizabeth Edwards and Janice Hart (eds), *Photographs Objects Histories: On the Materiality of Images* (London, 2004), pp. 1–15, p. 15.

41 Elizabeth Edwards, 'Thinking photography beyond the visual?', in J.J. Long, Andrea Noble and Edward Welch (eds), *Photography: Theoretical Snapshots* (London, 2009), pp. 31–48, p. 45.

42 Judith Butler, *Precarious Life: The Powers of Mourning and Violence* (London, 2004), p. 150; Judith Butler, *Frames of War: When is Life Grievable?* (London, 2009).

43 For a comparative example in Argentina, see Diana Taylor, *The Archive and the Repertoire: Performing Cultural Memory in the Americas* (Durham, NC, 2003), pp. 161–89.

44 Jacques Derrida, *Spectres de Marx: L'État de la dette, le travail du deuil et la nouvelle internationale* (Paris, 1993).

45 Colin Davis, '*État présent*: hauntology, spectres and phantoms', *French Studies* 59/3 (2005), pp. 373–9, p. 373.

46 Ibid., p. 379.

47 For an example of such uses of photography during a demonstration in Jijel, see: 'Photos du rassemblement du 5 juillet 2010 à Jijel', available at www. algeria-watch.org/fr/mrv/mrvdisp/photos_rassemblement_jijel_050710. htm (accessed 18 February 2014). For a discussion of such practices as part of transnational demands for human rights, see Andrea Noble, 'Family photography and the global drama of human rights', in Long, Noble and Welch (eds), *Photography: Theoretical Snapshots*, pp. 63–79.

48 'Les disparus ne sont pas dans mes poches […] vous me faites honte dans le monde, comme des pleureuses, avec vos photos': Nasséra Dutour, 'Algérie: de la Concorde Civile à la Charte pour la Paix et la Réconciliation Nationale: amnistie, amnésie, impunité', *Mouvements* 53 (2008), pp. 144–9, p. 147.

49 Ariella Azoulay, *The Civil Contract of Photography* (New York, 2008), p. 130.

50 Addi, 'Disappearance as a consequence of a lawless state power', p. 35.

51 This is not to overlook the small canon of films, alongside Beauvois's, which have been set during the civil war. These include: *Bab el-Oued City* (Merzak Allouache, 1994); *Barakat!* (Djamila Sahraoui, 2006); *La Fille de Keltoum* (Mehdi Charef, 2002); *Rachida* (Yamina Bachir-Chouikh, 2003) and *Rome plutôt que vous* (Tariq Teguia, 2006). None of them, however, has acquired the levels of notoriety or visual currency that photography has enjoyed during and since the conflict.

52 Deborah Poole, *Vision, Race and Modernity: A Visual Economy of the Andean Image World* (Princeton, NJ, 1997), p. 8.

53 Evans and Phillips, *Algeria*, p. 297.

Part II

Politics and Photographic Ethics at the Turn of the Twentieth Century

5 The Myth of Compassion Fatigue

David Campbell

The Dream of Photojournalism and the Cultural Anxiety of Images

The dream of photojournalism is that when a crisis is pictured the image will have an effect on its audience leading to action. In Philippe Wojazer's photograph of President Sarkozy at the Rwandan genocide memorial we see the relationship desired by this dream, albeit after the event. The President gazes at the memorial's photographic mural depicting refugees, and, the caption tells us, he was moved to write in the visitors' book, 'in the name of the people of France, I pay my respects to the victims of the genocide against the Tutsis.'

Sarkozy's encounter with the Rwandan genocide photo came during a state visit in which he remarked that France and the international community had failed to act during the genocide because they suffered a 'kind of blindness'.[1] Given the extensive television coverage and photographic reportage of the event, this was an extraordinary choice of words. But it does point to the fact that, despite the dream of photojournalism, we do not have much knowledge about the relationship between the photograph and the viewer, about what makes who react and how. A decade ago Stanley Cohen noted, 'we know nothing worthwhile about the cumulative effect of media imagery,' and little has happened in the meantime to meaningfully alter that conclusion with regard to photojournalism.[2] Jacques Rancière has sharpened the point in his essay on the 'intolerable image': 'The classic use of the intolerable image traced a straight line from the intolerable spectacle to awareness of the reality it was expressing: and from that to the desire to act in order to change it. But this link between representation, knowledge and action was sheer presupposition.'[3]

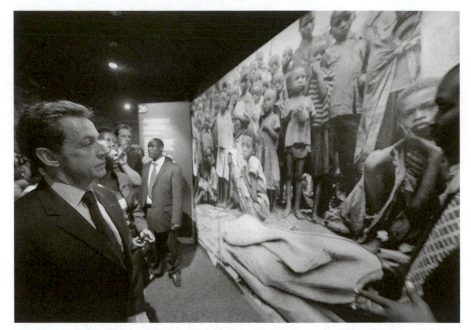

10. France's President Nicolas Sarkozy visits the memorial of the
Rwandan genocide in Kigali on 25 February 2010.
Photographer: Philippe Wojazer/AFP/Getty Images.

This line of argument is in contradistinction to the belief that there
are 'photos that changed the world'.[4] However, as Rancière notes, the
dominant mood of our time revolves around 'a general suspicion about
the political capacity of any image', and this suspicion is generated in part
by 'the disappointed belief in a straight line [visualised in the Sarkozy
photograph] from perception, affection, comprehension and action'.[5]
There is much to be done before we understand the work that images
produced by photojournalism do. Research to give us some worthwhile
knowledge about the cumulative effect of photographs is in its early
stages. Before we can construct a meaningful account that traces possible
links between visual representation, knowledge and action, we need to
dispense with some conventional wisdoms that purport to explain how
photographs work. The purpose of this essay is to undertake some of the
excavation necessary to clear the way for that construction. Among the
largest of the obstacles to be removed is the 'compassion fatigue' thesis.
 One of the most common claims relating to the alleged impact of
photographs of atrocity, violence and war is that they induce 'compassion

fatigue' in the public at large. This claim often starts with an assertion about our media-saturated world, and is part of the general suspicion about the capacity of images that Rancière noted. At its heart is the notion that, far from changing the world, photographs work repetitively, numbing our emotional capacity and thereby diminishing the possibility of an effective response to international crises. Expressions of this belief can be found in a wide range of disparate contexts, and numerous writers and photographers attest to the ubiquity of this view.[6] John Taylor notes the popularity of the claim that photography is analgesic, Carolyn Dean remarks that the belief is commonplace in both Europe and the United States, and Susie Linfield describes the thesis as 'a contemporary truism, indeed a contemporary cliche' such that 'to dispute this idea is akin to repudiating evolution or joining the flat-earth society.'[7]

Whenever there is a crisis, the claim of compassion fatigue is never far behind. The earliest usage of the term dates from 1968, and stems from a report by the Lutheran World Federation about appeals launched during the Biafra crisis.[8] Consider the 2010 earthquake in Haiti that killed more than 200,000 people and devastated the country. Media coverage was swift, extensive and intense. The focus on victims trapped in rubble

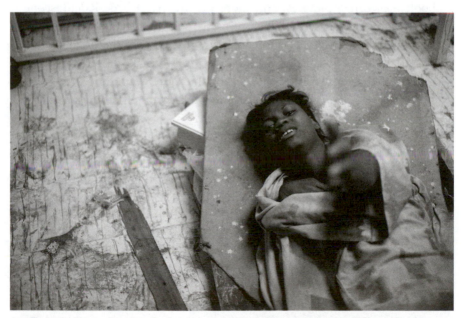

11. People lie in front of a hospital without treatment at night in Port au Prince, Haiti, 13 January 2010. Photographer: Ron Haviv/VII.

or suffering as a result was, as in Ron Haviv's photograph, up close and personal. The charitable response was vast and global. Yet alongside the coverage and the response were frequent iterations of the worry about compassion fatigue setting in.[9]

While anxiety about the alleged impact of extensive media coverage is commonplace in the digital era, it has a long history. Indeed, the very same anxiety can be found in much earlier contexts. Speaking in 1964, the famous photographer Dorothea Lange noted:

> It takes a lot to get full attention to a picture these days, because we are bombarded by pictures every waking hour, in one form or another, and transitory images seen, unconsciously, in passing, from the corner of our eyes, flashing at us, and this business where we look at bad images – impure. I don't know why the eye doesn't get calloused as your knees get calloused or your fingers get calloused, the eye can't get [...][10]

Even earlier, a writer in Weimar Germany argued:

> Today the eye of modern man is daily, hourly overfed with images. In nearly every newspaper he opens, in every magazine, in every book – pictures, pictures, and more pictures [...] This kaleidoscope of changing visual impressions spins so rapidly that almost nothing is retained in memory. Each new picture drives away the previous one [...] The result – in spite of the hunger for new visual impressions – is a dulling of the senses. To put it bluntly: the more modern man is given to see, the less he experiences in seeing. He sees much too much to still be able to see consciously and intensively.[11]

The fact that this same cultural anxiety about visual overload leading to desensitisation can be regarded as novel in 1932, then 1964, and again now, despite major transformations in the information economy over the last 80 years, suggests these concerns are something other than simple descriptions of the times. Indeed, claims of 'information overload' have an even longer history. Having located similar worries as far back as 1565, Vaughan Bell concluded:

> Worries about information overload are as old as information itself, with each generation reimagining the dangerous impacts of technology on mind and brain. From a historical perspective, what strikes home is

not the evolution of these social concerns, but their similarity from one century to the next, to the point where they arrive anew with little having changed except the label.[12]

Another label that signifies anxiety about the relationship between imagery and its social impact is 'pornography'. Emergencies, such as the Haiti earthquake, are speedily affiliated with worries about whether the press can publish graphic images without descending into the realms of 'disaster porn'.[13] As Dean makes clear, pornography as an account of cultural degradation has its own long history, but its use has intensified since 1960 so that it now functions as 'an allegory of empathy's erosion'.[14] Dean calls 'pornography' a promiscuous term, and when we consider the wide range of conditions it attaches itself to, the pun is more than justified. As a signifier of responses to bodily suffering, pornography has come to mean the violation of dignity, taking things out of context, exploitation, objectification, putting misery and horror on display, the encouragement of voyeurism, the construction of desire, unacceptable sexuality, moral and political perversion, and a fair number more. Furthermore, this litany of possible conditions named by 'pornography' is replete with contradictory relations between the elements. Excesses mark some of the conditions while others involve shortages. Critics, Dean argues, are also confused about whether 'pornography' is the cause or effect of these conditions.

The upshot is that as a term with a complex history, a licentious character and an uncertain mode of operation, 'pornography' fails to offer an argument for understanding the work images do. It is at one and the same time too broad and too empty, applied to so much, yet explaining so little. As a result, Dean concludes that 'pornography' is 'an alibi for a relationship between cause and effect that is never anywhere named or explained' and which 'functions primarily as an aesthetic or moral judgement that precludes an investigation of traumatic response and arguably diverts us from the more explicitly posed question: how to forge a critical use of empathy?'[15] The repeated and indiscriminate use of 'pornography' substitutes for evidence in arguments about the alleged exhaustion of empathy. It has become part of a fable that asserts we fail to recognise our ethical obligations towards others, and have become habituated to suffering, because of a claimed glut of pictures. It is, then, related to the idea of compassion fatigue in so far as both terms signify alleged obstacles to empathy. But they differ in that 'pornography' is said to corrupt because of an affective excess – a voyeuristic desire that compels people to look – whereas compassion fatigue is an affective

lack, the condition which allegedly promotes an aversion to seeing. Nonetheless, I will argue, the compassion fatigue thesis, like the repeated invocation of 'pornography,' is an allegory that serves as an alibi for other issues and prevents their investigation.

This essay contests the compassion fatigue thesis in its own terms in order to clear the way for later developing a more robust account of how images impact upon people. It proceeds by first looking at the emergence of compassion fatigue as a concept, what it involves and how it relates to imagery. What is notable at the outset is the way compassion fatigue means one thing in the context of health care and social work, and the reverse in relation to the media and politics. Susan Sontag is the writer who drove much of the popularity of this thesis in relation to photography, and the essay will unpack her arguments in *On Photography*, exploring their logic and supporting evidence (or lack thereof) before discussing how she retracted much of them in *Regarding the Pain of Others*. Sontag's reversal has had little impact on the ubiquity of the compassion fatigue thesis, and that is in large part a result of arguments like those found in Susan Moeller's book *Compassion Fatigue*. The third section of this essay dissects Moeller's claims to reveal how in her hand compassion fatigue is an empty signifier that becomes attached to a range of often-contradictory explanations. The limits of Moeller's text are exposed in the fourth section of the essay, which reviews all the available evidence of which I am aware relating to the associations between photographs, compassion and charitable responses. The essay concludes with some reflections on the reframing of the problem of how photographs work given the preceding deconstruction of the compassion fatigue thesis.

The Claim of Compassion Fatigue: Sontag's Epiphany and its Reversal

According to the *Oxford English Dictionary* – in draft additions added as recently as 2002 – compassion fatigue is an American term meaning 'apathy or indifference towards the suffering of others or to charitable causes acting on their behalf, typically attributed to numbingly frequent appeals for assistance, esp. donations; (hence) a diminishing public response to frequent charitable appeals'. The *OED* definition makes clear the causal relations, effects and evidence assumed by the idea of compassion fatigue. The cause (in something of a tautology) is the 'numbingly frequent appeals'

of charities acting on behalf of suffering others. The effect is apathy and/ or indifference, and the evidence of this effect is the 'diminishing public response' to the appeals. This framework is similar to the elements of what Cohen calls the 'populist psychology thesis' of compassion fatigue: claims about information overload, normalisation, and desensitisation.[16] Importantly, although the compassion fatigue thesis offers a generalisation about media, culture and society, it is in fact structurally individualistic, with the question of how a single person's desire to respond to the suffering of others can be engaged at its heart.

What is paradoxical about the idea of compassion fatigue, and what is not evident in the *OED* definition, is how it relates to the same concept within health care and social work. From perhaps the 1980s and certainly the 1990s, compassion fatigue was understood as 'secondary traumatic stress disorder', and diagnosed in people either suffering directly from trauma or individuals working closely with people suffering trauma. In this context, although it concerned a set of negative impacts on those affected – such as reduced pleasure and increased feelings of hopelessness – it derived from the problem that 'caring too much can hurt'. In other words, compassion fatigue was prompted by an excess of compassion rather than a lack of compassion. As the Compassion Fatigue Awareness Project states, when caregivers who have a strong identification with those suffering fail to practise 'self-care' they can be prone to destructive behaviours.[17] Other than the occasional inclusion of journalists in conflict zones amongst the 'trauma workers' who might be affected, the connection between this understanding of compassion fatigue and the use of the concept in general media critiques is not clear.

The link between photography and compassion fatigue comes about because of the role images have played in the charitable appeals and associated media coverage of suffering others. Susan Sontag is the most noted proponent of the idea that the photography of suffering has done much to numb the audience and help produce apathy and/or indifference. In *On Photography* she famously asserts: 'in these last decades, "concerned" photography had done at least as much to deaden conscience as to arouse it.'[18] In conjunction with the much-quoted statement that 'images anesthetize', Sontag provided the rhetorical force to launch and sustain the idea of photography's responsibility for compassion fatigue.[19]

It is worth undertaking a closer examination of Sontag's reasoning in order to understand what the concept of compassion fatigue assumes. Sontag claims that familiarity with images is what determines the emotions that people summon in response to photographs of suffering:

Don McCullin's photographs of emaciated Biafrans in the early 1970s [sic] had less impact for some people than Werner Bishchof's photographs of Indian famine victims in the early 1950s because those images had become banal, and the photographs of Tuareg families dying of starvation in the sub-Sahara that appeared in magazines everywhere in 1973 must have seemed to many like an unbearable replay of a now familiar atrocity exhibition.[20]

There is no supporting evidence for the vague claims that McCullin's photographs 'had less impact for some people' or that the images of dying Tuareg 'must have seemed to many like an unbearable replay'. While it would be wrong to insist on social scientific protocols for an interpretative essay, the insubstantial foundations on which this idea of repetition and familiarity leading to a failure of response has been built are revealed in these sentences. Sontag's analysis was written between 1973 and 1977, and the grounds for this argument seem even weaker when we consider that no more than seven years later the world was moved to the largest charitable event ever by both still and moving pictures of mass famine in Ethiopia.

So where does Sontag's conviction that 'the shock of photographed atrocities wears off with repeated viewings' come from?[21] Because she maintains that photographs of atrocity jolt viewers only because they offer them something novel, her conviction is founded on the 'negative epiphany' arrived at in a 'first encounter' with horrific pictures:

> For me, it was photographs of Bergen-Belsen and Dachau which I came across by chance in a bookstore in Santa Monica in July 1945. Nothing I have seen – in photographs or in real life – ever cut me as sharply, deeply, instantaneously. Indeed, it seems plausible to divide my life into two parts, before I saw those photographs (I was twelve) and after, though it was several years before I fully understood what they were about.[22]

Encountering photographs of the Nazi concentration camps for the first time is surely something that many of us can recall. However, a personal epiphany seems a weak basis on which to make absolute and universal claims about the power of photography, not least because each of us will experience our epiphanies on a timescale at variance with Sontag's. What is repetitive for her will be novel for others. Who is to say that the millions moved to charitable action by Live Aid in 1985 were or were not familiar with either Bischof's or McCullin's famine photographs?

Although Sontag's articulation of the relationship between photography and compassion fatigue from the 1970s has been pivotal to the concept's enduring power, 30 years later, in *Regarding the Pain of Others*, Sontag heavily qualified and largely retracted her earlier claims:

> As much as they create sympathy, I wrote [in *On Photography*], photographs shrivel sympathy. Is this true? I thought it was when I wrote it. I'm not so sure now. What is the evidence that photographs have a diminishing impact, that our culture of spectatorship neutralizes the moral force of photographs of atrocities?

Not everything posited in *On Photography* is abandoned in *Regarding the Pain of Others*. Sontag still operates in terms of assumptions about the scope and scale of our 'incessant exposure to images, and overexposure to a handful of images seen again and again'.[23] Equally, she persists with the proposition that 'as one can become habituated to horror in real life, one can become habituated to the horror of certain images.' What changes is the fact that this condition is no longer a given: 'there are cases where repeated exposure to what shocks, saddens, appalls does not use up a full-hearted response. Habituation is not automatic, for images [...] obey different rules than real life.'[24]

Sontag's increased attentiveness to contingency carries over into an appreciation of the different motivations of individuals and the different capacities of images. People, she writes, 'can turn off not just because a steady diet of images of violence has made them indifferent but because they are afraid'.[25] Pictures of the atrocious, she concedes, 'can answer to several different needs. To steel oneself against weakness. To make oneself more numb. To acknowledge the existence of the incorrigible.'[26] But in her clearest reversal, Sontag concludes 'harrowing photographs do not inevitably lose their power to shock.'[27]

The Persistence of Compassion Fatigue: Moeller's Empty Signifier

If Susan Sontag was the contemporary originator of the idea of compassion fatigue with regard to photography, then Susan Moeller is its contemporary populariser. Her book *Compassion Fatigue* is on the surface the most extensive discussion of the concept available.[28]

Published in 1999, it could not take account of the changes in Sontag's argument discussed above, but those changes have not curtailed the impact of Moeller's analysis. The problem with Moeller's argument is that it encompasses so many different factors that the idea of compassion fatigue functions as an empty signifier for a vast range of media-related concerns.

The unfocused yet assumption-laden nature of Moeller's argument is clear from the opening of her book: 'If the operating principle of the news business is to educate the public, why do we, the public, collapse into a compassion fatigue stupor? Are we too dull to keep up with the lessons? Or are the lessons themselves dulling our interest?' We can note that the mainstream media is understood principally in terms of education and that the (American) public is considered to be in a 'compassion fatigue stupor'. But it is the questions that map the binary contradiction which besets Moeller's text – is compassion fatigue a condition of the population that affects the media? Or is compassion fatigue a condition of the media that affects the population? As we proceed through Moeller's discussion this uncertainty is rife and unresolved, so that compassion fatigue is variously, and confusingly, understood as both a cause that acts on the media and an effect that results from the media's actions. Or, as Moeller states, 'compassion fatigue is a result of inaction and itself causes inaction.'[29]

When Moeller understands compassion fatigue as a cause, its power is said to be vast:

> Compassion fatigue is the unacknowledged cause of much of the failure of international reporting today. It is at the base of many of the complaints about the public's short attention span, the media's peripatetic journalism, the public's boredom with international news, the media's preoccupation with crisis coverage.[30]

What does compassion fatigue do? It acts as a prior restraint on the media. Editors and producers don't assign stories and correspondents don't cover events that they believe will not appeal to their readers and viewers.[31]

> Compassion fatigue abets Americans' self-interest [...] Compassion fatigue reinforces simplistic, formulaic coverage [...] Compassion fatigue ratchets up the criteria for stories that get coverage [...] Compassion fatigue tempts journalists to find ever more sensational tidbits in stories

to retain the attention of their audience [...] Compassion fatigue encourages the media to move on to other stories once the range of possibilities of coverage have been exhausted so that boredom doesn't set in.[32]

The most devastating effect of compassion fatigue: no attention, no interest, no story.[33]

Compassion fatigue ensures such a shallow understanding.[34]

In more ways than the metaphorical, compassion fatigue has become an insidious plague in society.[35]

Culminating with the representation of compassion fatigue in socio-medical terms as a plague – a metaphor of illness that Sontag would likely have objected to – Moeller regularly casts compassion fatigue as an actant that causes, founds, restrains, abets, encourages, ratchets, ensures and tempts.[36]

However, Moeller equally regards compassion fatigue as an effect, as something caused by something else:

Compassion fatigue is not an unavoidable consequence of covering the news. It is, however, an unavoidable consequence of the way the news is now covered.[37]

It's the media that are at fault. How they typically cover crises helps us to feel overstimulated and bored all at once.[38]

Causes of compassion fatigue are multiple. Too many catastrophes at once, and coverage that is too repetitious..[39]

Much of the media looks alike. The same news, the same pictures. What is the inevitable result much of the time? Compassion fatigue.[40]

Compassion fatigue is not the inevitable consequence of similar events or lingering events. It is a consequence of rote journalism and looking-over-your-shoulder reporting. It is a consequence of sensationalism, formulaic coverage and perfunctory reference to American cultural icons.[41]

But perhaps if the coverage of crises was not so formulaic or sensationalised or Americanised we wouldn't lapse so readily into a compassion fatigue stupor.[42]

In these moments, Moeller regards compassion fatigue not as a thing that acts, but the condition which results from action elsewhere: it is the unavoidable, inevitable consequence that the public lapses into as a result of someone or something else's fault.

The many and varied ways in which Moeller articulates the idea of compassion fatigue and the causal relations associated with it demonstrate that the term is an empty signifier – it has no agreed meaning and lacks stable referents, instead functioning something like a cultural meme around which a host of concerns and criticisms swirl. This can be demonstrated further by considering those few moments in which Moeller offers some substantive evidence for her multiple positions. The information in Moeller's book is derived from interviews with, or quotes from, important figures in America's mainstream press speaking about the intersection of politics, media and international events. Small anecdotes – such as the case of the *Newsweek* issue with a Luc Delahaye photo of an injured Bosnian child on the cover being one of the poorest selling weeks of all time – bear the weight of general arguments.[43] There are also limited references to newspaper stories on compassion fatigue, which offer up interviews from both citizens and sources such as Neil Postman, who was quoted in a 1991 *New York Times* story proclaiming:

> The sheer abundance of images of suffering will tend to make people turn away [. . .] People respond when a little girl falls down a well. But if 70,000 people in Bangladesh are killed, of course people will say, 'Isn't that terrible' but I think the capacity for feeling is if not deadened, at least drugged.[44]

The best way to consider the support for Moeller's argument is to examine her discussion of the US coverage and response to the Rwanda genocide. As with other chapters, the thorough analysis of the crisis in Rwanda is linked to a media critique via the occasional remarks of broadcasters, print journalists and editors, and buttressed by the odd quote from members of the public.[45] Citizens are cited for their complaints about the publication of graphic pictures from photographers like Gilles Peress, Tom Stoddart and others, while reporters remark on the challenges of covering a story as large as the mass killings in 1994. Moeller's central point is that when a nation fails to act decisively in the face of incontrovertible evidence of genocide, despite extensive media coverage, it is evidence of compassion fatigue either on the part of media or the public or both. But part of her own narrative shows the

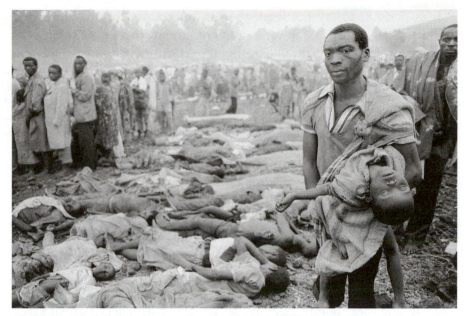

12. Victims of the cholera outbreak of 1994 in Goma, Zaire.
Photographer: Tom Stoddart/Getty Images.

problematic nature of compassion fatigue as a concept for the dynamics she wishes to examine.

Using a *Boston Globe* report on the charitable response to Rwanda, Moeller makes much of the fact that during the weeks of the mass killings Oxfam America received no more than the normal number of phone calls from people offering donations. Her conclusion is that 'the images of the genocide spurred few to donate money.'[46] However, after the killing ended and Rwanda became a refugee crisis, with hundreds of thousands fleeing to Goma and suffering from cholera as a result, Oxfam received more than 1,000 calls in 24 hours with people willing to donate vast sums of money. According to the *Boston Globe* reporter,

> all attribute the sudden interest to news coverage of the cholera epidemic that in the past four days has killed 7,000 Rwandans who have fled to refugee camps in Zaire. The link is so direct, they say, that phone calls peak immediately after graphic reports of dying Rwandan refugees are broadcast on news reports [. . .] Many callers are crying on the phone. Some ask if they can adopt orphaned children, others want to fly to Rwanda to volunteer.[47]

It is curious, to say the least, that an outpouring of compassion is mobilised as evidence for an argument about the pervasiveness of compassion fatigue. Furthermore, this report on the rise of compassion came just six weeks after the views in another American newspaper report cited by Moeller as evidence for the claim that 'the symptoms of compassion fatigue are getting worse':

> 'It wasn't too long ago,' wrote Richard O'Mara in *The Baltimore Sun*, 'that the face of an African child, frightened and hungry, could draw out the sympathies of people in the richer countries and, more importantly, stimulate a reflex towards rescue. That face became emblematic of the 1980s. But with all symbols it soon lost its human dimension, its link to the actual flesh-and-blood child. Now that face stirs few people. The child has fallen victim, this time to a syndrome described as "compassion fatigue".'[48]

Considering these points together demonstrates Moeller's rampant lack of clarity about what is or what is not compassion fatigue. The compassionate response towards Rwandan refugees is taken as evidence of the absence of caring during the genocide. For Moeller, photography is indicted in the process: she contends that 'in the case of Rwanda, clearly, the famine images [sic] touched people. The genocide pictures did not.'[49] Then, compassion fatigue is said to be getting worse and this is supported by an opinion which declares that the face of the child in distress no longer stirs people, when just six weeks later the graphic accounts of dying Rwandans are cited as the principal reason behind the massive jump in charitable giving for those refugees.

The fact that 'compassion fatigue' can be mobilised as a concept when a surge in charitable compassion is being discussed demonstrates how empty it is as a signifier. Nonetheless, Moeller identifies something important with her general if unfocused concerns regarding the Rwanda case. While compassion was not diminished – let alone exhausted – in the cases she considers, it is certainly differential. That is, while compassion as a reservoir of public empathy remains in plentiful supply, it is clearly directed towards some issues and not others, at some times and not others.

What Moeller has seized upon is the way in which humanitarian emergencies solicit both public and policy responses more readily than political crises. Moeller works hard to indict either the media or the public or imagery (or some combination of the three) as culpable for a

response that was clearly inadequate to the Rwandan genocide when it was underway. That the international response to the Rwandan genocide was, to put it mildly, insufficient, is by now well documented – as the Sarkozy photograph in the introduction reminds us.[50] In the case of the United States government, the lack of action was the continuation of a century's avoidance and indifference to some of humanity's greatest crimes.[51] Moeller is thus undoubtedly correct to argue that 'one difficulty in moving Americans toward engagement is that they consider few political themes or few international conflicts compelling enough to galvanize a concerted response.'[52] However, the Americans who are most responsible in this formulation are the successive administrations and policy-makers who have regularly declined to support international action on the grounds of the United States' national interest. This is not to deny that the media and the public also bear some responsibility for America's repeated failure to act, but it is clear that when the political leadership frames international crises in ways that lessen the chance for a timely and robust response, this provides others with a powerful lead that further diminishes the likelihood of a timely and robust response. We saw this in the context of the Bosnian War, when both American and European leaders represented the conflict as a civil war leading to humanitarian emergency rather than a political concern.[53] And we have seen it in the context of the violence in Darfur, where a humanitarian script trumped the genocide narrative, but only after a United Nations official declared that it was 'the world's worst humanitarian crisis', which differed from the genocide in Rwanda only in terms of the numbers affected.[54]

Moeller's critique of American public and policy attitudes towards international crises is persuasive in many respects, but it is not a critique that benefits from being conducted in terms of 'compassion fatigue'. Indeed, the overriding problem with Moeller's approach is the way 'compassion fatigue' becomes the alibi for a range of issues which, while related at some levels, demand specific investigations. In addition to the political critique, Moeller wants to argue that compassion fatigue is responsible for 'much of the failure of international reporting today', 'the media's peripatetic journalism' and 'the media's preoccupation with crisis coverage'. Moeller is correct that there are many areas of concern when it comes to international journalism, but 'compassion fatigue' as a general concept offers little purchase on problems that include everything from news narratives and television scheduling to the political economy of broadcasting, not least because the ecology of international news has been radically transformed in the decade since her argument was published.[55]

Finally, on top of the political and media critiques, Moeller deploys compassion fatigue as both a description and explanation of the public's allegedly 'short attention span' and 'boredom with international news'.[56] This raises questions: we could point to the way these claims necessarily invoke a past golden age in which attention spans were supposedly long and nobody was bored; or we could argue that these commonly repeated assumptions about audience behaviour are contradicted by Pew Research Center evidence which shows that 'people are spending more time with news than ever before.'[57] Either way, these thoughts require us to ask: what, actually, is the evidence for the existence of compassion fatigue, where that term refers to popular desensitisation?

What is the Evidence For or Against the Compassion Fatigue Thesis?

There are very few studies that have analysed audience consumption of and reaction to news in terms of claims about compassion fatigue. The first and best known is a 1996 paper by Kinnick, Krugman and Cameron which used a telephone survey of 316 Atlanta residents to measure attitudes towards AIDS, homelessness, violent crime and child abuse and the media coverage of these issues.[58] The authors found considerable variation between individuals; they argued that responses were issue dependent and observed that there was no such thing as a totally fatigued individual. They did conclude that there was a compassion fatigue phenomenon but that it was a situational variable rather than a personality trait. Equally, they did note that the mass media played a primary role, through both negative coverage and content that allowed avoidance, and that respondents readily blamed the media for their personal desensitisation and avoidance strategies.[59]

However, Kinnick, Krugman and Cameron qualified the media's role by pointing out how prior dispositions intersected with media coverage: 'results of the study suggest that for those who are initially disinterested or biased against victims of a social problem, pervasive media coverage likely serves to entrench negative feelings towards victims and foster densensitization.'[60] And, in a statement that reduced the primacy of the media's role, the authors concluded that 'level of media consumption [...] does not appear to be as influential in the development of compassion fatigue as individual tolerances for exposure to disturbing media content

and perceptions of the victims' "deservingness" of compassion.'[61] In pointing towards the disposition and state of individuals as causal factors in how they directed and expressed compassion, Kinnick, Krugman and Cameron provide a link to how social psychology claims to offer an account of how some people secure empathy from an audience. In the relevant literature much of this debate is conducted in terms of the 'identifiable victim effect', which, through its emphasis on how people continue to respond to appeals (part of the *OED* definition), stands in contradistinction to any claims about the contemporary prevalence of compassion fatigue.

Stemming from the work of Thomas Schelling in the 1960s, the identifiable victim effect describes the way 'people react differently toward identifiable victims than to statistical victims who have not yet been identified.'[62] It recalls the quote attributed to Joseph Stalin that 'one death is a tragedy; one million is a statistic' as well as the statement from Mother Teresa that 'if I look at the mass I will never act. If I look at the one, I will.' These claims seem to be based on the psychological intuition that an identifiable victim is *ipso facto* a more powerful emotional stimulus than a statistical victim – that, for example, the photograph of an individual person in distress in any given disaster is more effective than accounts of the millions at risk or dying from that situation.[63] For Paul Slovic, this incapacity to translate sympathy for the one into concern for the many, as evidenced in the way mass murder and genocide in places like Rwanda and Darfur are largely ignored, testifies to 'a fundamental deficiency in human psychology'.[64]

Although the literature on what motivates charitable giving (the home of much of these arguments) is relatively sparse, a series of recent studies in decision psychology have produced some interesting findings. Small and Lowenstein conducted a field experiment which demonstrated that when people were asked to contribute to a housing charity that had identified the recipient family, versus one that would find a family after the donation, people's contributions were higher to the one where the family was already identified.[65] Kogut and Ritov asked participants to donate towards treatment for one sick child or a group of eight sick children, with both the individual and the group represented in photographs. Although the total amount needed was the same in both cases, donations were higher for the individual child than for the group of children.[66] Small, Lowenstein and Slovic asked givers to respond to a statistical description of food shortages in southern Africa affecting three million children versus a personal appeal with a picture on behalf

of Rokia, a seven-year-old Malawian girl, and the identified victim triggered a much higher level of sympathy and greater donations.[67] In a similar study, when potential donors were faced with the option of helping just two children (the girl Rokia and a boy, Moussa) rather than a single individual, the response for the individual child was far greater than for the pair.[68] In analysing the form of the image that best elicits a response, Small and Verrochi found that sad facial expressions in the pictures of victims produced a much greater response than happy or neutral images, and that this was achieved through 'emotional contagion', whereby viewers 'caught' vicariously the emotion on a victim's face.[69] As a more detailed moment in the production of the identifiable victim, sad pictures generated greater sympathy and increased charitable giving.

These studies confirm the intuition that images are central to the transmission of affect, and that while some are more powerful than others, 'when it comes to eliciting compassion, the identified individual victim, with a [sad] face and a name, has no peer.'[70] This establishes the phenomenon and how it operates, but not why. Some of the reasons, at least according to the psychologists conducting these studies, could include the following:

- A single individual is viewed as a psychologically coherent unity, whereas a group is not;[71]
- Identifiable victims are more 'vivid' and hence more compelling than colourless representations;
- Identifiable victims are actual rather than likely victims;
- As an identified, actual victim, blame is more easily attached, whereas for people who are not yet victims responsibility is harder to assign;
- Identifiable victims generate concern when they are a significant proportion of their group. This is the 'reference group effect' which suggests, for example, that those infected with a disease that kills 90 per cent of a small population attract more sympathy than, say, one million victims in a country of 20 million people.[72]

As much as the social scientific methodologies of these studies suggest they have produced definitive reasons for the 'identifiable victim effect', they generate 'no evidence that these are the actual mechanisms that produce the effect'.[73] They reiterate, nonetheless, findings from related studies to suggest what is happening. Small and Lowenstein argue that 'people use distinct processes to make judgements about specific as

1. Martin Melaugh, '"Bloody Sunday": large scale in situ', Bogside, Derry,
18 September 1997. Copyright Cain.

2. Martin Melaugh, "'Bloody Sunday": large scale in situ', Bogside, Derry, 18 September 1997. Copyright Cain.

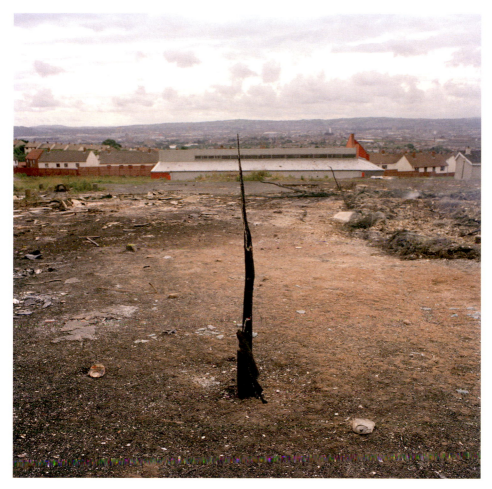

3. Paul Seawright, 'Black Spike, Belfast 1997', from the series 'Fires', 1997.

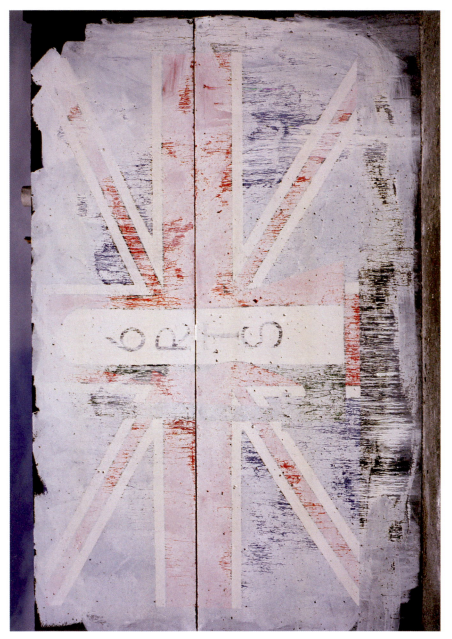

4. John Duncan, 'Untitled', from the series 'We Were Here', 2006.

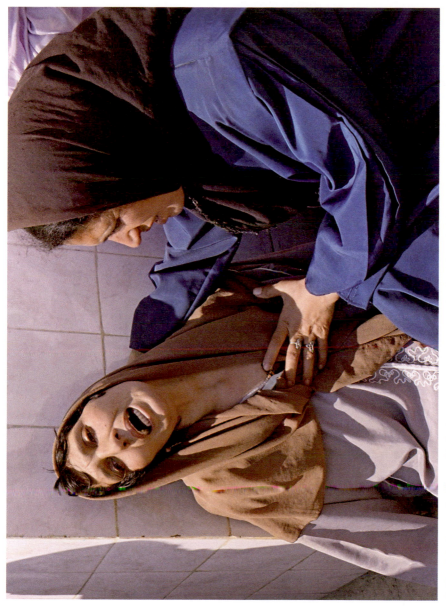

5. 'La Madone de Bentalha', A woman cries outside the Zmirli Hospital, where dead and wounded were taken after a massacre in Bentalha. Hocine Zaourar/AFP.

6. An image from Michael von Graffenried's *Inside Algeria*. © Michael van Graffenried, www.mvgphoto.com, courtesy Galerie Esther Woerdehoff Paris.

7. An image from Omar D's *A Biography of Disappearance, Algeria 1992*. © Omar D, courtesy Autograph ABP.

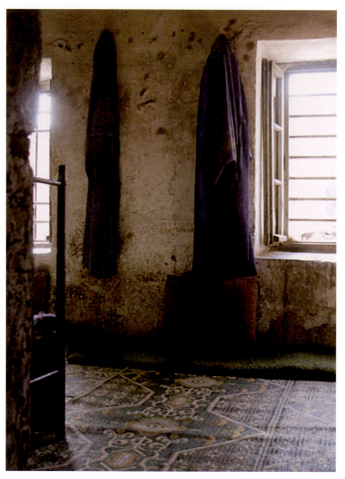

8. Burqas hang in a cell in a women's prison in Kabul, Afghanistan, on Thursday 29 November 2001. A month after the Northern Alliance marched into Kabul, the prison remains a reminder of the repression women suffered at the hands of the rigid Taliban. Marco Di Lauro/AP.

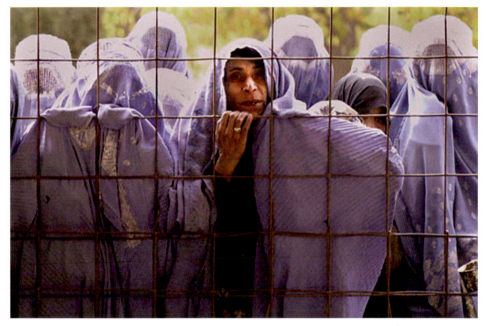

9. Amongst others covered in burqas, an Afghan woman shows her face as she tells the photographer, 'we don't need pictures, we need food' while Afghan women and children beg for food and money in Herat, Afghanistan, Saturday 8 December 2001. Kamran Jebreili/AP.

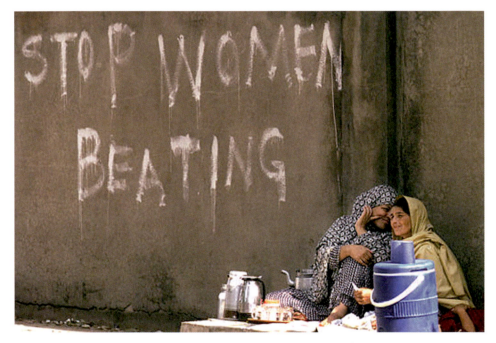

10. Women speak to each other under a sign against cruelty to women in Afghanistan outside the United Nations High Commission for Refugees office in Islamabad, Pakistan, Tuesday 2 October 2001. John McConnico/AP.

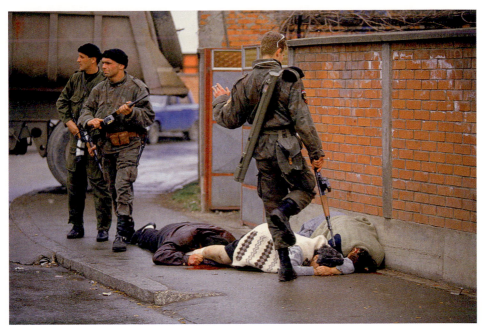

11. Ethnic cleansing – Arkan's Tigers kill and kick Bosnian Muslim civilians during the first battle for Bosnia in Bijeljina, Bosnia, 31 March 1992. Ron Haviv/VII.

12. The NATO war in Kosovo, Yugoslavia. April to June 1999. Gary Knight/VII.

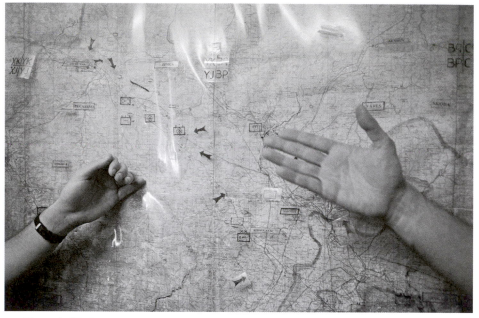

13. French UN peacekeepers explain ethnic divisions in central Bosnia, 1990. Gilles Peress/Magnum.

14. Crni Vrh, untitled No. 6. © Simon Norfolk.

15. Untitled. © Ziyah Gafic.

16. Left: The terrace of Stanley's house at Matadi which overlooked the Congo River, July 2003. Right: The marble terrace that extended from Mobutu Sese Seko's bedroom, overlooking a wide valley, at his palace in Gbadolite, July 2003. Guy Tillim, courtesy of L'Agence VU.

17. Left and right: People displaced for months by fighting between rebel groups, in this case between Jean Pierre Bemba's Rally for Congolese Democracy – Movement for Liberation, allied with Thomas Lubanga's Army of Congolese Patriots against the Rally for Congolese Democracy – Kisangani – Movement for Liberation.

Left: Thousands flee ahead of the battle near Biakato, January 2003.

Centre: A statue at the Central African Museum at Tervuren, Brussels, erected by King Leopold II, is titled 'La Belgique apportant le bien-être au Congo, 1920' ('Belgium brings civilisation to the Congo'), January 2004.

Right: Displaced people take refuge in a church at Erengeti, January 2003.

Guy Tillim, courtesy of L'Agence VU.

opposed to general targets', with the processing of information about specific individuals being more emotionally engaging than deliberation about abstract cases.[74] Small and Verrochi maintain that there is a difference between empathic feeling and deliberative thinking, with the emotional contagion produced by particular pictures of specific individuals happening outside of awareness.[75] Although they are distinct, these two processes can intersect. Indeed, if emotional engagement is significant enough, it can lead individuals to explore deliberatively contextual information about the identifiable victim they originally responded to. Here, though, some studies identify a potentially paradoxical outcome – the greater the deliberative thinking that takes place, the more the emotional engagement is overridden, sympathy diminishes and charitable donations decline.[76]

Having detailed the 'identifiable victim effect' and the images that contribute to it, these psychological studies have set out an interesting problematic even if they have not identified the causes for this effect. They also leave us with a number of challenging questions: is our capacity to feel limited such that anything beyond the specific individual leads to a decline in emotional concern for others?[77] How might other emotions, such as anger, disgust and fear affect sympathy? Would the role of pictured expressions on the faces of adults differ from those found with children?[78]

Many of these issues and questions become more complex when we move beyond small field experiments about charitable giving to large-scale social and political phenomena. Although, in a manner not dissimilar from Moeller's political critique, Slovic wants to maintain that the repeated American failure to respond to mass murder and genocide globally represents a fundamental psychological flaw – stemming from the inability to make an emotional connection to the victims of the violence – he concedes that in cases such as the South Asian tsunami of 2004 and Hurricane Katrina in 2005 there was a significant cultural response to the plight of millions of individuals who formed a collective and sometimes distant community of suffering. These moments were different, claims Slovic, because of what he calls the dramatic, intimate, exhaustive and vivid media coverage of these events for spectators beyond the danger zone. This stands in direct opposition to the compassion fatigue thesis, whereby the deluge of imagery is said to inevitably dull feeling. As a result, Slovic maintains – this time in opposition to Moeller's thesis – that the reporting of ongoing genocides is sparse and sporadic.[79]

Beyond the works cited above, there are various studies examining the compassion fatigue thesis. Stanley Cohen and Bruna Seu report on a 1998

pilot study at Brunel University in England where three focus groups of 15 people were shown Amnesty International appeals about Afghanistan and Bosnia.[80] Although the sample was small, Cohen and Seu confidently report that the emotional response of the subjects meant that 'the strong compassionate fatigue thesis [. . .] cannot be sustained.' Those in the focus groups recognised an accumulation of atrocity images but that did not produce indifference, even if they resented how charities played on their guilt for circumstances beyond their control. What the accumulation of images did produce was a sense of demand overload, meaning that there were too many demands on their compassion and insufficient means to determine which of the demands could be most effectively met.[81]

Birgitta Höijer's research during the 1999 Kosovo crisis, in which detailed telephone interviews and focus groups with more than 500 people in Sweden and Norway explored their reaction to images of suffering in news coverage, confirms much of Cohen and Seu's argument.[82] Höijer found that 51 per cent of respondents said they often or quite often reacted to atrocity images, 14 per cent said sometimes or not at all, with only 23 per cent saying they never reacted. Gender and age were important, with women reacting more than men, and older people reacting more than the young. In an important statement, Höijer says that 'women especially said that they sometimes cried, had to close their eyes or look away, because the pictures touched them emotionally,' thereby demonstrating that averting one's gaze can itself be an affective response rather than a sign of indifference. It is also a response that recalls the idea from the medical literature that 'caring too much can hurt'.[83] Höijer's research intersects with the literature on the 'identifiable victim effect' when she reports that the audience for the Kosovo images accepted the media's code of victimhood in which women and children were seen as innocent and helpless, and it was this victimhood which made them deserving of compassion.[84] Höijer does note that when the Kosovo crisis ran on into a 78-day war feelings of powerlessness overcame the audience such that time did undermine compassion. Even if this was expressed in terms of distantiation or numbness, it is not evidence of compassion fatigue. Rather, it confirms that compassion has to be connected to a finite outcome otherwise it could be directed towards a different issue. As a result, Höijer says her research 'opposes, or strongly modulates, the thesis about a pronounced compassion fatigue among people in general'.[85]

The final source of evidence that can cast concrete light on the compassion fatigue thesis concerns charity appeals. The *OED* definition

of compassion fatigue at the outset cited the 'diminishing public response' to such appeals as evidence. But is the public response diminishing? While answering that would require a detailed longitudinal study, a few observations suggest the public still respond quite eagerly to calls for charity. In Britain there are 166,000 charities, which received donations totalling £10 billion in 2009. In the United States, there are more than 800,000 charitable organisations, and Americans gave them more than $300 billion in 2007.[86] The British public's response to disasters like the 2010 Haiti earthquake (for which the Disasters Emergency Committee (DEC) raised £106 million) shows that the willingness to act on empathy for the victims of natural disasters is still considerable even when they are distant.[87] The DEC conducts consolidated appeals for the 14 leading aid non-government organisations (NGOs) in the UK, and a look at their various appeals over the last few years shows that there is a constant willingness to donate, albeit at variable rates – from the 2009 Gaza appeal's £8.3 million to the massive £392 million given for the 2004 tsunami appeal.[88] There are clearly differential responses, but these do not add up to a generally diminished response.

Conclusion

In order to clear the way for a sustained consideration of how the pictures produced by photojournalism work, this essay has worked through the various claims, subsumed by the idea of 'compassion fatigue', that seemingly explain how photographs of atrocity and suffering affect people generally. These assertions, made by a wide range of commentators and photographers, fall into three broad groups.

The first involves the global visual economy, including the media and NGOs. There is said to be a general and accelerating abundance of imagery that inundates and overwhelms the public, leading to widespread cultural anxiety. This overexposure can be the result of seeing a few images too often or too many pictures incessantly. The second deals with the nature of the pictures that allegedly overload us. There are either too many of the same type of images, their thematic content is unbearable (either too graphic or too violent) or the scale of the atrocity or suffering portrayed is too vast. The third set of statements deal with the audience for the images, which is said to have too short an attention span, shows a lack of interest, feels powerless or has a deadened conscience when faced with visual representations of humanity's problems. Taken individually

and investigated critically, each of these claims could have some merit, assuming some supporting evidence. But lumped together as components in a generalised and universalised condition called 'compassion fatigue' their contradictions outweigh their coherence. Indeed, in the context of media and politics, compassion fatigue has morphed into a catch-all concept that is both cause and effect, reason and consequence, which is somehow designed to explain many of the ills that beset both international reporting and global politics. It is little more than an allegory that serves as an alibi for other issues while preventing their critical investigation.

One of the striking things about the compassion fatigue thesis in media and politics is how it differs from the concept's usage in health care and social work, where it marks the consequences of an excess of compassion. However, this deployment of compassion fatigue does not offer the correct definition to which media and politics must conform, for definitional clarity is not our primary concern. What this alternative rendering of compassion does make clear, though, is the need for evidence to support the claim that something about the number or nature of images has drained the general public of its capacity to be both affected by and respond to representations of atrocity and suffering. This is all the more so because the major proponents of the idea of compassion fatigue in relation to photography (especially the early Sontag and the on-going Moeller) constructed their arguments with little if any evidence. As noted above, the evidence that is available demonstrates that, far from diminishing compassion, the public at large still gives generously, if differentially, to charitable appeals, using familiar and repeated imagery to foster a response to international events.

Photojournalism's dream has been that its pictures of crisis move viewers to respond. Given the persistence and scale of disease, famine, war and death in the late modern world, it is not difficult to conclude that somehow visual representation has failed, and that either the producers or viewers of our abundant imagery are culpable. In many ways, this is the great achievement of the myth of compassion fatigue: it has provided an answer to a question posed in its own terms. There may well be a problem with compassion, but it is not one of a generalised or universal fatigue brought on by repeated exposure to certain kinds of imagery. The problem might be that there is an excess of compassion, though not in the sense envisaged by the medical literature. Instead, there might be excess of compassion in so far as compassion, and only compassion, has become the dominant mode through which to interpret the public response to extreme events. Rendering our capacities solely in terms of compassion – either its excess or lack – is too singular and limited a view.

This is because, as James Johnson argues, compassion can only operate at an individualising level. By itself compassion cannot be the basis for political mobilisation because it is limited to a vicarious experience of suffering usually between two individuals (the one suffering and the spectator of that suffering), and can thus only ever deal with the particular rather than the general. As such, framing the problem in terms of either the diminishment or promotion of compassion means we are incapable of generating the move from singular expression to collective action.[89] The myth of compassion fatigue, then, frames the issue in a way that can only fail. 'Compassion fatigue' – aside from being unsupported even in its own terms – is entirely the wrong concept for thinking about how the images produced by photojournalism work. And for too long it has prevented that thinking from progressing.

Notes

1 Lizzy Davies, 'Sarkozy admits Paris errors over Rwanda genocide', *Guardian*, 26 February 2010, p. 17.
2 Stanley Cohen, *States of Denial: Knowing About Atrocities and Suffering* (Oxford, 2001), p. 169.
3 Jacques Rancière, *The Emancipated Spectator*, trans. Gregory Elliot (London, 2009), p. 103.
4 For example, *Life, 100 Photographs That Changed the World* (New York, 2003).
5 Rancière, *The Emancipated Spectator*, p. 103.
6 Here are some moments from 2010–12 in which this belief manifests itself: in an interview following his World Press Photo award, photographer Pietro Mastruzo noted: 'Shocking pictures do not really communicate anymore, because the audience is accustomed to looking at them' (in *Der Spiegel* online interview with World Press Photo winner: 'You Don't Have to Risk Your Life to Tell a Good Story', 23 February 2010, available at www.spiegel.de/international/world/spiegel-online-interview-with-world-press-photo-winner-you-don-t-have-to-risk-your-life-to-tell-a-good-story-a-679739.html (accessed 18 February 2014)). The late Magnum photographer Eve Arnold was reported as once saying, 'You know in the beginning we thought we were going to change the world. I think people live in so much visual material these days, billions of photographs annually, that they grow numb after too much exposure' (in Eve Arnold obituary, written by Olivier Laurent, 5 January 2012, available at www.bjp-online.com/british-journal-of-photography/news/2135528/magnum-photographer-eve-arnold-dies (accessed 18 February 2014)). The new media artist Peggy Nelson told Nieman Storyboard, 'we can't have all the news from everywhere and

everyone all the time. There's info overload and there's compassion fatigue', available at www.niemanstoryboard.org/2010/02/12/peggy-nelson-on-new-media-narratives-every-twitter-account-is-a-character (accessed 18 February 2014). In an analysis of disaster coverage, University of London professor Pavarti Nair wrote, 'The floods in Pakistan have given rise to a veritable deluge of photographs documenting devastation. On a daily basis, we have been seeing representations of untold suffering, as people struggle to survive, while filth and chaos reign around them. Nevertheless, despite efforts to mobilise relief, a certain degree of apathy often accompanies our responses to such images', available at www.guardian.co.uk/commentisfree/2010/aug/22/photo-reportage-thwarted-potential (accessed 18 February 2014). In his review of the Tate Modern's 'Exposed', noted photography writer Gerry Badger made a direct endorsement of Sontag's 1977 statement that 'Images anaesthetise'. Xeni Jardin, co-editor of *Boing Boing*, said of violent images on the web, 'human beings do not have an endless capacity for empathy, and our capacity is less so in the mediated, disembodied, un-real realm of online video [. . .] at what point do each of us who observe this material for the purpose of reporting the story around it, become numb or begin to experience secondary trauma?', available at www.guardian.co.uk/commentisfree/cifamerica/2011/apr/04/digital-media-xeni-jardin (accessed 18 February 2014). And award-winning documentarian Danfung Dennis introduced his new video app by claiming 'Society was numb to the images of conflict', available at http://lightbox.time.com/2011/11/11/a-new-way-to-photograph-war (accessed 18 February 2014). Even academic research projects exploring how images affect people start from bold assertions of compassion fatigue. See Charlie Beckett, 'Four steps to success in a humanitarian appeal', 15 November 2011, available at http://blogs.lse.ac.uk/polis/2011/11/15/four-steps-to-success-in-a-humanitarian-appeal (accessed 18 February 2014), which begins: 'People are exhausted by messages they receive from humanitarian NGOs. They've become desensitized to images of distant suffering and repeated appeals for help.'

7 John Taylor, 'Problems in photojournalism: realism, the nature of news and the humanitarian narrative', *Journalism Studies* 1 (2000), pp. 137–8; Carolyn Dean, *The Fragility of Empathy After the Holocaust* (Ithaca, NY, 2004), p. 2; and Susie Linfield, *The Cruel Radiance: Photography and Political Violence* (Chicago, 2010), p. 45.

8 *Oxford English Dictionary.*

9 'Haiti: compassion fatigue: relief groups worried people may start tuning out', Fox 25 News, Boston, 21 January 2010, available at www.myfoxboston.com/story/17766832/haiti-compassion-fatigue (accessed 18 February 2014); Clark Hoyt, 'Face to Face with Tragedy', *New York Times*, 23 January 2010, available at www.nytimes.com/2010/01/24/opinion/24pubed.html (accessed 18 February 2014).

10 'Oral history interview with Dorothea Lange, 1964 May 22', Archives of American Art, Smithsonian Institution, available at www.aaa.si.edu/collections/interviews/oral-history-interview-dorothea-lange-11757 (accessed 18 February 2014). The transcript records her comment tailing off as shown here. I am grateful to John Edwin Mason for this reference.

11 Paul Westheim, 'Bildermüde?', *Das Kunstblatt* 16 (March 1932), pp. 20–2, translated by, and quoted in, Mia Fineman, 'Ecce homo prostheticus: technology and the new photography in Weimar Germany' (PhD, Yale University, 2001). I am grateful to Mia Fineman for this reference.

12 Vaughan Bell, 'Don't touch that dial!', *Slate* 15 (February 2010), available at www.slate.com/articles/health_and_science/science/2010/02/dont_touch_that_dial.html (accessed 18 February 2014).

13 'Haiti coverage: "disaster porn"?', *The Week*, 20 January 2010, available at http://theweek.com/article/index/105296/Haiti_coverage_Disaster_porn (accessed 18 February 2014); and BBC Radio 4 *Today*, 'Are Haiti pictures too graphic?' 25 January 2010, available at http://news.bbc.co.uk/today/hi/today/newsid_8478000/8478314.stm (accessed 18 February 2014).

14 Dean, *The Fragility of Empathy After the Holocaust*, p. 39.

15 Ibid., pp. 36, 38.

16 Cohen, *States of Denial*, p. 187.

17 See www.compassionfatigue.org. See also Eric Gentry, 'Compassion fatigue: a crucible of transformation', *Journal of Trauma Practice* 1 (2002), pp. 37–61; Bertrand Taithe, 'Horror, abjection and compassion: from Dunant to compassion fatigue', *New Formations* 62 (2007), p. 135; and Charles Figley, 'Compassion fatigue: an introduction,' available at www.giftfromwithin.org/html/What-is-Compassion-Fatigue-Dr-Charles-Figley.html (accessed 18 February 2014).

18 Susan Sontag, *On Photography* (New York, 1977), p. 21.

19 Ibid., p. 20.

20 Ibid., p. 19. In an indirect rebuke to Sontag, McCullin writes in his autobiography that 'the whiplash of compassion and conscience never ceased to assail me in Biafra.' Don McCullin, *Unreasonable Behaviour: An Autobiography* (London, 1992), p. 124.

21 Sontag, *On Photography*, p. 20.

22 Ibid., pp. 19–20.

23 Susan Sontag, *Regarding the Pain of Others* (New York, 2003), p. 23.

24 Ibid., p. 82.

25 Ibid., p. 100.

26 Ibid., p. 98.

27 Ibid., p. 89.

28 Susan Moeller, *Compassion Fatigue: How the Media Sell Disease, Famine, War and Death* (New York, 1999).

29 Ibid., p. 52.

30 Ibid., p. 2.

31 Ibid.

32 Ibid.

33 Ibid., p. 12.

34 Ibid., p. 17.

35 Ibid., p. 40

36 See Susan Sontag, *Illness as Metaphor and AIDS and its Metaphors* (New York, 2001).

37 Moeller, *Compassion Fatigue*, p. 2.

38 Ibid., p. 9. How one can be simultaneously overstimulated and bored is not clear.

39 Ibid., p. 11.

40 Ibid., p. 32.

41 Ibid.

42 Ibid., p. 53.

43 Ibid., p. 37.

44 Celia Dugger, 'International calamities tax America's compassion', *New York Times*, 12 May 1991, available at www.nytimes.com/1991/05/12/nyregion/international-calamities-tax-america-s-compassion.html (accessed 18 February 2014).

45 Moeller, *Compassion Fatigue*, pp. 280–307; Susan Moeller, 'Compassion fatigue: graphic, complicated stories numb readers and viewers to atrocities', *Media Studies Journal* (Summer 2001), pp. 108–12.

46 Moeller, *Compassion Fatigue*, p. 235.

47 Quoted in Moeller, *Compassion Fatigue*.

48 Quoted in ibid., p. 304.

49 Ibid.

50 From the American perspective, see William Ferroggiaro (ed.), *The US and the Genocide in Rwanda 1994: Evidence of Inaction* (Washington, DC, 2001), available at www.gwu.edu/~nsarchiv/NSAEBB/NSAEBB53/index.html (accessed 18 February 2014).

51 Samantha Power, *'A Problem from Hell': America and the Age of Genocide* (New York, 2002).

52 Moeller, *Compassion Fatigue*, p. 110.

53 David Campbell, *National Deconstruction: Violence, Identity and Justice in Bosnia* (Minneapolis, 1998), especially chapter 5.

54 David Campbell, 'Geopolitics and visuality: sighting the Darfur conflict', *Political Geography* 26 (2007), p. 368.

55 For discussions of the problems of international reporting from a UK perspective, see Martin Moore, *Shrinking World: The Decline of International Reporting in the British Press* (London, 2010) and Martin Scott, *The World in Focus: How UK Audiences Connect with the Wider World and the International Content of News in 2009* (London, 2010). On the recent transformations in

international journalism, see Richard Sambrook, *Are Foreign Correspondents Redundant? The Changing Face of International News* (Oxford, 2010).

56 Moeller, *Compassion Fatigue*, p. 2.

57 Pew Research Center's Project for Excellence in Journalism, 'The state of the news media 2011', available at http://stateofthemedia.org/2011/overview-2/key-findings (accessed 18 February 2014).

58 Katherine N. Kinnick, Dean M. Krugman and Glen T. Cameron, 'Compassion fatigue: communication and burnout toward social problems', *Journalism & Mass Communication Quarterly* 73 (1996), pp. 687–707.

59 Ibid., p. 703.

60 Ibid., p. 702.

61 Ibid., p. 703.

62 Deborah A. Small and G. Lowenstein, 'Helping a victim or helping the victim: altruism and identifiability', *Journal of Risk and Uncertainty* 26 (2003), p. 5.

63 This tendency is discussed in Libby Brooks, 'The Turkish earthquake baby has evoked an empathy we too often repress', *Guardian*, 27 October 2011, available at www.guardian.co.uk/commentisfree/2011/oct/27/turkish-earthquake-baby-empathy (accessed 18 February 2014).

64 Paul Slovic, '"If I look at the mass I will never act": psychic numbing and genocide', *Judgment and Decision Making* 12 (2007), p. 82.

65 Small and Lowenstein, 'Helping a victim or helping the victim'.

66 T. Kogut and I. Ritov, '"The 'identified victim" effect: an identified group, or just a single individual?', *Journal of Behavioural Decision-Making* 18/3 (2005), pp. 157–67.

67 Deborah A. Small, G. Lowenstein and Paul Slovic, 'Sympathy and callousness: the impact of deliberative thought on donations to identifiable and statistical victims', *Organizational Behaviour and Human Decision Processes* 102/2 (2007), pp. 143–53.

68 Daniel Västjfäll, Ellen Peters and Paul Slovic, 'Representation, affect, and willingness-to-donate to children in need', cited in Slovic, '"If I look at the mass I will never act"', pp. 89–90.

69 Deborah A. Small and Nicole M. Verrochi, 'The face of need: facial emotion expression on charity advertisements', *Journal of Marketing Research* 46/6 (2009), pp. 777–87.

70 Slovic, '"If I look at the mass I will never act"', p. 86. The continued use of pathetic images in charity appeals for international humanitarian crises offers a strong contemporary inference for this claim. There is, however, one study which runs counter to this conclusion, arguing that its experiment with contrasting charity appeals showed photographs had less impact than expected, but that the response engendered by positive imagery exceeds that of the negative. See Evelyne Dyck and Gary Coldevin, 'Using positive vs. negative photographs for third-world fund raising', *Journalism Quarterly* 69/3 (1992), pp. 572–9.

71 Slovic, '"If I look at the mass I will never act"', p. 89.
72 Small and Lowenstein, 'Helping a victim or helping the victim', pp. 5–6.
73 Ibid., p. 14.
74 Ibid., p. 6.
75 Small and Verrochi, 'The face of need'.
76 Small, Lowenstein and Slovic, 'Sympathy and callousness'.
77 Slovic, '"If I look at the mass I will never act"', p. 90.
78 Small and Verrochi, 'The face of need'.
79 Slovic, '"If I look at the mass I will never act"', pp. 81–2.
80 Stanley Cohen and Bruno Seu, 'Knowing enough not to feel too much: emotional thinking about human rights appeals', in Mark Phillip Bradley and Patrice Petro (eds), *Truth Claims: Representation and Human Rights* (New Brunswick, NJ, 2002).
81 Ibid., pp. 193–4.
82 Birgitta Höijer, 'The discourse of global compassion: the audience and media reporting of human suffering', *Media, Culture and Society* 26 (2004), pp. 513–31.
83 Ibid., pp. 519–20.
84 Ibid., p. 521.
85 Ibid., p. 528.
86 David Campbell, 'How does the media persuade us to give to charities?', 21 February 2010, available at www.david-campbell.org/2010/02/21/media-charity-compassion (accessed 18 February 2014); Small and Verrochi, 'The face of need', p. 777.
87 See www.dec.org.uk/appeals/haiti-earthquake-appeal.
88 See www.dec.org.uk/appeals.
89 James Jonson, '"The arithmetic of compassion": rethinking the politics of photography', *British Journal of Political Science* 41 (2011), pp. 621–43.

6 Infra-Destructure

Ariella Azoulay

> *… and while you are returning home,*
> *your home,*
> *think of others*
> *don't forget the people of the tents …*
>
> Mahmoud Darwish, tr. Fayeq Oweis

I shall begin by characterising two types of disaster.

The first disaster, *par excellence*, needing the least amount of verbiage to merit the term, is a spectacular event that befalls a city from the outside as it were, bursting in and injuring it. Its outline is relatively clear. In the face of such a disaster, the sovereign power demonstrates by its deeds the urgent need to allocate resources and manpower and make decisions that enable it to contain the disaster, reduce its destructive effect, prevent its expansion and cope with its repercussions.

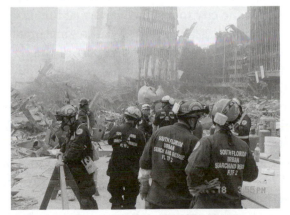

13. 9/11, the US Army Corps of Engineers, file photo.

14. Bus no 5, Tel Aviv. Photographer: Miki Kratsman.

Such disaster tends to become paradigmatic, an orchestrated object of mourning and memory. This happens regardless of the precise magnitude or the damages it has wrought. The work of memory manifests the power of the sovereign that administers it and its continued spatial consequences. Such is the Twin Towers disaster, such were the buses that exploded in Israeli city centres in the 1990s.

These photographs from Ground Zero or from Jerusalem city centre, showing the massive presence of rescue and rehabilitation forces, were taken immediately following the outbreak of disaster. They bear traces both of the outbreak and of the way in which the sovereign copes with it, acting to remove the remains of the calamity disrupting municipal activity, in order for the city to resume its normal function.

The second type of disaster is what I call regime-made disaster. It is ongoing and constantly impacts a defined part of the population under a regime that differentiates groups of citizens and non-citizens. These are made distinct from each other – among other ways – by the degree of their exposure to disaster. Regime-made disaster expresses both this differential rule and part of that which stabilises the differential structure of the body politic. Regime-made disasters do not usually *break out* – they *exist* and *persist*. Their most common form since the end of World War II has been life on the threshold of catastrophe lived by one group of governed people, abandoned by the ruling power, alongside and together with other groups who are protected against disaster.

The number of casualties in a regime-made disaster, or the damage to municipal infrastructure might be no smaller and even larger than that inflicted by spectacular disaster. However, the ruling power refrains from interrupting the disaster. These photographs, from Jabalya refugee camp and Jenin city in the northern West Bank were taken days or weeks after the cities were attacked.

As the photos readily show, this disaster is not of the first type since the wounded urban centre is still bleeding, dangerous, devoid of any rehabilitation horizon. Here, for example, Israel forbade the reconstruction of the emptied area at the centre of Jenin, leaving routes open for the movement of tanks in the next 'round' of attacks. A term such as *spaciocide*, coined by Sari Hanafi, or *urbicide*, used by Marshall Berman regarding Sarajevo, or by Stephen Graham later applied to Palestine – as well as the expression *threshold of catastrophe* that I have used myself referring to Palestine – all indicate the systematic nature of the destruction and the way in which it prevents the impacted population

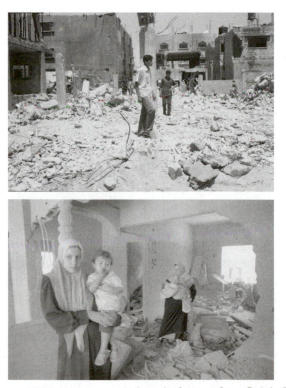

15a & 15b. Gaza, 2002: a one-tonne bomb dropped on Salah Shehada's house. Photographer: Miki Kratsman.

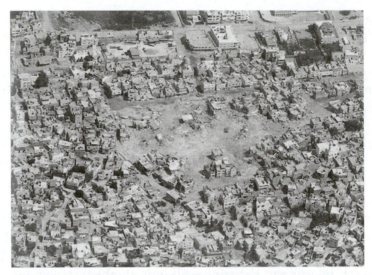

16. Israeli bulldozers levelled a 200 x 250 metre area, burying some civilians alive, and leaving over 4,000 people homeless.

from rehabilitating its urban space. These terms are efficacious, making visible the manifestation of a chronic disaster that prevents the outbreak of an ultimate disaster – one that could no longer be denied as such. Such an outburst would challenge the discourse of the ruling power. The latter attempts to obfuscate its own disaster-generating deeds and remain outside them. When disaster breaks out and wounds space, the inhabitants of Jenin or Gaza – certainly those living within and around the rim of the wound – are the first immediate victims who must be regarded as such on every level and aspect. Thus too, the theoretical thought conceptualising this injury expresses the urgency of focusing on the victims no less than the humanitarian forces sent to assist them. However, the weakness of terms like *urbicide* or *spaciocide* is in the assumption that the space targeted for destruction is a given unit, inside which the disaster takes place, and thus envisioning that the disaster 'belongs' to the impacted population.

The study of disaster should reframe its objects as an event involving all those affected by it – both its perpetrators and their accomplices, as well as those who are its direct victims. This enables one to rethink the body politic and its formation as a fundamental component of disaster. In order to reconstruct disaster in relation to the body politic as a whole, I propose to look at the time and space of the disaster. Only then will the

second type of disaster appear as what it really is: regime-made disaster, whose time and space coincide with the time and space of the regime.

I shall begin with the *time of the disaster*. These pictures, though taken weeks later, witness the moment of the outbreak of disaster, a moment of the kind that breaks up continuum, differentiates between disaster and non-disaster and requires us to relate to it as disaster. These pictures include traces of another time, from which one might deduce that a regime-made disaster is at hand. Note the void at the heart of the Jenin refugee camp. It is not the result of a fatal bomb exploding and erasing the area in one fell swoop, but rather the slow machination of tanks and bulldozers that wiped out about 200 houses one by one.

So, too, in Figure 17: indeed, within a few minutes, when the soldiers leave the home of Sirhan Sirhan's family, a blast will sound off and the home will be obliterated. But the precise plan to destroy 'only' the Sirhan Sirhan home, enabling the operation commander to credit himself with its success, lasted quite a while and involved quite a few Israeli citizens in uniform. Such traces of the time of disaster before its outbreak are evident as well in the building in Figure 18, whose collapse as a result of bombing from the air was preceded by months of attritional fire, until its dwellers evacuated it; or in others where long hours of slow, calculated

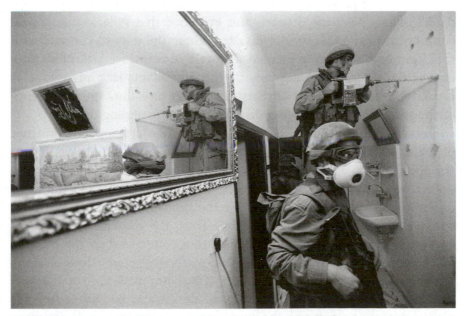

17. Sirhan Sirhan family house. Photographer: Nir Kafri.

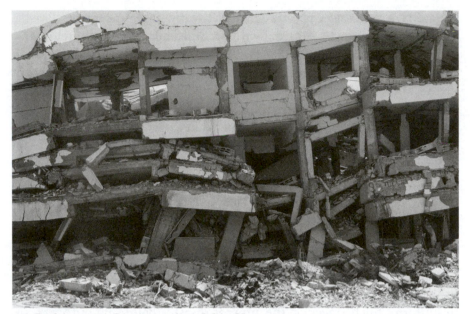

18. Rafah, 2005. Photographer: Miki Kratsman.

nibbling at the shell of a house take place until it turned into a pile of gravel and the authorities tallied another act of law enforcement.[1]

The time required for the fabrication of an 'outbreak' is part and parcel of regime-made disaster, and evidence that it lacks the crucial component of the first type of disaster, where the duty to contend with this kind of disaster is presented as totally uncontroversial. Here, in a case of the second kind, not only do the inhabitants lack any means or capacity to halt the spread of disaster, they are also the captive audience of the spectacle of the ongoing disaster and its expanding damage.

Under regime-made disaster, they witness disaster happening in front of their very eyes while sharing the space with those who do not regard the goings-on as disaster at all, or at most – at times – see it as a disaster only 'from the point of view' of the victims: a matter for humanitarian organisations called upon to contain the damage and yet leave things still on the threshold of catastrophe. Thus, the destruction of urban space and expulsion of its inhabitants are accompanied by the erection of encampments as a temporary solution for those who have become homeless. But the temporary solution itself becomes part of the new space, and thus a part of the regime-made disaster maintained by the sovereign regime along with the humanitarian organisations. The regime-

made disaster does not take place under pressure of time – it takes time, becomes its master and denies its subjects the ability to partake in setting its ending points. At times – in Israel/Palestine this is the permanent state of affairs – those who keep up the disaster do not realise, through various forms of self-deception, that they are perpetrating disaster. They imagine themselves existing in a different, parallel time, the time of *their own* history, wherein the disaster of the others does not appear as such, and that which does appear as disaster always seems to be the inevitable effect of the greater history, 'their own'.

From the point of view of those supposedly unaffected by the disaster, the demolition of about 200,000 houses since the founding of the State of Israel appears only as a series of incidents, each of which can be discussed and explained away 'as of itself', so that every case has some inner justification biting at its disastrousness. Justifications are numerous: a 'terrorist nest' just had to be cleansed, a road widened, a 'reprisal mission' carried out, sometimes one had to make sure the refugees would have nowhere to return, and also urban obstacles and public hygiene hazards simply had to be removed.[2] This is no one-time outbreak of disaster. It is, rather, a destruction pattern spread over a long time; over a period of 60 years each house demolition was only questioned – if at all – in the context of its particular justification.

From the day that the Israeli regime expelled 750,000 Palestinians and consolidated as a sovereign power under the British Mandate for Palestine, the continuous unfolding of its historical time has never been disrupted by the temporality of regime-made disaster. I have in mind interruption of the kind that a disaster like the war atrocities and ethnic cleansing in the former Yugoslavia inflicted upon the history of the Balkans. This is, however, the main time feature of regime-made disaster: it lacks the conditions needed to presence itself in a way that would break up the time in which it exists, and settle in. Much power is needed to continue to separate the time of the citizens, protected by the sovereign power, and the time of those it abandons. In addition to the force exerted upon those exposed to disaster, power is also exerted upon those mobilised to actually carry out the disasters: mainly by being required not to regard these acts as disasters and relegate them to the history of others. Time enables one to uphold the great lie of the national subject as having a time of its own, separate from others' time: the existence of Israeli time versus Palestinian time.

Let me move from the time of disaster to its *space*. Space was supposed to supply the convenient platform for the separate narratives. However,

19. The wall, As Sawahira ash Sharqiya, East Jerusalem. Photographer unknown.

the greater the efforts made to establish spatial separations, to divide and split space, every act of separation only further reveals how mixed this space is, how much power is required to maintain separation, how many more erasures are needed to erase any new mixture, and the traces of the power that is needed to erase, blur, distort and deceive in order to relate to the space in which two peoples live together as if it belonged to a single national subject. Here is the fantasy – total separation and isolation created by the Israeli regime as a picture of reality.

Here is a glimpse of one of the passages that Palestinians have to cross in order to maintain the Israelis' fantasy of separation.

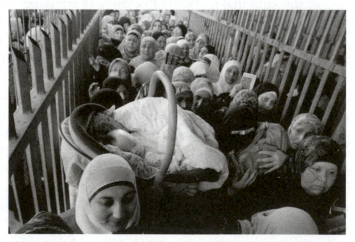

20. Qalandia, women crossing checkpoint, February 2012. Photographer: Bernat Armangue/AP.

However, where disaster is concerned, the fantasy of separation persists as reality. It separates the few Israelis who see disaster for what it is from all the rest. For those few, disaster is an irreducible part of their country, it is theirs no less than the Palestinians' even if the Palestinians are the ones who continue to pay its full price. Figure 21 is a photo from my own neighbourhood.

Until the State of Israel was founded, the Palestinian village of Summeil was here, contained as a part of urban Tel Aviv. A view from the air shows hardly a trace of it except topographically – a hill overlooking its surroundings.

21. Tel Aviv/Summeil, 2010. Photographer: Michali Bar-Or.

22. Tel Aviv/Summeil, 2010. Photographer: Michali Bar-Or.

Even at a closer look – without any preliminary knowledge or explicit intent to recognise expulsion, destruction and dispossession of the Palestinians and the exercise of such violence to Judaise space through disaster – these remains might appear to belong to an ancient layer of the city, scattered here and there throughout vibrant urban space.

In one of the rather rare tours organised by Zochrot, an NGO working against the erasure of the 1948 expulsion from Israeli consciousness, Israelis who have been educated not to recognise the disaster inscribed in the remains hear about it from a Palestinian who was evicted from his Summeil home. They learn to recognise the ways disaster is deployed in space, to identify themselves as a part of the disaster, a part of that which preserves the disaster at the heart of this city as an unrecognised one. Gradually, the disaster revealed to them ceases to be one that 'belongs' to others, or a past event. The fact that Israelis do not recognise it, or its dire urgency, should not be understood any more as a mere epistemological matter but as a part of the ontology of the disaster, of regime-made disaster. Recognising disaster is not just an epistemological question, but a part of the actual formation of disaster, of its ontology. The differentiation of Israeli Jews from the Palestinians in the extent of their exposure to disaster, in the unexercised ability to recognise it, in the unexerted power to authorise the ruling power to put an end to it, is the substance of which regime-made disaster is made.

23. A Palestinian in front of the house from which he was expelled in 1948, Tel Aviv/Summeil, March 2006. Photographer: Michael Jacobson.

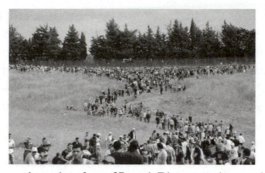

24. Nakba Day, northern border of Israel. Photographer: unknown.

Let us view this picture taken on 15 May (Nakba Day, which commemorates the expulsion of 1948), 63 years after the expulsion. From the point of view of the sovereign state, soldiers here are seen standing at its border and preventing its invasion by aliens. This point of view is rooted in a whole discourse and in the objective space, replete with separation walls. This can only enable one to see those standing at the border as invaders threatening the state's sovereignty. Immediately after they were expelled in 1948, the Palestinians began to demand their return. They have not desisted since. But in the field of vision shaped by the state along its borders, they are seen as 'infiltrators', 'invaders' or 'terrorists'. The incessant demand by the expelled to return to the *polis* is a demand to cease the drawn-out effects of the disaster and enable them, no longer exposed to it, to take part in reshaping their world. Their presence along the borders in a kind of swarm is an attempt to problematise the borders of the *polis* so that their claim – so far heard only from the outside – be heard inside as well. Their presence poses an enormous challenge to civilian space in Israel. At hand is not merely the recognition of the disaster of Palestinians, but rather recognition of the participation of Israeli citizens in an ongoing unending disaster.

In 1948, the Israeli regime began to demolish houses and has not stopped since. The massive destruction of 200,000 houses cannot be measured by the justification, as it were, of each specific case. This is a regime project as a whole, the intrinsic structure of the *polis* – its infra-destructure. This is no superficial destruction, limited to one place or another, but a viral phenomenon to which no place in this space is immune. It is part of the regime's existence formation. Continuous destruction preserves the constituent violence of 1948 that devastated the Palestinian home, and has made it an object for potential demolition

or confiscation. This disaster must not be seen or heard, and in order to prevent its appearance, more and more violence is required, whose traces cover the entire land. Non-recognition of the expulsion, robbery and dispossession as disaster necessitated the citizens' loyalty to the ruling power: a Jewish side facing these deeds either as non-disaster or as a Palestinian disaster, and in both cases, as nothing urgent. And so it has been for years, with nary a word of protest on the Jewish side.

The Arab Spring of 2011 has not passed Israel by. Indeed, when it arrived at the streets of Tel Aviv, the Palestinian disaster was not a central issue. But for the first time since the founding of the state, Israeli citizens challenged the national agenda in which keeping the Palestinians on the threshold of catastrophe played a major role. They demanded a new agenda. It broke down into numerous demands, but in every single encampment, one major principle was heard: heterogeneous claims and total rejection of any exclusionary claim. One tent in the middle of Tel Aviv's Rothschild Boulevard, erected by Jews and Palestinians, was named 'Tent 48'.

Talk of the disaster, continuing ever since, has spread from this tent all along and across public space.

Israeli citizens chose the tent as a kind of statement (an *énoncé*), addressing the ruling power.

25. Tent 48, Rothschild Boulevard, August 2011. Photographer: Ariella Azoulay.

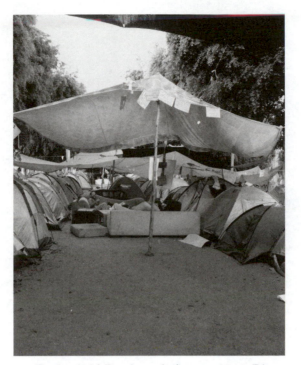

26. Encampment, Rothschild Boulevard, August 2011. Photographer: Ariella Azoulay.

By this they inadvertently retrieved and replicated the state's practice of oppressing and controlling the Palestinian population since 1948. For the Israeli regime, the tent became the natural home of the Palestinian, their predicament. Their very existence. The project of destruction carried out by the State of Israel maintains the Palestinian home as an unprotected space whose walls are penetrable to Israeli force. Its violent outburst might turn the Palestinians into tent-dwellers at any given moment and add to their urban space yet another public square made of rubble.

And now citizens use this tent voluntarily, challenging the political system: among other things, they demand recognition of the regime-made disaster that has been ongoing since its foundation in 1948, destroying landscape and environments, injuring cities and villages, invading and distorting the public and private spaces of the governed population.

The civil framework of analysis I am proposing here enables us to identify the continuity in time and space of the heterogeneous claims regarding the public and private space articulated through the encampments in the context of the civil awakening in Israel's streets on the one hand, and the swarm of demonstrators on its borders on the

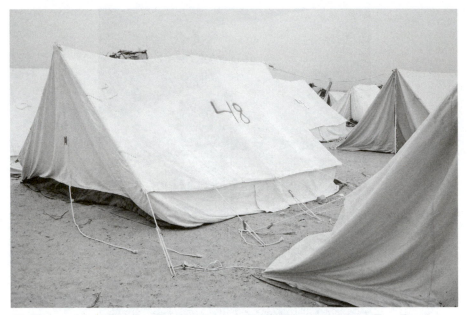

27. Ezbet Abed Rabbo, Gaza, February 2009. Photographer: Eva Bartlett.

other. Once this continuity is recognised, one can relate the injured city to the deformation of the *polis*, understand the city as the instantiation of the *politea*, see its infra-destructure as the expression of the infra-structure of its political regime. In the Israeli context, then, the discussion of injured cities must deal with the deformed *polis*, for there is hardly any injured Israeli city whose injury is not an effect of a deformed body politic and the naturalisation of the regime-made disaster that is shaping it continuously. This naturalisation enables the unhampered reproduction of the body politic as differential along the lines of those who recognise disaster for what it is, and the others who do not.

Notes

1 See my discussion of the 'Architecture of destruction' in Ariella Azoulay, *Civil Imagination: Political Ontology of Photography* (London, 2012).

2 See the section on 'Architecture of dispossession' in Ariella Azoulay, *From Palestine to Israel: A Photographic Record of Destruction and State Formation, 1947–1950* (London, 2011).

7 Watching War Evolve

Photojournalism and New Forms of Violence

Robert Hariman

War has changed, and photography has changed. The connection, if any, remains obscure, and for good reason: both statements are at once true and false.

War has changed: the military is a technology-intensive learning organisation; weapons have become ever more deadly, and command and control systems now span the globe. War now can consist of someone sitting in a windowless room in Arizona directing a drone strike on a specific house in Yemen. Hardly the stuff of romance – and not likely to produce a good photograph either. Except that war has not changed. Leadership is as important and difficult as ever; the boredom and terror of life in the ranks would be familiar to anyone who has marched to battle. Success still depends on both courage and luck, along the way innocents are slaughtered, and the physical, psychological and social traumas will last for generations. Great powers are much less likely to engage each other in declared wars involving set-piece battles, and yet both the USSR and the US have waged wars of futility in Afghanistan. One might wonder if the language of 'war' can accurately describe what is happening; more to the point, what language is needed to identify the nature of war in the twenty-first century? What media and what artistic resources are needed to understand how war might be evolving? And are there some truths that, at least initially, can be seen before they can be said?

Photography has changed: digital technologies have accelerated its comprehensive distribution across all societies, cultures and classes while severing the photographic image from an indexical relationship to its object. Everyone can and does take photographs without even having to carry a stand-alone camera, and images circulate continuously among

consumers who take it for granted that the image might be altered, stolen or used for any number of variant purposes from advertising to parody to character assassination. Everyone, it seems, is being pitched headlong into a society of the spectacle that substitutes fantasy for both art and power. Except that photography has not changed. The conventions of photography remain stable, from photojournalism to fashion magazines to the family photo album. The debates about the medium are equally conventional, examining the relationship of image to reality and image to text while worrying about its cognitive, moral and political effects. As this is happening, most of the good photographs are still taken by professionals, and dozens of photojournalists are killed every year in the line of duty. One might wonder if their sacrifice was in vain; more to the point, is photography so conventional that it cannot bring people to see what is new in the world? Is public culture too weighed down by billions of images for photographic truth to matter? If war were changing, would a photographer be able to see the change and show it to others and be understood?

As a song from another era said, 'There's something happening here / What it is ain't exactly clear.'[1] Technological, social, cultural, economic and political changes accumulate, and the suspicion is growing that the results may not cohere as continued forward movement along the path known as progress. The thesis of this chapter is that war is changing in a manner that appears progressive but is actually dangerous, and that contemporary photojournalism is exposing significant features of an emerging order of twenty-first-century violence. Each of these claims is difficult to prove, not least because of the complexity of the social processes involved and the manner in which civilisational change exceeds ordinary intentionality. There is no morality play to be had here: the army is not evil, and art is not redemptive. At the least, I hope to suggest that there is reason to worry about war despite the benefits of the 'long peace' of the last half-century, and that photojournalists are achieving one of the highest achievements of any public art, which is to reveal how a future disaster has emerged as a possible outcome of the present.

Violence, Morality and the Ethical Lens

First, the good news. War is killing fewer people now than in the first half of the twentieth century, and modern war kills fewer people proportionately than warfare did in pre-modern societies; civil violence such as murder and mugging has also been decreasing steadily around

the globe with the spread of modernisation. Ten years of war in Iraq and Afghanistan has killed 23,000 military personnel and 130,000 civilians, which is far fewer than the one to three million people killed in the Vietnam War.[2] Despite (and in part because of) the threat of mutually assured destruction by nuclear weapons, there have been no great power conflicts since the Korean War; in the half-century before that, somewhere around 77 million people were killed by warfare, and millions more were wounded, raped, terrorised or displaced.[3] The planet could have been poisoned unalterably by nuclear warfare, but that didn't happen, and so it might seem sensible not to worry too much about potential threats. Were there such threats, there is no reason to take seriously an imagined 'clash of civilisations' leading to military Armageddon, and economic megafauna such as the US, the EU and China cannot afford to attack one another even if they could disentangle their finances.

Nor are these changes accidental. A compelling convergence of evidence reveals that primitive societies were not (and are not) so close to subsistence that they could not afford to do much more than win individual honour in battle.[4] The rates of death by conflict are staggering in modern terms – roughly 15 per cent of the population – and the carnage included torture, the slaughter of women and children, and genocide as relatively common practices. This habituation to cruelty had extended well into the modern era – for several centuries travel was dangerous, few dared to walk their own city streets at night, and during the day bystanders were accustomed to seeing brawling and beatings in the street, not to mention the horrors of chattel slavery. Where once many people were armed, in societies around the globe many people live their adult lives without ever holding a weapon, watching a servant or child being beaten, or being physically threatened. This is not to deny the appalling rates of rape and domestic abuse, gang warfare and other forms of violence (that is hardly my intention), but it is notable that sexual and domestic violence has to be hidden, gang violence is contained to very specific localities, and state terrorism and other systemic violence is rationalised and denied. The conclusion seems clear: modernity has made human beings less violent. During the Cold War the low level of actual violence was always balanced by the potential destruction of the West and poisoning of much of the planet, but now even that threat has been reduced to the likelihood of a single explosion. Progress may not be perfectly linear, but it seems hard to dispute. So, why worry?

There are several reasons why complacency should not be an option. At the most general level, either of two contrasting conceptions of

human nature argue against it. If one believes that human nature is fixed biologically (and too little time has passed for evolutionary arguments about our moral nature), then the *capability* for violence is unchanged while technological progress provides ever more lethal weapons. If one believes that human conduct is profoundly shaped by culture, then one has to accept that habituation can work in any direction, that there can be cultures of war, and that those cultures can expand through a variety of means beyond actual armed conflict. Put the two perspectives together, and it appears that human beings are by nature always vulnerable to becoming habituated to new forms of violence.

A related consideration is that, although the body count may have dropped over time, the expenditures on warfare have increased dramatically. Some primitive societies may be economically dependent on war, and for a long time it was a good way to acquire wealth, but today superpower status brings with it an addiction to expenditures that far exceed return. The death tolls in the world wars of the twentieth century were followed by immediate demobilisation, whereas the national security state that was created at mid-century continues to expand despite loss of its *raison d'être*. Likewise, the massive increase in spending on private security forces – and their significant escalation in weaponry and related technologies – looks like something that was taken for granted by the Medici and other elites accustomed to lawlessness and is a disturbing deviation from the state's monopoly on violence that has been one of the first principles of modern civil society. The suspicion does arise that another order of violence might be emerging, with its relatively benign features arriving first and its more vicious features arriving later.

Finally, it should be said that the modern reduction of violence begs an important moral question: is relative gain better than absolute loss? One might imagine Satan pondering this dilemma. On the one hand, he could encourage primitive societies, as they have the highest kill ratios. On the other hand, they also have small populations, and 100 of them could not kill 70 million people in a few years. What to do? Go for the more elegant solution or the raw numbers? 'Oh, hell,' he would very likely conclude, 'I'll take the lower rate and make it up in volume.' So it is that moral sense still demands further reductions in violence. One cannot consistently applaud the statistical reduction and dismiss the actual body count as if it were something like an acceptable level of unemployment. Moreover, the devil's take has been pretty good lately despite the lack of great power conflicts: 5.4 million in Congo (including mass rape and sexual mutilation), 800,000 in Rwanda, as well as the Balkans, Chechnya,

the dirty wars of Latin America and more, not to mention the 40 million people who are currently displaced to other countries, usually by war and often to refugee camps that can become permanent stateless settlements.[5]

The more one looks into the moral dilemma, the more one can see how the case for modernity depends on who is counting and what is being counted. Are drug wars to be considered wars? Is the war over if the camps still exist? Are prisons less violent than public beatings? And if something important is being missed in the calculation of moral progress, can it be shown? The very fact that war photographers are now being called conflict photographers is indicative of the problem: conflicts are not as bad as wars, but they are more common, less likely to share a common definition or narrative, and for those being killed, just as deadly. In place of the conventions of war photography – the fallen, soldiers at rest, the general staff, the weapons, the barrage, the assault, caring for the wounded, caring for civilians, the home front and so forth – photographers now are trying to make sense of scenes that are not so readily legible. Likewise, they are working outside of the grand narratives of military history.[6] Instead of Grant and his staff in the field, or Ike meeting with paratroopers on 5 June 1944, we are shown a truck bed full of child soldiers not likely to be restrained by the one adult who is driving the vehicle. In place of bodies on the field at Antietam or on Buna Beach, we are shown a child looking at a pair of prosthetic limbs. Although never entirely free of the old stories and artistic conventions, the camera seems to be picking up on different causes and different effects. One might ask whether conflict photography is showing a present that is closer to the future than to the past.

To perhaps overstate the case, any comprehensive theory of photography should include a theory of violence, and photographers today are providing the material for a more accurate theory of warfare and related forms of violence in the twenty-first century. Nor should this be surprising: photography quickly became entangled with war, as both a form of reportage and a military technology.[7] This symbiotic relationship has led to a number of theoretical arguments. Although featuring the cinema, Paul Virilio places visual technologies at the centre of the cultural apparatus of modern militarisation.[8] Studies of propaganda describe how photography is used instrumentally for political domination, mobilisation for war and other forms of aggression.[9] More recently, 'bio-political' regimes are defined in part by their use of surveillance and optical coding to engineer an emergent order of dominion.[10] These critiques can work in tandem with theories of politics and aesthetics: in the older version, photography aestheticises violence and thus tends toward fascism; in

the newer version, photography is complicit in the distribution of the visible and thus of specific sanctions for violence.[11] Such claims can also benefit from a critical phenomenology that finds the photograph to be inherently violent, as the camera shoots, cuts, captures, rapes and kills.[12] Violence, it seems, is photography's second nature.

Fortunately, photography is saved from wholly vicious use by its profound relationship with the world. Because the camera records everything in the viewfinder, and because the technology is so widely distributed, the world as picture emerges as something radically plural. That plurality includes the many uses of the camera itself, not least how it has been taken up in the struggle for social progress. Photography has been defined by its relationship to war, but even more so by its use as a documentary medium on behalf of social reform. The camera has exposed multiple forms of violence, including war, poverty and oppression, and proved particularly effective at activating moral sense and mobilising public opinion.

In doing so, photography has developed a way of seeing the world that might be called an ethical lens: as people become habituated to photography's mediation of social reality, they encounter suffering as something that requires a response. Every photograph pulls the viewer into a minimal social relationship: the recognition of another person in one's social space evokes an awareness of the other's intentional standpoint, that is, of their ability to see you, address you, take turns and otherwise communicate about a shared world from a separate perspective. That may not foster greater identification with the other, but at the least it recognises personhood, records suffering and raises questions about the specific cause of their plight and one's obligation to help.

Of course, this relational demand is not absolute, and the encounter is always mediated by other codes: the viewer might see ethnicity, private property, natural selection or many other ascriptions that deactivate moral response. Ethical indifference will be particularly strong during war: the enemy has forfeited moral consideration, violence is normative and everything becomes articulated through standard narratives such as the defence of the homeland and the march to victory. Thus, for photography as for everything else, World War II remains the good war, one where the entire pictorial archive seems aligned with ethical imperatives and sanctions. If the archive culminates in the Holocaust photographs, the story is complete. As it happens, however, the archive also includes the photographs from Hiroshima and Nagasaki, and so the first hints of ethical ambiguity emerge. Subsequent wars became a story of ethical unravelling: Korea was a lesson in hubris, anti-colonial wars of

liberation led to decades of dictatorship, Vietnam proved to be one of a series of neocolonial fiascos, and successive wars in Israel produced the world's largest ghetto.

Photography's ethical lens has been muddied but not shattered by these events. Equally important, photography has taken the lead among the public arts in documenting those changes in modern violence that seem to elude conflict resolution and the restoration of something like peace. The photographic archive remains large and diffuse, of course, but current scholarship on photojournalism suggests at least two accounts of how war is changing. Each of these may be thought of as partial and complementary versions of a theory of violence in the early twenty-first century. On the one hand, violence is becoming untethered: because of the absence of political aims, there is no check on the ferocity or longevity of some warfare. On the other hand, violence is becoming re-institutionalised as the regime-made disaster; military and other state powers are used to degrade civil society in an occupied area to near the point of collapse, and keep it there.

For very different reasons, each of these conditions can appear consistent with a progressive view of history; such peculiar forms of war either occur in specific localities deprived of modern institutions and media coverage, or they obviously are restrained by institutional procedures and global media attention. They also can appear relatively insignificant, as they mark the two ends of a spectrum of violence while the vast middle area of inter-state warfare is largely dormant. But it is precisely because major power conflict is largely neutralised that the margins of the global system become the most representative sectors. Moreover, were an order of violence to emerge that was not defined by the state's monopoly on violence and the institutional practices of international relations, then it would be likely to become visible at the margins: in failed states and quasi-states, occupied territories and zones of anarchy. The rest of this chapter will sketch out each of the two forms of violence and identify some problems and strategies regarding visual documentation and public judgement.

Violence Untethered

The idea that violence 'has become less tethered to its political aims' has been articulated eloquently by Susie Linfield. Drawing on the emotionally exhausting encounter with photographs of mutilated children from

Sierra Leone, adding to that all we know about the brutality and scale of destruction in the African wars, and contrasting it to identification with the fighters of the Spanish Civil War, World War II and the wars of colonial liberation, Linfield confronts the profound disintegration of a previous structure of feeling, moral response and political action.

The breakdown is comprehensive. First, war itself has become disengaged from ideology. This is not merely a loss of a rationale: in place of being motivated, directed and constrained by those political objectives, the conflicts become wars of disintegration. 'Such conflicts are expressions not of imperial expansion, national liberation, socialist revolution, or even fascist counterrevolution, but are more akin to auto-exterminations.'[13] Linfield recognises that these wars will have causes, but she emphasises that conventional analysis in terms of political objectives cannot explain, for example, the horrific escalation from 'the battle over the Congo's coltan reserves to the carving up of young girls' vaginas'.[14]

A second breakdown follows: faced with endless, senseless violence, the viewer is cut off from identification with agents of change. There are no political leaders, idealistic volunteers or even martyrs for the cause. 'Internationalists drew their spirit and their energy not only from a protective concern for helpless victims but from a positive identification with fighters for just causes. In the post-Cold War conflicts, this sort of connection – this sort of fraternity – is more and more difficult to find. Indeed, it may be a luxury we can no longer afford.'[15] The loss is both moral and political. Without ethical direction and political purpose, one's affective response to the image of victimhood is pitched headlong into mere emotionalism and worse – the emotion of pity, and then, as one confronts one's helplessness, of self-pity. Conscientious encounter with the actual war becomes displaced by one's painful encounter with the image, and so most people will simply turn away. There is little else they can do, as the loss of political reason also means that there are no reliable channels for political action. Comparing the maimed child in Sierra Leone with the victims of the Spanish Civil War, Linfield notes that viewers then 'had a pretty good idea of what was to be done', as the conflict existed within a realm of 'traditional political aims and understandings'.[16] As violence becomes unconnected from any mechanism for conflict resolution, so the rest of the world becomes incapable of knowing how to respond. It would seem, then, that continued exposure to the images of senseless brutality would only extend moral and political paralysis.

Fortunately, Linfield does not end there. Instead, she begins to develop a compelling case for respecting compassionate engagement

through the image as a form of solidarity in a world being ruined by violence. Linfield recognises that 'compassion' requires justification. Unlike the condescension in pity, it seeks a shared humanity; instead of being non-political (as Arendt believed), it is realised in collective action. I believe that compassion is fundamental to both photographic testimony and a sustainable peace, but first more needs to be said about the changing nature of violence, as no one account is sufficient.[17] Thus, one should acknowledge where Linfield's argument requires some caveats. One problem is that of legibility and ethnocentrism. The absence of purpose may be merely the absence of some familiar purposes and perhaps a romantic ideal lodged within the European state system. Motives that are not legible to a particular viewer are still motives. A more ethnographic immersion in the wars would have to confront the appalling violence against civilians, but might find that it was not merely violence for its own sake. Assessment is further complicated by the fact that the images can't help evoking nascent racial ideologies; Africa is still dark, it seems, and it may be too easy to assume that raw emotions prevail. Let me be clear: I am not saying the Linfield makes this mistake (she acknowledges this and other complications noted here), but it could be another reason that some viewers conclude that political action would be hopeless. A third concern is that the argument, despite its attempt to identify a transformation underway in this specific historical moment, can't help but reinscribe historical amnesia. The sack of any city (and not least the sack of Rome in 1527), the Crusades, the Mongol invasions and many other episodes provide plenty of evidence of how violence can become untethered despite the presence of an ideological superstructure. Thus, the point might be better put if we considered how violence was becoming untethered once again, and consider how the causes would involve more than the absence of political aims. Finally, one has to say that, for those who are being destroyed, it really doesn't matter whether violence is rationalised or not. Nazi extermination camps remain the model of highly tethered violence, and one would never say that slaughter was rational or constrained. Even so, Linfield has demonstrated how the study of photography can provide a profound examination of the nature of violence in the early twenty-first century.

It also is important to stress that untethered violence represents a shift in the conditions of visibility. Compared to major military offensives, carpet bombing and prolonged battles that can be given place names, now horrific violence occurs at the relatively small scale of plundering a village or kidnapping children. Likewise, much of it occurs well away

from major media coverage. Racism could be involved, but there are many more obstacles as well, including the economic and political status of the region and lack of an obvious reason to cover events that seem to have no purpose, no basis for response and no remedy. And although amputated limbs have horrific visual salience, it is difficult to depict the horrors of gang rape, sexual mutilation, sexual slavery and forced conscription of child soldiers. Even if the attacks could be photographed, the trauma can be either too graphic or largely invisible and in any case a long way from the conventions of military journalism. So it is that photographers have had to become more artistically inventive to record how violence is spreading and changing. Figure 28 is illustrative in this regard.

A man dances on the roof of a ruined car before a bonfire in a slum. Wreckage of one sort or another extends in every direction, as fire and the thick, black smoke from burning tyres billows upwards. There are no weapons or uniforms or war dead, or any sign of warfare or the state, and yet the photo from Kenya's civil crisis of 2007–8 is unmistakably a portrait of violence.[18] But what kind of violence? The photo tells us little about

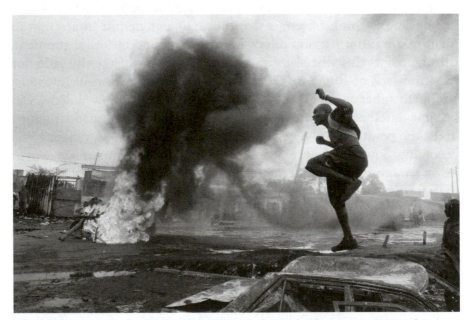

28. A man jumps on a burnt vehicle after he and other supporters of Kenya's opposition leader Raila Odinga set barricades on fire on a road in the Kibera slum of Nairobi, 16 January 2008.
Photographer: Simon Maina/Agence France-Presse-Getty Images.

the crisis, and certainly not who the man is, which side he is on, how this slum matters in the conflict or its resolution, or what issues are at stake. Perhaps it could be placed with images from around the globe of civic protest turned violent; typically these are photographs of demonstrators battling with police or rival mobs. Those images look much the same, however, as if there were one long-running political spectacle in the theatre of the Arab/African/Asian/Latin American/European/American street. The images are legible, and the violence depicted generally is in respect of clearly defined antagonisms. By contrast, here we see only destruction and joy combined, and the photograph itself seems untethered.

That may be why this image is at once familiar and yet scandalous. Instead of the stock characters of dissenting citizens and bullying cops, or mob frenzy and state terror, or soldiers and guerrilla fighters, or any other political scenario, we see a man exulting in the sheer ecstasy of destruction. An obscene truth is being revealed: what is violence and burning and horror to some is for others an experience of raw freedom as it can be perversely but powerfully known only through violent revenge and ruin. The sound track could be the 'Ode to Joy'.

Thus, the photograph is valuable because it captures how violence can become untethered, and how that can involve not only terrible victimhood but also full-throated pleasure. And one can easily imagine how it could spread, how anarchy and hatred could create a chain reaction that would unleash horror across an entire region. By capturing a moment that seems primarily, if perversely, aesthetic rather than political in any conventional sense, the photographer has captured something vital and terrible about the way that war can break loose from political restraints. Yet the photograph also is subject to concerns raised earlier: violence seems inescapably raced, and one should recognise that even slums have a structure, and that the seeming lack of political reason here could say more about the audience than the image. Even so, the image compels more than balanced deliberation; it challenges the viewer to recognise that war can become far more than politics by other means, and that as violence spreads, humanity can end up dancing in hell.

The Regime-Made Disaster

War is not one thing, however, and Linfield's model is not the only way to bear witness. Ariella Azoulay has identified the regime-made disaster as one of the distinctive forms of war in our time. The term describes the

condition of a population that is deprived of resources and otherwise injured to the point where it is just above becoming a humanitarian disaster, and then kept there. Azoulay argues that Israeli governing techniques keep the Palestinians in the Occupied Territories in this condition indefinitely.[19] Were the subject population actually dying in the streets from starvation, that would be evidence of criminal misrule by the occupying authorities. If they were conscripted for forced labour, that would be another obvious violation of international law. However, if the population is able to eat but has to devote inordinate time and energy to get to work while continually being subjected to shortages of power and other resources necessary for economic and civic development, then there is little basis for international military intervention.

This system of military partitioning and administration includes its own conditions of visibility. The regime-made disaster produces a continuous stream of suffering, but not massed or spectacular suffering. This is not the same condition that accompanies untethered violence, which metastasises in areas far removed from intensive Western media coverage, though often can be immediately condemned by media exposure; there is no argument for chopping off a child's hand. By contrast, the regime-made disaster usually operates below the threshold of demonstrable violence and produces effects that can be mistaken for the ordinary vicissitudes of a hard life. Hence, the paradox: on the one hand, it occurs within the full glare of media coverage; on the other hand, it is hard to confront the world regarding a process of continuous but distributed deprivations. A farmer has to go through a checkpoint to get to his fields, or a pregnant woman to get to a hospital, and the checkpoint can involve lengthy, uncomfortable, frustrating, frightening delays, and might be closed unexpectedly at any time – and is closed time and again when someone desperately needs it to be open. And what does one see: a line of people waiting (they don't look like they are starving)? A guard standing by an empty road (which has been closed for hours)? When violence is distributed through a system of state practices and often reduced to the 'petty sovereign' making decisions at a checkpoint, the result is a comprehensive destruction of civil society, but in a manner that is visually banal.[20]

So it is that the regime-made disaster depends on the very mechanisms that should alleviate it. These include humanitarian aid and Western media coverage. Consider each case. Because the situation is obviously distressed but not to an extent that justifies military intervention, it invites humanitarian responses. The subject territory becomes dotted with

aid agencies, which help people live on the verge of catastrophe but also inadvertently define the situation as humanitarian (like a famine) rather than political (like a civil war). Were they to withdraw, the result would be a genuine disaster, leading to international condemnation and more costly administration by the occupying power. But they don't withdraw, and thus they help to stabilise what should be seen as an unacceptable use of state power. The same holds for media coverage: being drawn to the few violent exchanges that do occur, the media constrain overt violence, which motivates further refinement of the less overt mechanisms for domination, which can continue to be hidden in plain sight for want of their spectacular quality. Any flare-up leads to images of physical destruction and funereal rituals, whereas there remains little reason to photograph a freeway running through the territories, even though Palestinians are prohibited from using it and have to use a winding dirt road instead. Photography – a vital medium for the humanitarian project – becomes, if not quite an instrument of domination, neutralised on behalf of abusive state power.

That is not Azoulay's conclusion, however; instead, she argues that photography provides an essential means for exposing the regime-made disaster and developing an alternative conception of citizenship. The regime is exposed by developing visual literacy as a civic skill: specifically, the ability to see how the photograph documents both regimes of domination and an inescapable plurality of experience. Thus, one should learn to read the traces left by past violence and distributed violence and to recognise other perspectives, especially what is seen by those for whom the status quo is a catastrophe. This visual literacy carries with it a civic relationship; the civil contract of photography, which defines photographic subjects and spectators as equals independently of any governing authority or attributions of civic status. Thus, citizenship is redefined as equality and a capacity of identification with others in a condition of plurality not severed by the distinctions of a governing power. Photography is redefined from merely documenting harm to providing a cultural resource for overturning an insidiously modern form of warfare.

The photo in Figure 29 appeared on page A8 of the morning edition of the *New York Times* with this caption: 'Tinderbox in Hebron, a Jewish settler threw wine at a Palestinian woman. The city is a center of tensions between settlers and Palestinians.'[21] The complete set of images, which included a photo on page 1 of an Israeli child being bathed and three other photos on page 8 labelled 'Veneration', 'Remembrance' and

29. A Jewish man throws wine at a Palestinian woman before a Purim parade in the West Bank city of Hebron. Photographer: Rina Castelnuovo/ *New York Times.*

'Preparation', clearly favoured the Israeli settlers. Even so, the photo gives the lie to the myth of taming the frontier in the Holy Land.

But why does it shock? He is not hitting her, and surely spraying her is less of a crime than, say, razing a house with a military bulldozer or blowing up a bus with a suicide bomber. Since there is violence enough on both sides, why make so much of a minor incident of teenage insolence? One reason to do so is that the photograph reveals what is rarely shown: the small acts of personal viciousness and humiliation that make up the practice of domination in an occupied land. The argument of the more and the less also applies; if a boy will do this, imagine what adults will do, and if a civilian acts so imperiously, imagine what soldiers at checkpoints will do. Even more important, it is clear that both the boy's aggression and the woman's protective reaction are often-practised, habitual responses. Were he taunting an older woman for the first time, it would be likely that he would look much more ragged, uncoordinated and either furtive or overly demonstrative. Instead, he could be a figure out of Whitman, throwing his weight around without breaking stride, a

figure of youthful grace on the city street. Likewise, she isn't being caught by surprise. Her head is already turned, her body hunched against the impending blow. She's been through this before, and she's learned that direct confrontation is not an option. This may be her neighbourhood, but it's his street.[22]

The photograph's power also derives from its capacity for analogy. Look at the woman's coat and hat and at the Star of David scrawled on the storefront; she could be in a German ghetto and all it takes is a change of costume to see him as a German soldier. Or they could be an African-American woman and a young Cracker in the Jim Crow South, or in one of the neighbourhoods in the US and Mexico today being destroyed by gang warfare. Whatever the comparison, it stems from recognising that a regime of violence can become deeply embedded in the habits and personalities of those in the space of domination, and that it is at once evident on the surface of things and yet seemingly banal, highly constrained and not even overtly political.

Part of the artistry of this photograph, which rightly won a World Press Photo award, is that the underlying structure of power has been exposed through an incidental but visually salient moment. The stream of blood-red wine arcing through the air snaps like a whip from the young tough to the older woman. The green metal facades provide just enough colour to accentuate the overall shabbiness of the neighbourhood: a place kept on the verge of catastrophe by the continual run of shortages, blackouts, curfews, lockouts and embargos. Even the temporality of the image is significant, as the obviously ephemeral action will leave only a trace of its violence: the stain on her clothing, subject to the choice of whether to bear the cost of removing it or the humiliation of continuing to wear it. The regime-made disaster benefits from specific conditions of visibility, but even so it is there to be seen.

That said, power is not likely to grow out of the lens of a camera. Azoulay has demonstrated how photography reveals a distinctive and powerful mode of violence in our time, but the argument is not without problems. One qualification pertains not to Azoulay herself but to likely use of her work, which is to assume that the regime-made disaster is a recent innovation. One could say that Ireland was a regime-made disaster for centuries, and one that didn't depend on unintended effects in media coverage. A more pointed objection is that in the Palestinian case, and perhaps others as well, the subject population and allied state actors bear some responsibility for the nature and longevity of the disaster. (This is why the territories are not like the Warsaw ghetto.) A third concern is

that intentionality can appear both essential for judgement and difficult to identify. The system of social partitioning, military administration, destruction of infrastructure, embargoing of trade and the like may reflect an original intention to divide and conquer, but it also seems to develop much more impersonally, and it then can operate without anyone having to have extraordinary motivations. (This is why the 'good German' analogy can apply.) Thus, the system can produce dysfunctional polities on both sides, but at the end of the day there seems to be no one to blame.

Nor would the case be easy to make. One problem is that the visual record is by necessity one of fragments and traces. The victors have taken most of the pictures, and there have been few visually salient incidents to record anyway. Second, the hermeneutic can appear circular: to see the traces of prior partitions or deprivations, or to see the plurality necessary for an alternative 'potential history', one has to already assume that damage has been done and that responsibility lies primarily on one side.[23] Third, when civic literacy becomes yoked to a forensic attitude, as often happens, one can be held hostage to technical standards that are, given the rest of the situation, not likely to provide a basis for pressing charges. This case becomes even more difficult if one is confronting the origin myth of the state, as Azoulay is doing in her work as a political dissenter.[24] Regardless of the stakes, the final difficulty is that the civil contract of photography will seem idealistic – that is, too much at odds with the realities of state power and the fact that human rights still depend primarily on the protections provided by state citizenship.

A Photographic Theory of Violence

Azoulay and Linfield have each marked a crucial element of what might be called photography's immanent theory of violence: that is, a theory that reflects the fragmentary but persistent documentation of destruction and suffering through the photographic encounter with victims and bystanders. The theory operates at two levels: a political phenomenology marked by compassion and the civil contract, and a figural repertoire that provides resources for thinking about conditions of chronic destructiveness. The two registers work together in that the one moves across state sovereignty and the other cuts across grand narratives.

Photography has always been not simply a way of recording the world, but a way of being in the world. The experience is similar to living within

a language, and so one's way of seeing will be entangled, yet not identical, with one's actions. And like a language, photography works as it develops its own history, practices and commentary. This *habitus* becomes more evident as it matures. Thus, Azoulay's contract reveals how interacting with photographs provides conventions for civil interaction more generally. The photographic event models a pattern of association which involves: ceding control of one's image to others but not the sovereign, thus strengthening trust and obligation regarding fellow citizens; accepting the role reversals of seeing and being seen and thus enacting a condition of equality; treating those in the image as being in one's world and recognising their grievances as if they were addressed to you, thus creating a community across borders and shifting citizenship from status to praxis.[25] A similar orientation can be articulated through the concept of compassion. As one becomes habituated through photojournalism to seeing the distant other compassionately, that way of seeing changes the spectator. Seeing becomes explicitly relational rather than merely representational, and one learns to see suffering and to extend one's moral imagination to view the world from that standpoint. That moment of moral perception cannot be merely emotional, and it should provide a basis for recognition that can lead to action. Thus, photography can model a mode of seeing that begins to repair the fabric of community at the moment of recognising how deeply it has been torn.

The continued development of photography, in conjunction with the transformation of war from major state conflict to a shadow state of globalised violence, has refocused the image politically and morally. Images of violence are less likely to record the official 'costs' of war and more likely to document unwarranted destructiveness, inhumanity, stupidity and sheer loss. Thus, modernity acquires a negative universality; distinctions based on progress are undercut by persistent failure and regression. The indictment need not be nihilistic, however, and the photographic testimony often includes a renewed commitment to Humanism. This is a humanism grounded in fallibility rather than reason, and in fatality rather than transcendence, but it remains all the more capable for that of emotional truth. Nor is it a merely philosophical humanism, for the images reproduce a relational knowledge that mixes social typifications with palpable particularity and thus challenges abstraction while calling for identification. Along the way, the photographs also show how people cope, endure and strive, not least because the violence is always experienced within a social and cultural fabric that, however badly rent, is still something more fundamental than

either power or ideology. Most important, the images engage spectators across the lines of state sovereignty. Although certainly interpreted through whatever frameworks are present, most of the images now articulate as well through a globalised *mise en scène* that cannot be easily reduced to geopolitical alignments.

It should not surprise that this humanism of the image is communicated through seemingly incidental techniques that need not be seen as parts of a coherent whole. The photographer's repertoire can be thought of as the visual equivalent of verbal figures in the lexicon of classical rhetoric: one can make both verbal and visual analogies, an unusual angle can do the work of unusual phrasing, and so forth. In order to communicate with the public audience, photography today will continue to employ all available conventions, but some of the work reflects a departure from more familiar exemplars of wartime photography. Along with images of the 'fallen', now we also see blood-stained floors. Along with homecoming reunions, we see bedrooms kept unchanged for children who will never return home. Along with brave partisan fighters struggling to make history, we see someone with an automated rifle sitting in an office chair at a makeshift checkpoint as if war were another day at the office. These additional images document some scenes that were simply overlooked in the past and some that are more novel, but all of these seemingly backstage, banal or otherwise marginal events may be representative of larger changes that are not yet wholly visible. In addition, the visual innovations provide a repertoire for thinking without recourse to prior narratives that would buffer emotional engagement and moral reflection.

As a very provisional summation of this emerging visual vocabulary, one could say that it involves fragmentation instead of narrative, banality instead of drama, traces instead of things, objects instead of people, and ruins as the product rather than the by-product of war.[26] Fragmentation is listed first as it is a fundamental feature of photography itself. As Alan Trachtenberg observed of civil war photography, by featuring specific moments in space and time without the narrative devices of tableau illustration (the previously favoured medium of reportage), the new medium led to 'a loss of clarity about both the overall form of battles and the unfolding war as such and the political meaning of events'.[27] Of course, the corresponding gain in realism more than compensated while the placement of the image within print media maintained the reigning narratives. A profound tension within public meaning had been created, however, particularly in regard to the realm where

the stakes were the highest. As war has become less defined by great power conflicts, photography's bias towards fragmentary eventfulness rather than coherent purposefulness acquires additional significance; fragmentation shifts from being one of photography's inherent limitations to becoming a resource for revealing the nature of war. The fragment might not reinforce either political ends or mechanisms of constraint, but it can be used with regard to compromised conditions of visibility and to evoke identification along lines that do not require institutional authority.

Banality is not necessarily the banality of evil, but something more pervasive. Indeed, a concept about dull, ordinary routine ties together several ideas. First, that violence should be measured in respect to how it invades, appropriates and alters everyday life, and not in terms of narratives of, say, making the world safe for democracy. Banality reveals the gap between war's purpose (if it has one) and the experience of everyday life. The troops leave to great fanfare, but someone then has to go home to an empty bed; snipers are a constant threat, but a soldier may be preoccupied with finding the right pair of socks. And when the war doesn't have a purpose, banality becomes the standard for measuring its destructiveness, that is, the extent to which it corrupts civil society to make trauma routine and routines punishing. Thus, banality carries the recognition that ordinary people adjust to violence and deprivation and of necessity can become accustomed to anything – instead of having to endure temporary deprivation on behalf of the eventual restoration of peace – and that this capacity for survival can be used against them. By documenting small gestures instead of dramatic events, the photograph reveals how violence is becoming normalised: for example, in police procedures for cleaning up a bomb scene or in the resigned demeanour of civilians waiting in line at the hospital. Banality becomes the condition in which violence can be seen as violence rather than a means to an end.

The ordinary world seems to be right in front of us, but the processes that shape it are harder to discern. Perhaps this is why an aesthetic of the trace has developed as visual media have become more pervasive. Photographers will show the blood or the feet but not the whole body, shattered glass but not the attack, and the weapons but not the perpetrators. Some of the time these decisions are simply practical or institutional, reflecting problems of access or norms of decorum. That is not the whole of it, however, and the continual production and reception of such images leads to a particular way of looking at events. The trace

communicates absence, loss and the failure of communication itself. The viewer is brought to consider what remains to be known in order to discern more than could meet the eye in any case. Traces can combine a forensic attitude with the pathos of mourning; one knows loss, but not yet fully why it happened. Any sense of narrative coherence or political justification has to be supplied in part by the audience; doing so will require that they follow emotional paths to then ask questions. The trace evokes a trial, and thus an idea of justice.

Objects, and particularly made objects, are traces of human activity, and particularly of collective activity. Stray clothing, yellow crime-scene tape, a broken padlock – these and other objects become signifiers of processes that extend beyond specific episodes. They also have strangely powerful affective capacities that may be particularly useful in evoking responses to events that seem illegible, politically compromised or unduly complicated. Just as a trivial item can function as a *punctum* within a photograph featuring individuals, so can the photograph of an object become a point of critical awareness in respect to a conventional political scenario. Religious zealots in a premodern society are one thing, but a plastic sandal or a mobile phone are things that confound easy dismissal. Objects also invoke collective experience – unless made by one's own hand, they cannot be recognisable otherwise – and industrialised, commercial objects invoke a global civil society. Jokes about shopping together can be made, but the more immediate point is that photographic humanism may have become richer, and somehow more attuned to the contemporary moment and more capable of identifying how violence degrades everyone, by turning from the human figure to images of human things.

A building is a large made thing, and perhaps the object most evocative of dwelling together. Although ruins have been a staple of wartime photography, the balance was often positive: a church steeple, monastery, or temple still standing after the attack, or a blasted cityscape demonstrating the power of aerial bombardment and the march towards victory. More recently, ruins seem to have acquired a different, even allegorical modality. The ruin stands, not as something to be rebuilt, but as an example of the techniques for maintaining a regime-made disaster, or as a sign of the comprehensive degradation of the society by protracted violence, or as an inadvertent memorial for the possible futures that now have been cancelled in that place. Indeed, the larger photographic record exposes a dual process: the building up of military installations (some to be abandoned to ruin, some effectively permanent) and the conversion of cities and entire countries to a state of sustainable catastrophe.

The list could go on, but never to produce a comprehensive lexicon for describing either war or photography. The war in Iraq included a major power military invasion, so-called 'sectarian' violence that metastasised throughout the country to seem increasingly untethered, and a subsequent stabilisation that has the marks of an inadvertent but durable regime-made disaster. The labels are applied to mark their inadequacy while making the general point that war was never fully represented and continues to elude classification, and that it seems to mutate, adapt and thrive despite all of the improvements in modern civil society. Those improvements include 24/7 global media coverage drawing on everything from camera phones to satellite surveillance. The plethora of images has not led to greater clarity about either war or politics, however. Instead, one is continually reminded that what should be whole has been maimed, and that what should be present has disappeared, and that progress may be a myth in the face of war's continuous, uncanny predation.[28]

War is changing, and photography is changing. Neither claim can explain the other, but the relationship remains important. Photographers and those who think seriously about photography are providing important resources for confronting how war is changing and how those changes evade or exploit norms of visibility. As they do so, the spectator can become more capable of profound engagement with the human condition, the terrible price we continue to pay for moral failure, the specific character of violence in our time, and perhaps even the action needed to advance peace rather than acquiesce to war. Any gains are to be had only for a limited time, however. War can never be seen entirely, and it takes the long view.

Notes

1 'For what it's worth' lyrics by Stephen Stills, Buffalo Springfield, 1967.
2 All figures include some estimates, and figures on Iraq and particularly on Afghanistan are sketchy. Iraq War casualties, available at http://en.wikipedia. org/wiki/Casualties_of_the_Iraq_War (accessed 18 February 2014); Iraq War body count, available at www.iraqbodycount.org (accessed 18 February 2014); casualties in Afghanistan and Iraq, available at www.unknownnews. org/casualties.html (accessed 18 February 2014); civilian casualties in the war in Afghanistan, available at http://en.wikipedia.org/wiki/Civilian_casualties_ in_the_War_in_Afghanistan_%282001%E2%80%93present%29 (accessed 18 February 2014).

 Vietnam War estimates range from one to three million Vietnamese deaths; for one example of a lower-range estimate, see Charles Hirschman,

Samuel Preston and Vu Manh Loi, 'Vietnamese casualties during the American war: a new estimate', *Population and Development Review* 21 (1995), pp. 783–812. US war deaths of 58,193 are recorded at The National Archives, 'Statistical information about casualties of the Vietnam War', available at www.archives.gov/research/military/vietnam-war/casualty-statistics.html (accessed 18 February 2014). Mathew White combines many sources to settle at 1,700,000/1,300,000 total deaths for the American phase of the war and 3,000,000/2,850,000 total deaths overall (median of totals/total of medians): *The Great Big Book of Horrible Things: The Definitive Chronicle of History's 100 Worst Atrocities* (New York, 2011); summarised at 'Death tolls for the major wars and atrocities of the twentieth century, Second Indochina War', available at http://necrometrics.com/20c1m. htm#Vietnam (accessed 18 February 2014).

3 Estimates for World War I settle around 15–17 million military and civilian deaths; estimates for World War II run between 50 and 78 million total dead. World War I casualties, available at http://en.wikipedia.org/ wiki/World_War_I_casualties (accessed 18 February 2014); World War II casualties, available at http://en.wikipedia.org/wiki/World_War_II_ casualties (accessed 18 February 2014). White finds 8.5 million military deaths in World War I to be authoritative, with civilian death estimates varying widely and hard to collate, although he settles on 15 million total, available at http://necrometrics.com/20c5m.htm#WW1 (accessed 18 February 2014); he estimates 65.6 million dead for World War II, 'National death tolls for the Second World War', available at http://necrometrics. com/ww2stats.htm#ww2chart (accessed 18 February 2014).

4 Lawrence H. Keeley, *War Before Civilization: The Myth of the Peaceful Savage* (New York, 1996); Steven Pinker, *The Better Angels of Our Nature: Why Violence Has Declined* (New York, 2011).

5 Second Congo War, available at http://en.wikipedia.org/wiki/Second_ Congo_War (accessed 18 February 2014); Rwandan genocide, available at http://en.wikipedia.org/wiki/Rwandan_Genocide (accessed 18 February 2014); 'UNHCR chief says 2009 "worst" year for voluntary repatriation in two decades', United Nations High Commissioner for Refugees, available at www.unhcr.org/4c11eadd9.html (accessed 18 February 2014).

6 These narratives range from comprehensive cultural myths such as the modern myth of progress to national narratives such as Manifest Destiny to formulaic stories of this war or that battle. A particularly common formula in press coverage is the 'commander narrative' as it has been identified by John Keegan: a critical moment will lead to victory because of a commander's decision, and this simplified characterisation fits together with the uniform behaviour of the troops, who move as one according to simplified motivations. John Keegan, *The Face of Battle: A Study of Agincourt, Waterloo, and the Somme* (New York, 1976). See also David D. Perlmutter,

Visions of War: Picturing Warfare from the Stone Age to the Cyber Age (New York, 1999).

7 Susan D. Moeller, *Shooting War: Photography and the American Experience of Combat* (New York, 1989).

8 Paul Virilio and Sylvère Lotringer, *Pure War*, trans. M. Polizzotti (New York, 1983).

9 David D. Perlmutter, *Photojournalism and Foreign Policy: Icons of Outrage in International Crises* (Westport, CT, 1998).

10 The two primary sources for this concept are Michel Foucault, *Security, Territory, Population: Lectures at the Collège de France, 1977–78*, ed. M. Senellart, trans. G. Burchell (New York, 2007); and Giorgio Agamben, *Homo Sacer: Sovereign Power and Bare Life*, trans. D. Heller-Roazen (Stanford, CA, 1998).

11 Here I reference common and somewhat mistaken use of Walter Benjamin, 'The work of art in the age of its technological reproducibility,' in M.W. Jennings, Brigid Doherty and Thomas Y. Levin (eds.), *The Work of Art in the Age of its Technological Reproducibility and other Writings on Media* (Cambridge, MA, 2008), and Jacques Rancière, *The Politics of Aesthetics: The Distribution of the Sensible*, trans. Gabriel Rockhill (London, 2004).

12 Particularly influential were Susan Sontag, *On Photography* (New York, 1977) and Allan Sekula, 'The traffic in photographs', in B.H.D. Buchloh, S. Guilbaut and D. Solkin (eds), *Modernism and Modernity* (Halifax, NS, 1983), pp. 121–54. For additional examples see chapter 1 of Susie Linfield, *The Cruel Radiance: Photography and Political Violence* (Chicago, 2010).

13 Ibid., p. 133

14 Ibid., p. 135.

15 Ibid., pp. 137–8.

16 Ibid., pp. 132–3.

17 Robert Hariman, 'Cultivating compassion as a way of seeing', *Communication and Critical/Cultural Studies* 6/2 (2009), pp. 199–203.

18 2007–2008 Kenyan crisis, available at http://en.wikipedia.org/wiki/2007–2008_Kenyan_crisis (accessed 18 February 2014).

19 Ariella Azoulay, *The Civil Contract of Photography* (New York, 2008); Ariella Azoulay, Atto di Stato: Palestina-Israele, 1967–2007, curated by Maria Nadotti (Milan, 2008); see also http://cargocollective.com/AriellaAzoulay.

20 Azoulay, *The Civil Contract*, p. 73. Azoulay borrows the phrase 'petty sovereign' from Judith Butler, *Precarious Life: The Powers of Mourning and Violence* (New York, 2004), p. 56.

21 Ethan Bronner and Isabel Kershner, 'Resolve of West Bank settlers may have limits', *New York Times*, 13 September 2009, available at www.nytimes.com/2009/09/14/world/middleeast/14settlers.html (accessed 18 February 2014). Note that the caption at the online slide show is

less vague and more accurate than the paper edition in respect to the actual political situation (which is not a 'conflict' between two equal sides with matching grievances): 'A settler tosses wine at a Palestinian woman on Shuhada Street in Hebron. The approach of some settlers towards neighboring Palestinians, especially around Nablus in the north and Hebron in the south, has often been one of contempt and violence.' 'Fervent believers', *New York Times* slide show, available at www.nytimes. com/slideshow/2009/09/13/world/20090913SETTLERS_6.html (accessed 18 February 2014).

22 'Palestinian control of Hebron is of the 20 or 30 square kiliometers of H1, which contains around 120,000 Palestinians. In H2, where more than 500 Jewish settlers live among 30,000 Palestinians, the Palestinian population's movements are heavily restricted which Israel argues is due to terrorist attacks. For instance, the Palestinians are not allowed to use the Shuhada Street, the principal thoroughfare, which was renovated thanks to fundings [sic] by the United States. As a result of these restrictions, about half the shops in H2 have gone out of business since 1994, in spite of UN efforts to pay shopkeepers to stay in business. Palestinians cannot approach near where the settlers live without special permits from the IDF.' Hebron, available at http://en.wikipedia.org/wiki/Hebron (accessed 18 February 2014).

23 Azoulay's concept of potential history has emerged recently as an important consolidation of an early theme in her work. It is defined in her exhibition, 'Potential History: Photographic Documents form Mandatory Palestine' and the Leslie Brooks Lecture: 'Photography and colonialism in Israel/Palestine', Durham University, 9 June 2011. 'Potential history should be understood here in the dual sense of unrealized possibilities that still motivated and directed the actions of various actors in the past, and of possibilities that may become our own and be reactivated to guide our actions' (exhibition flier and www.dur.ac.uk/mlac/news/displayevents/?eventno=10206). For other pertinent exhibitions and books, see Ariella Azoulay, available at http://cargocollective.com/AriellaAzoulay.

24 The challenge to the myth of the state is the leading edge of Azoulay's current work as a public intellectual. For example, Ariella Azoulay, *From Palestine to Israel: A Photographic Record of Destruction and State Formation, 1947–1950* (London, 2011).

25 There also is the question of what type of claim Azoulay is making regarding the civil contract of photography. Note her own account of the contract as a civil space that 'I invent theoretically' (*The Civil Contract*, p. 12), 'a social fiction' similar to Rousseau's social contract (p. 26). (Indeed, it also is similar to Hobbes's contract, which does not occur in a state of nature either.) Thus, a theoretical model is attempting to map actual phenomena that do not exist themselves in that form – that is, as explicit rather than tacit, as condensed

rather than diffuse, as uniform rather than varied, as rationalised rather than habitual, as logical rather than over-determined, as settled rather than continually negotiated, and so forth.

26 Space and image reproduction restrictions prevent developing these claims, but they are illustrated in numerous posts under the category of 'Visualizing War' at my co-authored blog, nocaptionneeded.com.

27 Alan Trachtenberg, *Reading American Photographs: Images as History, Mathew Brady to Walker Evans* (New York, 1989), pp. 74–5.

28 'If war is a "living" thing, it is a kind of creature that, by its very nature, devours us. To look at war, carefully and long enough, is to see the face of the predator over which we thought we had triumphed long ago.' Barbara Ehrenreich, *Blood Rites: Origins and History of the Passions of War* (New York, 1997), p. 238.

Part III

The 'Unstable' Image: Photography as Evidence and Ambivalence

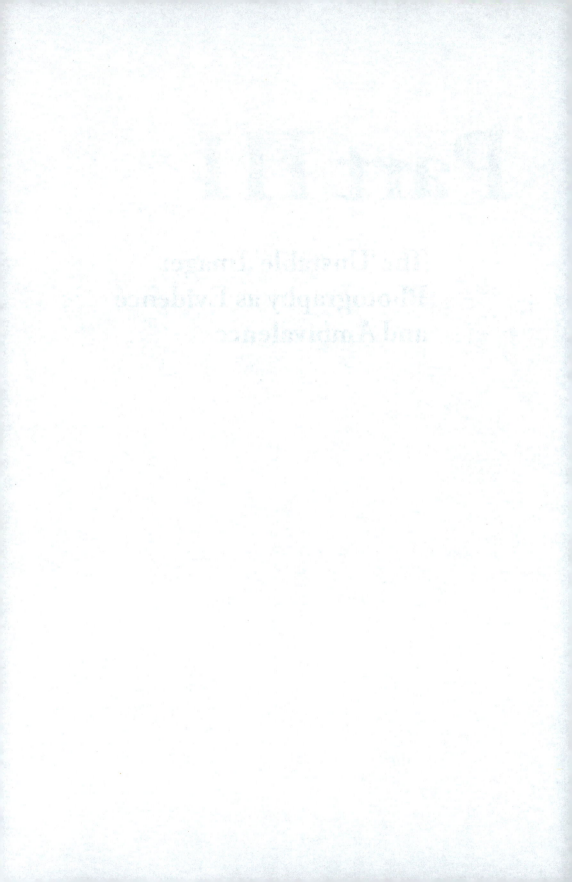

8 Photo-Reportage of the Libyan Conflict

Stuart Allan

What is it that compels the war photographer to risk their life to document the horrors of a war zone? It is not a matter of romance, nor addiction to danger, photojournalist Sean Smith insists, but rather a desire to perform the role effectively. Speaking as someone well aware of the attendant challenges, he stresses the vital necessity of being there, on the ground, to interpret people's experiences. 'The amount of war photojournalism being published by news organisations has shrunk dramatically over the years, but we should remember that we stop being news organisations when we stop going to the frontline,' he argues. 'Other forms of journalism are important, but without someone actually going and talking to and taking pictures of people in these situations, our take on the world becomes more and more distorted.'[1]

The importance of bearing witness to what is transpiring in harrowing circumstances is a lynchpin of war reporting. Risk-taking is perceived to be 'part of the job', routinely accepted as being inescapable when the demands of image-making require closer proximity than reason dictates (Robert Capa's well-known maxim, 'If your picture isn't good enough, you're not close enough', is recurrently upheld as a professional ideal). Accordingly, this chapter explores a number of questions confronting the photojournalist committed to recording the plight of human suffering in wartime. In taking as its focus photo-reportage of the recent conflict in Libya, it turns first to the professional context, paying careful attention to issues emergent in media commentaries when four storytellers – Michael Christopher Brown, Tim Hetherington, Chris Hondros and Guy Martin – became the story. Engaged in first-hand photo-reportage of the Gaddafi regime's relentless onslaught of the besieged city of Misrata, they came under direct attack themselves, the blood-stained consequences making news headlines around the world. The chapter then assesses the efforts

of ordinary citizen photographers intent on covering the conflict, before turning to examine the controversy engendered by media usage of the amateur video imagery of the then leader Muammar Gaddafi's capture and execution. In comparing and contrasting these instances, the chapter considers several implications for photojournalism in wartime, particularly where its ethical responsibilities in visual truth-telling are concerned.

'Make it Worth it'

Libyan leader Muammar Gaddafi's grip on power was proving increasingly precarious in the days leading up to the country's 'Day of Rage' on 17 February 2011, but an already grim situation for journalists and photojournalists became even more perilous afterwards. The regime's violent crackdown on what were peaceful public protests, including the firing of live ammunition into crowds as well as the arbitrary arrest of activists and bystanders, was shocking in its brutality. Clashes between the security forces and those opposed to the government soon turned into sustained armed conflict as cities and towns were swept up in the escalating crisis.

Dozens of journalists – both Libyan and foreign – were amongst those detained, assaulted or expelled in what an Amnesty International report called 'an extensive campaign of enforced disappearances' unleashed by the government.[2] Examples of mistreatment included the experiences of Lyndsey Addario and Tyler Hicks, both photographers with the *New York Times*, who were abducted along with two journalist colleagues, Stephen Farrell and Anthony Shadid, and abused while in captivity for six days.[3] Members of a BBC News crew were captured at a checkpoint in Al-Zahra and subsequently beaten. Getty Images photographer Joe Raedle, together with Agence France Presse photographer Roberto Schmidt and journalist Dave Clark, went missing near Ajdabiya. 'There is no negotiating. You couldn't ask questions. It was very one-way,' Raedle said after their release from detainment.[4] Some journalists were apprehended for weeks, even months, such as freelancer Matthew VanDyke, who eventually managed to escape from the Abu Salim prison in Tripoli where he was being held in solitary confinement. 'They told me nothing about what I was accused of, whether I would ever be released,' he explained to the BBC afterwards, 'they just locked me in a room and gave me food, kept me alive, and no real interaction with anybody for about six months.'[5]

In rapidly deteriorating conditions near to the fighting, several journalists were killed, evidently deliberately targeted in some instances. Al Jazeera cameraperson Ali Hassan al-Jaber died on 13 March when his car was ambushed as he travelled to Benghazi. Mohammad al-Nabbous, who had set up Libya Alhurra TV as an independent online service, was shot dead six days later in the same city. He had earned praise as the 'face of citizen journalism' due to his efforts to stream live feeds of raw footage and commentary provided by eyewitnesses to the carnage. Details of Nabbous's death were announced by his wife Perdita on the website. 'Please keep the channel going, please post videos, and just move every authority you have to do something against this. There's still bombing, there's still shooting, and more people are going to die,' she said in her short, tearful statement. 'Don't let what Mo started go for nothing, people. Make it worth it.'[6] South African photojournalist Anton Hammeri was killed on 5 April, close to the frontline on the outskirts of Brega. He had been travelling with Spanish photographer Manu Brabo and American freelance journalists James Foley and Clare Gillis when they were set upon by pro-Gaddafi forces. 'It all happened in a split second,' Foley later recalled. 'We thought we were in the crossfire. But eventually we realized they were shooting at us. You could see and hear the bullets hitting the ground near us.'[7] The surviving three were beaten and then detained for 45 days in various detention centres before being released by the Libyan authorities.

As the conflict raged with ever-fiercer intensity, Gaddafi's government resorted to desperate 'tactics of terror' to suppress the uprising of its citizenry. By mid-April, the country's third largest city, Misrata, had been under siege for several weeks. Hundreds of lives had been lost to aerial bombardments, rocket artillery and sniper fire, creating a humanitarian crisis as residents – and journalists – were effectively trapped in a deadly stalemate between government troops and anti-Gaddafi rebel fighters.[8] Precise details regarding what happened on the afternoon of 20 April took some time to emerge. Evidently earlier that morning a small group of photographers had arrived on Tripoli Street, the city's major thoroughfare, which was the frontline of an intense house-to-house battle. Situating themselves on the rebel side of street, they continued to seek secure vantage points. In what proved to be Tim Hetherington's last Twitter message, he wrote: 'In besieged Libyan city of Misrata. Indiscriminate shelling by Qaddafi forces. No sign of Nato.' Taking shelter against a wall, they waited for a lull in the fighting. Spanish photographer Guillermo Cervera, also a member of the group, later said they 'were coming backwards because we were scared of the fight' when

they were caught out. 'We were trying to get to a safe place. It was too quiet. It felt dangerous,' he recalled. 'I heard the whoosh of an explosion, and everybody was on the ground.'[9] Soldiers in the rebel militia would later tell journalists they were convinced the group had been deliberately targeted. In the meantime, unconfirmed reports were emerging on Twitter and Facebook that photojournalists in Misrata had been injured and possibly killed in a rocket-propelled-grenade attack. Friends and family feared the worst.

Within minutes of the attack, rebel fighters mobilised two ambulances to transport Tim Hetherington, Chris Hondros, Michael Brown and Guy Martin to Hikma Hospital, where they received prompt attention in a makeshift triage tent. Hetherington, bleeding profusely from a leg injury, was pronounced dead shortly thereafter when cardiac massage efforts failed. Doctors were initially able to revive Hondros, but the severity of his head injury meant he soon slipped into a coma. Photographer André Liohn, also at the hospital, verified swirling rumours on his Facebook page: 'Sad news Tim Hetherington died in Misrata now when covering the front line. Chris Hondros is in a serious status. Michael Brown and Guy are wounded but fine.' Despite the concerted efforts of the medical team, Hondros's brain trauma was such that he died at 10:45 pm that evening. Martin, working for the Panos Pictures agency, had been hit with shrapnel, suffering wounds to his abdomen and leg that required over six hours of vascular surgery. 'They say if the rocket's really close you never hear anything. I didn't hear anything,' he later told the BBC. 'I just remember falling to the ground and then waking up in hospital.'[10] Freelancer Michael Christopher Brown's left shoulder required surgery to remove shrapnel, his condition soon stabilising. 'As soon as I was hit', he later stated during an interview, 'the only thing that goes through your head is, "It's not worth it." [...] I mean, just to get a few pictures of guys with guns shooting at each other?'[11] Neither Brown nor Hetherington had been wearing protective gear in Misrata, according to fellow photographer Liohn. Libyan customs officials routinely seized helmets and flak jackets at the country's borders.[12]

Professionalism Under Fire

In what was widely acknowledged as one of the darkest days in the history of photojournalism, the price paid by these photographers underscored the constant dangers negotiated by those striving to document the

cruel realities of warfare.[13] Each of them had been in harm's way for the usual reasons, the most important being a shared commitment to bear witness to what was happening on the ground in a city transformed into a battleground. Images of the shelling of Misrata's residents constituted visual evidence of pressing significance, vital for the world to see when government officials were repeatedly denying that the military assault was taking place.[14]

Tributes to their professionalism under fire featured prominently in the ensuing news and editorial coverage, with particular attention given to the sacrifice made by Hetherington and Hondros in the service of their craft. 'Suddenly,' David A. Graham of the *Atlantic* observed, 'two of the leading photojournalists of their generation were gone.'[15] Intense feelings of loss found expression in a range of comments made by other photographers, several sharing personal recollections of experiences working together in treacherous conditions. 'We are not thrill seekers. Each photographer judges the risks necessary to help bring news of these conflicts to the international public,' *New York Times* photojournalist Michael Kamber observed. 'Tim and Chris had experienced hundreds of days of combat; they knew the risks as well as anyone,' he added. 'They endangered themselves so that others might see what was happening in a small port city on the coast of North Africa, a city few had heard of until they showed it to us, until it claimed their lives.'[16]

Born in Liverpool, England in 1970, Hetherington's photography had taken him to a number of trouble-spots, covering political upheaval in West Africa, as well as wars in Darfur, Sri Lanka and Afghanistan (where he co-directed and produced the Academy Award-nominated war documentary *Restrepo*), amongst others, in the employ of either news media or organisations such as Human Rights Watch. In Misrata, he was between assignments as a contributing photographer for *Vanity Fair*, spending much of his time on a multimedia project he was putting together. Once news of his death had been verified, *Vanity Fair* editor Graydon Carter posted an *in memoriam* on the magazine's website. Titled 'A loss in the family', he described Hetherington as being 'about as perfect a model of a war photographer as you're going to find these days, and one very much in the mold of Robert Capa and Larry Burrows.' He was a 'rangy, charming workhorse of a photographer', Carter added, who was 'impossibly brave', with 'a deft eye and unwavering dedication'.[17] Journalist and film-maker James Brabazon, a close friend of Hetherington, called him 'a leading light of his generation', maintaining that 'it's really not an exaggeration to

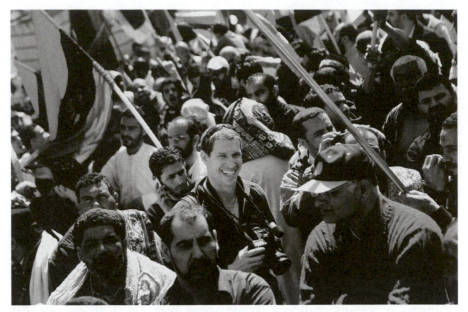

30. Photojournalist Tim Hetherington works a rally in Benghazi, Libya, 25 March 2011. Photographer: Finbarr O'Reilly/Reuters.

say that his eye and his ability, what he did, was unique. His reportage really defined a generation of covering conflict.'[18]

Hetherington was acutely aware of the pressing need for professional photojournalists to fashion new strategies of storytelling, particularly in light of the challenges posed by 'amateur' or 'citizen' photojournalists. While preparing for his journey to Libya, he shared his thoughts about the contribution ordinary individuals can make to news reporting. Referring to CNN's use of 'amateur videos' after the recent earthquake in Japan, he said he found them 'fascinating – almost more powerful than professional images. Why is that? It's the immediacy. And it's the intimacy. It's a personal view.' When questioned about whether a personal view interferes with journalistic objectivity, he replied: 'I've never been interested in objectivity.' Pressed on the point, he elaborated:

What is objectivity? There's always a perceived subjectivity – that Al Jazeera has a point of view, that CNN has a point of view. I'm not advocating citizen journalism necessarily. I think it's a great thing that the wires exist. We need everything. It all adds to the layers of understanding and meaning. I'm about being inclusive.[19]

For Hetherington, professionals should strive to be communicators, always alert to the need to produce imagery that people can relate to in their own way. Good work reveals something new, hence his belief in the virtues of experimentation using multiple forms as well as the importance of being sufficiently self-aware about the motivations shaping picture-making:

> I think it's got to come from yourself, first of all. That's the most honest place to be coming from. If I started saying that it came out of a desire to change the world, that's very suspect. Can't it come out of a place of personal curiosity? A desire to locate myself in the world and also have some utility?[20]

Described in this way, to 'have some utility' seems a modest objective, yet one in keeping with someone evidently all too aware of the reasons why photojournalists covering war need to make their images count. The radical, nonconformist edge to his work compelled him forward, even as it narrowed his chances of surviving his impassioned commitment to truth-telling.

Photographer Chris Hondros was described by journalist David Carr as someone 'who preferred a tweed blazer with elbow patches to fatigues' – 'an opera buff and an avid chess fan who never had the profile of a swashbuckling war correspondent' – and who was a remarkably accomplished photojournalist.[21] Born in New York City in 1970, he was the senior staff photographer for Getty Images at the time of his death, having covered conflicts in Kosovo, Angola, Sierra Leone, Lebanon, Afghanistan, Kashmir, the West Bank, Iraq and Liberia. His achievements included being nominated for a Pulitzer Prize in 2004 in recognition of his work in Liberia, and the next year he won the Overseas Press Club of America's Robert Capa Gold Medal award. Interviews with him over recent years revealed his concerns about the changing nature of war photography and its responsibilities. Likening the camera to 'an ordering tool', he suggested that 'photographs can be instrumental [in] bringing order to chaos.'[22] This capacity to narrativise was a recurrent theme in comments made about his influence from other photographers.[23] 'Chris made sacrifices in his own life to bring the hardships of war into the public eye, and that dedication created award-winning photographs that shaped the way people viewed the world,' friend and fellow photographer Tyler Hicks said when news of Misrata reached him.[24] Photojournalist Steve Hebert characterised Hondros's contribution in similar terms. 'Chris

understood the importance of what he did and that it was done inside a world no one would ever want to go,' Hebert suggested. 'He wanted to tell people's stories. And very few people in this industry have done it better.'[25]

In the immediate aftermath of the tragedy in Misrata, virtually all of the related news media commentary offered praise for the crucial role war photographers were playing in places such as Libya. Dissenting voices were rarely heard, *Guardian* blogger Andrew Brown being one exception. In acknowledging that the deaths of Hetherington and Hondros were making 'front-page news around the world', it was his contention that 'it is in fact the least saddening news from Libya this week.' While not denying that 'the two photographers who were killed were brave and selfless and should be honoured,' in Brown's view their deaths were 'less dreadful' than those of civilians 'who had the misfortune to live in a strategically important town'. Despite the risks, he reasoned, the photographers decided to be there, a choice denied others. 'It is inevitable we should feel most vividly the sufferings of those who are like us,' he argued. 'It is also perhaps inevitable and certainly praiseworthy that some photographers should be prepared to risk their lives to bring the sufferings of strangers close to hand and to try to tip that balance a little.' However, and herein lies the principal

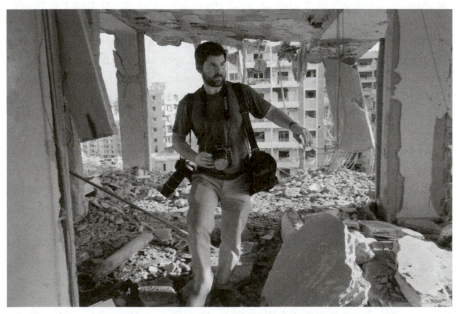

31. Getty Images photographer Chris Hondros walks the ruins of a building in southern Beirut, Lebanon, 21 August 2006. Getty Images.

point of tension, 'the more we admire them and approve of their work the less we should regard their deaths as ultimately tragic,' Brown maintained. Hetherington and Hondros were there to do something they thought was important, which meant they were prepared to accept the necessary risks. 'If we put them on the front page of newspapers, let's be honest that it is because we admire them, not because they show the pity or futility of war,' he concluded. 'On the contrary, their deaths, as much as their lives, do something to make some wars seem noble ones.'[26]

Related lines of criticism have been well-rehearsed over the years, not least where war photography is accused of glamorising conflict, possibly even exacerbating it by producing imagery that sparks public demands for military intervention.[27] Photography editor Roger Tooth believes that the 'rest of us are lucky that we can tap into their enthusiasm and bravery however misplaced it sometimes may be. In the end, motives are not important, it's the image on the page or screen telling the unadorned truth that counts.'[28] Regarding civilian deaths, the author Sebastian Junger insisted that photographers are not simply 'trying to snap a front-page photograph' for its own sake, but rather endeavour to chronicle the humanitarian crisis left in the wake of armed conflict. Those in the group under attack that day 'were capturing the horror of Misrata, but they were also capturing something much greater and more important: all of the tens of thousands of civilians that have been killed in the past decades,' he maintained. 'That's what they were going there for – Rwanda, Sarajevo, Liberia, the list goes on.'[29]

This capacity to convey the human cost of war was a theme Hetherington himself addressed in an interview conducted the year before, when he described his own efforts to convey the 'texture' of war – likened to 'boredom punctuated by sheer terror' – in all of its contradictions. 'I'm there as a witness,' he stated. 'And I'm just trying to record what I can in the very kind of frenetic environment.' He continued: 'I have always wanted to give a voice to my subjects. That's really important for me. It's their reality, and I'm mediating it for the public.' In words poignant in retrospect, he went on to say 'and I try [to] keep myself out of the way and out of danger, but obviously you're in a situation.'[30]

Citizen Imagery

Professional photojournalists working in war zones are becoming increasingly accustomed to encountering ordinary citizens wielding cameras, and

Libya was no exception. 'In some ways it's the ideal war for photographers – colourful, anarchic rebels taking on a professional standing army,' photography editor Roger Tooth suggested. In contrast with the ongoing conflict in Afghanistan, for example, access was relatively straightforward. 'To cover the Afghanistan conflict in any meaningful way, photographers have to be embedded with the Western armies, which means applying to and working with defence ministries and their press minders,' he pointed out. 'In Libya, if you have the dollars and the guts, you just follow the road into Benghazi and from there to the ever-moving frontline.'[31] Where professional cameras and lenses often attract the wrong sort of attention, the citizen with a camera-equipped mobile phone can surreptitiously capture stills or video footage that would be otherwise hard to obtain.

Here it is worth noting that a high proportion of the journalists and photographers able to enter Libya were freelancers, a large share of whom were witnessing conflict for the first time in their lives. Hannah Storm of the International News Safety Institute remarked:

> You can understand why new journalists or journalists inexperienced in covering conflict were drawn to Libya. It was on the doorstep and there was a sense of being part of history. But it was so dangerous because it was not like a traditional war – it was fluid and unpredictable, with the anti-Gaddafi fighters often not very familiar with the weapons they were using.[32]

In addition, she argued, a certain 'blurring of what it means to be a journalist' brought about by 'the rise of citizen journalism and journalist-activists' meant that the lure of this type of opportunity was difficult to resist, despite the dangers. Some of those involved struggled to cope without the benefit of training or adequate logistical support, commonly relying on 'fixers' – individuals living in the area who were prepared to assist them – to report what was happening. Suliman Ali Zway, otherwise employed as a construction worker, explained:

> I realised that without help the journalists weren't going to get the story out. It happened before in 2006. We had a revolution in Benghazi and it was controlled after 10 days because nobody could report it, nobody could get word out. I knew it would be important to help the journalists keep on top of things and to do everything it took to help them report the truth. [...] When you go to a frontline and it's just an army of volunteers with AK-47s fighting against a regular army, it's dangerous.[33]

Meanwhile some 130 foreign journalists in Tripoli were told by their official minders to remain in their hotel for their own safety – when it was readily apparent that the real reason was to stop them covering the demonstrations and the authorities' repressive responses to them. Shortly thereafter, according to one *New York Times* reporter, 'the government informed the journalists that it planned to fly them away from potential Friday protests to a Qaddafi stronghold in the south.' When the journalists objected, refusing to cooperate, 'the government temporarily locked them in their hotel, before arranging a bus trip to a central square that is a hub for pro-Qaddafi rallies.'[34]

It was against this backdrop that the significance of reportorial contributions made by ordinary Libyans came to the fore. 'When protests first began in Libya,' Al Jazeera reported, 'the media presence there was scarce so the story filtered out via social media thanks to courageous citizen journalists.'[35] Diverse forms of citizen reporting ('guerrilla journalism', as one professional called it) emerged via Twitter and Facebook, with efforts to block them circumvented by using proxy servers, amongst other strategies. 'The citizen journalists provide an alternative to the official media in their portrayal of the protests and the turmoil across the country,' BBC Monitoring observed. 'While state media showed only pro-Gaddafi protests, pictures and video from mobile phones told a different story.'[36] Some individuals crossed borders into neighbouring countries in order to upload eyewitness accounts and imagery to the web, despite guards at checkpoints reportedly confiscating cameras, memory cards, hard drives and telephone SIM cards – virtually anything containing video footage or still photographs.[37]

The sheer volume of such diverse forms of citizen imagery defied straightforward categorisation. 'Without a doubt,' journalist James Foley observed, 'home videos have played a huge role in the Libyan revolution,' whether shot from 'clunky early 1990s TV cameras' to newer handycams, or the ubiquitous mobile phones. Ranging 'from early videos of unarmed protestors being attacked in Benghazi, to shocking videos taken from captured Gaddafi troops filming their own atrocities', these images have 'sowed the righteous anger of thousands as they spread like wildfire on Facebook and YouTube'.[38] Struggling to keep abreast of unfolding developments, news organisations found themselves relying on materials ostensibly shared by eyewitnesses, all too aware that independent verification was near-impossible at times. Noteworthy in this regard was the use of qualified language in captions – 'this amateur image purportedly depicts' or 'this footage is said to show' – employed to

express this uncertainty. Telltale words such as 'purportedly' or phrases such as 'could be a pool of blood' signal the absence of independent verification, the unspoken acknowledgement that sometimes cameras – or, more to the point, the people holding them – do not always relay the truth. In so doing, the challenge for journalists endeavouring to cover a conflict they could not witness first-hand is implicitly acknowledged. At the same time, truth-claims hedged in such terms invited a nuanced relationship with readers, effectively crediting them with the interpretive skills necessary to differentiate subtle gradations in journalistic authority over contested evidence.

In the main, eyewitness reports from Libya were provided by citizen witnesses on an ad hoc, impromptu basis, frequently without the protection of anonymity. Amongst them were the rebels themselves, capturing imagery of jubilant celebration, as well as combat destruction and the human misery left in its wake. Likened to 'battlefield tourists' by some, those risking their lives to overthrow the Gaddafi regime recognised the value of both cameras and Kalashnikovs in waging war. For news organisations intent on processing this type of imagery, however, thorny problems of mediation emerged, both in terms of logistics as well as in respect of certain ethical implications. Differing views over what constituted appropriate, responsible and non-judgemental treatment, particularly where it risked being perceived as overly graphic or upsetting for distant audiences, simmered throughout the ensuing coverage.

'Pix or it Didn't Happen'

These tensions boiled over when photographs and video clips of captured former leader Muammar Gaddafi, wearing heavily bloodstained clothing whilst surrounded by ecstatic rebel fighters near the town of Sirte, surfaced on 20 October 2011. Grainy, blurry images of what appeared to be his slumped body were soon followed by shaky, staccato flashes of mobile telephone footage of him being dragged down the street. A further clip showed him splayed on the bonnet of a pickup truck, much of his face covered in blood, violently jostled by jeering rebels (the sound of euphoric gunfire in the background), while another revealed him staggering to the ground, where he was repeatedly kicked, evidently alive but clearly struggling to endure. Gaddafi's execution by his captors was not documented – or at least no imagery

of it has appeared thus far – but photographs of his corpse, revealing a bullet hole in his left temple, were posted online soon after. Initial reports claiming that the former leader had been killed by crossfire while being transported to a hospital for treatment following his arrest were dispelled in no uncertain terms. Still, concerns about verification continued to linger, with some news organisations hesitating to declare the Libyan leader dead prior to official confirmation – CNN's qualified claim 'Video appears to show fmr. Libyan leader's body' was typical. Explanatory text from Al Jazeera and Agence France Presse, the first relayers of mobile phone imagery from the rebel fighters for many Western news organisations, frequently failed to accompany the clips as they were rapidly re-appropriated over and over again across the webscape.

Journalists and their editors around the world were scrambling to ascertain the authenticity of what they were seeing. Compounding complications with sourcing, the explicit nature of photographs and video footage – replete with close-ups of the bloodied, evidently

32. An image captured from a mobile phone camera shows the arrest of Libya's strongman Muammar Gaddafi in Sirte on 20 October 2011. A Libyan National Transitional Council (NTC) commander told AFP that Gaddafi was captured as his hometown Sirte was falling, adding that the ousted strongman was badly wounded. AFP/DSK/Getty Images.

lifeless body of the Libyan leader – posed awkward questions of ethical judgement where the risk of transgressing the normative limits of public sensitivities were concerned. Under intense time pressure, television and internet editors and producers typically opted to 'go graphic', journalist David Barron observed, which meant their audiences 'saw images that would have been unattainable before cellphone cameras and internet sites and 24-second news cycles, and unimaginable before an era when news executives must make immediate, difficult choices in a competitive environment on which images are too gruesome to show.' Such decisions were seldom made on their own terms, not least when it was assumed that audience members would simply go online to find material otherwise left out of mainstream reporting (almost by way of mitigation, Barron cites an analyst's claim: 'We're spending a lot of money in Afghanistan, Libya and Iraq, and people want to see the snuff-out').[39]

A news organisation electing to disregard this type of gruesome material risked appearing irrelevant, it followed, suggesting to several commentators that a tacit shift from 'Should we show this?' to 'How should we show this?' was becoming increasingly discernible. Verbal forewarnings to television viewers, like those cautioning internet users from clicking past certain checks (e.g. 'Warning: This gallery contains graphic images. Viewer discretion is advised'), revealed presumptions made about audience sensibilities. Judgements regarding what was reasonable (or at least palatable) were context specific, corresponding to differing inflections of explicitness on the basis of what might be subsequently criticised for being exploitative, sensationalising, trivialising or simply 'bad taste'. Still, typically left unspoken was the further precept that presenting images of Gaddafi's battered corpse, or that of Osama bin Laden had they been made public, was deemed both morally and journalistically acceptable in a way that revealing images of the violated bodies of Westerners would not be.

Ethical quandaries demanded resolution in pragmatic terms where breaking news is concerned, with pressing decisions to be made about appropriate use – as opposed to sensational exploitation – of the imagery in the absence of agreed conventions. 'Did you need to see Gaddafi's corpse?' was the headline of a post by James Poniewozik of *Time* magazine, for example, who argued that because we live in the 'pix or it didn't happen' era, it was not surprising that 'the pix in and of themselves did not immediately prove that it happened' when first released. At the same time, disputes over the purpose such imagery served, he believed, missed a larger point:

The job of journalism – at least of breaking-news reporting like this – is not to determine what people should and should not feel and then work backward to produce the images that will engineer the ideal emotional response in the name of right thinking. It's not to try to encourage the right public reaction or head off a dangerous one (whereas that might be the entirely appropriate worry of a government). It is to get at the truth of what actually happened in an event.[40]

This refusal to privilege journalism's subjunctive claim on emotion, which some might typify as its moral duty to care (and to be seen to be caring), was recurrently reaffirmed on the basis of upholding a normative commitment to objectivity. The 'truth' of what had actually transpired took some time to establish, as noted above, which in Poniewozik's view was consistent with a 'conspiracy-minded age' of suspicion. 'What if someone dressed up a different corpse? What if the picture shows him wounded, not dead? What if it's Photoshopped? What if, what if?' he asked.

Even when veracity appeared to have been established, further questions remained regarding how best to display the imagery in a suitably responsible manner. Gaddafi's status as a dictator and war criminal meant he would not be accorded the respect that might be otherwise expected for a slain political leader. The extensive, repetitive play of video clips showing his evidently lifeless body were justified as necessary, in part, in order to put paid to doubts that he was really dead (thereby providing a counterpoint of sorts with the controversy generated by the Obama administration's refusal to release the photographs of al-Qaeda leader Osama bin Laden's body into the public domain). CNN's Laura Smith-Spark suggested that 'while the ethics of taking snapshots of dead dictators is still up for discussion, the ubiquity of cell phones equipped with cameras – and the way such images swiftly find their way to the waiting world – means such doubts are far less likely.'[41] Steven Baxter of the *New Statesman* offered a blunter appraisal. Because 'we live in a "pics or it didn't happen" era,' he argued, 'we don't trust the word of broadcasters and want to see for ourselves.' Hence one of the key reasons, he surmised, 'news outlets have been happy to splash the blood this time around,' with 'the trophy-like nature of Gaddafi's corpse' proving a grisly spectacle.[42]

As further digital photographs and video clips continued to emerge, the journalistic significance of this spectacle became increasingly problematic, not least with regard to the relative legitimacy of such

graphic forms of citizen witnessing. 'At the beginning of this second film there is a digitally animated ident proclaiming it to be the work of Freedom Group TV,' a *Daily Mail* report by Damien Gayle noted, before explaining that according to the group's Facebook page, they were a 'group of citizen journalists [whose] mission is to let the world know what is happening in Libya'.[43] BBC News' head of the multimedia newsroom, Mary Hockaday, echoed this sense of mission, conceding in a blog post that while imagery of the Libyan leader in his dying moments was 'undoubtedly shocking and disturbing', it was editorially justified to quell 'the swirl of rumour'. Conveying the drama of unfolding events 'in the age of mobile phones' meant being clear with audiences what had been verified, and what had not been, where the origins of 'emerging photographic evidence' was concerned. 'We judged that it was right to use some footage and stills, with warnings about their nature,' she insisted. As a news organisation, 'our role is to report what happened, and that can include shocking and disturbing things.'[44]

Ethical Questions

Tacit rules of journalistic filtering nevertheless apply – one of the explanations why image-taking in the hands of soldiers, activists and civilians can prove so unsettling, even emotionally traumatic when it breaks these rules. Michael Trice, in noting the power of imagery from 'decidedly unprofessional venues', remarked that in his view the 'amateur nature and unrestrained viewpoints of such videos does not feel like journalism'. Still, he added, 'to dismiss raw history for no other reason than its naked display of the pain, chaos, and joy of war represents a terrible form of censorship,' one that a society engaged in war could ill-afford in its public discourse.[45] For Susannah Breslin of *Forbes*, however, such imagery risked becoming the 'porn' of war. 'It's hard to look at the viral spread of Gaddafi's death images – being pulled through the street, slumped against someone's knee, covered in blood – and not think of pornography,' she wrote. In contrast with news images created by photojournalists, those relayed by a mobile telephone by whomever happened to be nearby were likely to be taken up and used precisely because they aroused intense, emotional reactions. 'While journalists are supposed to maintain some kind of moral compass, random spectators are not,' she argued. 'Therefore, with digital recorder running, there's no reason why you shouldn't record the fleeting moments of a self-

proclaimed "King of Kings" being reduced to a corpse.'[46] Recording such distressing eyewitness imagery is one matter, of course, while preparing distant audiences for its affective impact is a different concern altogether.

While some heralded this latest instance of 'citizen journalism' as a potential 'game-changer' that raised the stakes for news reporting, others expressed concern at what they regarded to be changing social taboos.[47] 'The threshold for publishing gruesome images like those of Muammar Gadhafi's death is falling as the internet and social media make many of the editorial decisions that used to be left to a small group of professional journalists,' Tom Heneghan and Peter Apps of Reuters stated.[48] Journalistic perceptions that public tolerance for such imagery is relaxing may well prove to be a self-fulfilling prophecy, of course, given the absence of agreed normative criteria to ascertain, let alone evaluate, change. Where to draw the line varied from one news organisation to the next as they pieced together the story, with ad hoc decisions evidently taken with reference to wider views about community standards, good taste and ethical benchmarks.

Former-editor-turned-*Observer*-columnist Peter Preston detected a new 'tone of vengeance' in much of the British coverage, however, which he attributed to the 'twin gods of modern journalism', namely 'the scoop' (debate having raged over who got the story first 'before Gaddafi's body was even cold') and the 'citizen-reporter-cum-camera-operator waving a mobile phone'. Factored together, they ensured this was 'a race beyond winning', in his view. 'It's all-embracing, all-consuming, utterly unavoidable: the defining taste of failure or success.' Editors can no longer 'sit piously on the sidelines any longer', being effectively 'doomed to compete, because not doing so is a kind of censorship – and a shot in the foot, not the head'.[49] *Newsweek*'s editors, when placing video footage on the magazine's Tumblr page, made a similar point about such pressures when they wrote: 'Warning: this is video of Muammar Gaddafi's corpse being kicked through the streets of Sirte. No way to whitewash that. We're posting it because many others have, and at this point, it's a video asset in the history books.'[50]

In the days that followed, press commentators continued to mull over the wider implications for journalism. 'On balance,' former newspaper editor Roy Greenslade maintained, 'I thought the publication of the Gaddafi pictures was justified, given the special circumstances surrounding the manner of his death, the context of his own tyranny and the widespread dissemination of them on the Internet.'[51] Columnist Suzanne Moore, writing in London's *Mail on Sunday*, took issue with the 'full technicolour footage of a dying Gaddafi', making a distinction

between what Libyans may need to see after suffering terrible injustices under his brutal regime ('as Romanians needed to see Ceausescu's body or as Italians passed round photos of the corpses of Mussolini and his mistress'), and what 'we' in the West do not. 'The needle of our collective moral compass is spinning,' she wrote. 'Gaddafi was bad, therefore all is permissible [...] Watch the compass spin its excuses: it's history; it's symbolism; it's new technology. My compass points downwards to grotesque gloating.' Meanwhile she added, 'we watch death. Live. On every screen, on every page. Death, the final frontier? No, not any more. The barbarians are not at the gates. We have become them.'[52]

This apparent disruption of a familiar politics of othering, whereby 'us' and 'them' dichotomies threatened to become destabilised, made apparent the ex-nomination (ostensible placing beyond words) of discomforting realties. In adopting a related line of critique, Jonathan Jones in the *Guardian* contended that to 'get upset by photographs of the dead Gaddafi is to pretend we did not know we went to war at all'. Moreover, he maintained, it is to 'fantasise that our own role is so just and proper and decent that it is not bloody at all'. In light of what he regards as the West's 'dangerous delusion' that war can be a decent, worthwhile endeavour, he poses the question:

> Why have the photographs and films of Gaddafi's end caused so much fuss and bother? Because they show us the reality of war that we are usually so good at ignoring. In 10 years of wars since 9/11 the worst pictures, the trophy images of the dead and grotesque scenes of roadside slaughter, have been kept away from the mainstream media, to be sought on the internet by those who wish to sup on horrors.
>
> But for once, with the death of Gaddafi, we have seen the face of war, washed in blood, bathed in cruelty. The horrible and haunting pictures of his last moments and his public exhibition simply show us, for once, what the wars of our time and all times look like. If we don't like what we see we must stop this foolish pretence that war, however 'just', can ever be anything but a brutal mess.[53]

There seemed to be little doubt that the very rawness of this footage was acutely unsettling to viewers otherwise habituated to routine, effectively sanitised renderings of the horrors of a war zone. Indeed, it arguably signalled a telling moment when the customary forms of journalistic mediation usually accompanying such imagery were dramatically transgressed.

Even for news organisations prepared to justify their use of such disturbing images on the basis that they were necessary facts integral to the truth of the story, characterising the precise nature of this type of citizen witnessing proved challenging. Several journalists and editors quoted in the coverage noted in passing that mobile phones had effectively served as weapons in the hands of those surrounding Gaddafi from the moment he was pulled from the storm-water drain in Sirte. 'The Arab Spring has demonstrated the power and all but unstoppable reach of the citizen journalist, although it's debatable whether the term can easily be used for the people responsible for the filming of Gaddafi's death,' Frank Krüger of South Africa's *Mail & Guardian* observed. 'Is it time for a new category,' he wondered, 'the "fighter journalist"?' Precedents of form and practice were discernible, not least with regard to imagery produced by soldiers in war zones. While examples of this type of combatant imagery can be traced back to the earliest days of photography in war zones, the harrowing documentation of torture in Abu Ghraib comes to mind as a profoundly disturbing case in point.[54] As the Gaddafi controversy recedes in time, however, it would seem that ethical misgivings over the morality of using such graphic images remains as one of the most memorably contentious concerns.

One telling silence in the vast majority of commentaries, in my reading at least, was revealed by Eilis O'Hanlon writing in Ireland's *Sunday Independent*. In describing what she called the 'unexpected stirrings of sympathy' felt for a brutal dictator prompted by the imagery of his violent death, she proceeded to point out that 'it is impossible not to empathise in that moment with another scared and wounded human being, at least not without becoming less human in turn.' She then makes the simple, albeit disquieting point that these 'pictures forced us to put ourselves in the role of the victim and feel accordingly hunted, terrified, defiled'.[55]

Respecting Limits

'After the attacks of Sept. 11, 2001,' David Carr of the *New York Times* observed, 'the business of war picked up and the bloody consequences have landed hard on people who bring cameras, rather than guns, to a firefight.' Against a backdrop of news organisations 'economising', with overseas bureaus closing down, he noted how photographers such as Hetherington and Hondros remained steadfast in their commitment to bearing witness to human suffering. In his words:

Even as warfare has changed – becoming in some cases more remote and more distant – the job of covering war has not. Missiles can be guided from great distances and drone aircraft can be commanded by a joystick, but journalists still have to go and see where the bombs landed.

Information has sprouted from all manner of new tools, including Facebook, Twitter and cellphone video. But no one has perfected the journalist drone.[56]

Both men were 'adventurers', he added, 'but not daredevils in the way war photographers are often portrayed in movies'. Photographer Marcel Mettelsiefen, there in Misrata at the same time, acknowledged how frequently the taking of risks is rationalised in the effort to 'capture the perfect image', which can be difficult to justify in retrospect. 'As a journalist, one wants to make a difference,' he explained, particularly in these circumstances.

I convince myself that I am able to show to people outside of Libya what is really happening there. That I can show that which Gadhafi would prefer remained hidden: the pain and suffering of Libyan civilians. That is what gives me the feeling that my work can really have an effect. But can it really? [...]

You ask yourself why you do this, why you are in this kind of situation even though you already set some limits. You ask yourself whether you will ultimately have the courage to respect these limits and pull back if things get too dangerous. When you start to get nervous, it is time to turn back.[57]

This type of self-reflexivity, hard-won in the grind of traumatic experiences, reaffirms the value of prudence, and thereby self-preservation in both personal and professional terms. 'And in Misurata, there are no clear front lines,' he added. 'Death can come from anywhere, and it can target anyone.'[58]

The incidents under scrutiny in this chapter, when considered in relation to the compulsion to bear witness, help to render problematic various assumptions about war photography. Familiar truisms prescribing that the professionalism of the photojournalist be defined on the basis of impartial, dispassionate relay – where facts and values are held in contradistinction – fail to withstand closer inspection. Photojournalists prepared to put their lives on the line in a war zone do so for a number

of reasons, but as we have seen above with regard to the coverage of the crisis in Misrata, a commitment to revealing the agonies of human suffering to distant publics is of paramount importance. The imperative to bear witness on behalf of those otherwise effectively silenced seldom proves to be the easy, straightforward course of action, but it is the vital one that the professional takes pride in choosing. Even when, as would appear to be increasingly the case, they risk being turned into military targets as a result.

This priority acquires ever-greater salience at a time when the proliferation of digital technologies is rewriting the relationship between professionals and their 'amateur' or 'citizen' counterparts. Video imagery shot by rebel fighters of the capture of Muammar Gaddafi may not be regarded by most as deserving of the label 'citizen journalism', but it is nonetheless a form of soldier witnessing, with its own distinctive precedents of photographic form and practice (the gradual consolidation of which has been underway long before the digital age emerged). The re-purposing of soldier imagery within journalistic conventions signals the uneven, evolving ecology of reportorial truth-telling, the ethical implications of which warrant sustained discussion and debate. This chapter has sought to offer a modest step in this direction.

Notes

1 Sean Smith, 'War photographers are not addicted to danger', *Guardian*, 22 April 2011.

2 Amnesty International, 'The battle for Libya: killings, disappearances and torture', Amnesty International (2011), available at www.amnesty.org/en/library/info/MDE19/025/2011 (accessed 16 March 2014); Committee to Protect Journalists, 'Journalists under attack in Libya: the tally', 20 May 2011, available at http://cpj.org/blog/2011/05/journalists-under-attack-in-libya.php (accessed 16 March 2014). International Press Institute, 'Deadly trends for journalists in 2011: 103 killed', 4 January 2012, available at www.freemedia.at/home/singleview/article/new-deadly-trends-for-journalists-in-2011-103-killed.html (accessed 16 March 2014).

3 'I heard in Arabic, "Shoot them",' Anthony Shadid recalled afterwards. 'And we all thought it was over' (cited in Jeremy W. Peters, 'Freed Times journalists give account of captivity', *New York Times*, 22 March 2011, available at www.nytimes.com/2011/03/22/world/africa/22times.html?pagewanted=all&_r=0 (accessed 18 February 2014)). On 16 February the following year, Shadid died from an acute asthma attack in Syria. The *New York Times*'s executive editor Jill Abramson wrote in an email to newsroom colleagues:

'Anthony died as he lived – determined to bear witness to the transformation sweeping the Middle East and to testify to the suffering of people caught between government oppression and opposition forces.' Former executive editor of the paper, Bill Keller, posted on Twitter: 'Yes, a poet, but first and foremost an incomparable witness. Anthony Shadid, a *New York Times* reporter, dies in Syria' (both quotations cited on the paper's blog, *The Lede*, on 17 February 2012).

4 'Miami photojournalist speaks about imprisonment in Libya at UM', CBS Miami, 12 April 2011.

5 Matthew VanDyke, , 'Freed US writer describes Libyan jail', interview with R. Atkins, BBC News, 26 August 2011, available at www.bbc.co.uk/news/world-africa-14674110 (accessed 16 March 2014).

6 C. Washbrook, 'Online journalist Mohammed Nabbous killed in Libya', Spy report, 20 March 2011, available at http://rafaelmartel.com/2011/03/19/online-journalist-mohammed-nabbous-killed-in-libya/ (accessed 16 March 2014).

7 J. Jensen, 'Reporters' release tempered by news of colleague's death', GlobalPost.com, 19 May 2011, available at www.globalpost.com/dispatch/news/regions/africa/110519/libya-journalist-death-anton-hammerl-james-foley-clare-gillis (accessed 18 February 2014).

8 International News Safety Institute, 'INSI-Misrata: how Tim Hetherington's death highlights the dangers for journalists in Libya', 20 April 2011, available at www.newssafety.org (accessed 18 February 2014).

9 The two quotations attributed to Guillermo Cervera are cited by Orla Guerin, 'Libya: UN warns of blurring aid and military operations', BBC News, 21 April 2011, available at www.bbc.co.uk/news/world-africa-13152392 (accessed 11 May 2014), and Ned Parker and Reed Johnson, 'Libya blast kills photojournalists Tim Hetherington and Chris Hondros', *Los Angeles Times* website, 21 April 2011, available at http://articles.latimes.com/2011/apr/21/world/la-fg-libya-photographers-20110421 (accessed 11 May 2014) respectively. Cervera, in Misrata as a freelance photographer, reportedly held Hetherington in his arms as he died.

10 'I was aware of the dangers before I went,' Martin later recalled when interviewed from his hospital bed. 'But I felt that the Middle Eastern uprising was an important story that I had to cover. Misurata was at the heart of the Libyan story and it seemed like the kind of warfare that doesn't happen much anymore – a small rebel army with small guns fighting a far superior army. We were there watching as these men fought for control of streets that they had lived in all their lives. It was just unbelievable.' Cited in J. Salter, 'Libya: In the line of fire', *Telegraph*, 28 May 2011.

11 Tina, 'Going beyond the frontline: Michael C. Brown returns to Libya', Emphas.is blog (accessed 23 June 2011).

12 C.J. Chivers, '*Restrepo* director and a photographer are killed in Libya', *New York Times*, 20 April 2011.

13 David Carr, writing in the *New York Times*, pointed out that the loss was 'akin in some ways to the 1971 helicopter crash in Laos that ended the lives of Larry Burrows, Henri Huet, Kent Potter and Keisaburo Shimamoto, four of the best photojournalists of their generation.' Here he added that 'we should not make the journalist's error of elevating the deaths of Tim and Chris about those of others. But beyond the personal loss for their families and friends, there is a civic loss when good journalists are killed.' D. Carr, 'War, in life and death', *New York Times*, 24 April 2011.

14 X. Rice and P. Walker, 'Misrata mortar attacks kill at least 15 civilians', *Guardian*, 21 April 2011. Five photographers – Brown, Cervera, Hetherington, Hondros and Martin – had travelled from the seaport Benghazi on a cargo vessel, the *Ionian Spirit*, sent to Misrata to deliver food and medicine, and to evacuate foreign workers on its return. Following the tragedy, the same ship was used to transport the bodies of Hetherington and Hondros out of Misrata. For further details of the humanitarian crisis in the city at the time, see Amnesty International, 'The battle for Libya' and J. Stock and M. Mettelsiefen, 'Life on the rebel side of the crosshairs', *Spiegel online*, 20 April 2011, available at www.spiegel.de/international/europe/misurata-s-sniper-war-life-on-the-rebel-side-of-the-crosshairs-a-758080.html (accessed 16 March 2014).

15 D.A. Graham, 'Libya war photographers' final hours', Daily Beast, 21 April 2011, available at www.thedailybeast.com/articles/2011/04/21/hetherington-and-hondros-last-stand-saw-heavy-shelling-no-nato-support.html (accessed 16 March 2014).

16 Michael Kamber, 'A group of conflict photographers runs out of luck', *New York Times*, 23 April 2011.

17 Graydon Carter, 'A loss in the family', VanityFair.com, 20 April 2011, available at www.vanityfair.com/magazine/2011/04/graydon-carter-remembers-tim-hetherington-201104 (accessed 16 March 2014).

18 X. Rice and J. Halliday, 'Documentary maker Tim Hetherington and photographer Chris Hondros killed', *Guardian*, 20 April 2011.

19 Tim Hetherington, 'Interview with J. Brown', *PBS Newshour*, aired 17 November 2010.

20 Tim Hetherington, 'Tim Hetherington's last interview', interviewed by R. Haggart, 13 April 2011, available at www.outsideonline.com/outdoor-adventure/media/Tim-Hetherington-s-Last-Interview.html (accessed 16 March 2014).

21 Carr, 'War, in life and death'.

22 Chris Hondros, 'Quiet spectacle: an interview with Chris Hondros', interviewed by J. Saffron, *Afterimage* 35/6 (May/June 2008).

23 Asked to comment on the proliferation of digital point-and-shoot cameras in war zones, in 'Quiet spectacle' Hondros pointed out that soldiers have carried snapshot cameras for a long time, so he saw little evidence to suggest 'the face of photography has been affected by soldiers ambling around in Iraq with digital cameras. Abu Ghraib and perhaps one or two other [situations] aside, not many pictures by soldiers have achieved any sort of large dissemination or cultural relevance.' A more notable concern in Iraq, in his view, was the employment of local people as photographers by Western news organisations. 'My own organisation [Getty Images] only employs one, but the large wire services employ dozens. They can, in that particular kind of conflict, go places that Western photographers can't go.' In his view, this kind of access 'goes to the heart of what you need a photographer for', although the professional upholds different standards of journalism. 'Is a photographer trained to go into a war zone as an observer to produce imagery that is relevant and cut through visual clutter and cliches to bring back profound moments?' Hondros asks rhetorically, given his apparent scepticism that 'local indigenous peoples [could be] trained in such a thing in large scale, quickly'.

24 Chivers, '*Restrepo* director and a photographer are killed in Libya'.

25 K. Hasty, 'Photojournalist Hondros killed in Libya; former *Observer* staffer', *Fayetteville Observer*, 21 April 2011.

26 A. Brown, 'Libya's front-page casualties have not suffered the most tragic fate,' Comment is Free blog, *Guardian*, 21 April 2011, available at www.theguardian.com/commentisfree/2011/apr/21/libya-front-page-casualties (accessed 16 March 2014).

27 G. Batchen, M. Gidley, N.K. Miller and J. Prosser (eds), *Picturing Atrocity: Photography in Crisis* (London, 2012); M. Griffin, 'Picturing America's "War on Terrorism" in Afghanistan and Iraq', *Journalism* 5/4 (2004), pp. 381–402; K. Parry, 'Media visualisation of conflict: studying news imagery in 21st century wars', *Sociology Compass* 4/7 (2010), pp. 417–29; S. Sontag, *Regarding the Pain of Others* (London, 2003); B. Zelizer, *About to Die: How News Images Move the Public* (New York, 2010).

28 R. Tooth, 'Photographers have to be near the action: sometimes too near', *Guardian*, 22 April 2011.

29 Graham, 'Libya war photographers' final hours'.

30 Hetherington, 'Interview with J. Brown'.

31 Tooth, 'Photographers have to be near the action'.

32 P. Beaumont, 'Reporting Libya: freelance coverage, full-time dangers', *Guardian*, 13 November 2011.

33 Joel Gunter, '"Wherever there was news, we went": Libya's "A Team" fixers on getting the story out', Journalism.co.uk, 17 November 2011, available at www.journalism.co.uk/news-features/-wherever-there-was-news-we-went-libya-s-a-team-fixers-on-getting-the-story-out/s5/a546770/ (accessed 16 March 2014).

34 M. Coker and S. Dagher, 'Gadhafi forces seek to widen grip', *Wall Street Journal*, 5 March 2011; and D.D. Kirkpatrick, 'Qaddafi brutalizes foes, armed or defenseless', *New York Times*, 4 March 2011.

35 Al Jazeera, 'Libya: the propaganda war', Listening post, 12 March 2011, available at www.aljazeera.com/programmes/listeningpost/2011/03/20113121012263363.html (accessed 18 February 2014).

36 BBC Monitoring, 'New media emerge in "liberated" Libya', 25 February 2011, available at www.bbc.co.uk/news/world-middle-east-12579451 (accessed 18 February 2014).

37 M.O'Neill, 'How YouTube is aiding the Libyan revolution', *Social Times*, 26 February 2011. For a more detailed discussion of citizen imagery in this regard, see Stuart Allan, *Citizen Witnessing: Revisioning Journalism in Times of Crisis* (New York, 2012), where I develop the notion of 'citizen witnessing' to attend to ways in which ordinary people, temporarily engaging in journalistic activity, recast the imperatives of bearing witness in times of war, conflict and crisis.

38 J. Foley, 'Like battlefield tourists, Libyan rebels film the fight', GlobalPost.com, 5 October 2011, available at www.globalpost.com/dispatches/globalpost-blogs/the-casbah/battlefield-tourists-libyan-rebels-film-the-fight (accessed 16 March 2014).

39 D. Barron, 'Graphic Gadhafi images highlight changed news era', *Houston Chronicle*, 20 October 2011.

40 J. Poniewozik, 'Did you need to see Gaddafi's corpse?', *Time*, 20 October 2011.

41 L. Smith-Spark, 'Graphic images capture Gadhafi's final moments', CNN, 20 October 2011, available at http://edition.cnn.com/2011/10/20/world/africa/libya-gadhafi-images/ (accessed 16 March 2014).

42 S. Baxter, 'Colonel Gaddafi, the trophy corpse', *New Statesman*, 21 October 2011.

43 D. Gayle, '"I killed Gaddafi", claims Libyan rebel as most graphic video yet of dictator being beaten emerges', *Daily Mail*, 25 October 2011.

44 M. Hockaday, 'The challenges of reporting Gaddafi's death', Editors Blog, BBC News, 21 October 2011, available at www.bbc.co.uk/blogs/theeditors/2011/10/the_challenges_of_reporting_ga.html (accessed 18 February 2014); and J. Halliday, 'Gaddafi death video: BBC defends use of "shocking" images', *Guardian*, 21 October 2011.

45 M. Trice, 'Frontline history is not war porn', Partisans.org, 21 October 2011, available at www.partisans.org/node/930 (accessed 16 March 2014).

46 S. Breslin, 'Why we love the porn of war', Forbes.com, 20 October 2011, available at www.forbes.com/sites/susannahbreslin/2011/10/20/qaddafi-dead/ (accessed 16 March 2014).

47 E. Lodish, 'Gaddafi's end: how cell phones became weapons of choice', GlobalPost.com, 21 October 2011, available at www.globalpost.com/

dispatch/news/business-tech/technology-news/111021/gaddafi-dead-killing-libya-cell-phones-international-news-global-media-mobile (accessed 16 March 2014).

48 T. Heneghan and P. Apps, 'Is gruesome no longer taboo?', Reuters.com, 21 October 2011, available at www.reuters.com/article/2011/10/21/gaddafi-death-images-idUSL5E7LL3ZC20111021 (accessed 16 March 2014).

49 P. Preston, 'Boundaries are crossed as grim images of Gaddafi flood the media', *Observer*, 23 October 2011.

50 *Newsweek*, 'Muammar Gaddafi's corpse', Tumblr post, 20 October 2011, available at http://newsweek.tumblr.com/post/11694030747/warning-this-is-video-of-muammar-gaddafis-corpse (accessed 18 February 2014).

51 R. Greenslade, 'Why Daily Record was censured by PCC for using picture of a dead man', *Guardian*, 25 October 2011.

52 S. Moore, 'Yes, he had it coming, but did we really need to gloat like barbarians?', *Mail on Sunday*, 23 October 2011.

53 J. Jones, 'The West wrings its hands over dead Gaddafi photos, but war is always hell', *Guardian*, 25 October 2011.

54 A. Gunthert, 'Digital imaging goes to war: the Abu Ghraib photographs', *Photographies*, 1/1 (2008), pp. 103–12; L. Kennedy, 'Securing vision: photography and US foreign policy', *Media, Culture & Society* 30/3 (2008), pp. 279–94; S. Sontag, 'Regarding the torture of others', *New York Times*, 23 May 2004; D. Matheson and S. Allan, *Digital War Reporting* (Cambridge, 2009).

55 E. O'Hanlon, 'Seeing death as it happens brings cruel realities of war to the fore', *Sunday Independent* (Ireland), 30 October 2011.

56 Carr, 'War, in life and death'.

57 M. Mettelsiefen, 'Photographing war in Misuarata: "there were four times when I could have died"', *Spiegel* online, 21 April 2011, available at www.spiegel.de/international/world/photographing-war-in-misurata-there-were-four-times-when-i-could-have-died-a-758634.html (accessed 16 March 2014).

58 Ibid.

9 Witnessing Precarity

Photojournalism, Women's/Human/Rights and the War in Afghanistan

Wendy Kozol

Two blue burqas hang on hooks on the back wall between sunlit windows in Marco Di Lauro's November 2001 photograph of an empty cell in a women's prison in Kabul, Afghanistan (see Plate 8). In the centre of the composition, the robes hang above a pillow propped up alongside a mat, as if someone is about to sit down or fill out the empty clothing, yet neither the caption nor the image provide any information about individual incarceration histories. Instead, the absence of human figures powerfully gestures towards a larger scale of women's suffering. Although the caption says that the 'prison remains a reminder of the repression women suffered at the hands of the rigid Taliban,' it is the burqas at the centre of the composition that signify this repression.

In recent years, feminist activists and scholars have become increasingly attentive to the politics of pity embedded in the visual discourse of women's human rights.[1] As transnational feminist scholar Inderpal Grewal argues, women's human rights advocacy has been closely identified with Eurocentric claims of universality and individualism, often resulting in representations of Third World women *only* as victims in need of rescue.[2] Similarly, Wendy Hesford analyses the ways in which the 'gendering of sympathy' in visual human rights discourse produces a 'moral vision of human rights internationalism [that] becomes entangled with global capitalism and hierarchical structures of recognition and visual technologies to produce and regulate human rights subjects'.[3] In other words, these scholars caution that while representations of women and children do important work of publicising violence, too often they

uncritically reproduce racialised narratives about a Third World marked by violence and gender victimisation. Feminists, moreover, argue that a relentless gaze at the burqa by Western news media prominently revitalises Orientalist fantasies about Muslim women, especially when this reportage ignores the diverse histories of veiling or contemporary social practices by Afghan women within their communities.[4] Notably, Di Lauro took this photograph just two months after 9/11, at a time when US vengeance narratives against the Taliban combined with a rescue narrative about victimised women to justify the war on terror. In key ways, the hanging-burqas photograph exemplifies the powerful connections between Western news media, women's human rights advocacy and the US-led NATO war in Afghanistan.[5]

While I find transnational feminist critiques of women's human rights discourse immensely persuasive and have contributed to this conversation elsewhere,[6] the emotional complexities created by the robes hanging on the hooks and the absence of human faces with whom to sympathise expose some of the limits of this analytic. Who do the burqas belong to? Why are the women incarcerated? What are we supposed to feel about them? Just as the empty robes raise unanswerable questions about Afghan women's human rights, the sun shining into a room devoid of any visible signs of incarceration unsettles the caption's claim of repression. Accompanying a 'politics of pity' that persists in contemporary photojournalism, I would argue, are affective resonances that trouble and can even destabilise authoritative witnessing practices.

Photojournalism has prominently claimed an ethical imperative in reporting on violent conflicts, even as photographers frequently recognise that the demand to bear witness is haunted by formal and situational complexities that historically have troubled this practice. Moreover, this ethical imperative remains indebted to European Enlightenment concepts of the human and humanitarianism that have operated in tandem with Western imperial expansion. Today, this imperative, as Liam Kennedy argues, 'needs to be understood in the contexts of shifting conditions of relationality, which shape the looking relations (of recognition and identification) that configure our affective responses to images of suffering'.[7] In this essay, I analyse how Associated Press (AP) news photographs of Afghan women mobilise each term in the concept of women's/human/rights in order to explore more deeply the contours of relationality within media witnessing of the war on terror.[8] In so doing, I both expand upon and trouble feminist analytics about the spectacular optics of women's human rights advocacy.

Far from being distinct entities, the intertwining of human rights advocacy and mainstream news media has been crucial to public awareness about 'distant suffering'.[9] Human rights advocates insist on the urgent need to publicise humanitarian crises, especially since state-sanctioned violence persists unabated, often in full public view, as in Afghanistan today. Yet, this demand for visibility occurs within, not external to, a media field dominated by a handful of news conglomerates such as the Associated Press. Given these institutional constraints, human rights and media scholars have long debated whether television, photojournalism and other visual media can mobilise empathy and action or if they simply produce spectacles that lack the critical insights necessary to foster political engagement. Many insist that the experience of seeing distant suffering can motivate viewers to move beyond personal or national self-interest and towards political activism. On the other side, scholars raise concerns about obstacles to political activism such as compassion fatigue and viewers' willingness to 'look away'.[10] How, though, to move beyond this conundrum in which to look risks being a voyeur and to look away risks a solipsistic denial of the *transnational connectivities* that link viewers to events far away?[11]

Through both online and published news outlets, Western viewers typically engage with social conflict occurring at a distance through media texts whose 'world-making properties and the imaginative demands they make' invite them into that world as witnesses.[12] In other words, Paul Frosh argues, distant viewers are not passive receivers of information about suffering but rather 'performative co-constructors of witnessing'.[13] Media witnessing is a complex set of practices and interactions between eyewitnesses (be they survivor-witnesses or news correspondents), technologies that transform experience into representation, and viewers. As other scholars argue, media witnessing of conflict zones calls upon viewers to make moral judgements about both the nature of violence and suffering and the credibility of witness testimonials.[14]

At the heart of this debate about the efficacy of visual media is the problematic of precarity. After all, the ways in which the media identify populations at risk have profound epistemological implications for knowledge production about human rights abuses, conflict zones and the transnational political economies implicated in this violence. If precarity, as Judith Butler states, 'designates that politically induced condition in which certain populations suffer from failing social and economic networks of support and become differentially exposed to injury, violence, and death', then to witness distant suffering in conflict zones is necessarily

dependent upon acts of selection that determine whose precarity becomes visible.[15] What, in other words, does precarity look like in the war in Afghanistan? In this essay, I examine how photographs of non-combatant Afghan women reproduce historically sedimented concepts of 'woman', 'human' and 'rights'. Based in a Eurocentric rescue narrative, this vision of precarity crucially entwines racialised sentiments about Third World women with the United States' rhetorical justifications for the war on terror. The final section then turns the terms of the debate around to consider the limits of precarity as a conceptual term. I consider how affects within photographic texts open up space for the potential recognition of differences, spaces that can potentially destabilise hegemonic scripts about populations at risk. What happens, in other words, when subjects of the camera's gaze become unruly, look back in unanticipated ways or otherwise do not conform to Western expectations of precarity? Might we begin to think through women's/human/rights beyond the lens of precarity?

Gazing at Precarity

The rescue of Afghan civilian populations from the Taliban's repressive regime was a central justification by the Bush administration for military intervention in Afghanistan in 2001 and remains today a prominent argument for continued military presence in the region. Coupled with claims about retributive justice for al-Qaeda's attack on 9/11, the Bush administration specifically charged the Taliban with violations of women's human rights. For instance, in First Lady Laura Bush's now-famous radio address to the nation on 17 November 2001, she said: 'The brutal oppression of women is a central goal of the terrorists [. . .] Civilized people throughout the world are speaking out in horror.' Hailed as civilised people, listeners were called upon to support the rescue of Afghan women – the human rights subject – from the brutality of the Taliban. Critics quickly decried this move as a manipulative deployment of women's human rights, pointing to the US government's prior neglect of women's issues in Afghanistan and elsewhere.[16] US support of the violently misogynist Northern Alliance in the war against the Taliban – along with extensive backpedalling in recent years by the Afghan government of Hamid Karzai with regard to women's rights – have, not unexpectedly, confirmed these initial critiques.

The Bush administration most clearly articulated its civilising mission of rescue in the National Security Strategy (NSS), released in September

2002, which states that the US will 'champion aspirations for human dignity' and oppose those who resist it.[17] The NSS unapologetically claims the US's 'aim is to make the world not just safer but better [. . .] And this path is not America's alone. It is open to all.'[18] Spelling out the Bush doctrine, this document justifies military actions anywhere in the globe by envisioning the supranational threat posed by terrorists (specifically described as pan-Islamic fanatics). Moreover, the NSS declares the US intent to 'wage a war of ideas to win the battle against international terrorism'.[19] Mobilisation of women's human rights in the support of this 'war of ideas', as is apparent in Laura Bush's comments, further militarised humanitarian intervention as a crucial tool in the war on terror.

Photojournalists who turned to Afghan women and children to visualise the innocent victims of the war have fed into this post-9/11 rescue narrative. A series of photographs taken in September 2001 of Afghan women fleeing to the Pakistani border in anticipation of a military attack includes a photograph by John McConnico in which the close-up framing brings the viewer into a shared space with two women standing in the foreground in blue burqas, including full face coverings.[20] In the background, little can be seen except a rural road with a few people walking into the distance. The caption provides no information about the women other than to describe them as 'burqa-clad', a reference that resonates intertextually with other political and media narratives about women's vulnerabilities under the Taliban. Numerous photographs like this one by both independent and affiliated photojournalists appeared in the first months of the war, thus providing visual support for the emerging post-9/11 justifications for the US war on terror.

The prominence of the burqa in AP's archive relies for its political resonance on centuries-long Orientalist claims about the oppression of veiled women. For instance, the compositional strategy of McConnico's photograph pulls the viewer into the scene but rather than encourage empathy or familiarity, proximity to the veil here emphasises social distance as it plays on historical desires to uncover and thus make visible the 'real' women behind the face coverings. Such routinised spectacles of suffering elide the long and diverse history of gender struggles and feminist movements in the Middle East. Likewise, in Afghanistan, a more complex gender society exists than hegemonic rescue narratives suggest. Central to these narratives is a presumption of universality, a belief that has proven to be a durable, if problematic, foundational claim for women's human rights. Feminist scholars and activists are particularly

sceptical of the ways in which claims of universality erase historical differences and inequalities. Julietta Hua argues, for instance, 'like the concept of human, the category woman is vexed by the fact that it is by definition a broad term used to refer to quite a number of people who may have very different relationships to the category.'[21] Afghan women have indeed faced tremendous violence, exploitation and oppression, but human rights discourse typically ignores women's agency and activism at the same time it presumes a lack of gender oppression in the West.[22] In providing no information about the communities of support or risk that condition these women's lives, photographs of fleeing Afghan women reproduce a 'politics of pity' that narrows the representation of gender in this conflict zone to that of male oppression and intense vulnerability for women. Moreover, photojournalists' gaze at women and children rarely includes communities or male family members who have likewise suffered not only from the Taliban regime but also from Euro-American imperial aggression in the region. This selective vision of precarity reinforces what Lilie Chouliaraki describes as mainstream media's mapping of the world into distinct zones of (spectator) safety that contrast with zones of (Third World) suffering.[23]

In the AP's coverage of the war on terror, who is visibly 'human' typically ties precarity to a gender politics based in the ideal of the innocent victim, as in Amir Shah's October 2001 photograph of two women clad in burqas selling food on a Kabul street.[24] One woman leans towards a girl not yet old enough to wear a burqa, while the other woman turns away from the camera. Shot at eye level with the women, men's feet are visible in the background but otherwise these women seem isolated and vulnerable. In front of this group sits a paltry collection of bread and other wrapped supplies, visually confirming the caption's claims about human rights conditions: 'Twenty-four years of war in Afghanistan – combined with drought, displacement, grinding poverty and human rights abuses – have turned the country into a humanitarian catastrophe.' Significantly, the two adult women lack any individuated subjectivity, both because their faces are not visible to the camera and because they remain nameless. Like the hanging burqas, the anonymous women function as synecdoches for women's human rights violations, reconfirming a universalising imaginary in which gendered forms of precarity are linked to a racialised vision of the Third World as impoverished and chaotic 'failed states'. Moreover, the caption disavows Western complicity in these conditions of suffering when it refers to 24 years of war, grinding poverty and human rights abuses without ever

mentioning foreign military intervention. Instead, the camera hails the viewer to witness conditions for the most vulnerable by drawing the gaze towards the girl who sits in the centre of the composition. This compositional strategy emphasises the girl's 'humanness', especially the attractive innocence of her youthful face, in sharp contrast to the absent subjectivities of the adult women who lack 'faces'.

Feminist witnessing, long an important strategy for social justice advocacy, has become more prominent since the emergence of women's human rights activism in the 1990s.[25] From survivor testimonials to international juridical proceedings, witnessing provides crucial means to garner public attention to abuses of women's human rights associated with state-sanctioned violence. Amid the varied circuits of witnessing, the witness located at a temporal, geographical and/or cultural distance from survivors performs an important function because witnessing is a social and political act, never just individual stories of suffering.[26] If witnessing entails both an enunciator and a listener or viewer, feminist witnessing rests in the recognition that, as Cathy Caruth observed, 'we are implicated in each other's trauma.'[27] Insightful critiques of the politics of empathy, though, caution against presuming the ability to share in another's pain, instead calling for acts of recognition to acknowledge the hierarchical inequalities that structure difference.[28] In this regard, media witnessing of distant suffering, including emotional appeals based in empathy and/or an ethics of care, are themselves conditioned by hierarchies of power and inequality.[29] In Shah's photograph, for instance, even as the young girl's visible face provides a means to recognise her humanity, this site of unveiling mixes the scopic desire to uncover hidden mysteries of gender and sexual alterity with Western fantasies of rescuing brown women.

Women's Human Rights and 'American Internationalism'

It is tempting to contrast this representation of gendered forms of precarity with pictures of women activists establishing educational opportunities and assuming leadership positions in 'post-Taliban' Afghanistan. One series from 2006, titled 'Five Years Later', for example, shows women in public settings, working, shopping without men and practising karate.[30] Moreover, in the first years of the war, photojournalists routinely featured feminist activists as well as women political leaders appointed to ministerial positions in the Karzai administration. Triumphalist reporting of the courage and determination of women and girls to claim

their rights, however, has lessened in recent years as the war drags on and persistent violence against women makes such claims less credible. While representations of empowerment importantly speak to women's political and social agency, connections between liberation and neoliberal interventionist politics problematises this visual turn to empowerment.

The Bush doctrine, outlined in policy statements like the NSS, promised US protection and aid to nations who remain compliant allies (implicitly denying the possible presence of 'terrorists' that may be 'homegrown', such as white supremacist groups). This promise of aid imagines that Afghans, Iraqis and other Muslims will abandon 'religious fanaticism' in order to become part of the transnational community that the document labels 'American internationalism'. Though the NSS explicitly claims to be a doctrine of national security, it necessarily also envisions a transnational citizen-subject, one who needs American assistance not only to combat terror but 'to do their part', that is, to be civilised into the 'American international' community.[31] As the NSS shows, the Bush doctrine of 'American internationalism' declared the legitimacy of military intervention as a means to produce an ideal transnational citizen freed from a backward society and now able to participate in the global marketplace.

With women figured as the most precarious members of Third World societies, Annabelle Sreberny notes that changing conditions for women are 'increasingly taken as an index of the democratization and development of a society'.[32] In coverage of the war in Afghanistan, photographs that show Afghan women's 'new' ability to move through public space routinely provide evidence of this supposed democratisation. These pictures visualise the politico-humanitarian narrative of once-immobilised and now-liberated bodies – women couldn't go out of their houses, couldn't move, couldn't work, couldn't move their bodies through space and now they can. If the burqa operates within the logic of Orientalism as a symbol of religious fundamentalism, throwing off the veil becomes a sign of liberation, democratisation and women's equality. In one AP picture, in the middle of a group of veiled women walking on a city street, one woman has uncovered her face and smiles at the camera.[33] Offering, at once, a before-and-after scene of liberation, the photograph seems to suggest that even the smile did not exist before the US invasion. Such scenarios equate Afghan women's 'new' ability to move through public space with a liberal ideal of rights-bearing citizenship.

Pictures of unveiled women that privilege an Enlightenment ideal of a rights-bearing subject operate within a logic of modernity. As

Hua observes, 'Women's human rights is implicated in this progressive, modern narrative as the so-called final global site where the resolution of all those roadblocks impeding emancipation must be addressed, and it is the "othered" bodies of the women victim to human rights violations that are signified as the last and latest subjects awaiting freedom.'[34] A triumphalist narrative about Third World women as 'the last and latest subjects awaiting freedom' is perhaps most evident in AP photographs of Afghan women's efforts to bring education to girls. Stories and pictures emphasise women's determination to teach girls amid often extremely dangerous conditions.[35] These courageous efforts resonate with one of feminists' most long-standing agendas, that is, to enhance women's opportunities through educational practices. The focus on education exemplifies the paradoxical structures of visual witnessing. On the one hand, pictures of women in positions of authority with captions that remind viewers of their struggles to create better conditions for themselves and their children serve as visual testaments to women's agency and activism. At the same time, such calls to witness these struggles occur within broader intertextual contexts in which liberation narratives ignore the complex historical determinants that shape current conditions of gender inequality. More specifically, the emphasis on education as a human right rarely includes discussions about the US and NATO's (highly equivocal) commitments to such efforts or how women's struggles continue to be compromised as much by foreign military intervention as by a resurgence of the Taliban. Moreover, ahistorical representations provide no insights into the gender politics within World Bank policies, WTO practices and the legacies of imperialism. Alongside photographs of women and children living in extreme poverty and refugees fleeing from violence, pictures of women at work or in the marketplace function as the obverse to the visualisation of precarity within women's human rights discourse. In that regard, photographs that embrace signs of women's progress typically hail viewers to be 'authenticating witnesses' to a Western imaginary about gender liberation.[36]

Importantly, liberation scenarios connect modernity to the global marketplace through this rhetoric of transnational citizenship. The NSS, for instance, promises modernity, civilisation and security to those who support the United States through a commitment to global free trade, which includes pro-growth legal and regulatory policies, tax incentives for capital investment, and other processes to ensure the growth of market economies favourable to Western investment. 'Our long-term objective should be a world in which all countries have investment-

grade credit ratings that allow them access to international capital markets and to invest in their future.'[37] The NSS's statement that nations with economic systems unreceptive to free trade do not accord their people 'freedom' attempts to legitimise the administration's reliance on global militarism to promote neoliberal political and economic policies. Real freedom, the Bush administration argues, is 'the freedom for a person – or a nation – to make a living. To promote free trade the United States has developed a comprehensive strategy [including] seize the global initiative.'[38] The Bush doctrine (one never repudiated by the Obama administration) outlines an agenda not just to combat 'Muslim terrorists' but also to restructure errant nations to be more cooperative with American capital investments.

Crucially, in the months after the fall of the Taliban, many photographs visualised women as newly constituted citizens through participatory acts in a global commercial culture. In the days after Kabul fell, for instance, pictures proliferated of women wearing nail polish and getting their hair styled as evidence of women's liberation. Often in these pictures, one or more women have removed their face coverings to look directly into the camera. In a 2006 photograph by Rodrigo Abd, two Afghan women walk past a storefront featuring six blonde mannequins in brightly coloured Western-style evening dresses.[39] Contrasting past and present in the picture, one woman wears a burqa with a full face covering while the other woman in a white headscarf stares directly at the camera. Located in the centre of the composition, her white scarf as much as her gaze calls attention to social change. Although her unsmiling stare remains inscrutable, the bright colours of the mannequins' clothing and the absence of any signs of war suggest a thriving consumer economy. Hailing liberation through participation in consumer culture, of course, ignores the complex intersections between families, communities, local economies, social imperatives and national and transnational terrains through which women negotiate identities, agency and rights. Women are configured instead as now-liberated agents in the marketplace in contrast to the spectre of indigenous masculinity found repeatedly in the United States' 'war on words'.

Grewal, Hesford and others have rightly challenged the pervasive representation of women's victimisation in visual human rights advocacy. To expand upon their critique, I argue, human rights advocacy operates (as it must) on the presumption that intervention can and does make a difference. Faith in the benefits of intervention necessarily must imagine the world into which women will achieve stability, security and rights.

The AP archive participates in conceptualising this world, often by utilising a long-standing convention in photojournalism of 'before and after' stories designed to map progress. In the archive, images of precarity that include extreme destitution, refugees fleeing violence, homelessness and signs of bodily injury starkly contrast with pictures of women buying goods in the marketplace, getting an education and participating in the political sphere. As important as it is to include representations of women's empowerment in the discourse of human rights, we must also recognise that such images often present a decontextualised ideal that confirms a Western imaginary about progress in the Third World. In this way, the witness is called upon to authenticate a story not only about human rights abuses but also, importantly, about what constitutes the social world in which women have 'rights'.

Precarious Witnessing

In AP's post-9/11 archive, non-combatant Afghan women appear as human rights subjects coping with extreme violence and displacement. As synecdoches of a failed nation state ravaged by decades of foreign intervention and repressive domestic governments, Afghan women embody highly contested concepts of identity as well as more abstract notions like 'transnational citizenship'. Following the logic of this critique, however, can back feminist analytics into a corner in which photojournalism appears to do little more than reproduce a Eurocentric gaze at gendered spectacles of precarity. Uneasy with this conclusion, I want here to offer a methodical intervention that more fully accounts for the politics of affect in media witnessing of conflict zones. As I argued in the introduction, Di Lauro's photograph of the two burqas reproduces a scopic gaze at gendered suffering, yet haunting allusions to unknowable subjectivities also push against hegemonic scripts. Witnessing is not a ntable ulte, as Jane Blocker argues, but rather one in which various actors, institutions, contexts and texts interact in efforts 'to authorize one kind of witness over another'.[40] In this section, I interrogate the ways in which representations of precarity not only reproduce the minefields of spectacle discussed above but also provide visual opportunities to grapple with subjectivity and relationality as potential means for resisting the hegemonic. As I asked in the introduction, what happens when the visible subject does not conform to expectations about who deserves rescue? Might we recognise subjectivity differently if precarity is defamiliarised?

Kamran Jebreili's 2001 photograph of a group of burqa-clad women huddled together behind a chain-link fence exemplifies the potentials and problematics of media witnessing (see Plate 9). In the centre foreground, the only woman not wearing a face covering grips the fence as she stares intently at the viewer. This, though, is not a portrait of a beautiful young girl such as Steve McCurry's widely reproduced 'Afghan Girl', originally published on a 1984 cover of *National Geographic*.[41] Instead, the central subject is an older woman whose missing teeth and ravaged face hauntingly gestures towards vulnerabilities that remain unavailable to the viewer's gaze. Moreover, the hand that grips the fence displays a gold wedding band that likewise hints at an unseen domestic life. The caption reports that the woman 'tells the photographer "we don't need pictures, we need food" while Afghan women and children beg for food and money in Herat, Afghanistan, Saturday, Dec. 8, 2001'. Through the caption, the woman's voice of agency directly chastises the news media's – and by extension the viewer's – scopic desires even as she articulates the needs of her vulnerable community. This close-up of a different kind of human rights subject also disrupts hegemonic expectations about which victims deserve humanitarian aid. Affective instabilities turn the witnessing gaze back onto the viewer in ways that expose some of the complex visual politics of witnessing precarity.

In *Precarious Life*, Judith Butler explores the possibilities for ethical responses to social violence like 9/11 that would reject the politics of vengeance which has, to date, compelled the American war on terror. She calls instead for the recognition of grief as constitutive of the experience of being human, one that reveals subjectivity to be contingent on relations with others. As she queries, 'From where might a principle emerge by which we vow to protect others from the kind of violence we have suffered, if not from an apprehension of a common human vulnerability?' Insistent, nonetheless, that vulnerability is 'allocated differentially across the globe', this call for a recognition of shared precariousness invites us to look at suffering with an eye toward an ethical politics intent not on revenge but on ameliorating conditions of precarity.[42]

To support an ethics based in recognition, Butler turns to Emmanuel Levinas's expansive concept of the face as the figurative stand-in for a gesture, the shrug of shoulders or other visible referents of the human. If visuality is foundational for recognition of the humanness of the other, as Levinas suggests, then we need to understand more fully how affects operate in visual reportage of conflict zones. In both *Precarious Life* and *Frames of War*, Butler's denunciation of the Western media

for its paternalism and Orientalist imaginings strongly echoes other transnational feminist critiques. Despite the richly generative insights of this scholarship, including a broad awareness of the polysemic and unstable nature of representation, scholars who focus solely on the content in visual representations often fail to consider the contested nature of these practices. Without more attention to *how* visual media looks at human vulnerability, not just *who* we look at, critics end up simply taking sides in the polarised debate about whether or not the media can be a site for empathy and political action. Drawing out Butler's argument about recognition, methodical attention to the aesthetic properties in images of conflict zones open up for consideration the role that affect plays in media witnessing.

In other words, while it is reasonable to argue that Jebreili's photograph reproduces a hegemonic gaze at suffering, the emotional intensity of the woman's hand gripping the fence exemplifies the ambivalent, contradictory and frankly messy affective politics of witnessing precarity. Distinct from historically constituted emotions like pity or sentimentality, affects can be understood as complex somatic and emotive responses. Or, as Mieke Bal says, affect is a 'felt uncertainty'.[43] Similarly, Jill Bennett argues that affect is what grabs the viewer and in so doing can function as a catalyst for a critical encounter with the politics on view.[44] In this regard, formal elements in representation prompt responses that are multiple, unpredictable and not necessarily aligned with each other. The human scale of Jebreili's photograph, which brings the viewer into the same visual plane with the woman's face and her intense grip on the fence, can provoke the 'squirm', to use Bennett's beautiful phrase to describe embodied responses to discomforting affective elements in an image.

Affects that expose a different kind of humanness reveal spectatorship and witnessing to be intertwined, not oppositional, looking practices.[45] While spectacle may dominate the viewer's gaze at this objectified figure of oppression, the camera also establishes a witnessing gaze in which this unruly appearance of human suffering destabilises attempts to harness 'humanness' to a Western imaginary. Importantly, while these felt uncertainties are not necessarily tethered to normative emotions like sentimentality, they are historically situated in intertextual contexts. Thus, affects can as easily lead to appropriation as to political critique. After all, affects based in understandings of relationality, such as care or compassion, cannot be separated from structures of power and domination; or, as Kennedy writes, 'postures of care and domination draw on

the same foundation, the primal scene of human vulnerability.'[46] In this regard, photojournalism, like other forms of mainstream media, messily produces both a Western imaginary *and* affective resonances that push up against the boundaries of that imaginary.

Taking this interrogation of affect further, what happens when subjects of the camera's gaze look back in unanticipated ways, or when women do not conform to Western expectations of precarity? In a photograph by John McConnico from October 2001, two women lean against a wall underneath graffiti that states, 'stop women beating' (see Plate 10). Drawing the eye to the corner where the women sit, this powerful cry for intervention written in English hails the viewer to witness within a political discourse about women's human rights made popular through Western feminist activism. The composition, moreover, emphasises distance, not relationality, between the subjects and the viewer. The medium-distance shot looking slightly down frames the image so nothing of the area is visible. The two women sitting against the wall appear isolated while the lack of surroundings erases the contexts of these women's lives, compositionally reinforcing their symbolic value for the viewer's distant gaze. After describing the subjects of the photograph, the caption explains that Britain and Pakistan issued a warning that the Taliban must hand over Osama bin Laden or face military strikes. The text thus reinforces the visual isolation of the two women within a narrative that reiterates US–NATO security claims about terrorism.

Yet, something more is going on here than a reliance on gendered spectacles of victimisation to support war rhetorics. Other than proximity, there are no indicators that these women are associated with the graffiti, or even that they are facing extreme hardships. Indeed, one woman leans over, whispering to her companion with what looks like a smile on her face. Competing affects between the women's gestures and the graffiti certainly do not discredit the demand to end abuse but do destabilise assumptions about these women's relationship to rights violations. The women's reactions to the camera suggest gendered subjectivities that remain unnarrated and inaccessible to the viewer but at the least trouble habitual assumptions in the West about Islamic society as violently patriarchal. Similarly, the affective pull in Jebreili's photograph of the woman at the fence lies precisely in the unknowability of the historical conditions of her suffering. As Butler insists, recognising the radical unknowability within the self can give rise to an ethical reckoning with the limits of knowing the

other. Does the inscrutability here call upon the viewer to recognise these women's subjectivities as inaccessible? Does it push the viewer to question assumptions about identity and precarity? My point here is that mainstream photojournalism depicts conflict zones in ways that both reproduce and problematise conventional notions of identity, recognition and relationality. In other words, the smiles and gestures refuse a monolithic reading, creating a 'mesmerizing uncertainty', albeit without necessarily undoing a rescue narrative. The affect, for a careful viewer, is to be pulled in and pushed back, to be compelled to look without necessarily finding a clear moral grounding.[47] Affects, as we see in both McConnico's and Jebreili's photographs, combine with content to provoke a critical encounter in which emotional complexities can destabilise the news media's hegemonic gaze at precarity.

This essay has analysed photographs of women's human rights in AP's coverage of the war in Afghanistan in order to explore some of the contingencies, contradictions and affective complexities of witnessing precarity. Calling attention to the ways that this archive typically suppresses how women live within the interstices of multiple citizenships and belongings, I also argue that often small elements in these pictures, such as a smile or the grip of a hand on a chain-link fence, remind us to consider further the relationship between visuality and political knowledge. In the AP archive of the war on terror, representational politics do not always constitute human rights in predictable ways. The terms of women's human rights mobilised in these pictures do not invoke an ideal status (for instance, freedom or liberty) but instead visualise gendered vulnerabilities fraught with the tensions of belonging to a community at war. These images are politically significant, and sometimes quite powerful, not because they speak a better truth or reach out past Orientalist narratives, but because affective elements within the images refuse a stable or monolithic reading. Photojournalism does not, indeed can not, create pure spaces of either progressive or hegemonic witnessing; instead this genre establishes conditions for grappling with, confronting and engaging with the affective politics of precarity as part of broader conversations about conditions of suffering and women's struggles for social and political empowerment within conflict zones. Photojournalism, in other words, creates not a clear narrative but rather produces a sense of inexplicability alongside the hegemonic logics of contemporary human rights discourse.

Notes

1 See Luc Boltanski, *Distant Suffering: Morality, Media, and Politics*, trans. Graham Burchell (Cambridge, 1999), pp. 3–19. For feminist analyses of this issue, see Inderpal Grewal, *Transnational America: Feminisms, Diasporas, Neoliberalisms* (Durham, NC, 2005); and Wendy S. Hesford and Wendy Kozol (eds), *Just Advocacy: Women's Human Rights, Transnational Feminisms and the Politics of Representation* (New Brunswick, NJ, 2005).

2 Grewal, *Transnational America*, chapter 3.

3 Wendy Hesford, *Spectacular Rhetorics: Human Rights Visions, Recognitions, Feminisms* (Durham, NC, 2011).

4 Among the extensive field of Middle East and North African feminist studies, see, for example, Lila Abu-Lughod (ed.), *Remaking Women: Feminism and Modernity in the Middle East* (Princeton, NJ, 1998); Suad Joseph and Susan Slyomvoics (eds), *Women and Power in the Middle East* (Philadelphia, 2001); and Shahnaz Khan, 'Between here and there: feminist solidarity and Afghan women,' *Genders* 33 (2001), available at http://www.genders.org (accessed 18 February 2014).

5 See, for example, Krista Hunt and Kim Rygiel (eds), *(En)gendering the War on Terror: War Stories and Camouflaged Politics* (Burlington, VT, 2006); and Barbie Zelizer, 'Death in wartime: photographs and the "other war" in Afghanistan', *Harvard International Journal of Press/Politics* 10/3 (Summer 2005), pp. 26–55.

6 Hesford and Kozol, *Just Advocacy*, pp. 1–29; and Wendy Kozol, 'Visual witnessing and women's human rights', *Peace Review* 20/1 (January 2008), pp. 67–75.

7 Liam Kennedy, 'American studies without tears, or what does America want?', *Journal of Transnational American Studies* 1/1 (2009), p. 8. See also Sharon Sliwinski, *Human Rights in Camera* (Chicago, 2011).

8 For this study, I reviewed Associated Press photographs of Afghanistan from the AccuNet/AP Multimedia Archive because it is one of the two largest producers of visual news in the world. See, for example, Ted Madger, 'Watching what we say: global communication in a time of fear', in D. Thussu and D. Freedman (eds), *War and the Media: Reporting Conflict 24/7* (London, 2003), pp. 87–100.

9 Boltanski, *Distant Suffering*.

10 For recent perspectives on this debate, see David Campbell, 'Horrific blindness: images of death in contemporary media', *Journal for Cultural Research* 8/1 (January 2004), pp. 55–74; Thomas Keenan, 'Mobilizing shame', *South Atlantic Quarterly* 103/2–3 (2004), pp. 435–49; and Rosalind C. Morris, 'Images of untranslatability in the US war on terror,' *Interventions* 6/3 (2004), pp. 401–23. Susan Sontag's last work, *Regarding the Pain of Others* (New York, 2003), also addresses this debate.

11 Grewal, *Transnational America*, p. 2.

12 Paul Frosh, 'Telling presences: witnessing, mass media, and the imagined lives of strangers', in Paul Frosh and A. Pinchevski (eds), *Media Witnessing: Testimony in the Age of Mass Communication* (New York, 2009), p. 51.

13 Ibid., p. 60.

14 For a recent exhibition on this issue, see Mark Reinhardt, Holly Edwards and Erina Dugganne (eds), *Beautiful Suffering: Photography and the Traffic in Pain* (Chicago, 2007).

15 Judith Butler, *Frames of War: When is Life Grievable?* (New York, 2010), p. 26.

16 See, for example, Sharon Smith, 'Using women's rights to sell Washington's war', *International Socialist Review* 21 (January–February 2002); and Lila Abu-Lughod, 'Do Muslim women really need saving? Anthropological reflections on cultural relativism and its others,' *American Anthropologist* 104/3 (2002), pp. 783–90.

17 The National Security Strategy of the United States of America, September 2002, p. 4, available at http://georgewbush-whitehouse.archives.gov/nsc/nss/2002 (accessed 16 March 2014).

18 Ibid., p. 1.

19 Ibid., p. 6.

20 John McConnico, 'Burqa clad women leave Afghanistan at the border between Afghanistan and Pakistan in Torkham, Pakistan, Saturday, Sept. 15, 2001', Associated Press photo, available at www.aparchive.com.

21 Julietta Hua, *Trafficking Women's Human Rights* (Minneapolis, 2011), p. xxii.

22 See Grewal, *Transnational America*, chapters 3–4; and Khan, 'Between here and there'.

23 Lilie Chouliaraki, *The Spectatorship of Suffering* (Thousand Oaks, CA, 2006), p. 83.

24 Amir Shah, 'Women clad in burqas sell food in Kabul, Afghanistan, Saturday, Oct. 20, 2001. Twenty-four years of war in Afghanistan – combined with drought, displacement, grinding poverty and human rights abuses – have turned the country into a humanitarian catastrophe', Associated Press photo, available at www.aparchive.com.

25 Niamh Reilly, *Women's Human Rights: Seeking Gender Justice in a Globalizing Age* (Malden, MA, 2009); and Kay Schaffer and Sidonie Smith, *Human Rights and Narrated Lives: the Ethics of Recognition* (New York, 2004).

26 Irene Kacandes, *Talk Fiction: Literature and the Talk Explosion* (Lincoln, NB, 2001).

27 Quoted in ibid., p. 96.

28 See, for example, Dominick LaCapra, *Writing History, Writing Trauma* (Baltimore, 2001).

29 Kennedy, 'American studies without tears'; Hesford, *Spectacular Rhetorics*, chapter 1.

30 See, for example, Faraidoon Poya, 'Women practice karate at a gym in Herat city, western Afghanistan, Wednesday, Sept 13, 2006. Five years into the US-led war in Afghanistan, the country is far from won over, or even safely on the path to stability and democracy', Associated Press photo, available at www.aparchive.com.
31 National Security Strategy, p. 9.
32 Annabelle Sreberny, 'Unsuitable coverage: the media, the veil, and regimes of representation', in T. Oren and P. Petro (eds), *Global Currents: Media and Technology Now* (New Brunswick, NJ, 2004), p. 175.
33 Bullit Marquez, 'An Afghan woman smiles as she reveals herself among other women in burqas while strolling in Kabul, Afghanistan on Saturday Jan. 26, 2002. Under the harsh Taliban rule, Afghan women were not allowed to go out in the open without donning a burqa, fully drawn so as to cover themselves from head to foot and could be beaten if any part of their body is revealed even by accident', Associated Press photo, available at www.aparchive.com.
34 Hua, *Trafficking Women's Human Rights*, p. xxv.
35 See, for example, Laura Rauch, 'Afghan women attend a school run by the Revolutionary Association of the Women of Afghanistan (RAWA) in Quetta, Pakistan, Monday, Oct. 22, 2001. Inside Afghanistan, RAWA runs secret schools for girls and women, an extremely dangerous undertaking. Teachers, and perhaps students as well, could face execution if caught by the Taliban', Associated Press photo, available at www.aparchive.com.
36 Jane Blocker, *Seeing Witness: Visuality and the Ethics of Testimony* (Minneapolis, 2009), pp. xiii–xxiii.
37 National Security Strategy, p. 18.
38 Ibid.
39 Rodrigo Abd, 'Two Afghan woman walk next to mannequins at a women's gallery downtown Kabul, Afghanistan, Monday, May 15, 2006', Associated Press photo, available at www.aparchive.com.
40 Blocker, *Seeing Witness*, p. xiii.
41 See, for example, Hesford, *Spectacular Rhetorics*, pp. 1–5; and Holly Edwards, 'Cover to cover: the life cycle of an image in contemporary visual culture', in Reinhardt, Edwards and Dugganne, *Beautiful Suffering*, pp. 75–92.
42 Judith Butler, *Precarious Life: The Powers of Mourning and Violence* (London, 2004), pp. 30–1.
43 Mieke Bal, 'The pain of images', in Reinhardt, Edwards and Dugganne, *Beautiful Suffering*, pp. 93–115.
44 Jill Bennett, *Empathic Vision: Affect, Trauma, and Contemporary Art* (Stanford, CA, 2005), p. 17.
45 Hesford, *Spectacular Rhetorics*, p. 57.
46 Kennedy, 'American studies without tears', p. 9.
47 Many thanks to Sandra Zagarell for this insight.

10 The Forensic Turn

Bearing Witness and the 'Thingness' of the Photograph

Paul Lowe

I have been a witness, and these pictures are my testimony. The events I have recorded should not be forgotten and must not be repeated.

James Nachtwey

Many photographers, their representatives and their critics see 'witnessing' as a key feature of their role. For Peter Howe, a former picture editor at *Life* magazine who has worked with many of the most significant photographers, 'the job of the photojournalist is to witness those things that people don't want to think about. When they're doing their job right, they are taking photographs that people don't want to publish by their very nature.'[1] Tom Stoddart published *I-Witness*, a monograph of his images from the world's trouble spots; a recent Reuters multimedia presentation is simply entitled 'Bearing witness: five years of the Iraq War' and claims that 'This is their testimony – bearing witness to ensure the story of Iraq is not lost.'[2] Many photographers echo these sentiments. Susan Meiselas maintains that she feels part of a 'tradition of encounter and witness – a "witness" whose work has been based on a concern about human rights violations'.

However, this role of witness is more complex than at first sight, and Meiselas articulates some of the self-reflexivity necessary in this role in her understanding of the potential and the limitations in the act of witnessing:

the other side of 'witness' is that we do intervene, and we intervene by the fact of our presence in a particular place. We change how people see themselves sometimes and how others may come to see

them. I'm also concerned about how we see ourselves in the process of our role as witnesses.[3]

In this statement, she highlights the ongoing dilemma for photographers of suffering: the interplay between the desire to engender a social good – the ending of exploitation, discrimination or extermination – with the desire not to expose the victim to further unnecessary suffering, either in the performative act of being photographed, or the re-performative act of displaying that image to an audience. The potential ethical reward for exposing the injustice visually therefore has to be balanced against the potential ethical penalty of re-victimisation. To complicate this issue further, in the extreme case of the imaging of atrocity, the presence of an optical trace of the atrocity has become almost an essential prerequisite for its acknowledgement by society. For Judith Butler, the photograph is now 'built into the notion of atrocity, and photographic evidence establishes the truth of the claim of atrocity in the sense that photographic evidence has become all but obligatory to demonstrate the fact of atrocity'.[4]

Traumatic representation is therefore caught in a paradox of representation. The more degrading or acute the trauma, the more the potential subject might be seen to be re-victimised by the act of representation and the less able they might be to give active consent to such an act. However, from the point of view of bearing witness, and the social and moral good that witnessing might entail, the more violent that trauma becomes, the more valuable and important it becomes that the trauma is witnessed. This is the continual dilemma of the witness to atrocity, the more desperate and debased the story, the more significant it becomes and the more necessary and likely it is to be reported.

Images of atrocity are therefore deeply problematic, in that they potentially create a tension between form and content and are often accused of re-victimisation, compassion fatigue, exploitation and the aesthetisation of suffering. How to resolve this dilemma has been a major question for both critics and practitioners alike. As an alternative, therefore, there is considerable potential in examining images associated with atrocity that do not depict the actual act of violence or the victim itself, but rather depict the circumstances around which the acts occurred. Such images of the absence of visible violence can lead the viewer into an imaginative engagement with the nature of atrocity, and the nature of those who perpetrate it. In exploring this absence, Arendt's 'banality of evil'[5] can be taken to mean that the spaces in which atrocities take

place are often nondescript, everyday and banal, and that the people who commit them may appear on the surface to be so as well, even if their interior motivations and rationales are far more complex than that they were simply following orders.[6] Photography, with its optical-mechanical process, is adept at recording the banal facts of the scene, and by inviting the viewer to scan the image for minute details, often generates a tension between such mundanity and the audiences' knowledge of the potential import of the situation garnered via a caption.

The genre of 'aftermath photography', exploring the topography of sites of conflicts, is well established, but this paper will examine the photographic representation of objects and things rather than landscapes in order to emphasise the 'thingness of the photograph', an approach I identify as 'post-factum witnessing'.[7] As a contribution to the debate, through examining case studies from the conflict in the former Yugoslavia, this chapter will therefore explore the possibility that the act of bearing witness to past atrocities can be located in the photograph itself, rather than in the photographer, and that the unique material qualities of the image as an independent object serve to enhance its role as a social agent in its own right. The materiality and durability of the image, combined with its temporal ability to transcend linear time, generates the possibility of photographs themselves becoming social agents and bearing witness to past events, lives and crimes, untethered from their authors. This materiality obtains whether the image is encountered as a physical print on a gallery wall, reproduced in a book or viewed digitally on a screen; the photograph exists as an independent artefact in and of itself as well as serving as the visual testimony of the photographer. As such, it becomes a form of secondary witnessing that is portable and easily viewed. In the case of images of atrocity, photographs that do not show the act of violence itself, but rather allude to it by depicting the perpetrator or the aftermath, might engage our imaginations more successfully than those that are more graphic, from which we are simply repulsed. Images of things that depict the traces of people rather than of people themselves can potentially avoid much of the ethical quagmire of photojournalist practice whilst retaining its emotional and moral impact. The photograph operates at several levels: it is often a visual record of material things in the world, yet is also a thing in itself, with its own material qualities, it thus has a dual 'thingness'. The material presence of the thing is therefore amplified by the material presence of the photograph.

The Durable Materiality of the Image

Photographs are durable vestiges of memory; fragmentary traces of traces, they perform the simultaneous possibility of the known and the unknown, the seen and the unseen, the presence and the absence, and contain within the frame the ghostly shreds of a past reality as well as the knowledge that that reality is no longer there. As Olivier observes, 'like archaeology, photography inscribes events in matter,'[8] making the 'past present and tangible'.[9] Like shards of a tarnished old mirror that has been shattered, photographs reflect the past into the present in a fragmentary, partial way, but with careful reassembly they carry the potential to restore coherence to the overall view. Like shards, however, they can also wound, piercing the viewer with a significant detail or bruising them with the brutal testimony that what is in the photograph is now lost forever, destroyed by time. The photograph is simultaneously a technologically determined artefact, evidence that a specific thing existed at a specific juncture in history, a subjectively edited composition, and a repository for memories, feelings and emotions. By playing on the imagination of the viewer, the image can project backwards and forwards through temporal space. Thus each image retains within the frame a self-contained story, a sense of occurrences before the photograph and possibilities afterwards. As Moeller explains: 'the recognition that the image is a record of what has happened up to that instant inspires questions about what might come to pass. Photographs freeze time, then dole it out infinitely, as long as one chooses to look and wonder. They are the "residue" of continuous experience.'[10]

This ability of the photograph to oscillate between past and present, to re-present the past into the present, is analogous to contemporary approaches to understanding time from a historical and archaeological perspective. The traditional historicist view that time is linear and progressive has been challenged by concepts of time as being folded and layered, with moments connecting with each other across space and time rather than progressively one after the other.[11] Time thus becomes a much more fluid, interactive concept, which Shanks describes as a 'river, forking, branching, slewing, slowing, rolling back on itself' or even as a 'crumpled handkerchief, in which apparently widely separated points may be drawn together into adjacency'.[12] This is a key concept for the understanding of how photographs operate. As soon as the image is captured, it becomes historical, in the sense that that moment has passed. Subsequent engagements with the image are vivifications of the past: they make

connections between the past event, emotion or feeling and the present condition of the viewer. This follows Baer's assertion that photographic temporality is not linear and chronological, but rather more consists of 'singular bursts and explosions'[13] and thus offers the viewer a 'chance to see in a photograph not narrative, not history, but possibly trauma'.[14] By its very nature, the image can only be experienced after the event itself, so the temporality of photography matches that of traumatic memory. As Caruth explains, trauma is characterised not by the event itself but rather by the 'structure of its experience or reception' so that the event is 'not assimilated or experienced fully at the time, but only belatedly, in its repeated possession of the one who experiences it'.[15] The photograph is arguably a valuable form of bearing witness as opposed to simply witnessing, as it necessarily involves a retelling or reinterpretation of the past by an engagement with the traces and evidence of that past in the present, and a recognition and involvement with the histories of both people and places. As Olsen observes, the past is 'not left behind but gathers and folds into the becoming present, enabling different forms of material memory'.[16]

Another function of the camera that enhances its effect is its propensity for recording details. Paradoxically this operates on a macro and micro level: the camera records everything before it, according the same level of value and fidelity to every element of the frame, but in its very nature the camera slices details out of a continuous narrative, creating fragments of experience that provide a discontinuous narrative of events. Many have noted this characteristic of the camera, including Trachtenberg, Barthes, Sontag and Edwards,[17] who describe it as a 'levelling of equivalence of information, with the trivial and the significant intertwined and shifting place'.[18] Each of these 'fragments' tells its own story, but together they can form a more complete picture of an event. Photography is therefore uniquely suited to exploring the banal and ordinary; by paying attention to things, the camera can endow them with a presence and stature that transcend their immediate value. The photograph's dual 'thingness' allows it a privileged position as a social observer. By paying attention to mundane, often banal things in the world, the photograph can elevate objects to an enhanced status, making them reveal their often hidden meanings. As Edwards explains, this allows photographs as things to

emerge as powerful and active players, extending or replacing embodied experiences and connecting with spiritual ones, such as [...] historical experience, imagination, and memory that can be accorded a certain agency in the making of history, allowing them to become social actors,

impressing, articulating and constructing fields of social actions in ways that would not have occurred if they did not exist.[19]

The idea of the image creating a performative space into which the viewer is invited to project their imagination makes the act of photographic production and consumption more akin to that of the theatre or even opera. It is a space in which the everyday is heightened by the emphasis on dramatic moments to create an encounter that amplifies the situation and draws attention to it, a space where the co-existence of the everyday and the extreme can collide in the encounter of traumatic realism.[20] This performative space can be an uncomfortable one, however, especially when viewing images of the victims of atrocity, where the audience can be troubled by its inability to act and its complicity in potentially re-victimising the subject through the repetition of seeing. Photographs need to be seen through two lenses, as it were: the micro lens of the specific moment and circumstances around the taking of the image, and the macro lens of how it might be read imaginatively as a metaphor for some larger, more general theme.[21] By oscillating between the evidential weight of the fixity of the specific moment and the generality of the broader reading, a performative space is generated in which the subject, photographer and audience collaborate to provide new interpretations. The mobilisation of the imagination thus lies at the heart of photography's ability to emote, the extraordinary power that an inanimate object has to open up an emphatic relationship with the viewer, a relationship where an emotional dialogue can be established between the subject and the audience, mediated by the framing eye of the photographer. As Struk notes, 'our imaginations, informed by the context of the photograph, complete the narrative of that which we do not see, that which lies outside of the image.'[22] The spatial selectiveness of the frame elucidates the possibility of a world outside of the image that may yet impinge on it, a portent of the troubles to come. As Hirsch observes, the viewer 'fills in what the picture leaves out. The horror of looking is not necessarily in the image but in the story we provide to fill in what is left out of the image.'[23]

The Sober Hope of Bearing Witness

The work explored in this chapter does not involve the photographer directly witnessing the event itself, but rather the traces of it, acting as secondary witnesses in vocalising the inanimate landscape to reveal its

evidence. Blustein establishes the role of proxy witness as someone to whom the rights of the witness have been transferred by a victim who is unable to bear witness him or herself, or who wishes to share the burden of witnessing by delivering their testimony to that third party.[24] The photographer of the traces of an event, either physical or metaphorical, thus plays a role akin to a secondary witness, except that they are calling on the topology of the space itself rather than the human victim to deliver their testimony. Because the secondary witness did not witness the actual event itself, but rather its trace, the act of secondary witnessing takes on an overtly moral character as the witness is actively choosing to make their statement about the past rather than passively being there at the time of the occurrence.

Through a process of research in advance and then engagement with the space, the photographer as secondary witness seeks to discover in the terrain the traces of the traumatic experience that are often hidden and obscured either physically or metaphorically in the land. As Booth notes, this is an active process of the witness bringing the story of the land back to life, back into the present as the 'trace and the witness restore [...] what is absent [...] they overcome the distance, the temporal distance that separates the present from what is being given in the act of witnessing.'[25] He expands on this idea, expressing the sense that the lacuna that is a hidden presence in the landscape is waiting to be articulated by the witness, the 'hollows or indentations left by the past, unannounced and mute but awaiting memory's voice, a witness, a poet, an orator, or a monument'.[26] These 'hollows' of memory embodied in the world are thus filled in by the witness in the act of paying attention to them; by discovering them anew and presenting them to an audience they are made relevant once more. Olivier concurs that the land preserves the sense of the past within its contours, arguing that 'time and space are fused, precisely because the past has not been buried beneath the present like some souvenir. It is present in matter, as a feature, and as a part of the design and the patterns of the space.'[27] Thus by actively seeking to discover the absences of presence in these hollows of trauma and to pay attention to them, the act of secondary witnessing provides a powerful reminder of the past presented to the present and becomes an act of active remembrance and even accusation against the perpetrator, an act of moral witnessing.

Thus the existence of testimony becomes an affirmation of the rights of the victim to be known and heard, an affirmation that deserves to be afforded respect independently of any future good that might come

from such recognition. The social act of witnessing, and then performing that witnessing to an audience serves to re-suture the victim into the social fabric, repairing by the act of recognition in some form the rupture of the violent act. The testimony then becomes a symbolic statement of the witnesses' alliance with the moral good against the forces of evil: a landmark that retains its relevance long after the atrocity has passed into history. Clearly, the photographic image, with its ability to encompass both referential and imaginative elements, is unusually well suited to perform such a symbolic role.

The Forensic Turn: Peress, Norfolk and Gafic

The conflict in the former Yugoslavia presented a serious moral challenge to the role of journalists and photographers in that, despite their work uncovering serious and widespread human rights abuses and war crimes, Western governments and public opinion failed to intervene. Instead, they continued to depict the fighting as a result of 'age-old ethnic grievances' rather than a systematic policy of genocide by one state against another. The failure of traditional journalistic forms of witnessing is exemplified in the work of Ron Haviv, whose images of war crimes and human rights abuses from the early stages of the war were widely published, but ultimately had little impact on the decision-making processes of Western governments. His photographs of Arkan's paramilitary Tigers ethnically cleansing the town of Bijeljina on the eve of the conflict in Bosnia in April 1992 provided graphic evidence of the extent of the complicity of Serbian forces in the attacks on Muslim civilians (see Plate 11).[28] At the time, Haviv was convinced that these photographs would have a significant impact, because of their timing and because of their content, but he was ultimately disappointed and disillusioned with their impact:[29]

> I was very happy when the pictures were published. It was a week before the first shots were fired in Sarajevo. There were lots of reports from journalists, diplomats, spies, everybody, that Bosnia was going to be very bad. I thought these pictures would provide a final push, so the world would stop this. But obviously nothing happened. It was really incredibly disappointing.[30]

As the conflict dragged on, some photographers therefore began to reassess their role, beginning to shift their perceived identities away

from journalism and into the arena of human rights activism. By employing some of the methodology of evidence-gathering in their approach to the story, and by using visual strategies that echo those of forensic photography, photographers used the language of human rights and legal discourse to add a moral imperative to their work. Having covered the conflict since the initial phases in Croatia, as the Kosovo emergency unfolded Gary Knight made a deliberate choice to cover the events differently from his usual approach as a contact photographer for *Newsweek*, shooting to weekly and sometimes daily deadlines. For Knight, this was a 'very deliberate and thought-out process' in which he asked his editor at *Newsweek* for the space to be able to 'take on this issue of war crimes, take it on and deliver the images when they are ready, and not be under pressure to deliver them to deadlines'.[31] Knight notes how he approached the story as a 'curator of a crime, rather than as a journalist, photographing mass graves and scenes of crime and interpreting the charges of murder, persecution and deportation', arguing that the 'universal language of photography renders the concept of war crimes less alien to those for whom the idea is normally abstract'.[32]

Photographers and journalists worked together with human rights investigators to undertake a systematic process of triangulation, by interviewing survivors and cross-referencing testimonies to establish potential sites of abuse, which they then followed up on the ground. Carole Bogert of Human Rights Watch (HRW) notes that the reporters and researchers who entered Kosovo with NATO in 1999 found a 'chillingly accurate *nature morte*: almost invariably, the dead bodies were just where the refugees said they'd be'.[33] Gilles Peress and other journalists and photographers, including Gary Knight, were able to follow the evidence of these testimonies to the locations, where they often found the scene of an atrocity to be exactly as described by the victims (see Plate 12).

Taken together, Peress's and Knight's work in Kosovo demonstrates a clear awareness of the genre of evidential, legal and forensic photography, and they use this as a deliberate strategy to present their arguments. Key in this is the use of 'crime scene'-like close-up images of the still lives of the aftermath of atrocities, a visual trope that establishes this 'legalistic' approach and validates the more conventional photojournalist images in their projects, giving them a deeper meaning than a conventional presentation might obtain.[34] The repetition of similar images also builds up a 'weight of evidence', and by offering multiple viewpoints of the same or similar scenes, builds up a more complete sense of a depth of coverage and evidence. The similarities between the role that the photograph

plays in journalistic discourse and in the courtroom is striking. In both arenas the photograph serves to help the audience grasp complex issues by simplifying them and by giving a sense of place and orientation that textual descriptions alone cannot deliver. Both also deploy the strategy of using found photographs of both victims and perpetrators, again playing with the audience's expectations of how such genre images operate.

The temporality in both these projects is significant as well. At the time of making the images, both photographers were working for news publications, and both had their photographs extensively published in this context. However, the work then entered another arena of human rights discourse as both had their images used on websites like HRW.[35] Finally, by publishing their images in books several years after the events took place, they form part of the discourse around bringing to justice the perpetrators of the crimes. For Knight, this experience of multiple outputs was very much a turning point in his career, moving him from a journalistic agenda to new territory:

> It has totally changed the way that I work since; I was no longer interested in being a journalist per se. I remain interested in using journalism and the media as part of my tool set but no longer interested in running around chasing lots of stories. I'm much less interested in creating beautiful photographs and more interested in using photography as a means to an end.[36]

Peress argues that the presence of such a large volume of photographic material from the Balkans was a key driver of the desire of the international community to seek justice in the region, maintaining that without the efforts of journalists he doesn't think the 'tribunal would exist, and without the tribunal we would not have the justice. The dark deeds happen in darkness, if it's just a flicker of light it's worth it.'[37]

Gilles Peress

Gilles Peress produced three major bodies of work in the former Yugoslavia, all published as books. The first, *Farewell to Bosnia*, was created during the conflict in 1993–4, the second, *The Graves*, documents the exhumation of mass graves after the war ended, and the third, *A Village Destroyed*, follows the final act of the period in Kosovo in 1999. Each book uses a variety of aesthetic strategies, but common to them all is the

use of a forensic, crime scene-like style of image-making that focuses on objects and traces rather than landscapes of people. Peress has said that as his work has developed, he works much more like a forensic photographer in a certain way – collecting evidence, explaining how he has:

> started to take more still lifes, like a police photographer, collecting evidence as a witness. I've started to borrow a different strategy than that of the classic photojournalist. The work is much more factual and much less about good photography. I don't care that much anymore about 'good photography'. I'm gathering evidence for history, so that we remember.

Peress maintains, however, that working in this forensic way requires a change in emphasis from the general to the specific, requiring a new set of skills and influences on methodologies that generates 'a shift in relationship to journalism, the tendency to generalise things, to put everybody in big categories and to overlook details as a hindrance to a few pages, a shift to attention to details; details of method, fieldwork, anthropology, sociology, tradition of investigation, familiar with ethnographies and narratives'.[38] The evidential approach generates other problems too, especially in terms of how to produce images that can carry legal force yet also be relevant to a mass audience, creating what Peress describes as a 'dialectical struggle between form and content to produce images that are plausible evidence but also plausibly meaningful to the public in the abstract or to the judicial system'.[39] A closer examination of Peress's work will explore how these concepts are used in practice.

Farewell to Bosnia opens with a double page spread of a map, coated in plastic, showing central Bosnia (see Plate 13). The positions of military formations have been marked onto the plastic overlay with a thick chinagraph pen. Two unknown hands point to locations on the map. This photograph of one form of documentary recording presented on top of another creates a series of overlapping marks. The map of the terrain below is a representation of the landscape of Bosnia, which is overlaid with another representation of the distribution of UN and combatant forces. This is then interpreted by the hands of the unknown presenters, which is then photographed by Peress. Arrows point in different directions, creating both a sense of movement across the frame and a sense of the complexity of the scenario. The names of towns across the region emerge as if from newspaper reports of the fighting and ethnic cleansing, and military nomenclature displays the opposing forces by

using a series of symbols. The image thus becomes a commentary on representation and the inherent problems of reducing a complex situation into a simplified form. The map appears to give an overview of the terrain, but in fact masks the nuances and details of the events, and abstracts human suffering and violence into a flat, two-dimensional space lacking in emotion. It also becomes a commentary on the military briefing, which seeks to reduce the human cost of war to 'collateral damage' by masking it behind statistics and symbolic representations of violence. By opening the book with this image, Peress establishes the sense of a terrain to be explored or encountered, a map to be traversed by the viewer, and a visual puzzle to be solved. The viewer cannot make sense of the map, lacking the necessary information about what it represents. It invites a process of engagement on a journey to find out what is occurring. The viewer is also made aware of the inherent problems in reducing human experience to a two-dimensional visual representation. In this sense, the map is operating as what Shanks has called a 'cognitive and perceptual prostheses' that 'augments certain visual relationships while minimizing or not registering others' and in doing so 'reduces out the noise of background phenomena'.[40]

A Village Destroyed likewise uses details as a central feature of its approach. A spread of images over several pages shows photographs made inside the Serbian police headquarters in Pristina, which was allegedly used as a torture and interrogation centre.[41] They contrast close-up photographs of a wire garrotte, knuckle dusters, clubs and a chainsaw with a table laden with empty tequila bottles, another with playing cards and police caps, and a wall on which Serbian Orthodox religious icons are hung next to glamour pin-ups and a football team line-up. The other spread shows the destruction of an ethnic Albanian village near Djakovica and includes still lifes of the interiors of the devastated houses, Albanian men's caps ground into the dirt, and a single, plastic rose amongst the rubble. This focusing in on small details of the scene is central to Peress's method and provides another example of how the concept of traumatic realism applies to the process of photography as well as literature. Peress explains how

> history, as it unfolds, is not always a very obvious monument or architecture in front of you. There is a lot of the trivial of life and there is a lot of notions of simultaneity of life, of life that goes on while catastrophe unfolds, and so on. And this is why I work the way I do; I work extremely open to what's around me. I document from the

most minute detail to the most spectacular scene [...] I do work in a
very open way and I document everything that's around me. It's a very
existential approach. I shoot pictures of the glass of water I drink if I
feel that it means something at that time.[42]

Simon Norfolk

The work so far surveyed has dealt with images that are produced
relatively contemporaneously to the events they depict, even the still
lifes and interiors of Peress's and Knight's forensic investigations were
recorded only a few weeks or months after the atrocities they describe.
As such, their temporality projects an event from the past into the
present only in the sense that it holds that moment from the past and
preserves it into the moment of reviewing by the audience. However,
the works that will now be explored operate with a different sense of
time, in that they project a moment in the apparent present backwards
into the past, in order to make those connections between a place
and its history visible. As such, they challenge the concept that time
is linear and progressive, suggesting that it is more fragmentary and
looped. A photograph can connect past to present, and present to past.
Indeed, it can also connect present and past to the future, in suggesting
what might be as well as what has been. As Shanks notes, photographs
have the potential to draw together different temporalities, what he
describes as 'memory as actuality – the juxtaposition of different times
in the now'.[43] Images of the 'present' can thus refer back to past events,
reminding the viewer of the events that took place in that space, and
foregrounding the idea that time is not simply a linear narrative, but
rather a looped one, where what is happening today bears on the past
as much as the past bears on the present, bringing the 'recognitions of
the present' to bear not only on our understanding of the past, but also
of the effects of the past on the present'.[44]

Ten years after the end of the conflict in the former Yugoslavia, and
the massacre of some 8,000 Muslim civilians at Srebrenica, Norfolk
travelled to the region to produce a body of work about the genocide
there. Although Norfolk is best known for his use of large-format
landscapes of the sites of conflict, he has also photographed details and
still lifes as part of his strategy to explore how to photograph the past
in the present, and it is this aspect of his work that will be explored
here.[45] *Bleed* is arguably Norfolk's most abstract and metaphoric work

(see Plate 14). The cover image is of a frozen expanse of water, in which a series of bubbles lie encased in the ice. In the centre of the frame is a tiny fragment of blood red, and although it is unclear exactly what it is, it appears to be a thread or even some organic matter. The book opens with a series of definitions of the terms solution, dissolve and absolution, which establishes the multiplicity of meaning of the words, and the tension between the states of liquid and solid and answers and guilt. This is followed by six page plates of details of the surfaces of frozen bodies of water, reproduced at almost life size or even greater. The photographs are full bleed, giving the impression that they continue over the edges of the page, filling the entire field of the viewer's eye with the image and suggesting that it carries on beyond the confines of the book. These images appear organic, and the sense of scale is disorientating: they appear like constellations of stars as much as minute frozen pockets of air. Some appear to lie over water of infinite depth, others merely seem to form a thin skin over the mud below. Some of the images are like aerial photographs, with features that resemble rivers and hills seen in flattened perspective. In one frame, the ice is opaque across much of the image, but in one corner an amoeba-like fracture has formed, through which the underlying riverbed can be seen clearly. This opening sequence is key to the whole project, as it establishes the sense that information, evidence, meaning is hidden underneath a veneer of protective film, and that this veneer will shortly be subject to the thaws of spring and reveal more of its hidden depths as the material nature of the frozen water is literally transformed. The images, in resembling satellite surveillance photographs, echo the sense that, as with the Nazi concentration camps, Western military powers had prior knowledge of the atrocities occurring below, but were unable or unwilling to intervene on the ground to prevent them.

These images are strikingly beautiful too, in their monochromatic palettes of pale blue, white and brown – the swirling eddies of the frozen water creating complex patterns that lead the eye on a dance around the frame. Norfolk describes his thought process whilst making these images as:

> sitting at this gravesite thinking about ice, about it melting, a secret bleeding and leaking. Wondering what was the content of the gas in those bubbles, and the sense of being there now when it was frozen, beautiful and aesthetic, but when those bubbles unfreeze they might contain the stench of violence, something held and released.[46]

This is a conscious strategy to exploit the aesthetic qualities of his images in order to advance his moral message better.

> In a gallery, I watch people look at the pictures, especially the fine details, and you can see their minds working, searching, thrown back upon their own critical resources for once, forced to reassess their expectations of what information the picture is going to give them. I'm endeavouring to set up a tension in the image between beauty and horror, two things that are normally separated in modern culture [...] these two categories are kept apart, but I think it is more realistic to collide the two together.[47]

The motivation for this work in Bosnia was a sense that Norfolk had something to contribute, not to the understanding of the plight of the victims, but rather to the psychology of the perpetrators. *Bleed* is therefore a work about guilt, and the fear that a crime will be uncovered and punished. The frozen landscapes of eastern Bosnia become a powerful metaphor for the secrets that lie buried under the earth, secrets that in time are bound to leach out into the open. Norfolk describes the project as trying to get inside the mind of a war criminal, trying to engage with the 'feeling of what it might be like to be inside these men's minds' as they try to 'wash away the feelings of guilt about the crimes they have done'.[48] For Norfolk knowing exactly the right location of the gravesites is of vital importance, in that it establishes the credibility of the work in an almost forensic way. For him, it would have been a 'disappointment to take them in the general area, it needs to be done true in an old school way; it would be a real weakness if it was just in the vague area of the site.'[49] This locative quality of the image is even more vital when using the landscape to evoke memories of an event rather than depict it as it is happening; without this it wouldn't have what he describes as the 'rootedness' necessary in this genre of work. He argues that 'it's even more important when the picture uses metaphors; if the detective work was poor then the whole project would unravel quickly. The only way you can come at it in such a symbolic way is if you are one hundred percent sure that here are the locations – otherwise it's a weak, feeble approach.'[50]

This detailed research is the foundation of Norfolk's practice; without it he believes his work would lack any credibility or even visual force. The research process underpins the fieldwork, meaning that Norfolk is tuned into the nuances of the history that he is trying to coax out of the landscape. He describes the encounter of his understanding of the situation with the scene itself thus:

The moment of taking the picture is the ignition point, the coalescence of all the research you have done. When the picture works it's the spark where all those things collide, the boots in the snow, the detective work, the academic wading through reports looking for that single quote that gives the location, the journalistic thing that you do when you sit with the investigators and have a cup of tea. The artistic, creative part is the final twenty five per cent; an interesting and clever way to represent the thing photographically – the metaphor – a lining up – the storytelling, the factual stuff, the newness that you brought to the table, the cleverness about a new way of photographing. Then it's as if the pictures fall out of the camera, you just have to go and scoop them up, the pictures are waiting to be gathered in. That's when it's a great picture, it's all in a line – you feel it in your gut when you get it, a kind of Damascene moment.[51]

This is a contemplative process, slowed down by the technicalities of the large camera and tripod, as Norfolk elaborates, 'what's nice about the 5x4 is you spend hours in a place thinking about it, hours just walking around, trying to make pictures, and failing, getting the camera out and putting it away again over and over.' In some ways, taking the image is less important than the experience of being in the moment of creative and intellectual discovery, when all the elements of research and interpretation connect with the world itself, in a 'moment of satisfaction, when the picture making is quite secondary; all these things are in the same place now so I'll make a picture to solidify it, make it permanent, and make a record.'[52]

Ziyah Gafic

Ziyah Gafic is a Bosnian photographer who experienced the war as a teenager, and his work largely deals with post-conflict societies. Most of Gafic's work takes the form of extended bodies of documentary work, in which he identifies himself as an 'unreliable storyteller', emphasising the subjective and personal nature of photography. He explains how 'whatever I did, I was telling my own story, it's very selfish, it's almost like a fiction, it's my construct, you decide for almost all of the things you photograph, I want this or that, and you build your narrative yourself.'[53]

However, for a recent project, Gafic shifted his approach towards that of the forensic, producing a book of images of the personal

effects found on the bodies of the victims of Srebrenica after they were exhumed from mass graves; the images are all shot in the same, simple, frontal style, set on the stainless steel mortuary table at the identification centre in Tuzla.[54] The genesis of the project came when he photographed a small selection of the items for another project, during which time one of the mortuary team asked if the work was going to be published, because if so there was a chance that someone might recognise the items as belonging to a lost loved one. Gafic realised that for someone in that situation it is potentially mentally easier to browse through a book than to have to go to the morgue and look at the items themselves, seeing this as 'much more humane'.[55] He therefore set out to document all of the objects held in the morgue, several thousand in total. There was an additional motivation too in this, to explore the limits of objectivity, as much of his work previously was, in his own words, subjective. In this project he wanted to 'test the potential to do something that was as objective as it can be. There was no editing, I shot everything I got hold of, and all in the same way. The only criteria for selection were that it could be recognised as preserving its original shape.'[56] Entitled *Quest for Identity*, the book shows the individual objects and personal effects recovered from the bodies after they have been cleaned and catalogued, arranged in sets according to the type of object depicted. Pages of delicate, fragile objects, toothbrushes, watches, cigarette lighters, combs, glasses and other assorted personal effects are laid out as if on display in a museum (see Plate 15).[57] Some look almost like primitive artefacts, a flint for lighting fires and an amulet to protect from evil. Family photographs appear too, their surfaces decayed and distorted by the water and soil. These objects have a real poignancy, a sense of the lives of those who owned them, a materiality that in their preservation maintains the memory of those who are lost. Eric Stover[58] writes of the process of forensic investigation, a description that has much in common with that of constructing a body of photographic work from thousands of images: 'reconstructing human behaviour from physical evidence is like piecing together a multidimensional puzzle. Pieces may be missing, damaged, or even camouflaged, but each piece has its place. The challenge is to find the fragments, reconstruct them, and chart their placement in an accurate manner.'[59]

This detached presentation, however, provoked a very emotional response from audiences. As Gafic explains, the typical response to the work is 'extremely subjective, they are all common items that we all have. It doesn't matter that these were things that people were carrying when

they were executed. Even if they were just ordinary items, when you see them in such a repetitive way it's cross cultural.' He emphasises how the shared experience of ownership of common global commodities impacts on the viewer, noting that 'Seiko watches are all around the world. It's very similar to Proust's madeleine. It works like that, narrowed down to an actual item that in its familiarity triggers a chain of thoughts.' He goes on to identify two main responses to the work: people recognising similar items that they owned, or their parents owned, and surprise at the things that people carry with them to execution, the 'unspectacular ordinariness of it, super ordinary items in extraordinary situations'.[60] A major feature of this approach is that the viewer is able to spend time looking at the images; as they are not repulsed by them, they convey the effects of violence without depicting the act itself. The book is accompanied by a website and iPad app that will allow relatives of the missing to browse through the images in the hope of recognising an object to assist in the identification of the remains of their loved ones. This demonstrates a key feature of the photographic process that gives the opportunity for an event, person, thing or place to travel spatially and temporally beyond its initial location. As Gafic explains, the problem with the 'actual objects is that they are immobile, physically locked in one singular place, but pictures in the digital era are mobile. It gives mobility to an immobile object. And it allows it to migrate and eventually spread the word.'[61]

The Emotions of Things

The post-factum witness arguably avoids much of the critique of photojournalistic practice whilst retaining much of its emotional and moral force. By not depicting the trauma itself, but rather the space in which it occurred, this approach cannot be accused of victimisation or re-victimisation, or of exploitation of its subject. However, it expands on the humanistic potential of the photojournalistic image to engage the audience in an imaginative connection with the situation by suggesting the trauma that occurred rather than directly detailing it. This delicate balancing act between showing too much and too little is a central feature of the artistic practice of representing atrocity; as Hirsch explains, the challenge is to 'precisely find the balance that allows the spectator to enter the image, to imagine the disaster, but that disallows an over-appropriative identification that makes the distances disappear, creating too available, too easy an access to this particular past'.[62] This distancing

in spatial and temporal terms but remaining close in emotional and imaginative ones is a vital component of this kind of memory work. As Simon elucidates,

> Testimony necessitates a practice of remembrance in which one is required to draw near but yet remain distant, a memorial stance in which one is required to study, teach and keep/preserve the memories of another, not in ossified form, but through a 'handing down' whose substance lies in vitality, inventiveness and renewal.[63]

The re-engagement with the traces and places of trauma fulfils this necessity by encouraging the audience to actively engage with the event that occurred, by examining the space of the photograph for clues to understanding the experience. Zelizer identifies the physicality of the image as acting as a conduit by which the audience might fix the event more clearly, arguing that the 'capacity to forge a personal connection with a traumatic past depends first on the materiality of photographs, whereby photographs stand-in for the larger event they are called to represent.'[64]

By presenting an alternative reading of the event which relies on an emotional and imaginative reliving of it, the post-factum image simultaneously creates an environment in which the viewer can at once encounter the horror of the atrocity whilst not being repelled or tarnished by it by feeling directly complicit in it by re-viewing the victim. This re-engagement also acts as a conduit between past and present, and can act to propel the audience forwards towards some form of moral outcome. In doing so, Booth argues that a 'bridge is constructed between time present and past, not only so as to permit us to see more clearly what happened but also, and in so doing, to make present, to act on it, and so to restore justice to the parties, absent or present.'[65] In filling in the hollows of absence left by the lack of physical presence of the victim in the image with an imaginative re-engagement, the act of secondary bearing witness can attest to their value and importance. As Booth poignantly notes, 'memory justice speaks with the voice of the silenced victims. It is the vehicle of their presence, a second life that witnessing and doing justice breathes into them.'[66]

Photographs can thus act as embodied sites that can transfer a sense of experience through space and time. By paying attention to things, to details and to objects, the photograph can elevate them from the status of unnoticed elements into that of significant carriers of emotional and

psychological depth and meaning. This transformation endows the thing photographed with the qualities of the person that possessed it, enhancing the connection between the viewer and the subject through the object rather than directly through an image of the person themselves. Through this process of embodiment, the photograph can crystallise the essence of a scene, as 'the vague and ambiguous become concrete and the raw and the physical are made meaningful.'[67] The image of a thing operates with a different set of resonances than that of a person, the emotions it generates are different, more poignant and reflective, and thus perhaps more effective in instigating in the viewer the sense of bearing witness to the person. As a durable, material object intimately associated with time and memory, the photograph thus serves as a unique artefact to connect past, present and future. The temporal and spatial mobility of the photograph serves to locate the witnessing act in the image itself more than the photographer. It is the presence of the image that determines its usefulness in bearing witness, not the testimony of its author.

Notes

1 Peter Howe, *Shooting under Fire: The World of the War Photographer* (New York, 2002), p. 174.
2 See: http://iraq.reuters.com.
3 Susan Meiselas, in K. Light (ed.), *Witness in Our Time: Working Lives of Documentary Photographers* (Washington, DC, 2000), p. 107.
4 Judith Butler, *Frames of War: When is Life Grievable?* (London, 2009), p. 70.
5 Hannah Arendt, *On Violence* (London, 1970).
6 For a critique of the phrase 'banality of evil', see Ron Rosenbaum, 'The evil of banality: troubling new revelations about Arendt and Heidegger', *Slate*, 30 October 2009, available at www.slate.com/id/2234010/pagenum/all (accessed 18 February 2014), in which he describes it as the 'most overused, misused, abused pseudo-intellectual phrase in our language', and S. Alexander Haslam and S.D. Reicher, 'Questioning the banality of evil', *Psychologist* 21/1 (2008), pp. 16–19, available at www.thepsychologist.org.uk/archive/archive_home.cfm?volumeID=21&editionID=155&ArticleID=1291 (accessed 18 February 2014).
7 Many critics have elaborated on this developing genre of 'aftermath photography' or 'post reportage', with David Campany claiming that photography is now a 'secondary medium of evidence. This is the source of the eclipse of the realist reportage of events and the emergence of photography of the trace or "aftermath"', in David Campany, *Art and Photography* (London, 2003), p. 27. Much of this work adopts aesthetics of observation and detachment, whilst others deploy an aesthetic that

demonstrates the contradiction that the locations of atrocity are often simultaneously locations of striking visual quality. See Ian Walker, 'Desert stories of faith in facts', in M. Lister (ed.), *The Photographic Image in Digital Culture* (London, 1995), and works by Sophie Ristelhuber, Paul Seawright and Luc Delahaye for examples of the genre.

8 Laurent Olivier, *The Dark Abyss of Time* (Lanham, MD, 2011), p. 63.

9 Bjornar Olsen, *In Defense of Things: Archaeology and the Ontology of Objects* (Lanham, MD, 2010), p. 109.

10 Susan Moeller, *Compassion Fatigue: How the Media Sell Disease, Famine, War and Death* (London, 1999), p. 44.

11 See Steven Connor's discussion of Serres's views on history in Michel Serres's 'Milieux', a paper given at the ABRALIC (Brazilian Association for Comparative Literature) conference on 'Mediations', Belo Horizonte, 23–6 July 2002.

12 Michael Shanks, 'Towards an archaeology of performance', paper delivered at SAA Meetings, Denver, 2002.

13 Ulrich Baer, *Spectral Evidence: The Photography of Trauma* (Cambridge, MA, 2002), p. 7.

14 Ibid., p. 6.

15 Cathy Caruth, *Trauma: Explorations in Memory* (Baltimore, MD, 1995), p. 4.

16 Olsen, *In Defense of Things*, p. 126.

17 Alan Trachtenberg, *Reading American Photographs: Images as History, Mathew Brady to Walker Evans* (New York, 1989); Roland Barthes, *Camera Lucida* (London, 1993); Susan Sontag, *On Photography* (New York, 1977); and Elizabeth Edwards, *Raw Histories: Photographs, Anthropology and Museums* (Oxford, 2001).

18 See Edwards's essay 'Entangled documents: visualised histories' in Susan Meiselas, *In History* (New York, 2008) and her introduction to *Raw Histories* for more on the social biography of images and how they perform as historical actors: Edwards, *Raw Histories*, p. 5.

19 Ibid., p. 17.

20 In this I acknowledge Edwards's thoughts in *Raw Histories* on the relations of performance and photography.

21 For a more complete exploration of this concept see Georges Didi-Huberman, *Images in Spite of All* (Chicago, 2008).

22 Janina Struk, *Photographing the Holocaust: Interpretations of the Evidence* (London, 2004), p. 212.

23 Marianne Hirsch, 'Family pictures: Maus, mourning, and post memory', *Discourse* 14/1 (1992–3), p. 10.

24 Jeffery Blustein, *The Moral Demands of Memory* (Cambridge, 2007).

25 W.J. Booth, *Communities of Memory: On Witness, Identity and Justice* (Ithaca and London, 2006), p. 86.

26 Ibid., p. 74.

27 Ibid., p. 62.

28 For a description of the early stages of the attacks on Bosnia see, for example, Chuck Sudetic's reports from the region for the *New York Times*, such as this excerpt from one from 4 April 1992, 'Serbs attack Muslim Slavs and Croats in Bosnia': 'The Serbian units that attacked Bijeljina belong to the Serbian Volunteer Guard commanded by Željko Ražnatović, a reputed gangster known as Arkan who is wanted for bank robberies in Western Europe and widely described in the Yugoslav press as an assassin for the Yugoslav secret police. Mr. Ražnatović's men are known to be the best-trained and best-equipped fighting force the Serbs have. They took part in attacks by Serb forces on Croatia's eastern panhandle and have been condemned by international human-rights organisations for atrocities and widespread looting.'

29 As the first pictures of attacks on non-Serb civilians in Bosnia, the images were widely circulated at the time. Chuck Sudetic, a reporter for the *New York Times* who covered the conflict including the early days in April 1992, noted how the images established command responsibility for the atrocities: 'The Bijeljina photographs show members of a militia with links to Slobodan Milosevic [...] actually beginning the bloodbath in eastern Bosnia. The faces of the perpetrators and their victims are identifiable. The nature of the crime is clear. The pictures can and should be used as evidence before the international tribunal trying people for crimes of war in Yugoslavia', Ron Haviv, *Blood and Honey* (New York, 2000), p. 17. At the time, Haviv's photographs were seen by the Bosnian president, Alija Izetbegović, and had a profound impact on him: 'It was unbelievable almost. The civilians being killed, pictures showed dead bodies of the women in the streets. I thought it was a photomontage. I couldn't believe my eyes, I couldn't believe it was possible', Laura Silber and Allan Little, *The Death of Yugoslavia* (New York, 1995), p. 248. Haviv's images were later used as part of the Hague Tribunal's successful indictment of the leading Serbs in the organisation of the atrocities in Bijeljina. In the trial of Momcilo Krajišnik, the ICTY prosecutor, Mark Harmon, showed Haviv's photographs in order to demonstrate the circumstances pertaining in eastern Bosnia in 1992.

30 Haviv quoted in John Kifner, 'A pictorial guide to hell', *New York Times*, 24 January 2001.

31 Gary Knight, interview with the author, September 2011.

32 Knight, interview, 2011.

33 Carroll Bogert, 'Introduction', in Gilles Peress, Eric Stover and Fred Abrahams, *A Village Destroyed* (Berkeley, CA, 1999), p. 2.

34 See S.G. Erlich and Leyland V. Jones, *Photographic Evidence* (London, 1965) for a technical guide to crime scene photography. See also the Royal Canadian Mounted Police training website for a procedural account of

how to gather photographic evidence, available at www.rcmp-learning.org/
docs/ecdd1004.htm (accessed 18 February 2014), and police pictures for a
more interpretative exploration of the history of crime scene photography.
Luc Sante, *Evidence* (New York, 1992) is a fascinating collection of early
police photographs of crime scenes from the US, and Mike Mandel and
Larry Sultan's seminal *Evidence* (New York, 2003) contains an extraordinary
array of images from a whole variety of documentary projects where pure
observation of an event was the motivation. Taken out of context, these
images are a powerful aesthetic statement.

35 *A Village Destroyed* was originally published by Human Rights Watch as
a report of the same title published in October 1999: see www.hrw.org/
reports/1999/kosovo3 (accessed 18 February 2014).

36 Knight, interview, 2011.

37 Gilles Peress, interview with the author, 2008.

38 Peress, interview, 2008.

39 Ibid.

40 Michael Shanks, 'Archaeology and the visual', a discussion with Tim
Webmoor for the Sawyer Seminar at Stanford Humanities Center,
available at http://documents.stanford.edu/michaelshanks/admin/versions.
html?pageid=144&versionnum=13 (accessed 18 February 2014).

41 Peress, Stover and Abrahams, *A Village Destroyed*, pp. 106–7.

42 Gilles Peress, interview with ASX, 'Interview with Gilles Peress: images,
reality and the curse of history' (1997), available at www.americansuburbx.
com/2010/07/theory-interview-with-gilles-peress.html (accessed 18 Feb-
ruary 2014).

43 Michael Shanks, 'Landscape aesthetics – the politics (continued)', available at
www.mshanks.com/2011/07/landscape-aesthetics-the-politics-continued
(accessed 18 February 2014).

44 Dora Apel, *Memory Effects: The Holocaust and the Art of Secondary Witnessing*
(New Brunswick, NJ, 2002), p. 7.

45 See his series of still lifes of the detritus of war in Iraq, 'Archaeological
treasures from the Tigris Valley', available at www.simonnorfolk.com
(accessed 18 February 2014).

46 Simon Norfolk, interview with author, October 2011.

47 Simon Norfolk, interview with author, 2004.

48 Norfolk, interview, 2011.

49 Ibid.

50 Ibid.

51 Ibid.

52 Ibid.

53 Ziyah Gafic, interview with author, May 2012.

54 The International Commission on Missing Persons (ICMP) was
established at the initiative of the US president, Bill Clinton, in 1996 at the

G7 summit in Lyon, France. Its primary role is to ensure the cooperation of governments in locating and identifying those who have disappeared during armed conflict or as a result of human rights violations. ICMP also supports the work of other organisations, encourages public involvement in its activities and contributes to the development of appropriate expressions of commemoration and tribute to the missing. The organisation was established to support the Dayton Peace Agreement, which ended the conflicts in Bosnia and Herzegovina. ICMP is currently headquartered in Sarajevo. By matching DNA from blood and bone samples, ICMP has been able to identify 16,289 people who were missing from the conflicts and whose mortal remains were found in hidden graves. See www.ic-mp.org (accessed 18 February 2014).

55 Gafic, interview, 2012.
56 Ibid.
57 These images are powerfully reminiscent of Walker Evans's essay for *Fortune* magazine, 'Beauties of the common tool' (July 1955), where he photographed everyday tools against a simple background, elevating them to the status of fine art sculptures shot for a museum catalogue.
58 Eric Stover is the director of the Human Rights Center and Adjunct Professor of Public Health at the University of California at Berkeley, and has collaborated with Peress regularly.
59 Gilles Peress, *The Graves* (New York, 1998), p. 158.
60 Gafic, interview, 2012.
61 Ibid.
62 Marianne Hirsch, 'War stories, witnessing in retrospect', in S. Hornstein and F. Jacobowitz (eds), *Image and Remembrance: Representation and the Holocaust* (Bloomington, IN, 2003), p. 10.
63 Roger Simon, 'The paradoxical practice of Zakhor: memories of "what has never been my fault or my deed"', in Roger I. Simon, Sharon Rosenberg and Claudia Eppert (eds), *Between Hope and Despair: Pedagogy and the Remembrance of Historical Trauma* (Oxford, 2000), p. 18.
64 Barbie Zelizer, 'Finding aids to the past: bearing personal witness to traumatic public events', *Media, Culture and Society* 24 (2002), p. 699.
65 Booth, *Communities of Memory*, p. 115.
66 Ibid., p. 157.
67 Olsen, *In Defense of Things*, p. 35.

11 Ruins and Traces

Exhibiting Conflict in Guy Tillim's Leopold and Mobutu

Caitlin Patrick

The idea that photojournalism, and to a lesser extent documentary photography, are 'dying' genres in today's global visual economy has been roundly discredited by many commentators and by practitioners themselves. Few would deny that expanding digitisation technologies and the development of the internet have significantly changed the production, distribution and consumption patterns of most still images and reshaped definitions of what a 'photograph' actually is. Taking Geoffrey Batchen's definition to heart, however, 'the photographic as a vocabulary of conventions and references lives on in ever-expanding splendour.' As Batchen argues, the 'desire to photograph' remains strong, and it is crucial to unpack and understand 'the peculiar arrangement of knowledges and investments that that desire represents'.[1]

This chapter will consider a long-standing social 'investment' in documentary photography and photojournalism – their perceived value as critical tools to advocate for political and social change. It will explore a current element within this larger issue, an abiding sense of anxiety regarding the 'critical potential' of 'late photography', a relatively new style of predominantly gallery-based work. On a broader scale, the politics and economics of documentary photography and photojournalism in the gallery context as a whole has become a talking point, as is evident in Glenn Ruga's curator's statement for the New York Photography Festival 2012, themed 'The Razor's Edge: Between Documentary and Fine Art Photography'.[2] While definitions vary, late photography can be generally defined as that in which remnants of human activity, existence or 'intervention' of some kind remain, but little else. This photography often contains no people, or even an easily

definable subject, and thus is often read as a critique of the traditional, humanistic style and content of photojournalism. Late photography's surge in profile in gallery and book contexts within the last 20 years has been of specific interest to several recent commentators.[3] Using a body of work by South African photographer Guy Tillim as an imperfect but relevant example of the style, this chapter will illustrate how some late photography, rather than becoming the ambivalent, depoliticised 'art' that its critics fear, can reproduce the long-standing Western viewing patterns it often claims to counter.[4]

A passage from Susie Linfield's recent work in support of the political and ethical power of photography illustrates well a broader concern with how photojournalism and documentary are interpreted in the gallery context. Linfield vigorously defends photography from what she sees as its denigration to merely a 'servant to capitalism' by a long line of influential commentators. She sees risks to viewer understanding and engagement, however, when certain photos (in this case those of renowned photojournalist James Nachtwey) are shown with minimal or no captions in a gallery context. Linfield acknowledges the success of 'art' photographers, such as Cindy Sherman, in provoking rich viewer experiences with a lack of captions or photo titles. Yet, for a photographer like Nachtwey, 'this is exactly the wrong choice' in Linfield's eyes. 'Photojournalism works in the opposite way: meaning – moral, political, aesthetic – is deepened through specificity; only when we know what we are looking at can we begin to engage the why and how.'[5] Linfield's argument highlights what Debbie Lisle has noted is a prevailing discomfort with viewer ambivalence, particularly in the documentary and photojournalistic traditions. Ambivalence is seen as a dangerous emotion: 'what are we to do with such ambivalence? Does it have any critical potential? Can such a lack of closure offer any hope for resistance and political change?'[6]

As Linfield, Lisle and other recent commentators have noted, such anxieties about viewer ambivalence hinge upon the long-held desire of many within the documentary photography and photojournalistic communities to secure a sequence linking the creation of a photograph, the viewing of that photograph and resultant political action and/or critical awareness in viewers. Reasons for the 'failure' of this sequence have been identified at various junctures in the practice of these genres, particularly in the composition and content of photographs, the institutions through which they are distributed, and the social situations of potential viewers. Linfield eloquently argues that the inevitably 'impure' and imperfect

nature of this process does not automatically equate with the practice of these types of photography being a futile endeavour.[7] Yet the question of how to move forward in practice after a widespread theoretical acceptance of all photography's essential ambiguity, to be outlined further below, remains contentious and hinges upon ongoing consideration of these particular junctures.

Focusing on the style and content of the photograph itself, Lisle argues in support of ambivalence, with particular reference to late photography, as an 'active' emotion that provides space for novel, new viewer engagement with photographs. Commentators such as John Roberts, however, have suggested that much late photography risks becoming a site of 'glacial', 'detemporalised' and 'distanced' contemplation for viewers. Photographic practices such as these, which embrace a role as 'memorial' and 'post-traumatic' accounts of events, are seen to abdicate their role as interrupters and interrogators of events.[8] David Campany concurs and also implicates the space of distribution, suggesting that 'documentary behaves differently in art and so do its audiences.'[9] He has highlighted the risks of some currently popular styles of primarily gallery-based documentary work, such as late or aftermath photography, becoming 'sublime' and 'mournful', encouraging 'ideological paralysis' in those 'who gaze at it with a lack of social or political will to make sense of its circumstance'.[10]

The debate over the stylistic strategy of 'ambivalence', 'stillness' or 'openness' in recent photojournalism and documentary photography, and how display in gallery institutions affects and relates to this style choice, thus need to be historically contextualised. Additionally, and following from Batchen's linkage of the term 'desire' to photography, one could ask: if photojournalism and documentary photography are now regularly a part of gallery spaces and cultures, do they *want* to be there? Have certain features of the current economic, cultural and technological climate pushed photojournalists and documentarians into the gallery for want of other distribution and consumption spaces?

The continuing growth of television as a news and entertainment medium competing with photography throughout the latter half of the twentieth century would appear to support this argument. The long-term decline of news magazines, formerly regarded as key supporters of photojournalism and documentary, began with *Life* and *Look* in the 1970s and continues to date, particularly in the North American market.[11] Throughout the 1980s and 1990s, industry consolidation and changing management structures at many news media organisations

have negatively impacted opportunities for long-form, investigative news and for photojournalism and documentary critical of neoliberal economic models.[12] Finally, the recent exponential growth of the internet, in particular the myriad of free visual and textual content it provides to users, has further exacerbated financial challenges for traditional media. This has led to cost-cutting measures and reduced budgets for commissioning photojournalism and documentary work. The possibilities offered by the internet for the growth and distribution of these genres are only beginning to be explored, however, and require further study in their own right. The internet as a medium may actually mitigate some of these other factors.[13]

While the above-mentioned issues might lend some support to the idea of a 'push-into-galleries' scenario, it is also clear that many photojournalists and documentarians have embraced opportunities to work in this new environment. Briefly outlining the historical arrival of these genres in gallery spaces will illustrate both these push–pull dynamics, as well as a blurring of boundaries that would define these genres as significantly different from 'art'.

Documentary and Photojournalism's 'Artistic Turn'

John Szarkowski's tenure as photography director at the Museum of Modern Art in New York from 1962 to 1991 is seen, by critics and supporters alike, as crucial for developing widespread acceptance of photography as a collectible art form.[14] Szarkowski exhibited a significant amount of documentary photography, but his choices from within this genre and his work to create a canon of photographic history were subjected to fierce debate and critique from the 1970s through to the 1990s. Specifically, his commitment to a formalist approach to photographic curation was derided by critics who wished to expose the politics inherent in such a process, insisting that photography had few or no 'essential' characteristics but was rather a technology invested in by different structures of power.[15]

Using distinct approaches, these critical figures, from a variety of Marxist, feminist, (post-)structural and post-colonial theoretical perspectives, generally advocated for a 'cultural history of the photographic image – an analysis of the precise historical and material conditions out of which discursive meaning and authority is constituted'.[16] Influenced by these critiques, conceptual artists of the 1970s initially often used

photographs in their practice to challenge rigid art genre divides and the social elitism of gallery and museum institutions. These formerly avant-garde transmedia, pastiche and pop-culture-influenced works, however, were soon themselves embraced by these spaces. Public museums and galleries made stated efforts to become more diverse and 'multivocal' during the 1980s and 1990s, when they simultaneously were required to become more entrepreneurial in their funding strategies. Many early supporters of these projects became disillusioned with their integration into an increasingly globalised and commercial art world; 'the very "ambivalence" of appropriation as an act, between the original and the copy, the political and the apolitical, would gradually become a recognisable style.'[17] Nonetheless, the influence of these practices remains to present. As Campany has recently suggested, 'The gallery has become the space to look askew at the general field of the photographic, to engage directly or indirectly with a commentary upon the image world at large.'[18]

Documentary photography, despite its long association with reformist and progressive movements, was indicted on several accounts by these various 'post-' critics from the 1970s onwards. Notably, the unequal power dynamics between (usually) affluent, Western male documentarians and their poor, less-powerful, racialised or in some way 'pathologised' subjects were highlighted. Additionally, documentary's predominant styles and modes of display were seen as counterproductive to meaningful social change. As articulated by Martha Rosler, 'In the liberal documentary, poverty and oppression are almost invariably equated with misfortunes caused by natural disasters: causality is vague, blame is not assigned, fate cannot be overcome.'[19] Far from having an influence restricted to art photography practices, these critiques had a significant impact on many practitioners of documentary photography. As will be shown below, many adopted new stylistic strategies and authorial approaches – some relatively novel and some influenced by other photographic genres and mediums – which overtly acknowledged the photographer's inevitable social situatedness and limitations.

The influence of such critiques was eventually felt even among some photojournalists, who have generally been more sheltered from such debates due to industry norms and separated viewing contexts from galleries. Commentaries highlighting concerns such as photojournalism's frequent use of formulaic subject matter and the repetition of a particular, largely Western-centric worldview have now occurred in a plethora of forums for many years.[20] The tensions involved in the frequent claims of photojournalists to both distanced-objectivity *and* engaged-witness

status has also been discussed recently by David Campbell and Alfredo Cramerotti.[21] One might argue, in fact, that to work successfully in the gallery sphere practitioners must, to a certain extent, relinquish their allegiance to some 'traditional' photojournalistic principles. The 'New Photojournalism' of the late 1970s and early 1980s is an early example of this shift in self-conception among a small number of photojournalists. Andy Grundberg isolates the publication of Susan Meiselas's *Nicaragua* book in 1981 as a key breakthrough for 'art' photojournalism, which was quickly followed by Gilles Peress's *Telex Iran* in 1984. Post-Vietnam, Meiselas's colour photos of war were not unique, but Grundberg suggests that they represented an important stylistic shift, as did Peress's black and white images.[22] While this work retained a claim to photojournalistic status in its presentation of newsworthy current events, it drew the traditional conceit of photojournalistic 'objectivity' into question. In the cases of Meiselas and Peress, there appeared to be a desire to stylistically highlight the complexity of the issues they were photographing and their own uncertain position in doing so. Linfield notes some of these important new visual strategies in her assessment of *Telex Iran*:

> Peress's stark yet crowded photographs are edgy, jarring, weirdly cropped. Some are framed through windows of buses or shops, reminding us that these *are* images rather than direct or 'national' transmissions of life [...] Peress never lets us forget that everything we see here is filtered through his lens and his sensibility.[23]

Although 'ambivalent' could be an overstatement of this phenomenon, Meiselas's and Peress's photos represented a break from traditional photojournalistic content and iconography of conflict, facilitating and, in a sense, 'requiring' more lengthy consideration by viewers. In terms of outputs and distribution, the collection and curating of this work into books and exhibitions was also important. Currently active photojournalists had not been shown in the gallery sphere with such prominence before, and these distribution spheres allowed practitioners new levels of control over the sequences and contexts in which their work was shown. Book formats also facilitated easy, ongoing circulation of the photos to audiences over an extended period more efficiently and attractively than archived newsprint.

A blurring of genre boundaries thus becomes evident at this time, with photojournalists moving into art spheres and artists showing a long-term interest in working with the photograph as a medium. Two

general types of recent, gallery-based photographic projects with links to photojournalism and documentary photography are identified in a 2009 article by John Roberts.[24] Within the first loose grouping, photography is used as a means of interrupting, reworking or reflecting on an issue or event. Their inheritance from earlier conceptual work is thus fairly clear. These types of work have often taken the form of archive explorations and 'curations' of existing photographic material, drawing on historical collections as well as the huge volumes of visual material now appearing online and mixing 'straight' photography with openly manipulated works to challenge such distinctions.[25] Recent concepts such as the 'archival impulse' and Cramerotti's 'aesthetic journalism' highlight this prevailing interest in questioning the social uses of the visual document in such work as well as an integration of journalistic forms of social, cultural and political investigation. Roberts is supportive of these types of projects, along with traditional and newer forms of the 'photo-text book', as means 'of counter-production, of counter-archiving, and of interruption and reordering of the event'.[26] These types of projects may be shown in galleries, but their critical and political potential is not seen as necessarily 'lost' within these spheres due to their stylistic and conceptual approaches.

Alongside these projects, new styles, including much of what is called late photography, have alternately articulated their critique of past and existing photographic styles through encouragement of a prolonged viewer focus *within* the frame of the image. It is precisely this perceived failure to conceptually move viewers outside its borders, and a resultant (over)emphasis on the 'object' qualities of the photo, which concerns critics like Roberts, Campany and, to an extent, Linfield. In contrast, Lisle is more optimistic about the productive possibilities for viewer enquiry within the image itself. A variety of strategies are used to facilitate this contemplative process, both in late photography and other styles, and are shown by Julian Stallabrass to render this type of work highly conducive to gallery agendas, suggesting why this photographic style has thrived in this particular marketplace. Some of his points will be drawn out below in specific examples.[27] Briefly, these strategies often include a scaling up of the photograph in size and references in style and content to earlier artistic traditions, particularly painting. In the case of late photography, there is an additional turn away from 'action'-dominated and human-populated images towards the stillness of detritus, ruins and what remains after the action of conflict has passed.

In the last 15 years, photographers of conflict – notably late photographers with considerably different approaches to those of Meiselas and Peress –

have begun showing extensively in gallery spaces. Former photojournalist Luc Delahaye made an announced shift towards art in 2001 and is often associated with the late photography moniker. His recent *History* series of photographs is shot on medium-format panoramic cameras to be printed at great scale, aiming to create an encounter between the viewer and the photographic object comparable to much venerated historical artwork.[28] Delahaye's large-format *Taliban*, a four x eight foot, muted-colour photo of a dead Taliban solider sprawled on dusty ground, was presented in 2003 for $15,000 in a New York gallery usually catering for folk and fine art collectors.[29] Jodi Mailander Farrell notes that many prints by well-known photojournalists sell for around $1,000, making this kind of art accessible for collectors with smaller budgets who are often younger and feel more affinity with photography than with other art forms. Delahaye's work is cheap, however, in comparison with many earlier, now-canonised photographers; a Diane Arbus photo sold for over $450,000 at auction in 2004.[30] Thus while photography in general is becoming more ubiquitous, prices for particular works are rising where traditional art standards such as provenance, canonical significance, limited production and print condition can be secured.[31]

The creation of both financial and artistic 'value' through the carefully timed release of limited-edition prints currently provides one avenue for professional photographers to create a brand and following. This has become a standard feature of photography as 'art'.[32] Another characteristic of the art market is the importance of a physical object for collection; here, photography's greatest strength – infinite reproducibility – can become its weakness, particularly in the digital age of instant photographic creation and easy manipulation. As noted above in reference to Delahaye, many photographers producing for the gallery market have thus created works of great scale, crafted on medium- and large-format cameras, which are less accessible than various popular digital models and further distinguish their outputs from current 'mass' photography.[33] As critic Michael Fried argues, this restitution of the 'tableau' format for display also stylistically enables photographers to encourage the drawn-out and contemplative experiences between viewers and image mentioned above, which is largely what the gallery encounter has historically been expected to facilitate.[34] Viewers are offered great descriptive image clarity at close range but then must shift back to take in the photo in its entirety. Campany suggests the success of these works in galleries stems from their partial satisfaction of the demands of both formalist and post-modern critics. The immense descriptive detail of these works provides a sense of modernist, medium-

specific completeness and singularity to the photo. Yet they also facilitate post-modern questioning of photography's social functions by refusing the traditional subject matter and role of the conflict photojournalist and by highlighting still photography's distinction from more currently dominant mediums like the moving image.[35]

Despite these gallery-based developments, much photojournalism remains 'relatively unreconstructed' in its resistance to questioning of its realist and 'objective' style, a situation driven largely by institutional and distribution norms and constraints.[36] These industry norms are heavily influenced by the choices, or perceived requirements, of news media editorial and managerial staff. Structurally and economically, important divides also exist between photographers – primarily dwindling media staff and wire-service photojournalists, who often do not own their image copyrights and work to tight assignment deadlines – and those with the freedom to display and sell their work in other spheres and time for self-organised projects. The selection processes that are at the institutional core of the art world eliminate many who are not producing work deemed to be of sufficient conceptual relevance and stylistic originality. What is needed for a news photo remains different from what is considered good art and it is an often highly desirable but difficult feat for a single photographer to succeed in both markets. As has been shown above, late photographers have overwhelmingly chosen the art world for distribution, working within a set of conceptual principles that this sphere institutionally supports.

In turning now to look specifically at Guy Tillim's photography, this chapter will consider a body of work that incorporates many of the trends discussed above, including a blurring of the art, documentary and photojournalism genres, many visual tropes of late photography and the shift of a former photojournalist to a gallery setting. Like some other work placed in this category, however, Tillim's work still employs particular, well-worn allegories as part of its visual strategies and resists too much 'openness' in viewer interpretation through caption usage. The cultural pervasiveness and depth of particular discourses for representing and interpreting 'Africa' is also evident when analysing Tillim's work.

Ruins and Traces: Guy Tillim's Congo

Born and raised in Johannesburg, Guy Tillim started taking photos in the mid-1980s, as the South African apartheid regime began to collapse. At this stage, Tillim's work was primarily shown in typical photojournalistic

spaces such as newspapers and magazines; he was part of the Afrapix photo collective. Although he worked for news wires Reuters and Agence France Presse throughout the early 1990s, Tillim's recent work has been increasingly displayed in gallery spaces. In terms of content and style, when looking back on his early career work Tillim has expressed some regret over his choice of subject matter, seeing his shots of the violence and action of the liberation struggle as contributing to a new 'orthodoxy' of vision and memory in South Africa. Retrospectively, he wishes he had turned his camera upon fellow whites of his own generation, among the last to reach adulthood under apartheid. In their stories, Tillim sees a perspective that is often unheard and which enriches and complicates stories about the South African state.[37]

Tillim's photographic productions of the last ten years have regularly included images from the Democratic Republic of Congo (DRC). The *Leopold and Mobutu* work discussed here has been shown primarily through exhibitions and as a book. Launched in 2004, it was exhibited in the UK during 2005, a year in which various factors coincided to generate great public interest and awareness of poverty and suffering on the African continent under the banner campaign of Make Poverty History. Graham Harrison has productively explored the extent to which the original global trade-justice and debt-elimination message of Make Poverty History was transformed by a variety of later-affiliated institutions and individuals into a campaign primarily associated with ideas of charity and aid to the African continent in particular.[38] This included a shift throughout the campaign to the use of more 'traditional' visuals of suffering, needy African citizens. Tillim's work largely avoids this established visual iconography; yet the recalcitrant power and appeal of the African 'heart of darkness' narrative remains in the photos' display and captioning, creating a 'preferred reading' for viewers that displaces much of the possible ambiguity.

The now well-acknowledged and problematic tendency of Western media to vacillate between simplistic positive and negative representations of a homogenised 'Africa', is acknowledged by the *Guardian*'s Jonathan Jones, whose 2005 exhibition review nonetheless praises *Leopold and Mobutu* for its exposure of Congo's 'mad, chaotic and evil' conditions. For Jones, the excellence of Tillim's work lies in its complex and 'chillingly beautiful' representation of the links between Congo's present and past. Rather than showing an 'unaccountable present' as many contemporary news photos do, Jones argues, Tillim's work 'presents a catastrophe whose causes lie in a terrible past'.[39] As this chapter will argue, however,

the cross-historical comparisons encouraged by the series in part prevent it from complicating predominant Western conceptions of the African continent on a level beyond the visual.

Leopold and Mobutu sits at the borders of art, photojournalism and documentary photography. The series tackles Congo's modern history of dictatorial governance and exploitation through the creation of visual linkages between physical remainders or traces of its past regimes and the country's current condition. Tillim's interest, particularly in landscapes and architectural remains, continues as a key focus of his more recent work.[40] Both in terms of its institutional placement – in galleries and a book – as well as in its content and style, often described as 'complex', 'enigmatic', 'quiet' and 'luminous', Tillim's work employs several strategies associated with late or aftermath photography by Lisle and Campany. As Campany suggests with reference to other 'late' work, Tillim's photos, both in their style and content but also in this context of viewing, are not intended to 'break news'.[41] The small-circulation book and the contemplative space of the gallery are removed from the rapid-fire formats in which Western audiences tend to receive current events – on television, websites, or via numerous new forms of digitally-enabled tweets, posts or feeds.[42] Significantly, Tillim's conception of what photography is capable of as a medium is circumscribed, avoiding the language of 'necessary witnessing' common to much photojournalism. He argues, 'To change peoples' views presumes a lot about the value of the image and I'm not sure I'm prepared to presume that much.'[43]

Leopold and Mobutu in exhibition form consisted of a series of single images, diptychs and triptychs, roughly half of which are depictions of colonial and Mobutu-era ruins and remnants and half are scenes of current life and conditions in the DRC.[44] The book format preserves many similar juxtapositions of photos, but alternates more frequently between photos of modern Congo and traces of its colonial past. Tillim has spoken of wanting to avoid the 'false drama' of 'photojournalistic iconography'[45] and much of this series is comprised of subject matter that does not regularly illustrate news pages. Living human subjects do feature in many of the photos and are depicted more like standard photojournalistic or documentary subjects in the latter third of the exhibition, to be discussed below in more depth. Tillim uses landscapes and ruined objects, however, as a key means of interpreting Congo. As Lisle outlines in her description of this genre, 'To different degrees, then, the Late Photographers of War all traffic between absent presences and present absences which are symbolized most powerfully in the material

remnants – the detritus – that populate these images.'[46] Congolese citizens who do appear in the 'ruins' photos are often 'markers of scale' rather than photographic subjects, a trait also noted by Roberts in his assessment of Luc Delahaye's recent work.[47]

Tillim's photos invite, and often require, slow viewing, like much late and gallery photography. A diptych shown in both book and exhibition presents, on the left, a parched landscape of russet vegetation and cracked stones. Beside it, in muted shades of grey, green and blue, the viewer is shown an expanse of grey slabs, this time thinly covered in what is presumably rainwater (see Plate 16). Both landscape images appear with no obvious, single point to which the eye is drawn. The 'detritus' of which Lisle and Campany write is incredibly scarce here, producing what might be seen as a strong example of the blank and 'mute' trend in late photography. Captions are provided, however, and serve to emphasise image similarities and the enduring force of nature to outlast and ultimately erase all human endeavour; as Stallabrass suggests in his short review essay, 'overwhelming all attempts at civilization with an exuberant growth of heat and corruption'.[48] The left-hand photo is titled 'The terrace at Stanley's house at Matadi which overlooked the Congo River, July 2003' and the right as 'The marble terrace that extended from Mobutu Sese Seko's bedroom, overlooking a wide valley, in Gbadolite, July 2003'. In both situations – that of Henry Morton Stanley, the long-dead colonialist explorer and colleague of Belgium's King Leopold, and Mobutu, Congo's long-term postcolonial dictator only more recently deceased in exile – the land and environment of Congo itself is visibly working to erase their abodes from view. The comparative possibility for viewers, knowing that in both cases these are the physical traces of brutal exploiters of the general Congolese citizenry, is potentially heavily determined by the book/exhibition's introductory text and the photo captions.

The legacies and physical traces of past eras and their literal absorption back into the land of Congo provide the essential link to late themes and subject matter in *Leopold and Mobutu*. The terrace example above is among the most visually indicative of the style. Several others taken at Mobutu's looted and destroyed palace provide hints of the dictator's opulent lifestyle and also facilitate a viewer 'writing-in' process which Lisle notes as important to late photography.[49] This 'writing-in' process does not likely foster a potential solidarity and connection between the photos' absent subjects and viewers as Lisle suggests in her analysis of other late works. Nonetheless, viewers are free in this case to imagine

these ruins in their pristine states during dictatorships past, to read the titles of moulding books on shelves and the colonial-era graffiti carved into trees among other things. On an individual and visual basis, these ruins photos resist viewers' search for clear emotional or narrative direction and instead facilitate potential contemplation and exploration, a trait again discussed by Lisle as key for the late genre. Finally, in addition to adhering to Campany and Lisle's shared understanding of 'belatedness' in temporal and technological senses, these photos also share many late photos' classical composition. Such composition often follows the rule of thirds, the use of leading lines and diagonals to draw eyes into the photo, and relies on basic symmetrical shapes throughout the images.[50] Despite such evident crossovers with late photography visual themes and approaches, however, *Leopold and Mobutu* counters its ambiguous or surprising moments in many respects; captioning and juxtaposition within both the book and the exhibition do a significant amount of framing work, creating an overall message for the exhibition that Tillim himself acknowledges.

A Limited Ambivalence: Preferred Readings in *Leopold and Mobutu*

In defending the value of the 'radically open' image, Lisle notes in her assessment of other late photographers that 'even the most politically astute Late photographers can be seduced by the dominant ethical viewing relations that usually govern our visualisations of war.'[51] While offering images of Congo that at times vary considerably from traditional photojournalistic iconography in their absence of discernable 'action' and directed point of focus, *Leopold and Mobutu* presents a political position that to a large extent does lead viewers towards a long-standing Western viewing relationship with 'Africa'. Made visually, through juxtaposition of photos and textually with captions, the series highlights the historical continuity of exploitation and violence in the country. While these brutal and oppressive conditions undoubtedly existed and continue to exist in parts of Congo, the overstatement of similarities across more than a century runs the risk of rendering them as inherent, inevitable features of Congo itself. As Stallabrass suggests, this sense of continuity risks providing the Western viewer with a confirmation of the discursively powerful, oft-repeated 'heart of darkness' narrative.[52] Congo and Africa are 'destined' to the tragedies of conflict and corruption.

The *Leopold and Mobutu* photo book contains a foreword by Adam Hochschild, author of a history of Congo entitled *King Leopold's Ghost*, which provides detailed information on the country's colonial era. The penultimate paragraph encourages a 'cross reading' of the entire series, drawing together the Leopold, Mobutu and current eras into a continuous history of suffering and exploitation. As indicated above, and discussed with reference to Simon Norfolk's work by Lisle, captions often curtail the 'openness' of photos and encourage particular connections to be made between the component photos of diptychs and triptychs. An example is found in the sixth diptych of the exhibition, which also appears close to the end of the book. The viewer is presented with an image of a young boy urinating on an old rusting boat with a pulled-down statue lying across it. Behind these elements, more recent building ruins and a large power pylon with apparently functional lines attached are also visible, potentially jarring the viewer with the sudden appearance of 'modernity' after surveying a country otherwise in ruins. The accompanying diptych image is a close-up shot of dismembered statue feet, which a caption states are those from the footless statue lying across the boat in the other image. Captioning in this case goes on to direct the viewer towards only the historical aspects of the photos to continue securing the cross-historical allegory:

> The statue of Henry Stanley which overlooked Kinshasa in colonial times. It rests on a steamboat that belonged to the African International Association, a company publicly charged by Leopold with a philanthropic and 'civilising' mission that veiled its true purpose of annexing and exploiting natural resources. The statue was removed during the Mobutu period of Africanisation in the 1970s and dumped in a government transport lot in Kinshasa. The boots belonging to the statue are found in another lot, September 2003.[53]

Representation of present-day Congolese life overtakes the ruins photographs to make up much of the last third of the exhibition and appear at more dispersed intervals in the book. The exhibition triptychs portray scenes of fleeing, heavily burdened people, the displaced at rest with their possessions, and militia groups in training, all in black and white, which are reminiscent in style of more 'traditional' photojournalism or documentary photography of conflict. Their deviation from the predominant choice of muted colour also distinguishes them from the rest of the exhibition. They are all taken in eastern DRC, leading to the

exhibition's conclusion in this region, where the traces of past dictators do not visually appear in an obvious sense as in many of the earlier images. In each case, however, a colour photo, which returns the viewer to the colonial past, is introduced as the central panel of the triptych. Two military uniforms from this era are photographed in their museum cases and placed between current photos of Mai Mai militia groups training. A religious statue of a benevolent Virgin and child Jesus bringing 'civilisation' to a small black child on the Virgin's lap is inserted, providing a visual metaphor for colonial hierarchies (see Plate 17).

The artisanal mining industry in the north-east is also touched on in three diptychs that show some similarity with the work of Marcus Bleasdale, Cedric Gerbahaye and Dominic Nahr, other photographers of eastern Congo who have tended towards a more photojournalistic style.[54] Miners and their armed guards are shown at work, as well as moneychangers and diamond buyers. In these cases, however, no visual or allegorical link is made between these activities and contemporary beneficiaries of this economic exploitation; these linkages work primarily in a backward-looking historical direction. Those purchasing Congolese minerals and funding militia activities at present no longer erect commemorative statues of themselves. They instead thrive on anonymity and the complex, globalised nature of commodities sales and production, almost none of which is illustrated in this series. A single shot of a Russian cargo plane, briefly captioned as 'loading goods on the runway at Goma' provides the only, oblique glimpse within the series to a modern, outside world economically linked to Congo. A United Nations helicopter and parading Uruguayan peacekeepers (shown solely in the book form) are the only other non-Congolese elements identified in the current-day photos.

Tillim's *Leopold and Mobutu*, as noted above, is an imperfect example of late photography. It both embraces some of the sub-genre's stylistic approaches and authorial positioning yet also simultaneously overwrites its potential ambivalence with allegorical references, visual and textual. These often secure the very type of dominant viewing relations critiqued by Lisle and others. *Leopold and Mobutu* reflects Tillim's dislike of what he sees as photojournalism's frequent creation of 'false drama' through the use of an established canon of content and style. In a sense that runs deeper than merely referring to stylistic features of his photos, Tillim identifies himself as wanting to avoid 'activist' photography that has a particular 'mission'; he prefers photography that 'asks rather than answers questions' and accepts its 'circumscribed' position.[55] Visually, many of *Leopold and Mobutu*'s individual images subscribe to these goals, relatable

to those of other late photographers. Only half of the included photo sets contain a human subject and those who do appear are not easily interpreted as the classic African 'passive objects of pity' stereotype. The ruins photos in particular do not lend themselves to evidential or news illustrative usage. Their portrayal of decaying objects to a certain extent facilitates a viewer 'writing-in' process or, at minimum, offers a representation of an African 'crisis' situation that breaks with many Western norms.

Significantly, however, Tillim's 'quiet' ruins photography is heavily framed by textual aspects outside the photos' borders and by visual juxtapositioning of images. This framing both removes some of the possibilities for 'late' ambivalence from the photo series while simultaneously 'securing' an allegorical, African 'heart of darkness' narrative. The cross-historical comparative theme, one could argue, encourages a melancholic, backward-looking view across Congo's past to highlight a continuity of oppression and dictatorship in which international involvement visually disappears after King Leopold. Viewers are encouraged to reflect on the durability of oppressive governance in Africa in a way that allows non-Africans, at least, to avoid consideration of their own potential complicity in and relationship to ongoing suffering in Congo. The space for open-ended, non-prescriptive viewer contemplation is weakened by an overlaid preferred reading that supports a narrative of repeated African state 'failure' rather than an insight into the complex realities of Congo's current politics and economics.

Conclusion: Documentary's Opposing Impulses

Documentary photography and photojournalism are interconnected genres 'with pasts', ones which have come under sustained analysis and critique throughout the second half of the twentieth century. While social investment in these photographic genres' potential to generate political and critical awareness remains, their claims to 'objectivity' and any singular 'truth' have been theoretically shaken to the core. Photographers, particularly those increasingly working outside the institutional boundaries of mainstream news media, are encouraged, if not required, to consider their own social position with regards to their work. Post-structural and post-colonial critiques have normalised an understanding of photographs as inevitably 'open' documents whose interpretive possibilities for viewers can be strongly 'suggested' but never absolutely secured.

On top of this significant re-conception of photography as a practice, economic and technological changes of the last 25 years have pushed and pulled documentary photographers and photojournalists in different directions, including towards a greater engagement with 'art' – its institutions, theories and canonised historical works. 'The condition of the artist', in the words of Derrick Price, with its perceived greater possibilities for producer conceptual control and project autonomy, clearly has its appeal and benefits.[56] Institutional criteria for the style and presentation of photography as 'art' remain, however, and are crucial for an industry that has traditionally depended on exclusivity and the singular nature of art 'objects'. These factors therefore limit the amount and the kinds of documentary and photojournalistic work that end up in this sphere. To the extent that late photography has met such criteria, outlined above, it has succeeded in this space.

Guy Tillim's *Leopold and Mobutu* photography arguably works in the gallery space for a variety of reasons. His more restrained ruins and traces photos in particular present the landscape of Congo in a novel way for modern viewers, one that avoids more traditional photojournalistic news representation of 'Africa' through portraiture, passive victimhood and violent action shots. This, plus a lack of obvious focal point in several of the photos, facilitates a more extended period of viewer engagement, with the subject matter in frame deemed important for museum and gallery works. Tillim's institutional placement in the photo book and gallery space, where slower viewing has long been culturally normalised and audiences tend to be educated middle and upper classes, also inevitably shapes viewer response to his work, though this chapter has not explored these factors in depth.

In contrast to the 'activist' stance of photographers of Congo such as Marcus Bleasdale, Tillim appears less comfortable highlighting the political or critical possibilities of his photos.[57] It is left to viewers to make what Lisle would suggest is already a 'political' choice in their responses to his work, whether this be boredom, confusion, fascination, pity, melancholy acceptance or critical reflection. As this chapter has shown, Tillim overlays *Leopold and Mobutu* with a preferred cross-historical reading which to a large extent undermines its ability to be 'ambivalent'. His authorial stance, however, is closely aligned with that of many late photographers, as Lisle describes them, focused on the site of the photograph in itself. It is such a gaze, directed primarily within the image frame, that is often read by critics like Roberts and Campany as a 'melancholic', 'limited' and 'closing' gesture. They argue instead in support

of a photo-document that becomes 'the sequential and intertextual building block of a practice of reading within the archive'.[58] One might think of this as an outward- rather than inward-facing viewer relation to the photograph.

Given the significant technological, economic and cultural changes currently taking place, the uneasy genre of 'documentary photography' struggles to span many deviating understandings of its functions and strategic approaches to its creation and distribution. Photojournalism is also far from immune to these questions though it continues, more so than documentary, to maintain a descriptive language of truth, objectivity and realism within the news industry sector. From an institutional perspective, it will be interesting to observe how and if 'documentary' retains categorical significance as it is pulled in significantly different directions by its evidential and advocacy roles and its ability to highlight and emphasise complexity and ambivalence.

Notes

1 All quotes are from Geoffrey Batchen, *Burning with Desire: The Conception of Photography* (Cambridge, MA, 1997), p. 216.

2 Glenn Ruga, 'Curator's statement – the razor's edge: between documentary and fine art photography', New York Photography Festival 2012, available at http://nyph.at/ruga/curator_statement.html (accessed 18 February 2014).

3 See David Campany, 'Straight images of a crooked world', in P. Seawright and C. Coppock (eds), *So Now Then* (Cardiff, 2006); David Campany, 'Safety in numbness: some remarks on problems of "late photography"', in D. Green (ed.), *Where is the Photograph?* (Maidstone, 2003); Debbie Lisle, 'The surprising detritus of leisure: encountering the late photography of war', *Environment and Planning D: Society and Space* 29/5 (2011), pp. 873–90; John Roberts, 'Photography after the photograph: event, archive and the non-symbolic', *Oxford Art Journal* 32/2 (2009), pp. 281–98.

4 Lisle, 'The surprising detritus of leisure', pp. 873–90.

5 Susie Linfield, *A Cruel Radiance: Photography and Political Violence* (Chicago, 2010), pp. 217–18.

6 Lisle, 'The surprising detritus of leisure', p. 875.

7 Linfield, *A Cruel Radiance*, pp. 44–5.

8 Roberts, 'Photography after the photograph', pp. 281–98; and Lisle, 'The surprising detritus of leisure', p. 874.

9 Campany, 'Straight images of a crooked world', p. 8.

10 Campany, 'Safety in numbness', p. 132.

11 See 'The state of the news media 2011', Pew Research Center's Project for Excellence in Journalism, available at http://stateofthemedia.org/2011/magazines-essay (accessed 18 February 2014).

12 See Julian Stallabrass, 'Sebastião Salgado and fine art photojournalism', *New Left Review* 223 (May–June 1997), pp. 131–60; Eric Klinenberg, 'News production in a digital age', *Annals of the American Academy of Political and Social Science* 597 (January 2005), pp. 48–64.

13 See David Campbell 'Photojournalism in the new media economy', *Nieman Reports* (Spring 2010), available at www.nieman.harvard.edu/reports/article/102097/Photojournalism-in-the-New-Media-Economy.aspx (accessed 18 February 2014).

14 See Sean O'Hagan, 'Was John Szarkowski the most influential person in 20th century photography?', *Guardian* online, 20 July 2010, available at www.guardian.co.uk/artanddesign/2010/jul/20/john-szarkowski-photography-moma (accessed 18 February 2014); Christopher Phillips, 'The judgment seat of photography', *October* 22 (1982), pp. 27–63; Abigail Solomon-Godeau, *Photography at the Dock: Essays on Photographic History, Institutions and Practices* (Minneapolis, 1994).

15 See the work of Victor Burgin (ed.), *Thinking Photography* (London, 1982); Philips, 'The judgment seat of photography'; Allan Sekula, *Photography Against the Grain: Essays and Photoworks 1973–83* (Halifax, NS, 1984); Rosalind Krauss, *The Originality of the Avant-Garde and Other Modernist Myths* (Cambridge, MA, 1985); John Tagg, *The Burden of Representation: Essays on Photographies and Histories* (London, 1988); Solomon-Godeau, *Photography at the Dock*.

16 Douglas Nickel, 'History of photography: the state of research', *Art Bulletin* 83/3 (2001), p. 554.

17 Alexandra Moschovi, 'Changing places: the rebranding of photography as contemporary art', in H. Van Gelder and H. Westgeest (eds), *Photography Between Poetry and Politics: The Critical Position of The Photographic Medium in Contemporary Art* (Leuven, 2008), p. 146.

18 David Campany, 'Thinking and not thinking photography', *Engage* 14 (2004), p. 3, available at www.engage.org/downloads/152E25A7F_14.%20David%20Campany.pdf (accessed 16 March 2014).

19 Martha Rosler, 'In, around, and afterthoughts (on documentary photography)', in R. Bolton (ed.), *The Contest of Meaning: Critical Histories of Photography* (Cambridge, MA, 1992), p. 307.

20 David Campbell, 'Horrific blindness: images of death in contemporary media', *Journal for Cultural Research* 8/1 (January 2004), pp. 55–74; Paul Frosh, 'To thine own self be true: the discourse of authenticity in mass cultural production', *Communication Review* 4/4 (2001), pp. 529–45; Paul Frosh, 'Telling presences: witnessing, mass media and the imagined lives of strangers', *Critical Studies in Media Communication* 23/4 (2006),

pp. 265–84; Beverly Hawk (ed.), *Africa's Media Image* (Westport, CT, 1992); Stephen Mayes, address to World Press Photo awards ceremony (2009), available at https://www.lensculture.com/articles/stephen-mayes-lecture-by-stephen-mayes-on-photojournalism-today (accessed 16 March 2014); John Taylor, *Body Horror: Photojournalism, Catastrophe and War* (New York, 1998).

21 David Campbell, 'Constructed visibility: photographing the catastrophe of Gaza', prepared for The Aesthetics of Catastrophe conference, Northwestern University, Chicago (2009), available at www.david-campbell.org/2009/06/05/photographing-the-catastrophe-of-gaza (accessed 18 February 2014); Alfredo Cramerotti, *Aesthetic Journalism: How to Inform Without Informing* (Bristol, 2009).

22 Andy Grundberg, *The Crisis of the Real: Writings on Photography* (New York, 1999), pp. 185–6.

23 Linfield, *The Cruel Radiance*, p. 239.

24 Roberts, 'Photography after the photograph', pp. 297–8.

25 The 'Archive Fever: Uses of the Document in Contemporary Art' exhibition, organised by Okwui Enwezor and shown at the International Centre of Photography in New York in 2008 is an example of this phenomenon. Many more are listed in Cramerotti's *Aesthetic Journalism*.

26 Roberts, 'Photography after the photograph', p. 295.

27 Julian Stallabrass, 'Museum photography and museum prose', *New Left Review* 65 (September–October 2010), pp. 93–124.

28 Peter Lennon, 'The big picture', *Guardian*, 31 January 2004, available at www.guardian.co.uk/artanddesign/2004/jan/31/photography (accessed 18 February 2014).

29 Jodi Mailander Farrell, 'New York is awash in photojournalism – but is it art?', *Pop Matters* (22 October 2007), available at www.popmatters.com/pm/article/new-york-is-awash-in-photojournalism-but-is-it-art (accessed 18 February 2014).

30 Philip Gefter, *Photography After Frank* (New York, 2009), p. 198.

31 'Programme 6: Snap Judgements', *The Genius of Photography*, BBC series (2007); Julian Stallabrass, *Art Incorporated: The Story of Contemporary Art* (Oxford, 2004).

32 Ibid.; Stallabrass, 'Museum photography and museum prose'.

33 Several different photographers might be given as examples here. Simon Norfolk and Luc Delahaye both work at large-scale with medium- or large-format cameras. Many considered as 'art' photographers, such as Andreas Gursky and Jeff Wall, produce very limited numbers of large prints.

34 Michael Fried, *Why Photography Matters as Art as Never Before* (Princeton, NJ, 2008), p. 145.

35 Campany, 'Straight pictures of a crooked world', p. 10.

36 Seawright and Coppock (eds), *So Now Then*, p. 6.

37 'Documentary in a new context', Guy Tillim interviewed by Jim Casper, Lens Culture (2008), available at www.lensculture.com/articles/guy-tillim-documentary-in-a-new-context (accessed 16 March 2014).

38 Graham Harrison, 'The Africanization of poverty: a retrospective of Make Poverty History', *African Affairs* 109/436 (2010), pp. 391–408.

39 Jonathan Jones, 'Ghosts in the dark', *Guardian*, 30 August 2005, available at www.guardian.co.uk/culture/2005/aug/30/1 (accessed 18 February 2014).

40 See examples of Tillim's work at www.stevenson.info/artists/tillim.html (accessed 18 February 2014).

41 Campany, 'Safety in numbness'.

42 It should be noted that the *Leopold and Mobutu* image series was undertaken (according to www.michaelstevenson.com/contemporary/exhibitions/congo/congo1.htm (accessed 10 June 2014)) to accompany a documentary film based on Adam Hochschild's book, *King Leopold's Ghost*, which explores Leopold's exploitative and extremely violent colonial period in DRC's history. Information on the film is difficult to find, but it was apparently released in 2006 and was directed by Pippa Scott – see http://movies.nytimes.com/2006/08/18/movies/18ghos.html (accessed 10 June 2014). Because so little information could be found on the film, it is not discussed as a key distribution outlet for these photos by Tillim.

43 'Documentary in a new context', Guy Tillim interviewed by Jim Casper.

44 Tillim's *Leopold and Mobutu* exhibition can be viewed online at www.michaelstevenson.com/contemporary/exhibitions/congo/congo1.htm.

45 'Documentary in a new context', Guy Tillim interviewed by Jim Casper.

46 Lisle, 'The surprising detritus of leisure', p. 877.

47 Roberts, 'Photography after the photograph', p. 290.

48 Julian Stallabrass, 'Corruptible Kodak', *Photoworks* (Autumn–Winter 2005–6), p. 34.

49 Lisle, 'The surprising detritus of leisure', p. 884.

50 Ibid., p. 880.

51 Ibid., p. 879.

52 Stallabrass, 'Corruptible Kodak', pp. 32–5.

53 See this diptych online at: www.stevenson.info/exhibitions/congo/congo1.htm (accessed 10 June 2014); it is diptych 6.

54 See examples of these photographs on Bleasdale's website: www.marcusbleasdale.com (accessed 10 June 2014); Nahr's website: http://dnahr.tumblr.com (accessed 10 June 2014); and Gerbahaye: www.agencevu.com/photographers/photographer.php?id=214 (accessed 10 June 2014).

55 'Documentary in a new context', Guy Tillim interviewed by Jim Casper.

56 Derrick Price, 'Surveyors and surveyed: photography out and about', in L. Wells (ed.), *Photography: A Critical Introduction* (Oxford, 2009).

57 'Documentary in a new context', Guy Tillim interviewed by Jim Casper.

58 Roberts, 'Photography after the photograph', p. 294.

Select Bibliography

Abu-Lughod, Lila, *Remaking Women: Feminism and Modernity in the Middle East* (Princeton, NJ, 1998).
———— 'Do Muslim women really need saving? Anthropological reflections on cultural relativism and its others', *American Anthropologist* 104/3 (2002), 783–90.
Addi, Lahouari, 'Disappearance as a consequence of a lawless state power', in Omar D, *Devoir de mémoire/A Biography of Disappearance, Algeria 1992* (London, 2007), pp. 29–37.
Agamben, Giorgio, *Homo Sacer: Sovereign Power and Bare Life*, trans. Daniel Heller-Roazen, (Stanford, CA, 1998).
Al Jazeera, 'Libya: the propaganda war', Listening post, 12 March 2011, available at www.aljazeera.com/programmes/listeningpost/2011/03/201131210122263363. html (accessed 18 February 2014).
Allan, Stuart, *Citizen Witnessing: Revisioning Journalism in Times of Crisis* (New York, 2012).
Amnesty International, 'The battle for Libya: killings, disappearances and torture', Amnesty International (2011), available at www.amnesty.org/en/library/info/ MDE19/025/2011 (accessed 18 February 2014).
Apel, Dora, *Memory Effects: The Holocaust and the Art of Secondary Witnessing* (New Brunswick, NJ, 2002).
Azoulay, Ariella, 'Photography and colonialism in Israel/Palestine', Leslie Brooks Lecture, Durham University, 9 June 2011, available at www.dur.ac.uk/mlac/news/ displayevents/?eventno=10206 (accessed 18 February 2014).
Arendt, Hannah, *On Violence* (London, 1970).
Azoulay, Ariella, *From Palestine to Israel: A Photographic Record of Destruction and State Formation, 1947–1950* (London, 2011).
———— *The Civil Contract of Photography* (New York, 2008, 2012).
———— *Civil Imagination: Political Ontology of Photography* (London, 2012).
Baer, Ulrich, *Spectral Evidence: The Photography of Trauma* (Cambridge, MA, 2002).
Bal, Mieke, 'The pain of images', in M. Reinhardt, H. Edwards and E. Dugganne (eds), *Beautiful Suffering: Photography and the Traffic in Pain* (Chicago, 2007).
Barron, David, 'Graphic Gadhafi images highlight changed news era', *Houston Chronicle*, 20 October 2011.
Barthes, Roland, 'The photographic message', in *Image-Music-Text*, trans. Stephen Heath (London, 1977).

────── *Camera Lucida: Reflections on Photography*, trans. Richard Howe (London, 1984, 1993).

Batchen, Geoffrey, *Burning with Desire: The Conception of Photography* (Cambridge, MA, 1997).

Batchen, Geoffrey, Mick Gidley, Nancy K. Miller and Jay Prosser (eds), *Picturing Atrocity: Photography in Crisis* (London, 2012).

Baxter, Stephen, 'Colonel Gaddafi, the trophy corpse', *New Statesman*, 21 October 2011.

BBC Monitoring, 'New media emerge in "liberated" Libya', BBC (2011), available at www.bbc.co.uk/news/world-middle-east-12579451 (accessed 18 February 2014).

Beaumont, Peter, 'Reporting Libya: freelance coverage, full-time dangers', *Guardian*, 13 November 2011.

Bell, Vaughan, 'Don't touch that dial!', *Slate* 15 (February 2010), available at www.slate.com/articles/health_and_science/science/2010/02/dont_touch_that_dial.html (accessed 18 February 2014).

Benjamin, Walter, 'The work of art in the age of its technological reproducibility', in Michael W. Jennings, Brigid Doherty and Thomas Y. Levin (eds), *The Work of Art in the Age of its Technological Reproducibility, and Other Writings on Media* (Cambridge, MA, 2008).

Bennett, Jill, *Empathic Vision: Affect, Trauma, and Contemporary Art* (Stanford, CA, 2005).

Blocker, Jane, *Seeing Witness: Visuality and the Ethics of Testimony* (Minneapolis, 2009).

Blustein, Jeffrey, *The Moral Demands of Memory* (Cambridge, 2007).

Boltanski, Luc, *Distant Suffering: Morality, Media and Politics*, trans. Graham Burchell (Cambridge, 1999).

Booth, W.J., *Communities of Memory: On Witness, Identity, and Justice* (Ithaca, NY, and London, 2006).

Boudjelal, Bruno, *Disquiet Days/Jours intranquilles* (London, 2009).

Breslin, Susanna, 'Why we love the porn of war', Forbes.com, 20 October 2011, available at www.forbes.com/sites/susannahbreslin/2011/10/20/qaddafi-dead (accessed 16 March 2014).

Bronner, Ethan and Isabel Kershner, 'Resolve of West Bank settlers may have limits', *New York Times*, 13 September 2009, available at www.nytimes.com/2009/09/14/world/middleeast/14settlers.html?_r=0 (accessed 18 February 2014).

Brooks Libby, 'The Turkish earthquake baby has evoked an empathy we too often repress', *Guardian*, 27 October 2011, available at www.guardian.co.uk/commentisfree/2011/oct/27/turkish-earthquake-baby-empathy (accessed 18 February 2014).

Brown, Andrew, 'Libya's front-page casualties have not suffered the most tragic fate', Comment is Free blog, *Guardian*, 21 April 2011, available at www.theguardian.com/commentisfree/2011/apr/21/libya-front-page-casualties (accessed 16 March 2014).

Burgin, Victor, *Thinking Photography* (London, 1982).

Burroughs, Robert M., *Travel Writing and Atrocities: Eyewitness Accounts of Colonialism in the Congo, Angola, and the Putumayo* (New York, 2011).

Burrows, Larry, 'A degree of disillusion', *Life*, 19 September 1969, pp. 66–75.

Butler, Judith, *Precarious Life: The Powers of Mourning and Violence* (New York and London, 2004).

————*Frames of War: When is Life Grievable?* (New York and London, 2009, 2010).

Campany, David, 'Safety in numbness: some problems of "late photography"', in D. Green (ed.), *Where is the Photograph?* (Maidstone, 2003).

Campany, David, *Art and Photography* (London, 2003).

———— 'Straight images of a crooked world' in P. Seawright and C. Coppock (eds), *So Now Then* (Cardiff, 2006).

———— 'Thinking and not thinking photography', *Engage* 14 (2004), available at www.engage.org/downloads/152E25A7F_14.%20David%20Campany.pdf (accessed 16 March 2014).

Campbell, David, *National Deconstruction: Violence, Identity, and Justice in Bosnia* (Minneapolis, 1998).

———— 'Horrific blindness: images of death in contemporary media', *Journal for Cultural Research* 8/1 (January 2004), pp. 55–74.

———— 'Geopolitics and visuality: sighting the Darfur conflict', *Political Geography* 26 (2007), p. 368.

———— 'Constructed visibility: photographing the catastrophe of Gaza', paper prepared for the Aesthetics of Catastrophe conference, Northwestern University, Chicago, 2009, available at www.david-campbell.org/2009/06/05/photographing-the-castrophe-of-gaza (accessed 18 February 2014).

———— 'How does the media persuade us to give to charities?', 21 February 2010, available at www.david-campbell.org/2010/02/21/media-charity-compassion (accessed 18 February 2014).

———— 'Photojournalism in the new media economy', *Nieman Reports* (Spring 2010), available at www.nieman.harvard.edu/reports/article/102097/Photojournalism-in-the-New-Media-Economy.aspx (accessed 18 February 2014).

Carr, David, 'War, in life and death', *New York Times*, 25 April 2011.

Carter, Graydon, 'Graydon Carter remembers Tim Hetherington', VanityFair.com, 20 April 2011, www.vanityfair.com/magazine/2011/04/graydon-carter-remembers-tim-hetherington-201104 (accessed 16 March 2014).

Caruth, Cathy, *Trauma: Explorations in Memory* (Baltimore, MD, 1995).

Casper, Jim, 'Documentary in a new context', Guy Tillim interviewed by Jim Casper, Lens Culture (2008), available at www.lensculture.com/articles/guy-tillim-documentary-in-a-new-context (accessed 16 March 2014).

CBS, 'Miami photojournalist speaks about imprisonment in Libya at Um', CBS Miami, 12 April 2011.

Cerf, Juliette and Charles Tesson, 'Benjamin Stora: L'absence d'images déréalise l'Algérie. Elle construit un pays fantasmé qui n'existe pas', *Cahiers du cinéma*, hors série (February 2003), pp. 7–13

Cherif, Benyoucef, *Algérie: Une saison en enfer* (Paris, 2003).

Chivers, C.J. '"Restrepo" director and a photographer are killed in Libya', *New York Times*, 20 April 2011.

Chouliaraki, Lilie, *The Spectatorship of Suffering* (Thousand Oaks, CA, 2006).

Cmiel, Kenneth, 'The recent history of human rights', *American Historical Review* 109/1 (2004), pp. 117–35.

Cohen, Stanley, *States of Denial: Knowing About Atrocities and Suffering* (Oxford, 2001).

Cohen, Stanley and Bruno Seu, 'Knowing enough not to feel too much: emotional thinking about human rights appeals', in Mark Phillip Bradley and Patrice Petro (eds), *Truth Claims: Representation and Human Rights* (New Brunswick, NJ, 2002).

Coker, Margaret and Sam Dagher, 'Gadhafi forces seek to widen grip', *Wall Street Journal*, 5 March 2011.

Committee to Protect Journalists, 'Journalists under attack in Libya: the tally', 20 May 2011, available at http://cpj.org/blog/2011/05/journalists-under-attack-in-libya.php (accessed 16 March 2014).

Coppin, Noémie and Lucile Pinero, 'Les mondes clos de Michael von Graffenried', *Libération*, 27 April 2010, p. 24.

Cramerotti, Alfredo, *Aesthetic Journalism: How to Inform Without Informing* (Bristol, 2009).

Davies, Lizzy, 'Sarkozy admits Paris errors over Rwanda genocide', *Guardian*, 26 February 2010, p. 17.

Davis, Colin, 'État *présent*: hauntology, spectres and phantoms', *French Studies* 59/3 (2005), pp. 373–9.

Dawson, Graham, 'Trauma, place and the politics of memory: Bloody Sunday, Derry, 1972–2004', *History Workshop Journal* 59/1 (2005), p. 165.

Dawson, Graham (ed.), *Making Peace with the Past? Memories, Trauma and the Irish Troubles* (Manchester, 2010).

Dean, Carolyn, *The Fragility of Empathy After the Holocaust* (Ithaca, NY, 2004).

Delannoy, Pierre-Alban, *La Pietà de Bentalha: étude du processus interprétatif d'une photo de presse* (Paris, 2005).

Derrida, Jacques, *Spectres de Marx: L'État de la dette, le travail du deuil et la nouvelle internationale* (Paris, 1993).

——— 'Taking a stand for Algeria', *Parallax* 4/2 (1998), pp. 17–23.

Didi-Huberman, Georges, *Images in Spite of All* (Chicago, 2008).

Djebar, Assia, 'Raïs, Bentalha: un an après', *Research in African Literatures* 30/3 (1999), pp. 7–14.

Doyle, Coleman, *People at War* (Dublin, 1975).

Dugger, Celia, 'International calamities tax America's compassion', *New York Times*, 12 May 1991, available at www.nytimes.com/1991/05/12/nyregion/international-calamities-tax-america-s-compassion.html (accessed 18 February 2014).

Dutour, Nassera, 'Algérie: de la Concorde Civile à la Charte pour la Paix et la Réconciliation Nationale: amnistie, amnésie, impunité', *Mouvements* 53 (2008), pp. 144–9.

Dyck, Evelyne J. and Gary Coldevin, 'Using positive vs. negative photographs for third-world fund raising', *Journalism and Mass Communication Quarterly* 69/3 (1992), pp. 572–9.

Edwards, Elizabeth, *Raw Histories: Photographs, Anthropology and Museums* (Oxford, 2001).

——— 'Entangled documents: visualised histories', in Susan Meiselas and Kristen Lubben (eds), *Susan Meiselas: In History* (New York, 2008).

——— 'Thinking photography beyond the visual?', in J.J. Long, Andrea Noble and Edward Welch (eds), *Photography: Theoretical Snapshots* (London, 2009).

Edwards, Elizabeth and Janice Hart, 'Introduction: photographs as objects', in Elizabeth Edwards and Janice Hart (eds), *Photographs Objects Histories: On the Materiality of Images* (London, 2004).

Edwards, Holly, 'Cover to cover: the life cycle of an image in contemporary visual culture', in M. Reinhardt, H. Edwards and E. Duganne (eds), *Beautiful Suffering: Photography and the Traffic in Pain* (Chicago, 2007).

Ehrenreich, Barbara, *Blood Rites: Origins and History of the Passions of War* (New York, 1997).

Ehrlich, S.G. and Leland V. Jones, *Photographic Evidence* (London, 1965).

Entelis, John P., 'Algeria: democracy denied, and revived?', *Journal of North African Studies* 16/4 (2011), pp. 653–78.

Evans, Martin and John Phillips, *Algeria: Anger of the Dispossessed* (New Haven, CT, 2007).

Evans, Walker, 'Beauties of the common tool', *Fortune* (July 1955).

Ewans, Martin, *European Atrocity, African Catastrophe: Leopold II, the Congo Free State and its Aftermath* (London, 2002).

Farrell, Jodi Mailander, 'New York is awash in photojournalism – but is it art?', *Pop Matters* (22 October 2007), available at www.popmatters.com/pm/article/ new-york-is-awash-in-photojournalism-but-is-it-art (accessed 18 February 2014).

Feldman, Allen, 'The structuring enemy and archival war', *PMLA* 124/5 (2009), p. 1712.

Ferrell, Jeff, Keith Hayward and Jock Young, *Cultural Criminology: An Invitation* (London, 2008).

Ferroggiaro, William, (ed.), *The US and the Genocide in Rwanda 1994: Evidence of Inaction* (Washington, DC, 2001), available at www.gwu.edu/~nsarchiv/ NSAEBB/NSAEBB53/index.html (accessed 18 February 2014).

Figley, Charles, 'Compassion fatigue: an introduction', available at www.giftfromwithin.org/html/What-is-Compassion-Fatigue-Dr-Charles-Figley.html (accessed 18 February 2014).

Fineman, Mia, 'Ecce homo prostheticus: technology and the new photography in Weimar Germany' (PhD, Yale University, 2001).

Flusser, Vilém, *Towards a Philosophy of Photography*, trans. Anthony Matthews (London, 2000).

Foley, James, 'Like battlefield tourists, Libyan rebels film the fight', GlobalPost.com, 5 October 2011, available at www.globalpost.com/dispatches/globalpost-blogs/ the-casbah/battlefield-tourists-libyan-rebels-film-the-fight (accessed 16 March 2011).

Foucault, Michel, *The Archaeology of Knowledge*, trans. A.M. Sheridan Smith (London, 1989).

——— *Security, Territory, Population: Lectures at the Collège De France, 1977–78*, ed. M. Senellart, trans. Graham Burchell (Basingstoke and New York, 2007).

Fox -Bourne, Henry R., *Civilisation in Congoland: A Story of International Wrong-Doing* (London, 1903).

Franklin, John Hope, *George Washington Williams: A Biography* (Durham, NC, 2008).

Fried, Michael, *Why Photography Matters as Art as Never Before* (Princeton, NJ, 2008).

Frosh, Paul, 'To thine own self be true: the discourse of authenticity in mass cultural production', *Communication Review* 4/4 (2001), pp. 529–45.

———— 'Telling presences: witnessing, mass media, and the imagined lives of strangers', in Paul Frosh and A. Pinchevski (eds), *Media Witnessing: Testimony in the Age of Mass Communication* (New York, 2009).

Gayle, Damien, '"I killed Gaddafi", claims Libyan rebel as most graphic video yet of dictator being beaten emerges', *Daily Mail*, 25 October 2011.

Gefter, Philip, *Photography After Frank* (New York, 2009).

Gentry, Eric, 'Compassion fatigue: a crucible of transformation', *Journal of Trauma Practice* 1 (2002), pp. 37–61.

Graffenried, Michael von, *Inside Algeria* (New York, 1998).

———— *Journal d'Algérie 1991–2001: Images interdites d'un guerre invisible* (Paris, 2003).

Graham, Colin, 'Every passerby a culprit? Archive fever, photography and the peace in Northern Ireland', *Third Text* 19/5 (2005), pp. 567–80.

Graham, David A., 'Libya war photographers' final hours', Daily Beast, 21 April 2011, available at www.thedailybeast.com/articles/2011/04/21/hetherington-and-hondros-last-stand-saw-heavy-shelling-no-nato-support.html (accessed 16 March 2014).

Grant, Kevin, 'Christian critics of empire: missionaries, lantern lectures and the Congo Reform Campaign in Britain', *Journal of Imperial and Commonwealth History* 29/2 (2001), pp. 27–58.

———— *A Civilised Savagery: Britain and the New Slaveries in Africa, 1884–1926* (New York, 2005).

Grattan Guinness, Harry, *Congo Slavery: A Brief Survey of the Congo Question from the Humanitarian Point of View* (London, c. 1904).

Greenslade, Roy, 'Why Daily Record was censured by PCC for using picture of a dead man', *Guardian*, 25 October 2011.

Grewal, Inderpal, *Transnational America: Feminisms, Diasporas, Neoliberalisms* (Durham, NC, 2005).

Griffin, Michael, 'Picturing America's "War on Terrorism" in Afghanistan and Iraq: photographic motifs as news frames', *Journalism* 5/4 (2004), pp. 381–402.

Griffiths, Philip Jones, *Vietnam Inc.* (London, 2001).

———— *Agent Orange: 'Collateral Damage' in Vietnam* (London, 2003).

———— interview, *Digital Journalist* (January 2003), available at http://digitaljournalist.org/issue0401/griffiths_intro (accessed 18 February 2014).

———— 'Q&A – war photography and Vietnam', *Open Democracy* (April 2005), available at www.opendemocracy.net/philip_jones_griffiths_q_a_war_photography_and_vietnam_0_ (accessed 18 February 2014).

———— *Vietnam at Peace* (London, 2005).

Grimaldi, Fulvio, 'Original Statement to the Widgerly Tribunal' (1972), reproduced in the testimony and records of the Lord Saville Inquiry (2010), available at www.bloody-sunday-inquiry.org.uk/reports/kstatements/arcahive/M34.pdf (accessed 18 February 2014) and www.bloody-sunday-inquiry.org.

Grimaldi, Fulvio and Susan North, *Blood on the Streets* (Dublin, Rome, London, 1972).

Grundberg, Andy, *The Crisis of the Real: Writings on Photography* (New York, 1999).

Guerin, Orla, 'Libya: UN warns of blurring aid and military operations', BBC News, 21 April 2011, available at www.bbc.co.uk/news/world-africa-13152392 (accessed 11 May 2014).

Guillot, Claire, 'Michael von Graffenried: la réalité panoramique', *Le Monde*, 27 May 2010, p. 22.

Gunter, Joel, '"Wherever there was news, we went": Libya's "A Team" fixers on getting the story out', Journalism.co.uk, 17 November 2011, available at www.journalism.co.uk/news-features/-wherever-there-was-news-we-went--libya-s-a-team-fixers-on-getting-the-story-out/s5/a546770 (accessed 16 March 2014).

Gunthert, André, 'Digital imaging goes to war: the Abu Ghraib photographs', *Photographies* 1/1 (2008), pp. 103–12.

Heatherington, Tim, 'Tim Hetherington's last interview', interviewed by R.Haggart, 13 April 2009, available at www.outsideonline.com/outdoor-adventure/media/Tim-Hetherington-s-Last-Interview.html (accessed 16 March 2014).

Halliday, Josh, 'Gaddafi death video: BBC defends use of "shocking" images', *Guardian*, 21 October 2011.

Hanrot, Juliette, *La Madone de Bentalha: histoire d'une photographie* (Paris, 2012).

Harris, John, *Rubber is Death* (London, c. 1905).

Harrison, Graham, 'Philip Jones Griffiths', *Photo Histories* (2008), available at www.photohistories.com/interviews/23/philip-jones-griffiths?pg=all (accessed 18 February 2014).

Harrison, Graham, 'The Africanization of poverty: a retrospective on "Make Poverty History"', *African Affairs* 109/436 (2010), pp. 391–408.

Hariman, Robert and John Louis Lucaites, *No Caption Needed: Iconic Photographs, Public Culture and Liberal Democracy* (Chicago, 2007).

Hariman, Robert, 'Cultivating compassion as a way of seeing', *Communication and Critical/Cultural Studies* 6/2 (2009), pp. 199–203.

Haslam, S. Alexander and S.D. Reicher, 'Questioning the Banality of Evil', *Psychologist* 21/1 (2008), pp. 16–19, available at www.thepsychologist.org.uk/archive/archive_homecfm?volumeID=21&editionID=155&ArticleID=1291 (accessed 18February 2014).

Hasty, Kim, 'Photojournalist Hondros killed in Libya: former *Observer* staffer', *Fayetteville Observer*, 21 April 2011.

Haviv, Ron, *Blood and Honey* New York, 2000).

Hawk, Beverly (ed.), *Africa's Media Image* (Westport, CT, 1992).

Hawkins, Hunt, 'Mark Twain's involvement with the Congo Reform Movement: "A fury of generous indignation"', *New England Quarterly* 51/2 (1978), pp. 147–75.

Heneghan, T. and P. Apps, 'Is gruesome no longer taboo?', Reuters.com, 21 October 2011, available at www.reuters.com/article/2011/10/21/gaddafideath-images-idUSL5E7LL3ZC20111021 (accessed 16 March 2014).

Herron, Tom and John Lynch, *After Bloody Sunday: Representation, Ethics, Justice* (Cork, 2007).

Hesford, Wendy, *Spectacular Rhetorics: Human Rights Visions, Recognitions, Feminisms* (Durham, NC, 2011).

Hesford, Wendy S. and Wendy Kozol (eds), *Just Advocacy? Women's Human Rights, Transnational Feminisms, and the Politics of Representation* (New Brunswick, NJ, 2005).

Hetherington, Tim, 'Interview with J. Brown', PBS Newshour, 17 November 2010.

Hirsch, Marianne, 'Family pictures: mourning, and post memory', *Discourse* 14/1 (1992), pp. 3–29.

—————— *Family Frames: Photography, Narrative and Postmemory* (Cambridge, MA, 1997).

—————— 'War stories, witnessing in retrospect', in Shelley Hornstein and Florence Jacobowitz (eds), *Image and Remembrance: Representation and the Holocaust* (Bloomington, IN, 2003).

Hirschman, Charles, Samuel Preston and Vu Manh Loi, 'Vietnamese casualties during the American war: a new estimate', *Population and Development Review* 21 (1995), p. 783–812.

Hochschild, Adam, *King Leopold's Ghost: A Story of Greed, Terror and Heroism in Colonial Africa* (New York, 1998).

Hockaday, Mary, 'The challenges of reporting Gaddafi's death', Editor's Blog, BBC. co.uk, 21 October 2011, available at www.bbc.co.uk/blogs/theeditors/2011/10/the_challenges_of_reporting_ga.html (accessed 18 February 2014).

Höijer, Birgitta, 'The discourse of global compassion: the audience and media reporting of human suffering', *Media, Culture and Society* 26 (2004), pp. 513–31.

Hondros, Chris, 'Quiet spectacle: an interview with Chris Hondros', interviewed by J. Saffron, *Afterimage* 35/6 (May/June 2008).

Hopkinson, Amanda, 'Philip Jones Griffiths', *Guardian*, 24 March 2008, available at www.guardian.co.uk/artanddesign/2008/mar/24/photography (accessed 18 February 2014).

Howe, Peter, *Shooting under Fire: The World of the War Photographer* (New York, 2002).

—————— 'The Vietnamization of Philip Jones Griffiths', *Digital Journalist* (July 2005), available at http://digitaljournalist.org/issue0507/griffiths.html (accessed 18 February 2011).

—————— 'The dauntless spirit: Philip Jones Griffiths, 1936–2008', *Digital Journalist* (April 2008), available at http://digitaljournalist.org/issue0804/the-dauntless-spirit-philip-jones-griffiths-1936-2008.html (accessed 18 February 2014).

Hoyt, Clark, 'Face to face with tragedy,' *New York Times*, 23 January 2010, available at www.nytimes.com/2010/01/24/opinion/24pubed.html (accessed 18 Feburary 2014).

Hua, Julietta, *Trafficking Women's Human Rights* (Minneapolis, 2011).

Hunt, Krista and Kim Rygiel, *(En)Gendering the War on Terror: War Stories and Camouflaged Politics* (Burlington, VT, 2006).

International Press Institute, 'Deadly trends for journalists in 2011: 103 killed', 4 January 2012, available at www.freemedia.at/home/singleview/article/new-deadlytrends-for-journalists-in-2011-103-killed.html (accessed 16 March 2014).

International News Safety Institute, 'How Tim Hetherington's death highlights the dangers for journalists in Libya', 20 April 2011, available at www.newssafety.org (accessed 18 February 2014).

'The Inconvenient Kodak Again', *Official Organ of the Congo Reform Association*, February 1906.

Jensen, Jon, 'Reporters' release tempered by news of colleague's death', GlobalPost.com, 19 May 2011, available at www.globalpost.com/dispatch/news/regions/africa/110519/libya-journalist-death-anton-hammerl-james-foley-clare-gillis (accessed 18 February 2014).

Joly, Martine, 'L'invisible dans l'image', *Sciences Humaines* 83 (May 1998).

Jones, Jonathan, 'Ghosts in the dark', *Guardian*, 30 August 2005, available at www. guardian.co.uk/culture/2005/aug/30/1 (accessed 18 February 2014).

——— 'The West wrings its hands over dead Gaddafi photos, but war is always hell', *Guardian*, 25 October 2011.

Jonson, James, '"The arithmetic of compassion": rethinking the politics of photography', *British Journal of Political Science* 41 (2011), pp. 621–43.

Joseph, Suad and Susan Slyomovics, *Women and Power in the Middle East* (Philadelphia, 2001).

Judd, Louis J. (ed.), *Mark Twain: The Contemporary Reviews* (Cambridge, 1999.

Kacandes, Irene, *Talk Fiction: Literature and the Talk Explosion* (Lincoln, NB, 2001).

Kamber, Michael, 'A group of conflict photographers runs out of luck', *New York Times*, 23 April 2011.

Keegan, John, *The Face of Battle: A Study of Agincourt, Waterloo, and the Somme* (New York, 1976).

Keeley, Lawrence H., *War Before Civilization: The Myth of the Peaceful Savage* (New York, 1996).

Keenan, Thomas 'Mobilizing shame', *South Atlantic Quarterly* 103/2–3 (2004), pp. 435–49.

Keller, Bill, 'Yes, a poet, but first and foremost an incomparable witness: Anthony Shadid, a New York Times reporter, dies in Syria', *Twitter* (2012), available at https://twitter.com/billkeller2014/status/170513821524430848 (accessed 18 February 2014).

Kennedy, Liam, 'Securing vision: photography and US foreign policy', *Media, Culture, & Society* 30/3 (2008), pp. 279–94.

——— 'American studies without tears, or what does America want?', *Journal of Transnational American Studies* 1/1 (2009).

——— 'Framing compassion', *History of Photography* 36/3 (August 2012), pp. 306–14.

Kennedy, Pagan, *Black Livingstone: A True Tale of Adventure in the Nineteenth-Century Congo* (New York, 2002).

Khan, Shahnaz, 'Between here and there: feminist solidarity and Afghan women', *Genders* 33 (2001), available at www. genders.org (accessed 18 February 2014).

Khanna, Ranjana, *Algeria Cuts: Women and Representation, 1830 to the Present* (Stanford, CA, 2008).

Kifner, John, 'A pictorial guide to hell', *New York Times*, 24 January 2001.

Kinnick, Katherine, Dean M. Krugman and Glen T. Cameron, 'Compassion fatigue: communication and burnout toward social problems', *Journalism and Mass Communication Quarterly* 73 (1996), pp. 687–707.

Kirkpatrick, David D., 'Qaddafi brutalizes foes, armed or defenseless', *New York Times*, 4 March 2011.

Klinenberg, Eric, 'News production in a digital age', *Annals of the American Academy of Political and Social Science* 597/1 (2005), pp. 48–64.

Knightley, Philip, *The First Casualty: The War Correspondent as Hero and Myth-Maker from the Crimea to Iraq* (Baltimore, MD, 2004).

'The Kodak on the Congo', *West African Mail*, Special Congo Supplement, September 1905.

Kogut, Tehila and Ilana Ritov, 'The "identified victim" effect: an identified group, or just a single individual?', *Journal of Behavioral Decision Making* 18/3 (2005), pp. 157–67.

Kozol, Wendy, 'Visual witnessing and women's human rights', *Peace Review* 20/1 (2008), pp. 67–75.

Krauss, Rosalind, *The Originality of the Avante-Garde and Other Modernist Myths* (Cambridge, MA, 1985).

LaCapra, Dominick, *Writing History, Writing Trauma* (Baltimore, MD, 2001).

Le Sueur, James D., *Algeria Since 1989: Between Terror and Democracy* (New York, 2010).

Lennon, Peter, 'The big picture', *Guardian*, 31 January 2004, available at www.guardian.co.uk/atanddesign/2004/jan/31/photography (accessed 18 February 2014).

Lequeret, Elisabeth and Charles Tesson, 'Yamina Bachir-Chouikh: des gens viennent voir leur histoire, leur vie. Ce n'était pas arrivé depuis longtemps', *Cahiers du Cinéma* (February 2003), pp. 26–31.

Life, 100 Photographs That Changed the World (New York, 2003).

Light, Ken (ed.), *Witness in our Time: Working Lives of Documentary Photographers* (Washington, DC, 2000).

Limpkin, Clive, *The Battle of the Bogside* (London, 1972).

Linfield, Susie, *The Cruel Radiance: Photography and Political Violence* (Chicago, 2010).

Lisle, Debbie, 'The surprising detritus of leisure: encountering the late photography of war', *Environment and Planning D: Society and Space* 29/5 (2011), pp. 873–90.

Lodish, Emily, 'Gaddafi's end: how cell phones became weapons of choice', GlobalPost.com, 21 October 2011, available at www.globalpost.com/dispatch/news/business-tech/technology-news/111021/gaddafi-deadkilling-libya-cell-phones-international-news-global-media-mobile (accessed March 2014).

Louis, William R., 'Roger Casement and the Congo', *Journal of African History* 5/1 (1964), p. 99.

Mackintosh, C.W., *Dr. Harry Guinness: The Life Story of Henry Grattan Guinness* (London, 1916).

MacLeod, Scott, 'Images of a war in Algeria', *Time*, 19 April 1999.

Madger, Ted, 'Watching what we say: global communication in a time of fear', in-D. Thussu and D. Freedman (eds), *24/7, War and the Media: Reporting Conflict* (London, 2003).

Matheson, Donald and Stuart Allan, *Digital War Reporting* (Cambridge, 2009).

Mandel, Mike and Larry Sultan, *Evidence* (New York, 2003).

Mayes, Stephen, address to World Press photo awards ceremony, (2009), available at www.lensculture.com/articles/stephen-mayes-lecture-by-stephen-mayes-on-photojournalism-today (accessed 16 March 2014).

Meiselas, Susan, *In History* (New York, 2008).

Mettelsiefen, Marcel, 'Photographing war in Misurata: "there were four times when I could have died"', *Spiegel* online, 21 April 2011, available at www.spiegel.de/international/world/photographing-war-in-misurata-there-were-four-times-when-i-could-have-died-a-758634.html (accessed 16 March 2014).

Meyerowitz, Joel, *Aftermath: World Trade Center Archive* (New York, 2006).

McCullin, Don, *Unreasonable Behaviour: An Autobiography* (London, 1992).

Michelson, Bruce, *Printer's Devil: Mark Twain and the American Publishing Revolution* (Berkeley, CA, 2006).

Miller, Russell, *Magnum: Fifty Years at the Front Line of History* (London, 1997).

Moeller, Susan D., *Shooting War: Photography and the American Experience of Combat* (New York, 1989).

—— *Compassion Fatigue: How the Media Sell Disease, Famine, War and Death* (New York, London, 1999).

—— 'Compassion fatigue: graphic, complicated stories numb readers and viewers to atrocities', *Media Studies Journal* (Summer 2001), pp. 108–12.

—— 'A hierarchy of innocence the media's use of children in the telling of international news', *Harvard International Journal of Press/Politics* 7/1 (2002), pp. 36–56.

Moore, Martin, *Shrinking World: The Decline of International Reporting in the British Press* (London, 2010).

Moore, Suzanne, 'Yes, he had it coming, but did we really need to gloat like barbarians?', *Mail on Sunday*, 23 October 2011.

Morel, E.D., *King Leopold's Rule in Africa* (London, 1904).

—— *Red Rubber* (first published London, 1904).

Morris, Rosalind C., 'Images of untranslatability in the US war on terror', *Interventions* 6/3 (2004), pp. 401–23.

Morrison, Wayne, 'A reflected gaze of humanity: cultural criminology and images of genocide', in Keith J. Hayward (ed.), *Facing Crime: Cultural Criminology and the Image*, (Oxford, 2010).

Moschovi, Alexandra, 'Changing places: the rebranding of photography as contemporary art', in H. Van Gelder Westgeest and H. Leuven (eds), *Photography between Poetry and Politics: The Critical Position of the Photographic Medium in Contemporary Art* (Leuven, 2008).

Moyn, Samuel, *The Last Utopia: Human Rights in History* (Cambridge, MA, 2010.

National Security Strategy of the United States of America, September 2002, available at http://georgewbush-whitehouse.archives.gov/nsc/nss/2002 (accessed 16 March 2014).

Newsweek, 'Muammar Gaddafi's corpse', Tumblr post, 20 October 2011, available at http://newsweek.tumblr.com/post/11694030747/warning-this-is-video-of-muammar-gaddafis-corpse (accessed 18 February 2014).

Nickel, Douglas, 'History of photography', *Art Bulletin* 83/3 (2001), p. 554.

Noble, Andrea, 'Family photography and the global drama of human rights', in J.J. Long, Andrea Noble and Edward Welch (eds), *Photography: Theoretical Snapshots* (London, 2009).

O'Hagan, Sean, 'Was John Szarkowski the most influential person in 20th-century photography?', *Guardian* online, 20 July 2010, available at www.theguardian.com/artanddesign/2010/jul/20/john-szarkowski-photography-moma (accessed 18 February 2014).

O'Hanlon, Eilis, 'Seeing death as it happens brings cruel realities of war to the fore', *Sunday Independent* (Ireland), 30 October 2011.

O'Neill, Megan, 'How YouTube is aiding the Libyan revolution', *Social Times* 26 February 2011.

Ó'Síocháin, Séamas and Michael O'Sullivan, *The Eyes of Another Race: Roger Casement's Congo Report and 1903 Diary* (Dublin, 2003).

Oldfield Sybil, 'Harris, Alice (1870–1970)', in Sybil Oldfield, *Women Humanitarians: A Biographical Dictionary of British Women Active between 1900 and 1950* (London, 2001), pp. 94–7.

———'Harris, Sir John Hobbis (1874–1940)', in Lawrence Goldman (ed.), *Oxford Dictionary of National Biography*, online edn (Oxford, 2004, available at www.oxforddnb.com/view/article/40721 (accessed 18 February 2014).

Olivier, Laurent, *The Dark Abyss of Time* (Lanham, MD, 2011).

Olsen, Bjørnar, *In Defense of Things: Archaeology and the Ontology of Objects* (Lanham, MD, 2010).

Omar D, *De Devoir de mémoire/A Biography of Disappearance, Algeria 1992* (London, 2007).

Parker, Ned and Reed Johnson, 'Libya blast kills photojournalists Tim Hetherington and Chris Hondros', *Los Angeles Times* website, 21 April 2011, available at http://articles.latimes.com/2011/apr/21/world/la-fg-libya-photographers-20110421 (accessed 11 May 2014).

Parry, Katy, 'Media visualisation of conflict: studying news imagery in 21st century wars', *Sociology Compass* 4/7 (2010), pp. 417–29.

Peffer, John, 'Snap of the whip/crossroads of shame: flogging, photography, and the representation of atrocity in the Congo reform campaign', *Visual Anthropology Review* 24/1 (2008), pp. 55–77.

Peress, Gilles, 'Interview with Gilles Peress: images, reality and the curse of history', interview with ASX (1997), available at www.americansuburbx.com/2010/07/theory-interview-with-gilles-peress.html (accessed 18 February 2014).

——— *The Graves* (New York, 1998).

Peress, Gilles, Eric Stover and Fred Abrahams, *A Village Destroyed* (Berkeley, CA, 1999).

Perlmutter, David D., *Photojournalism and Foreign Policy: Icons of Outrage in International Crises* (Westport, CT, 1998).

——— *Visions of War: Picturing Warfare from the Stone Age to the Cyber Age* (New York, 1999).

Peters, Jeremy W., 'Freed *Times* journalists give account of captivity', *New York Times*, 22 March 2011, available at www.nytimes.com/2011/03/22/world/africa/22times.html?pagewanted=all&_r=0 (accessed 18 February 2014).

Pew Research Center, 'The state of the news media 2011', Pew Research Center Project for Excellence in Journalism, available at http://stateofthemedia.org/2011/overview-2/key-findings (accessed 18 February 2014).

Phillips, Christopher, 'The judgment seat of photography', *October* 22 (1982), pp. 27–63.

Pinney Christopher, 'Introduction: "How the other half ...", in C. Pinney and N. Peterson (eds), *Photography's Other Histories* (Durham, NC, 2003).

Pinker, Steven, *The Better Angels of Our Nature: Why Violence Has Declined* (New York, 2011).

Poniewozik, James, 'Did you need to see Gaddafi's corpse?', *Time*, 20 October 2011.

Poole, Deborah, *Vision, Race and Modernity: A Visual Economy of the Andeán Image World* (Princeton, NJ, 1997).

Power, Samantha, '*A Problem from Hell': America and the Age of Genocide* (New York, 2002).

Preston, Peter, 'Boundaries are crossed as grim images of Gaddafi flood the media', *Observer*, 23 October 2011.

Price, Derrick, 'Surveyors and surveyed: photography out and about', in L. Wells (ed.), *Photography: A Critical Introduction* (Oxford, 2009).

Rancière, Jacques, *Disagreement: Politics and Philosophy*, trans. Julie Rose (Minneapolis, 1999).

―――― *The Politics of Aesthetics: The Distribution of the Sensible*, trans. Gabriel Rockhill (London, 2004).

―――― 'The emancipated spectator', *Artforum* 45/7 (2007), p. 277.

―――― *The Emancipated Spectator*, trans. Gregory Elliot (London and New York, 2009).

―――― *Dissensus: On Politics and Aesthetics*, trans, Steve Corcoran (London, 2010).

Reilly, Niamh, *Women's Human Rights: Seeking Gender Justice in a Globalizing Age* (Malden, MA, 2009).

Reinhardt, Mark, Holly Edwards and Erina Duganne, (eds), *Beautiful Suffering: Photography and the Traffic in Pain* (Chicago, 2007).

Rice, Xan and Josh Halliday, 'Documentary maker Tim Hetherington and photographer Chris Hondros killed', *Guardian*, 20 April 2011.

Rice, Xan and Peter Walker, 'Misrata mortar attacks kill at least 15 civilians', *Guardian*, 21 April 2011.

Roberts, Hugh, *The Battlefield, Algeria 1988–2002: Studies in a Broken Polity* (London, 2003).

Roberts, John, 'Photography after the photograph: event, archive, and the non-symbolic', *Oxford Art Journal* 32/2 (2009), pp. 281–98.

Roby, Marguerite, *My Adventures in the Congo* (London, 1911).

Ronnie, Art, *Counterfeit Hero: Fritz Duquesne, Adventurer and Spy* (Annapolis, MD, 1995).

Rosenbaum, Ron, 'The evil of banality: troubling new revelations about Arendt and Heidegger', *Slate*, 30 October 2009, available at www.slate.com/articles/life/the_spectator/2009/10/the_evil_of_banality.html (accessed 18 February 2014).

Rosler, Martha, 'In around and afterthoughts (on documentary photography)', in R. Bolton (ed.), *The Contest of Meaning: Critical Histories of Photography* (Cambridge, MA, 1992).

Ruga, Glenn, 'Curator's statement – the razor's edge: between documentary and fine art photography', New York Photography Festival 2012, available at http://nyph.at/ruga/curator_statement.html (accessed 18 February 2014).

Salhi, Zahia Smail, 'Algerian women, citizenship, and the "family code"', *Gender and Development* 11/3 (2003), pp. 27–35.

Salter, Jessica, 'Libya, in the line of fire', *Telegraph*, 20 May 2011..

Sambrook, Richard, *Are Foreign Correspondents Redundant? The Changing Face of International News* (Oxford, 2010).

Sante, Luc, *Evidence* (New York, 1992).

Schaffer, Kay and Sidonie Smith, *Human Rights and Narrated Lives: The Ethics of Recognition* (New York, 2004).

Scott, Martin, *The World in Focus: How UK Audiences Connect with the Wider World and the International Content of News in 2009* (London, 2010).

Seawright, Paul and Cristopher Coppock, *So Now Then* (Cardiff, 2006).

Sekula, Allan, *Photography Against the Grain: Essays and Photoworks* (Halifax, NS, 1973–83).

——— 'The traffic in photographs', in B.H.D. Buchloh, S. Guilbaut and D. Solkin (eds), *Modernism and Modernity* (Halifax, NS, 1983).

Shanks, Michael, 'Archaeology and the visual', discussion with Tim Webmoor for the Sawyer Seminar at Stanford Humanities Center, 2009, available at http://documents.stanford.edu/michaelshanks/admin/versions.html?pageid=144&versionnum=13 (accessed 18 February 2014).

——— 'Landscape aesthetics – the politics (continued)', 2011, available at www.mshanks.com/2011/07/11/landscape-aesthetics-the-politics-continued (accessed 18 February 2014).

Silber, Laura and Allan Little, *The Death of Yugoslavia* (New York, 1995).

Silverstein, Paul A., 'An excess of truth: violence, conspiracy theorizing and the Algerian civil war', *Anthropological Quarterly* 75/4 (2002), pp. 643–74.

——— *Algeria in France: Transpolitics, Race and Nation* (Bloomington, IN, 2004).

Simon, Roger I., 'The paradoxical practice of Zakhor: memories of "what has never been my fault or my deed"', in Roger I. Simon, Sharon Rosenberg and Claudia Eppert (eds), *Between Hope and Despair: The Pedagogical Encounter of Historical Remembrance* (Oxford 2000).

Sliwinski, Sharon, *Human Rights in Camera* (Chicago, 2011).

Slovic, Paul, '"If I look at the mass I will never act": psychic numbing and genocide', *Judgment and Decision Making* 12 (2007), pp. 79–95.

Small, Deborah A. and George Loewenstein, 'Helping a victim or helping the victim: altruism and identifiability', *Journal of Risk and Uncertainty* 26.1 (2003), pp. 5–16.

Small, Deborah A., George Loewenstein and Paul Slovic, 'Sympathy and callousness: the impact of deliberative thought on donations to identifiable and statistical victims', *Organizational Behavior and Human Decision Processes* 102/2 (2007), pp. 143–53.

Small, Deborah A. and Nicole M. Verrochi, 'The face of need: facial emotion expression on charity advertisements', *Journal of Marketing Research* 46/6 (2009), pp. 777–87.

Smith, Sean, 'War photographers are not addicted to danger', *Guardian*, 22 April 2011.

Smith, Sharon, 'Using women's rights to sell Washington's war', *International Socialist Review* 21 (January–February 2002), pp. 39–43.

Solomon-Godeau, Abigail, *Photography at the Dock: Essays on Photographic History, Institutions and Practices* (Minneapolis, 1994).

Sontag, Susan, *On Photography* (New York, 1977).

——— *Illness as Metaphor and AIDS and its Metaphors* (New York, 2001).

——— *Regarding the Pain of Others* (London and New York, 2003).

——— 'Regarding the torture of others', *New York Times*, 23 May 2004.

Sreberny, Annabelle, 'Unsuitable coverage: the media, the veil, and regimes of representation', in T. Oren and P. Petro (eds), *Global Currents: Media Technology and Now* (New Brunswick, NJ, 2004).

Stallabrass, Julian, 'Sebastião Salgado and fine art photojournalism', *New Left Review* 1/223 (May–June 1997), pp. 131–60.

――― *Art Incorporated: The Story of Contemporary Art* (Oxford, 2004).

――― 'Corruptible Kodak', *Photoworks* (Autumn–Winter 2005–6).

―――'Museum photography and museum prose', *New Left Review* 65 (September–October 2010), pp. 93–124.

Stock, J. and M. Mettelsiefen, 'Life on the rebel side of the crosshairs', *Spiegel* Online (2011), available at www.spiegel.de/international/europe/misurata-s-sniper-war-life-on-the-rebel-side-of-the-crosshairs-a-758080.html (accessed 16 March 2014).

Stora, Benjamin, *La Guerre invisible: Algérie, années 90*, (Paris, 2001).

――― 'L'absence d'images déréalise l'Algérie: Elle construit un pays fantasmé qui n'existe pas', *Cahiers du Cinéma* (February 2003), pp. 7–13.

Struk, Janina, *Photographing the Holocaust: Interpretations of the Evidence* (London, 2004).

Sturken, Marita, *Tangled Memories: The Vietnam War, the AIDS Epidemic, and the Politics of Remembering* (Berkeley, CA, 1997).

Sultan, Larry and Mike Mandel, *Evidence* (New York, 2003).

Swaisland, H.C., 'Bourne, Henry Richard Fox (1837–1909)', *Oxford Dictionary of National Biography*, available at www.oxforddnb.com/view/article/31993 (accessed 18 February 2014).

Tagg, John, *The Burden of Representation: Essays on Photographies and Histories* (London, 1988).

――― *The Disciplinary Frame: Photographic Truths and the Capture of Meaning* (Minneapolis, 2009).

Taithe, Bertrand, 'Horror, abjection and compassion: from Dunant to compassion fatigue', *New Formations* 62 (2007), p. 135.

Taylor, Diana, *The Archive and the Repertoire: Performing Cultural Memory in the Americas* (Durham, NC, 2003).

Taylor, John, *War and Photography: Realism in the British Press* (London, 1991).

――― *Body Horror: Photojournalism, Catastrophe and War* (Manchester and New York, 1998).

――― 'Problems in photojournalism: realism, the nature of news and the humanitarian narrative', *Journalism Studies* 1 (2000), pp. 137–8.

Thussu, Daya Kishan and Des Freedman, *War and the Media: Reporting Conflict 24/7* (London, 2003).

Tooth, Roger, 'Photographers have to be near the action: sometimes too near', *Guardian*, 22 April 2011.

Trachtenberg, Alan, *Reading American Photographs: Images as History, Mathew Brady to Walker Evans* (New York, 1989).

Trice, Michael, 'Frontline history is not war porn', Partisans.org, 21 October 2011, available at www.partisans.org/node/930 (accessed 16 March 2014).

Twain, Mark, *King Leopold's Soliloquy* (Boston, MA, 1905).

VanDyke, Matt, 'Freed US writer describes Libyan jail ordeal', BBC World Africa (2011), available at www.bbc.co.uk/news/world-africa-14674110 (accessed 18 February 2014).

Virilio, Paul, *A Landscape of Events*, trans. Julie Rose (Cambridge, MA, 2000).

———— *The Original Accident*, trans. Julie Rose (Cambridge, MA, 2005).

Virilio, Paul and Sylvère Lotringer, *Pure War*, trans. M. Polizzotti (New York, 1983).

Wack, Henry W., *The Story of the Congo Free State* (London and New York, 1905).

Walker, Ian, 'Desert stories or faith in facts?', in M. Lister (ed.), *The Photographic Image in Digital Culture* (London, 1995).

Washbrook, C., 'Online journalist Mohammed Nabbous killed in Libya', Spy report, 20 March 2011, available at http://rafaelmartel.com/2011/03/19/online-journalist-mohammed-nabbous-killed-in-libya/ (accessed 16 March 2014).

The Week, 'Disaster porn?', *The Week*, 20 January 2010, available at http://theweek.com/article/index/105296/Haiti_coverage_Disaster_porn (accessed 18 February 2014).

White, Matthew, *The Great Big Book of Horrible Things: The Definitive Chronicle of History's 100 Worst Atrocities* (New York, 2011).

Widgery Inquiry, *Report of the Tribunal Appointed to Inquire into the Events on Sunday, 30 January 1972, which Led to Loss of Life in Connection with the Procession in Londonderry on that Day* [Widgery Report] (London, 1972), available at http://cain.ulst.ac.uk/hmso/widgery.htm (accessed 18 February 2014).

Williams, Eliza, 'Follow the Americans', *Creative Review*, 30 March 2007, available at www.creativereview.co.uk/cr-blog/2007/march/philip-jones-griffiths-on-vietnam (accessed 18 February 2014).

Wilson, Donald R., 'Philip Jones Griffiths dies in London', National Press Photographers Association, available at www.nppa.org/news_and_events/news/2008/03/griffiths (accessed 18 February 2014).

Wollen, Peters, 'Vectors of melancholy', in R. Rugoff (ed.), *The Scene of the Crime* (Cambridge, MA, 1997).

Yous, Nesroula, *Qui a tué à Bentalha? Chronique d'un massacre annoncé* (Paris, 2000).

Zelizer, Barbie, 'Finding aids to the past: bearing personal witness to traumatic public events', *Media, Culture and Society* 24/5 (2002), pp. 697–714.

———— 'Death in wartime photographs and the "other war" in Afghanistan', *Harvard International Journal of Press/Politics* 10/3 (2005), pp. 26–55.

———— *About to Die: How News Images Move the Public* (New York, 2010).

Index